Cellini and the Principles of Sculpture

Benvenuto Cellini is an incomparable source on the nature of art-making in sixteenth-century Italy. A practicing artist who worked in gold, bronze, marble, and on paper, he was also the author of treatises, discourses, poems, and letters about his own work and the works of his contemporaries. Collectively, these works show Cellini to be an authority on the reigning ideas about the virtues and properties of artists' materials, and a vivid witness to the poetically charged processes of transforming those materials into meaningful forms. In this study, Michael Cole looks at the media in which Cellini worked and at the perspective Cellini's artworks and theoretical writings offer on these. Examining how Cellini and those around him viewed the act of sculpture in the late Renaissance, he situates Cellini's views in the context of the history of art, science, poetics, and ethics. Cole demonstrates Cellini's continuing relevance to the broader study of artistic theory and practice in his time.

Michael Cole, a scholar of Late Renaissance and Baroque art, is assistant professor at the University of North Carolina, Chapel. Hill. Cole's work has appeared in the *Burlington Magazine*, *Studies in the History of Art*, and *Art History*. His 1999 *Art Bulletin* article on Cellini won the Arthur Kingsley Porter Prize from the College Art Association.

Cellini
and the Principles of
Sculpture

MICHAEL W. COLE

University of North Carolina, Chapel Hill

CAMBRIDGE
UNIVERSITY PRESS

PUBLISHED BY THE PRESS SYNDICATE OF THE UNIVERSITY OF CAMBRIDGE
The Pitt Building, Trumpington Street, Cambridge, United Kingdom

CAMBRIDGE UNIVERSITY PRESS
The Edinburgh Building, Cambridge CB2 2RU, UK
40 West 20th Street, New York, NY 10011-4211, USA
477 Williamstown Road, Port Melbourne, VIC 3207, Australia
Ruiz de Alarcón 13, 28014 Madrid, Spain
Dock House, The Waterfront, Cape Town 8001, South Africa

http://www.cambridge.org

First published 2002

Printed in the United Kingdom at the University Press, Cambridge

Typefaces Bembo 11/13.5 pt. and Centaur *System* LaTeX 2$_\varepsilon$ [TB]

A catalog record for this book is available from the British Library.

Library of Congress Cataloging in Publication Data

ISBN 0 521 81321 2 hardback

Publication of this book was in part made by possible by a grant from The Publications
Committee, Department of Art and Archaeology, Princeton University.

To My Parents

Contents

List of Illustrations

Acknowledgments

This book has become a deposit for many accumulated debts, and I can only begin to repay them with these words. I conducted much of my early research on Cellini while a Fellow at the Kunsthistorisches Institut in Florence from 1996 to 1998. I owe thanks to the Samuel H. Kress Foundation for supporting me in these years; to the Insitut and to its Director for their hospitality; and to the other scholars then based in the city, especially Crispin De Courcey-Bayley, Frank Fehrenbach, Henry Keazor, Britta Kusch, Stefanie Solum, and Ulrich Pfisterer, for making Florence such an exciting place to work. I also wish to thank the staffs of Davis, Sloane, and Wilson libraries in Chapel Hill; of the Archivio di Stato, the Biblioteca Laurenziana, Biblioteca Nazionale, and especially of the Biblioteca Riccardiana in Florence; of the Bibliothèque Nationale in Paris; of Firestone and Marquand libraries in Princeton; of the Biblioteca Hertziana in Rome; and of the Biblioteca Marciana in Venice for making their resources and their personal expertise available to me.

The project itself first took form as the doctoral dissertation I submitted to Princeton University in the spring of 1999. I am grateful to the Mrs. Giles Whiting Foundation, which supported a year of writing in 1998 and 1999; to two model teachers, Patricia Fortini Brown and John Pinto, who offered me invaluable guidance in the years I was a student there; to Yoshiaki Shimizu, who, with Professors Brown and Pinto, advised me on how to rewrite the dissertation as a book; and especially to Thomas DaCosta Kaufmann, who advised the dissertation, and who, over the years I worked on the project, unfailingly steered me in profitable directions. For reading versions of what became individual chapters in this book, I am grateful to Elizabeth Cropper, Amy Gutman, Esther DaCosta Meyer, Alexander Nehamas, Ulrich Pfisterer, François Rigolot, and Madeleine Viljoen. I also owe thanks to Kathleen Weil-Garris Brandt, Wolfger Bulst, Charles Dempsey, Pietro Frassica, William Hood, Stanko Kokole, Peta Motture, Eike Schmidt, Louis Waldman, Kurt

Zeitler, and Dimitrios Zikos, who have generously offered information and ideas on specific points along the way.

Aspects of the arguments in Chapter 2 were presented in lectures at the Charles Singleton Center for Italian Studies in Florence, on the invitation of Professor Cropper; at the University of Kassel, on the invitation of Berthold Hinz; and at the spring 2000 meeting of the Renaissance Society of America in Florence. Earlier versions of Chapter 4 were presented in 1999 at the Center for Human Values at Princeton University and at the University of North Carolina in Chapel Hill. An abbreviated version of Chapter 1 was presented at a fall 2000 conference on Cellini organized by Beth Holman at the Bard Graduate Center for the Decorative Arts; an excerpt from Chapter 3 was incorporated into a paper delivered at a conference organized by Alessandro Nova and Anna Schreuers at the University of Frankfurt. On all of these occasions, I benefited from discussions with audience members, and I am grateful to my hosts for the opportunities to share my work. A shorter and somewhat different version of some of the material that appears here in Chapter 2 appeared earlier under the title "Cellini's Blood," *Art Bulletin* 81 (1999): 215–35. In preparing that material, I received helpful comments from two anonymous readers.

I completed the book at Chapel Hill, where I have been tremendously fortunate to benefit from the erudition and insight of my colleague Mary Pardo. The comments of my readers at Cambridge University Press, John Paoletti, David Summers, and Robert Williams, as well as those of my editor, Beatrice Rehl, were fundamental in shaping the book as it now exists. Finally, I owe thanks to the Publications Committee of the Department of Art and Archaeology at Princeton University, which generously defrayed the book's publication and production costs.

Chapel Hill
December 2000

Cellini
and the Principles of
Sculpture

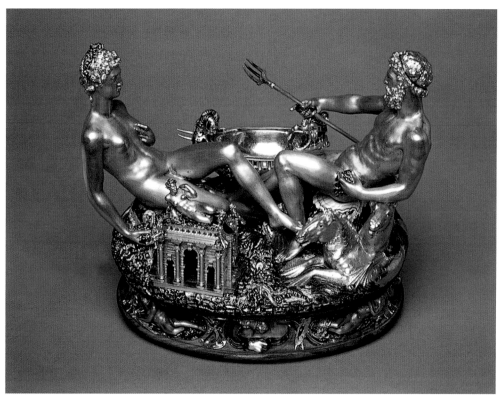

PLATE I. Benvenuto Cellini, *Saltcellar*. Vienna, Kunsthistorisches Museum.

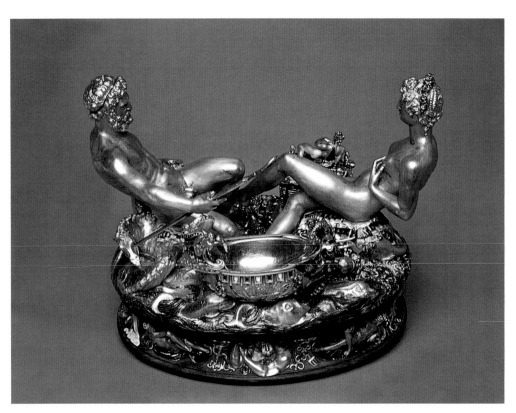

PLATE 2. Cellini, *Saltcellar.*

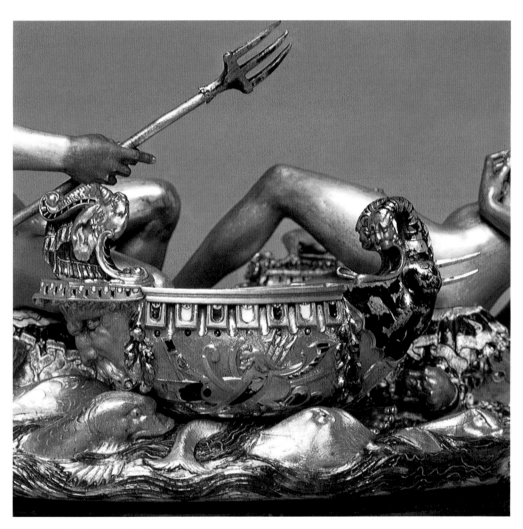

PLATE 3. Cellini, *Saltcellar* (detail).

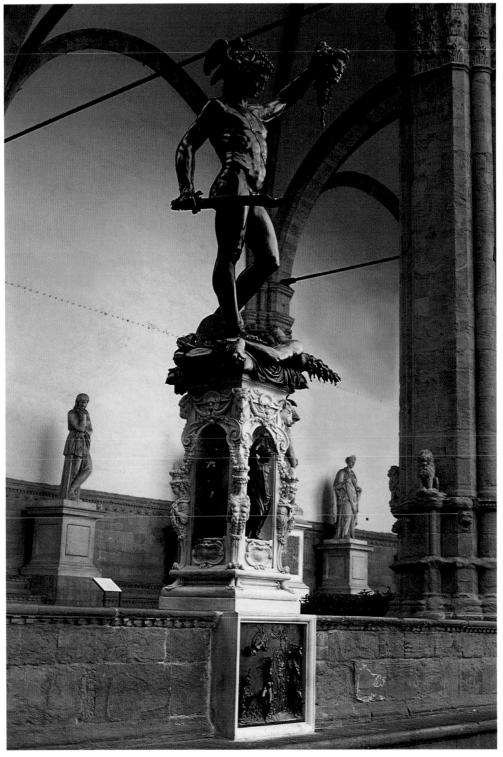

PLATE 4. Cellini, *Perseus and Medusa*. Florence, Piazza della Signoria (photo: Wolf-Dietrich Löhr).

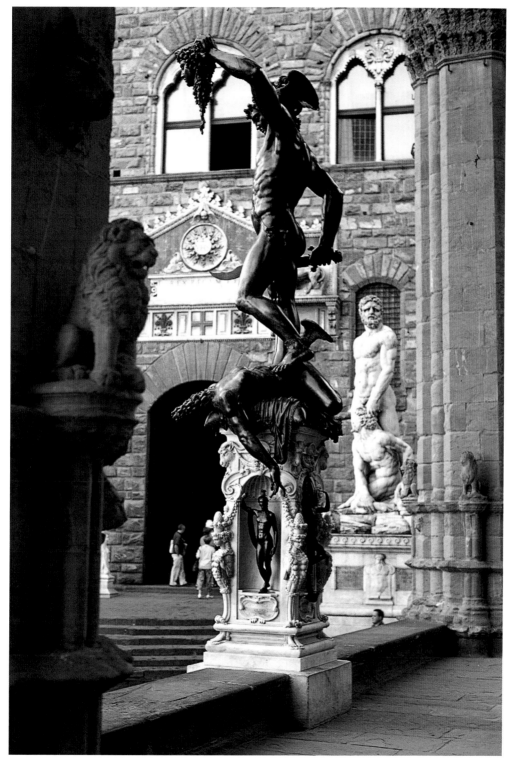

PLATE 5. Cellini, *Perseus and Medusa* (photo: Wolf-Dietrich Löhr).

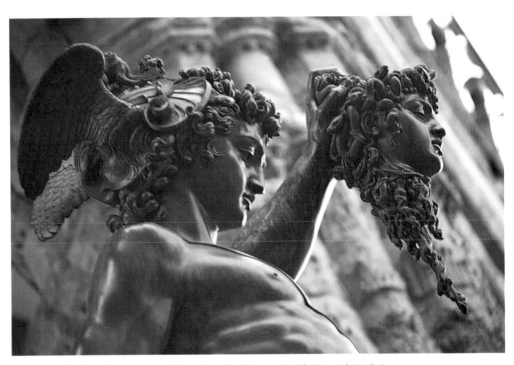

PLATE 6. Cellini, *Perseus and Medusa* (detail. Photo: Wolf–Dietrich Löhr).

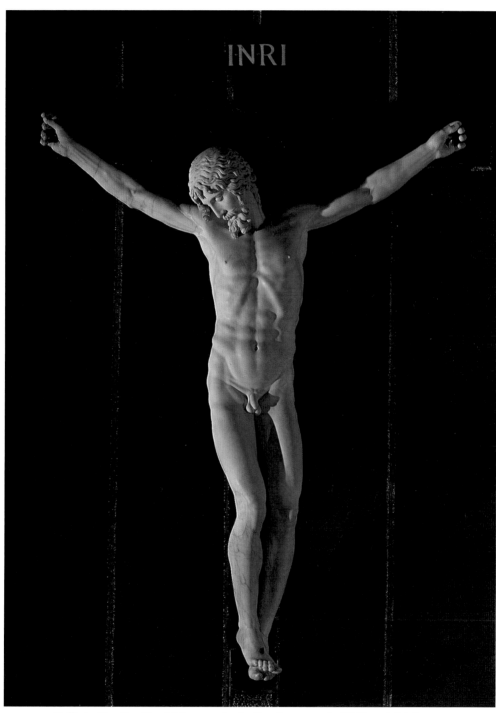

PLATE 7. Cellini, *Crucifix*. Real Monasterio de San Lorenzo de El Escorial (photo: Archivo Ordonoz).

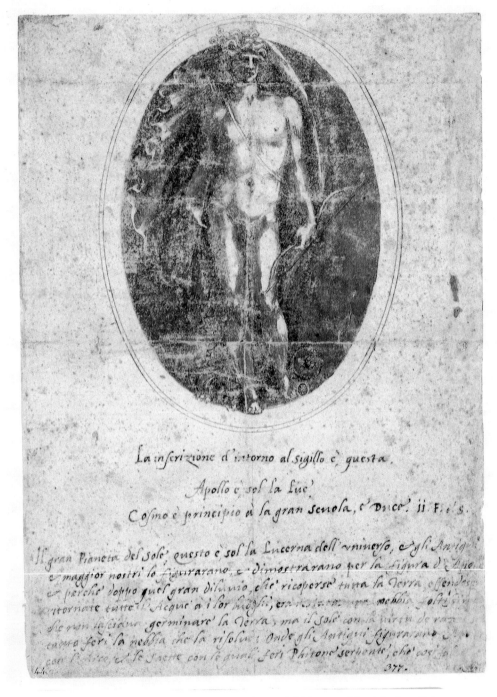

PLATE 8. Cellini, Design for the Seal of the Accademia del Disegno. Munich, Staatliche Graphische Sammlung.

Introduction

*S*culpture, writes the painter, is an art of noise, dirt, and sweat. In contrast to painting, the picture of the mind, sculpture is the product of the body; it is the active pathway into the visual arts, the alternative to the contemplative life. Sculpture is, as it was with the ancients, an art of the hand, a *techne*, and as such, it is the very antithesis to painterly pastimes like poetry or music.

This argument, vividly articulated by Leonardo da Vinci in the Codex Urbinas, may well seem to encapsulate early modern painting's image of itself.[1] Thus, Rubens, coloring the canvas to recitations of Tacitus, reincarnates Leonardo's painter, "who sits at his easel at great ease, well-dressed, and wielding the lightest brush," "accompanied by music or readers of varied and beautiful works."[2] Portraits of painters, meanwhile, make similar points; the activities of Sofonisba Anguissola, Paolo Veronese (Fig. 1), and Paul Bril are sublimated into music; images of Raphael and Titian go so far as to suppress reference to manual practice altogether. As for the difference of painting from sculpture this entails, Antonfrancesco Doni, for one, suggested that personifications of Painting and Sculpture should be clothed differently, because the work of painting is "most pleasant," while that of sculpture is "bitter, hard, [and] exhausting."[3] The painter Federico Zuccaro, in a lecture on "The Definition of Sculpture," began his characterization of the medium with a reference to sculptors' distinctive "trauaglio e sudore."[4]

By the end of the sixteenth century, such a view of the sister arts and their difference was a cliché. And for this very reason, apologies for *sculpture* become especially captivating. Sculptors, to be sure, were no less insistent than painters that their craft involved its specific intelligence. Yet faced with the question of whether their art was more *operative* than painting, defenders of sculpture, it turns out, might well agree that it was. Michelangelo portrayed himself not in the fine clothes of the gentleman, but in a protective turban (Fig. 2) − a reference to the very marble dust that Leonardo derided.[5] Contemporaries of

1. Veronese, *Wedding at Cana* (detail). Paris, Louvre (photo: Réunion des Musées Nationaux/Art Resource).

Vincenzo Danti and Giambologna compared the sculptors to Hercules and to the Roman soldier Talassius. Bernini, among all the subjects of his early works, chose to place his face on the one that was most dynamic, the *David* who winds every muscle in preparation to unleash a strike. Adriaen de Vries, finally, favored an image of Vulcan, swinging his hammer amidst the heat and the soot of a foundry.[6] Sculptors and their viewers knew condemnations such as Leonardo's, yet they did not reject the allegation that their craft was one of works. Rather, they began to ask what sculpture's very exercises might amount to.

That move is the subject of the present book. Its argument concerns the ways in which artists and their observers gave meaning to things people did when they made sculpture. At its center is a figure whose theory and practice supremely exemplified the expanse, and significance, of the Renaissance

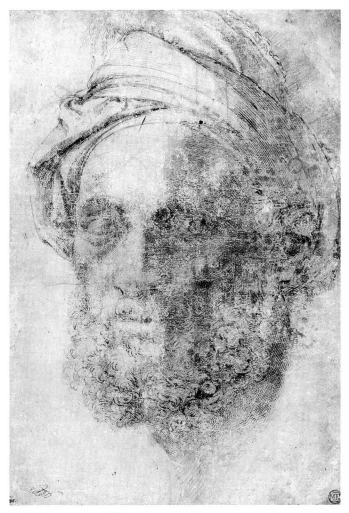

2. Michelangelo, *Self-Portrait*. Paris, Louvre (photo: Réunion des Musées Nationaux/Art Resource).

sculptor's field: the artist and writer Benvenuto Cellini. An heir to Michelangelo in a culture grappling with the question of what good works were, Cellini demonstrated an unparalleled concern with the functions that constituted the sculptural vocation. His works orient an understanding of the sculptural act.

Cellini claimed that his profession consisted of a definable array of *esercizi*, or *lavori*.[7] The story he eventually told of his life was a tale of how he, uniquely, managed them all.

Born in Florence in 1500, Cellini was the son of an engineer. Fascinated with the mirrors and other ingenious objects he saw his father invent, and

probably watching both Leonardo and Michelangelo at work, he decided at an early age to become an artist.[8] In his teens and twenties, Cellini traveled between Florence, Siena, Bologna, Pisa, and Rome, passing through a number of goldsmiths' and painters' shops, making cameos, vases, rings, candlesticks, and other *minuterie* (all now lost or unidentifiable), seldom spending more than a few months with any one master.[9] In 1528, he was in Mantua, working for Cardinal Ercole Gonzaga, and in the late 1520s, he finally landed in Rome, where he became a die-cutter for the Pontifical mint.[10] In 1535, this post lost, his reputation compromised by his murder of a rival goldsmith, and fearing the intrigues happening around the newly elected Pope Paul III, Cellini fled the city for Florence, where he designed a series of coins for Florence's first, short-lived Medici Duke, Alessandro I. After another brief stay in Rome, Cellini traveled to Padua, where he designed a portrait medal for Cardinal Pietro Bembo,[11] then on through Switzerland to France, where he made a medal for King Francis I.

The loss of Cellini's precious metalworks creates the rather skewed impression that Cellini was, in the 1530s, primarily a coin-maker. Both extant works and textual records, however, document the phase of his career that began when the artist, having returned to Rome, entered the circle of Ippolito D'Este, the new Cardinal of Ferrara. The cardinal encouraged Cellini to think about works on a new scale, and, securing Cellini's freedom after he had been imprisoned for theft, arranged the artist's most consequential move: a transfer to the court of the French king at Fontainebleau.[12] Cellini was invited to France to make a series of twelve silver candleholders, scaled to the size of the king and formed in the image of Roman deities, for Francis's dining room. Of these, however, only a few seem to have progressed to the design stage, and only one, no longer extant, was carried out. Rather than seeing to his assignment, Cellini used the opportunity of his new court position to test the bounds of his previous artistic profile. While he continued making metalworks, these would now include such fantasies as the great Vienna *Saltcellar*. The tiny building the *Saltcellar* featured (Fig. 3) reflected Cellini's still bigger visions – to redesign Fontainebleau's Porte Dorée, outfitting it with monumental bronze ornaments, and to construct for the chateau a titanic fountain. When Cellini returned to Florence in 1545, now to work for Alessandro's successor, Duke Cosimo I de' Medici, it was similarly grand projects that he would pursue. Assigned to undertake a large bronze *Perseus*, he expanded his design beyond what had been stipulated in the original commission, incorporating marble as well as metal, *historie* in relief as well as sculpture in the round, and seven independent figures in place of the original one. At the same time, Cellini exploited the time and resources that came with his salaried position to work on a number of independent projects, including a series of free-standing works of stone.

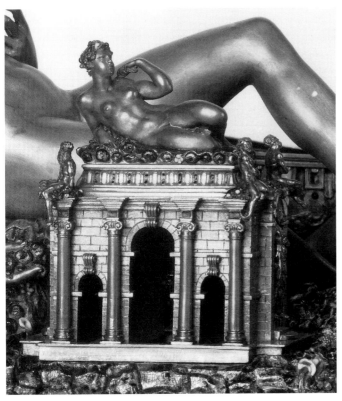

3. Benvenuto Cellini, *Saltcellar* (detail: *Tempietto*). Vienna, Kunsthistorisches Museum.

Beginning in 1554, the year in which the *Perseus* was unveiled, Cellini's efforts began to be shadowed by compromises and disappointments. He spent the better part of a decade developing plans for his own tomb, negotiating a space allotment with the brothers at two churches, designing its basic components (Fig. 4), stipulating which artists, following his demise, should execute its ornaments, carving with his own hand its centerpiece, a marble *Crucifix*. By the late 1550s, however, Cellini had failed to secure a location for its display; eventually, he gave the *Crucifix,* a fragment of larger plans, to the Duke.[13] Still more frustrated was Cellini's pursuit of the commission for the largest public project that came available in those years, the *Neptune* fountain Cosimo envisioned as the succession to the *Perseus* in the Piazza della Signoria. Having convinced the Duke to allow a competition for the assignment, Cellini spent months preparing first a small wax design, then, in the sealed-off bay behind the *Perseus*, a full-scale gesso mock-up of his idea, only to lose the commission to Bartolommeo Ammannati.[14] Assigned to make a series of bronze reliefs for the pulpits of the Florence cathedral, his work on these was interrupted when Cellini was imprisoned, twice, for assault in 1556, and for sodomy in 1557.

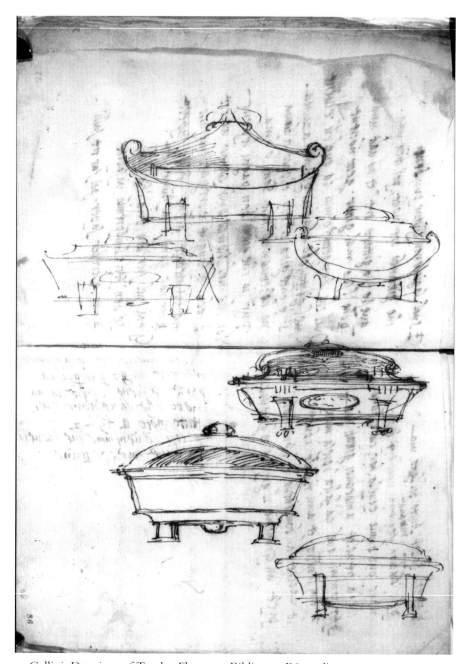

4. Cellini, Drawings of Tombs, Florence, Biblioteca Riccardiana.

Cellini returned to the reliefs with a revised scheme in the early 1560s, but completed none of them. When, in the spring of 1564, it was decided that the newly formed Florentine Accademia del Disegno should hold elaborate obsequies for the deceased Michelangelo, Cellini submitted a detailed proposal

for the appearance of the catafalque. It was rejected.[15] When the city's artists collaborated on far more extravagant urban decorations for the wedding of Grand Duke Francesco I, Cellini did not participate.[16] In his final years, the artist who had earlier boasted about his triumphal advancement from goldsmith to monumental sculptor opened a new goldsmith's shop. By the time of his death in 1571, designs for the objects this shop produced seem to have been his only artistic possibilities.[17]

It is no accident that it was in the late 1550s and in the 1560s that Cellini first turned seriously to writing about himself, filling books with comments on his earlier practice, verbally defending the honor that his works had done him. These texts, it is often said, betray Cellini's extraordinary vanity. What should not be overlooked, however, is that the texts also illustrate Cellini's exceptional keenness to the workings of his world. From his writings, it is evident that Cellini read broadly. He announces that he consumed the Bible, the *Divine Comedy*, and Giovanni Villani's *Chronicles*.[18] His own poetry, some of which was published in his lifetime, testifies to his familiarity not only with Petrarch, but also with Laura Battiferri, Francesco Maria Molza, and other major Cinquecento writers.[19] He certainly knew the work of Ariosto and Bembo, and probably that of Francesco Berni; he exchanged burlesque *proposte* and *risposte* with other poets of his city.[20] Both Benedetto Varchi and Antonfrancesco Grazzini praised his compositions; another contemporary noted his knowledge of Dante.[21] The forms of his *Trattati* – also published, in edited form, in his lifetime – suggest his familiarity with "recipe books" and other works of applied science.[22] His allusion to Narcissus in his famous 1547 letter to Varchi indicates that he knew Alberti's *Della Pittura*, probably in its recent vernacular publication; elsewhere, he announces his awareness of the writings of Sebastiano Serlio and Leonardo da Vinci.[23] While he may not have joined his younger brother in attending a proper Latin school, the fact that his father read medical literature and composed Latin epigrams, and that the artist's own friends addressed Latin poetry to him, suggests that he may even have had a basic proficiency with that language.[24] Nor was Cellini's knowledge merely bookish. His pages consistently bespeak his eagerness to converse with experts in other fields, learning about contemporary practices, and boasting about his own knowledge. He followed a Sicilian priest to learn about the art of necromancy, he went to a metallurgist to learn about mines, he associated with students of alchemy. Throughout his life, he followed the work of medical doctors. He fought with soldiers, he performed with musicians. He befriended intellectually more illustrious contemporaries, and was confident enough of his abilities to challenge an eminent poet like Luigi Alamanni when contriving conceits for artworks. Operating between the *bottega* and the court, tirelessly traveling between cities and countries, Cellini had access to the widest learning.

All of the evidence suggests that Cellini was prepared to engage the thinking of contemporaries in myriad fields with knowledge, decorum, and wit. When it is remembered that this person also authored a short work of architectural theory, two discourses on *disegno*, and an essay on pedagogy – and that he documented his undertakings not only in scores of poems and in a lengthy autobiography, but also in volumes of letters and *ricordi* – it is little wonder that Cellini later became a case study for nineteenth-century theorists of the *uomo universale*.[25] Goethe, admiring what he referred to as the *Allgemeinheit* of Cellini's talent, deputized the goldsmith to speak for the entire craftsman's rank.[26] Burckhardt, promoting Cellini as a man "who can do all and dares do all," promoted the artist as a paragon of individual expansiveness and perfection.[27] Opinions like these suggest that Cellini has been fundamental not only to the historiography of sixteenth-century art, but also to that of the Renaissance as such; it is significant, therefore, that they are opinions the artist himself cultivated.

Cellini's writings portray their creator as an actor of seemingly limitless versatility. What is striking, though – and what is missed in the arguments of the nineteenth-century historians – is how Cellini keys his performative flexibility to a sense of professional specificity. In his *Discourse on Architecture*, Cellini writes scornfully about a Ferrarese haberdasher who decided one day to make buildings rather than buttons. One could not but fail to make good designs, Cellini supposed, when one approached the task without training as a painter or sculptor.[28] In the preface to his *Treatise on Goldsmithery*, similarly, Cellini attacks what he describes as the artistic equivalents of suburban storekeepers, directionless workers who sell bread one day and pharmaceuticals the next, who try to do everything rather than learning the right practice of any single métier.[29] The haberdasher and the jack-of-all-trades, for Cellini, were foils to his own life's virtue; they indicated how his own achievements, far from proving infinite competency, began with the coherence of personal *Bildung* and vocational trajectory. Cellini discriminated a connectedness to his life; at points throughout the *Autobiography*, he notes the episodes that count as digressions from the central narration he wants to relate, that of his professional progress.[30] Conversely, when Cellini attributes to himself the incredible accomplishments he does, he delights in suggesting how these draw on, or reflect, his skills as an artist. Preparing for a duel, Cellini compares his swordsmanship to his "other art."[31] Escaping from prison, he employs a ruse involving the modeling of fake door hinges in wax.[32] Challenged to bring a beautiful date to a dinner party, he 'makes' one by disguising a young boy with golden ornaments.[33] Assisting at a surgical operation, Cellini applies his knowledge of cutting instruments to the invention of a scalpel.[34] Episodes like these argue that, if the artist was "universal," then his universe was anchored in his occupational identity and enabled by his art. "I resolved," Cellini writes at one point, "to devote all my

powers to working in all [my] professions equally."[35] Scope, he suggests, is a virtue, but only when it is professional. Cellini's universality depends, in large part, on the artist's application of his wit to his most repetitive operations. Herein, the present book suggests, lies Cellini's enduring historical value: His art and writings, which constitute the most informative late Renaissance source on sculptural technique in his day, also present acutely perceptive reflections on contemporary sculptural poetics.

This book thus posits an alternative to the views represented by the great modern study of what is now generally held to be the artist's *oeuvre*, John Pope-Hennessy's 1985 monograph *Cellini*. Above all, it resists Pope-Hennessy's premise that Cellini's writings were "true to tone as well as fact," as well as his consequent remark that Cellini should be admired, above all, for having "had a tape recorder built into his personality."[36] This resistance is not based so much on proofs of the extent to which Cellini wrote fictions about himself and others – although such proofs can be and have been given.[37] Rather, it rests on the sense that the transparent, factual histories to be found in Cellini's writings are not always the aspects of those documents that best serve an account of Cellini as an artist. The present book is not primarily concerned with Cellini's reliability as a witness or reporter; it is concerned, instead, with how Cellini understood his own exercises in relation to the things he saw going on around him, and with what that understanding, in turn, reveals about the sculptural profession in his time.

To understand Cellini's art of sculpture, it is necessary to begin with Cellini's representation of that art in his sculptural works. For while Cellini's writings no doubt contribute immeasurably to his interest – the artist himself, in fact, claimed to merit attention because he, unlike his expert colleagues, did not fall into the "error of silence" – this ought not disguise the degree to which his silent art was already discursive.[38] Cellini referred to the competing proposals for his *Saltcellar* as "designs made with words," effectively putting them on par with the designs he made with his hands.[39] The base of the *Perseus*, which, with its Hermathenic program, nods to the Florentine literary academy, also includes the figure of the "Iddea della Natura," whom Cellini later promoted as the ideal protectress of the artists' academy. In his poetry, Cellini refers to his *Perseus* as his "book."[40] Later, he would invent an alphabet constituted entirely by tools (Fig. 5).[41]

Cellini's objects themselves tell the first version of the story the artist later repeats in his *Vita* and *Trattati*; they are the primary evidence of the kinds of artistic choices he faced while moving through his successive fields of practice. These sculptures, while ostensibly wide-ranging in subject, share a consistent

5. Cellini, Design for the Seal of the Accademia del Disegno (detail). London, British Museum. © The British Museum.

aim: They seek to demonstrate the artistry inherent in the various acts they represent, and to relate that artistry to Cellini's own. As the chapters that follow will argue, Cellini turned to such subjects as the provision of salt, or the spilling of blood, or the "mastering" of a competitor, for their implications about his own sculptural labors. Cellini's imagery traced the changing conditions of his artistic office; by coordinating this imagery with his later writings, the book will suggest, it is possible to reconstruct the strategies with which Cellini fashioned his career. The studies that follow maintain that Cellini's art takes its real significance from its complementarity to the discussions of sculptural performance that constitute the major part of Cellini's later writing. Unlike Pope-Hennessy's book, which aimed to offer a comprehensive, biographically organized survey of Cellini's sculptural output, the present study will concentrate on a number of passages in Cellini's sculpture that are, like Cellini's writings, informatively self-referential. These passages, which highlight the different operations his sculpting involved, help to define key qualities of Cellini's and his contemporaries' artistic theory and practice.

The book consists of four semi-monographic chapters, each of which treats one field in which the artist worked. The first chapter, on Cellini's labors with precious metals, looks especially at the *Saltcellar* Cellini invented in Rome in early 1540 and reformulated in France in the years immediately following. It argues that that object's central idea, the union of earth and water responsible for the generation of salt, conceives composition in a manner that likens the intelligence of the goldsmith to that of the natural historian. As such, it suggests, the work speaks to the question of what the peculiar wisdom of one in Cellini's original profession might be. As a *summa* of Cellini's work as a goldsmith and as a crucial move toward more ambitious undertakings in metal, the *Saltcellar* illustrates some of the ideas that will emerge throughout the book as principles of Cellini's sculptural art.

Chapter 2, on bronze statuary, concerns the making of Cellini's colossal *Perseus* in Florence a few years later. The chapter proposes that the *Perseus*, while competing with the colossal works of stone already present in its intended setting, also depended upon the history of goldsmithery, both the personal history Cellini represented by virtue of his own training, and the broader local history

that had charged the goldsmith to attempt ambitious casts. These motivations converged in Cellini's modification of the *Perseus*'s commissioned appearance to include a prominent representation of Medusa's blood. Both advertising the work's condition as *infused*, and evoking the mythical hardening of liquid into coral, the statue's blood emblematized the scene of casting in which the work originated. If the *Saltcellar* reminds the viewer how goldsmithery involved a basic expertise in metallic composition, the *Perseus* illustrates the reapplication of that expertise on a colossal scale.

The *Perseus*, no less than the *Saltcellar*, was a transitional work, establishing Cellini as the head of a workshop that turned out large works not only in bronze, but also in marble. While Cellini's skill in metal was never doubted, his expanded role presented particular challenges. The third chapter consequently looks at Cellini's first exercises as a marble sculptor, viewing these exercises against the cultural and political background that conditioned his new medium. It proposes that Cellini's first independent work in stone, the *Apollo and Hyacinth*, acknowledged his situation not only by raising the topic of artistic mastery, but also by challenging the grounds on which his anticipated rivals could diminish his achievement. The conception of marble sculpture entailed by the *Apollo* would inform all of Cellini's works in that medium. And the difficulties that work involved provide a kind of view in negative of the metal-worker's specialization.

Chapter 4, finally, considers Cellini's *disegno*. Stepping back from the series of professional maneuvers that constituted Cellini's career, the chapter highlights a broader issue raised throughout the artist's late sculptures and writings: that of how the practice of the sculptor accorded with broader ideals of good action. Like the previous three chapters, it suggests that Cellini aimed to produce not only particular kinds of images, but also particular kinds of works; far from being transparent depictions of their subjects, his artworks always define, through those subjects, a mode of constituent artistic labor. The final chapter begins with Cellini's assertion that design is the first principle of virtue, and proceeds to discuss the intersection, in Cellini's time, of sculptural and moral theory. The chapter considers the implications of this intersection for contemporary representations of heroism; looking in particular at the dialogue between Cellini, his predecessors, and his successors in the Florence's Piazza della Signoria, it examines some ways in which artists like Cellini could both establish and pursue particular forms of excellence.

Following Cellini, more or less chronologically, through his experiments with different materials, the chapters in this book double the self-portraits Cellini himself composed in his own professional histories. Throughout the book, nevertheless, it will remain important that Cellini's thoughts and actions were, in important ways, *not* personal. The possibility that Cellini's works carry the meanings that these pages attribute to them requires that others – other

artists, but also different kinds of experts – thought or could have thought similarly about the topics or issues that the working sculptor encountered. Cellini, the book implies, should no longer interest us as a misplaced Romantic hero; instead, he should interest us because his curiosity, his artisinal flexibility, and his vocational situation coordinately allowed him to filter, interweave, and re-articulate standard discourses in his time. Cellini's works, as the book's conclusion will suggest, particularize more general topics, but precisely on account of this, they constitute an outlook on a field of shared concerns. Because of the way Cellini approached both sculpture and writing, an analysis of his occupations can have yields for the broader study of late Renaissance art.

Primary among these yields is a contribution to the history of the sculptural medium. In the last several decades, art historians have developed an increasingly refined critical and historical apparatus for thinking about painting; there are now good articles and books devoted to perspective, color theory, light and shadow, pictorial composition, and related topics. The existing armory for dealing with the category of sculpture, however, remains considerably more limited. On the whole, discussions of sculpture as such have focused on two topics: The arguments adduced to defend the side of sculpture in what have come to be called the "paragone" debates, and the technical and symbolic ways in which sculptors used materials.

Scholarship on the first of these topics has been concerned primarily with the form and sources of the *paragone* as a literary phenomenon. Few discussions of the *paragone*, and in particular of the *paragone* in its sixteenth-century form, have shed light on sculptural practice, let alone actual sculptures.[42] As two of the most consequential Cinquecento *paragone* exchanges were those prompted by Benedetto Varchi's *Lezzioni* in the late 1540s and by the death of Michelangelo in the early 1560s, and as Cellini was a major voice in both of these, Cellini's contributions to the *paragone* invite consideration.[43] At the same time, a study of Cellini that is also to be a history of art must deal with what can be understood as a sort of by-product of the *paragone*'s occasion: the possibility of thinking through actual sculptural projects in terms of medium. This book will work from the assumption that Cellini's own literary history legitimates bringing topoi from the *paragone* arguments to bear on Cellini's sculptural works. Because sculptures are the book's real object, though, the book will also proceed cautiously here. Taken in themselves, *paragone* writings are insufficient theoretical sources for the discussion of late Renaissance sculpture. The lines they draw are frequently too sharp: That writers could agree with Leonardo, for example, that sculpture is a distinctively operative art, does not mean that there is *no* act of painting, or that painting in Cellini's day could not sustain the sort of analysis that the *paragone* seems to recommend for sculpture. At the same time, the picture the *paragone* presents is often not sharp enough. Because

its topics are conventional and even formulaic, *paragone* writings can fail to capture what a particular sculptor is doing with a medium.

The book maintains that the *paragone* was not the only discourse that enabled thoughts about the sculptural medium, and in this, it at least partially adheres to the intuitions of a growing literature on sculptors' materials. Particularly since the publication in 1980 of Michael Baxandall's *Limewood Sculptors of Renaissance Germany*, scholars have become newly interested in questions of how and why sculptors used the stuffs they did.[44] Studies now inquire not only into the "natural" properties of stones, woods, and metals, but also into the broader conceptual and institutional conditions of sculptural production.[45] On all of these topics, Cellini's writings are informative and to date under-utilized texts, and the degree to which the present book follows Baxandall's cue will be immediately evident. Though the materials of sculpture are pro-tagonists in this study, however, they are not its primary subjects. Indeed, the topic here – the sculptor's act, the kind of performance that a sculptor could undertake when exploring a given conjunction of subject and medium – is in some ways the opposite of, or counterpart to, that of the sculptor's material. A guiding thought through each of the following chapters is that the sculp-tor's work amounts to a repertoire of procedures (composing, casting, carving, modeling, drawing), and that these procedures realize not only the material, but also the artist. In part, the idea is to mine Cellini, his sources, and his critics for a historically apt language to describe what artists were thought to be doing when they made three-dimensional objects. In part, it is to ask how taking up one or another sculptural approach gained resonance on analogy to other sorts of practices (alchemy, medicine, necromancy, combat, statecraft) that contem-poraries cared about. In Cellini's time, artists believed that when particular tasks were done in particular ways, they could assume an almost allegorical status, typologically duplicating the deeds of heroes, of nature, of God. Michelangelo viewed marble carving, the stripping away of skin to reveal the purged form beneath, as a model of redemption; Cellini, similarly, understood an act like designing as a path to a more general condition of excellence. One sort of artis-tic practice might show Cellini to be devout, or divine; another might prove him magisterial, or wise. The book will consider the ways in which sculptors' acts contributed to their vocational identity, informed their thinking about the cultural roles they played, and affected the kinds of imagery they made.

Beyond its contribution to the history of the sculptural medium, finally, the study may have a more general yield, one pertaining to our understanding of the historical phenomenon sometimes called "Mannerism." The great Cellini scholar Piero Calamandrei once pronounced that, were it not for the existence of the *Autobiography*, "We would hardly be able to distinguish Cellini from the other mannerists of his time."[46] While it is a goal of this book to work against the prejudices that motivated that comment, a more neutral restatement

of Calamandrei's notion is worth considering, especially when Mannerism, in turn, is held to involve the distillation of object-making into something like pure artistry, an "art of art."[47] If Mannerist art is supremely self-reflective, if it is, so to speak, a first-person style, then in what ways does Cellini exemplify it?

An answer to this question will have to reckon with the fact that egregious artistry has long been associated with self-absorption, solipsism, cultural alienation. When Michael Camille, to take but one particularly powerful example, attacks art made *as* art for contributing only to a cult of the author's name, to a dissolution of the object's ethical and devotional importance, he enlists a mode of criticism almost as old as the "art" he questions.[48] If, as evidence suggests, such criticism emerged with particular vigor just after the middle decades of the sixteenth century, its targeting of Mannerism in general and Cellini's generation of artists in particular seems particularly fraught.[49] Artfulness was something for which, even in their day, artists like Cellini could be held responsible.

These circumstances made it all the more possible for the artists most guilty of, or committed to, making conspicuously produced, as opposed to conspicuously functional, objects, to be concerned with the intellectual and moral implications their artfulness held. While it is true that early modern artists were fascinated with the fame of their names[50] and with the commodity-value of their talent,[51] this did not mean that they consequently viewed their art as soulless, or as autonomous. Sometimes, artistry itself could assume something like a ritual significance; making an object in the right way could be a question of devotion and of proper form. Other times, the commitment to one or another form of artistry could refocus ethical or political concerns; making something in one or another way could be a principled matter. The fact of being artfully produced, in sum, did not, as we sometimes assume, make works vain. It could, on the contrary, allow artists new modes of social and religious connectedness.

The chapers that follow consider the artist's successive undertakings in metal, in stone, and on paper; his choice and use of visual subject and motif to remark and characterize his endeavors; and his coordination of word and image to expand adeptness at art into more momentous ethical and religious achievement. Drawing on many of the writer's own texts, as well as on contemporary art theory, poetics, technology, moral philosophy, and natural history, the study offers a perspective on how the sixteenth-century sculptor, through his artistic acts, could participate in his culture.

Salt, Composition, and the Goldsmith's Intelligence

We maintain that artificers know more than experts.

– Alexander of Aphrodisias[1]

If I knew all the virtues of salts, I think I would do marvelous things.

– Bernard Palissy[2]

When Vasari famously made *disegno* a limiting term, defining with it a province occupied exclusively by architecture, painting, sculpture, and the practices involved in their conception, he knowingly diminished whatever artistic fields fell outside *disegno*'s bounds. As his accounts of how craftsmen became *disegnatori* showed, moreover, a peculiar casualty of Vasari's scheme was the art of goldsmithery. Though he realized that many of the designers he most admired had attained their skills with goldsmiths, Vasari hinged his accounts of their art not on the outcome of this training, but rather on the abandonment of it, assigning to each artist an imagined moment of self-discovery. His typical biography would include a decisive point in the artist's apprenticeship when, bored with his activities, he turned on his master, rejecting the goldsmith's principles in order to take up more ambitious things. Thus, Lorenzo Ghiberti began as a goldsmith, but quit after finding that he "delighted much more in the art of sculpture and design."[3] Masolino, trained in the same way, took up painting at the age of nineteen, and thereafter did nothing else.[4] Brunelleschi stayed in the goldsmith's shop only until he was overcome by "a desire to make great sculptures."[5] Ghirlandaio, "made by nature to be a painter," took no pleasure in his early work as a goldsmith, and soon found himself doing nothing but designs.[6] Antonio Pollaiuolo, turning from goldsmithery to painting, discovered the new art to be "so different from that of the goldsmith, that had he not been resolved to abandon entirely his former art, he would probably

have gone back to it." Only because he was driven by *shame*, Vasari writes, did Pollaiuolo manage to stay with painting.[7]

Watching the psychodramas of Vasari's pivotal young artists accumulate, it is tempting to conclude that Vasari ends up spotlighting what he would occlude. While he insists that *disegno* was something of which goldsmiths themselves were remarkably ignorant, he suspiciously implies that, time after time, *disegno* was something that students discovered while they were working in goldsmith shops. Though the *Lives* set out to characterize an art, or at least a group of artists, that *break* with goldsmithing they end up suggesting that the phenomenon we know as the Renaissance *depended on* the studios goldsmiths had established. Though Vasari would give the impression that goldsmithery was a matter merely of diligence and industry, his stories ultimately encourage a closer look at the arts that competed with Vasari's, at views that, better than Vasari's, reveal what the activities of the goldsmith were like. Cellini is a tempting place to begin, not only because Vasari accommodates his career, too, to the conventional format – Bandinelli could not understand, Vasari writes, how Cellini went so quickly from being a goldsmith to being a sculptor[8] – but also because Cellini's own later art and writings offer a very different impession of what the goldsmith, *qua* goldsmith, already knew.

Even at the end of his career, Cellini took his work as a designer to be grounded in his background as a goldsmith, and the normative pedagogy he outlined for successors, accordingly, was very different from the one Vasari promoted. Cellini insisted, for example, that the arts of design were not three, but four: architecture, painting, sculpture – which he limited to work in "earth" – and metalwork, which included everything from small decorative objects to monumental bronze casts.[9] When he wrote his two *Treatises*, one on goldsmithery, the other on sculpture, he made them two parts of the same book. His autobiography presents the youth, as a goldsmith, being observed by his patrons as he drew ancient sculpture and modern painting,[10] and the advanced artist, again as a goldsmith, conceiving his own poetic programs. As a whole, Cellini's writings suggest that the expert goldsmith, to know his trade, had to know the canon his artistic predecessors had left, had to be able to lay out his own blueprints, and had to be able to invent.

It might be argued that Cellini's vision of the goldsmith's capacities, and even of the goldsmith's *disegno*, is most powerfully formulated not in a text, but in a precious object: the *Saltcellar* he executed in France in the early 1540s (Figs. 6 and 7). The object, which incorporates classical characters and naturalist themes, which demonstrates an understanding both of ancient Roman architecture and of the modern Michelangelesque nude, and which, in these and other ways, lays the ground for Cellini's later, larger works, was all, the artist insists, of his own design. What's more – as Peter Meller first noticed – the table ornament contains a probable self-portrait of the artist in the form of

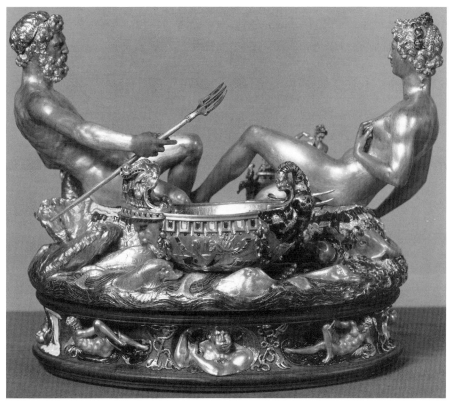

6. Cellini, *Saltcellar.* Vienna, Kunsthistorisches Museum.

the container that, had the work been used, would have been filled with salt (Fig. 8).[11] Meller convincingly suggested that the portrait-vessel puns on the idea of "having salt in one's head," of being witty, intelligent. The observation raises a cluster of basic questions about the artist, his profession, and the profession's place in the culture of Cellini's time. If the boat is a self-portrait, how does it fit into the larger program of the saltcellar? And what significance does the object as a whole, with its witticism, then hold for Cellini's *oeuvre* more generally? Just what might a goldsmith's intelligence amount to? And just how might that intelligence compare to the intelligence of, say, a poet, a painter, a sculptor, or a king?

Assumptions about Cellini's intelligence, and consequently about the way he might have thought about his work, have long shaped the histories written about him. On the one hand, Cellini's successive positions in three of the most sophisticated courts in Europe, his friendship with the most prominent poets and philosophers of those milieus, and the evidence of his own writings have encouraged historians to set store by his testimonies in their overviews of sixteenth-century art theory.[12] On the other hand, an older view of Cellini as the paradigmatic Renaissance artisan, interested exclusively in the crafting of

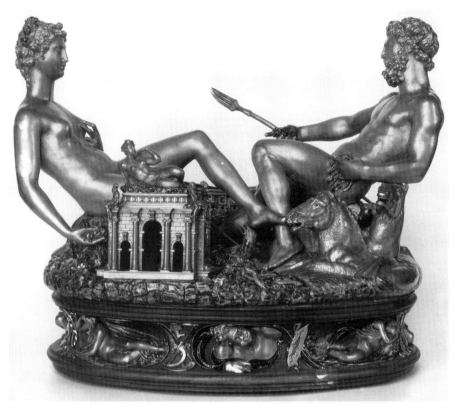

7. Cellini, *Saltcellar.*

materials, continues to find defenders.[13] For these reasons, an explicit reference like the *Saltcellar's* to the artist's intelligence demands especial attention.

Cellini claims to have made the model for the work (now lost) while enjoying the protection of Cardinal Ippolito D'Este in Rome, and the final version (now in Vienna) some years later, while working for King Francis I in France. He thus presents the object as a bridge between two very different sets of circumstances in two very different environs. Regarding the "intelligence" of the work in particular, moreover, Cellini offers a thorny starting point with his own story, written two decades after the fact, of the work's origins:

> The Cardinal told me, along with those two others, that I was to make him a model for a saltcellar, and that he wanted it to go beyond the bounds of all those who had made saltcellars in the past. Messer Luigi [Alamanni], with regard to this, and apropos of this salt, said many marvelous things; messer Gabbriello Cesano, too, said very beautiful things about the subject. The Cardinal, listening carefully and extremely happy with the designs that the two great *virtuosi* had made with their words, turned to me and said, "Benvenuto, the design of messer Luigi and that of messer Gabbriello both please me so much that I wouldn't know

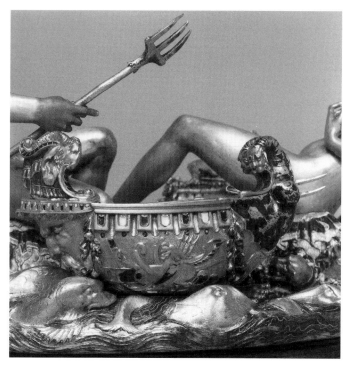

8. Cellini, *Saltcellar* (detail).

which of the two to choose. I'll leave the decision to you, since you are the one who must make the work."

To this, I said, "You know, my lords, how important the sons of kings and emperors are, and you see the marvelous splendor and divinity that appears in them. Nevertheless, if you ask a poor humble shepherd whether he has more love and affection for these sons or for his own, he will certainly tell you that he has more love for his own children. In the same way I have great love for my children, those which I bear in my profession. And as such, my most reverend patron, the first thing that I will show you will be my work and my invention. For there are many things that are beautiful to say, but which, when made, do not work out very well."[14]

Cellini's anecdote suggests that the intelligence of the saltcellar includes the artist's *opera* and *inventione*. But what are to be made of these? Cellini's remarks about the nontranslatability of the poets' verbal conceits, along with his subsequent description of how he set about making his model, might encourage the supposition that Cellini subordinated literariness for the sake of form. Charles Hope, for one, argues that "the sculptor [of the *Saltcellar*] took as his starting point the problem of devising a satisfactory composition, and only then chose an appropriate subject to fit."[15] Yet Cellini's story might also seem to intend just the contrary of this. In claiming responsibility not only for the execution, but

also for the invention of the piece, the goldsmith might be aiming to arrogate "poetic" duties normally given to others. In this spirit, both Julius Schlosser and Andreas Prater, in contrast to Hope, have assumed that Cellini's work was eminently literary. For Schlosser, its invention relied on key concepts from contemporary art theory (beauty, grotesque, caprice, conceit); for Prater it constituted a dense allegory relating to the interests of its ultimate sponsor, King Francis I.[16]

We need to keep all three of these views – Hope's contention that Cellini was interested in composition, Schlosser's that he was aware of theory, Prater's that he was considering his patrons – in mind. Still, there remains much to say about the intelligence the *Saltcellar* involves, about the kind of knowledge implied by its creation. Looking more carefully at Cellini's imagery, it should be possible to place the work at the intersection of the modes of thinking that happened inside and outside the workshop. For the intelligence to which Cellini refers with his self-portrait, and the work that that intelligence guided, are accidental neither to the imagery that the artist chose to use, nor to the stories that Cellini later told about that imagery's origins. Knowing how to make can be exclusive, disqualifying as ignorant ideas that come from people who only know how to speak, but it can also be inclusive, encompassing a kind of wisdom that matches the goldsmith with other artists in other media, and that qualifies him to enter the circles of the court.

In the Italian, Cellini's account of the Cardinal's commission reads as follows:

> Ancora m'aggiunse il Cardinale, insieme con quei dua sopra ditti, che io gli dovessi fare un modello d'una saliera; ma che arebbe voluto uscir dell'ordinario di quei che avean fatte saliere. Messer Luigi, sopra questo, approposito di questo sale, disse molte mirabil cose; messer Gabbriello Cesano ancora lui in questo proposito disse cose bellissime.[17]

The last sentence raises an issue of terminology: the proposals of the *virtuosi*, Cellini tells us, were "approposito di questo sale." Conceivably, Cellini's choice to use a word other than the "saliera" of the previous sentence could indicate that "sale" here refers not to the container, but to the substance it contains; perhaps the *virtuosi* spoke to him of the marvels of *salt*. The epigraph by Palissy that opens this chapter, an exclamation that appears in his own discussion of salty wonders, shows how possible such a conversation was. On the other hand, Cellini's choice of words could indicate that in the artist's idiolect, the words *saliera* and *sale* were interchangeable. In Cellini's Italian, as in modern English, a "saltcellar" could be referred to simply as a "salt."[18] Either way, it is worth

pausing over the possibility that, in making a saltcellar, Cellini was thinking about its primary contents.

Cellini writes that the larger figures in both the wax model he made in Rome and in the precious object he made in Paris are reclining personifications of *Terra* and *Mare*, Land and Sea. Prater has suggested, however, that the conjunction they represent might also be read in terms of elemental science. Referring to Aristotle's *Physics*, and taking "Land" and "Sea" to betoken "Earth" and "Water," Prater treats the work as an illustration of the erotic conjunctions that happen between male and female elements in the subplanetary cosmos.[19] This reading has not won universal acceptance; it has been objected, for instance, that Cellini, were his intention to show something about the elements generally, would likely have included not just two, but all four.[20] The proposal that the work indeed shows something like an elemental marriage, nevertheless, can be developed with greater cogency by looking more carefully at Cellini's subject, and by taking into evidence not only the ideas in Aristotle's *Physics*, but also those in his *Meteorologica*. It is in the *Meteorologica*, rather than the *Physics*, that Aristotle discusses the crucial material in Cellini's object – salt. In fact, Aristotle offers an etiology of salt that casts Earth and Sea in its starring roles.

Salt, Aristotle observed, is found in the liquid waste products of the human body, especially sweat and urine. Since the earth itself is a body, he reasoned, it must also produce salt, and with combustive operations similar to those of humans. The mystery this left, however, was how salt ended up in the sea; to explain this, Aristotle turned to weather patterns. The earth, he conjectured, must emit a residue, or "exhalation," into the air. There it would meet the exhalations of the earth's counterpart, the sea, and when the earth's dry exhalations met the sea's wet ones, clouds would form, and they would rain. It must be rain, he concluded, that brought salinity to the globe's bodies of water. Salt, that is, might be found primarily in the sea, but it did not originate there. Had the earth and sea not cooperated in providing its key ingredients, salt could not have come to be.[21]

Aristotle's discussion informed not only the meteorologies that followed his, but also the general history of saline chemistry.[22] A number of his readers reasoned that, if salt depended on both land and sea, it must be composed of two elements, earth and water. Thus, Albertus Magnus wrote succinctly that salt is "composed of something earthy which is moistened and mixed with something burnt."[23] Closer to Cellini's time, Giorgius Agricola asserted that salt is generated

> when an earthy body is mixed with a wet one, or, on the contrary, when a wet body is mixed with an earthy one, such that now the first body, now the second, overcomes the other. In this manner the flavors in the water are born . . . and the material of this flavor is thus earth and water.[24]

Salt, a stony mineral found in mines, must be earthy. But salt was also clear, and it dissolved in water, suggesting that it was watery as well.

If Prater, then, is correct in viewing Cellini's conjunction as an elemental one, that conjunction arguably relates not only to general ideas about elemental "marriage," but also to more particular notions about the birth of salt. And once Cellini's object is taken to concern, specifically, the origins of salt, the meteorological, or better, oceanological, aspect of the imagery opens a new direction for interpretation. To Aristotle's theoretical discussion, for one thing, can now be added the more empirical one in Pliny's *Natural History*, which describes the way salt is isolated for use:

> [Salt] is made in Crete without fresh water by letting the sea flow into the pools. Around Egypt, it is made by the sea itself which penetrates a soil that is soaked, I believe, by the Nile.[25]

From at least the times of the early Romans, salt was produced by a "running" seawater that penetrated land.[26] At the point of union between this land and water, fluidity was eliminated (either by using earth itself as a filter, or by letting the water evaporate in the Sun), and the salt extracted. This process becomes especially suggestive in view of Cellini's own description of the action he showed:

> I made an oval form rather larger than a half braccio big – almost two thirds – and on this form, following how the Sea shows itself to embrace the Land, I made two figures well over a palm big, in a sitting posture, entering into each other with their legs, just as one sees certain long branches of the sea entering the land.[27]

The *Saltcellar*, as Cellini describes it, is an illustration of a coastal dynamic. It is an allegorical picture of a seashore, the interpenetration of two geological bodies (Fig. 9).

According to Cellini's description, the agent in the *Saltcellar* that does the entering is the figure Cellini alternatively refers to as *il Mare* (the Sea) and as Neptune. His right hand holds a trident, while his left hand rests against his hip. In each hand, additionally, he gathers a blue band of enamel. These bands must be the reins for the sea horses behind him; that they are in his hand and not tied to the animals indicates that the horses are *sfrenati*, unbridled, which explains why they battle behind the Sea's back (Fig. 10). The idea here probably comes from Book 1 of Ovid's *Metamorphoses*, when Neptune calls to the rivers:

> "Apply your forces, for there is need – open your houses, and unrein your runs." So commanded, the rivers, with unbridled course, entered into the sea. Then Neptune struck the earth with his trident; she trembled, and with that tremor, she opened the way for the waters.[28]

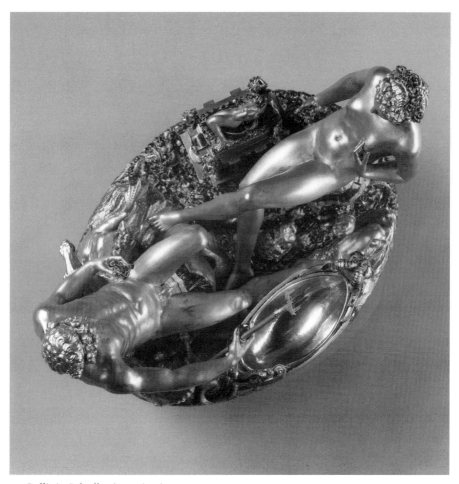

9. Cellini, *Saltcellar* (top view).

Cellini's forms corporealize the action of the water. The body of the water has an origin, caused by Neptune's unbridling, and a mouth, roughly identifiable with the mouths of the fighting horses. It also has a flow: just as Ovid describes how, with the tides unleashed, "dolphins invade the woods, brushing against the high branches," so does Cellini show dolphins moving both with and as his stream, coursing along Neptune's left side toward land (Fig. 7).[29]

The general conception of this personification, the idea of using the body as a geographical phenomenon, is something Cellini could have taken from ideas about river gods.[30] The Sea's legs can represent branches of water for the same reason that sculptures of the Nile identify the physical head with the fluvial source; the body itself is a flow.[31] The whole *figura* of the Sea, in this respect, might be compared with that of Cellini's contemporary *Nymph of Fontainebleau* (Fig. 11); the recumbent nude presides over a watery passage that originates with spiraling force, then streams in waves along a narrowed

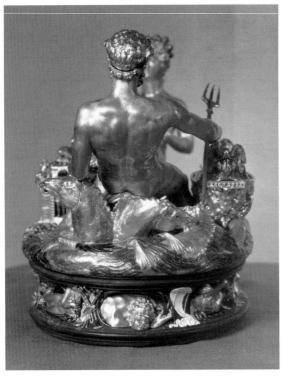

10. Cellini, *Saltcellar* (fighting horses).

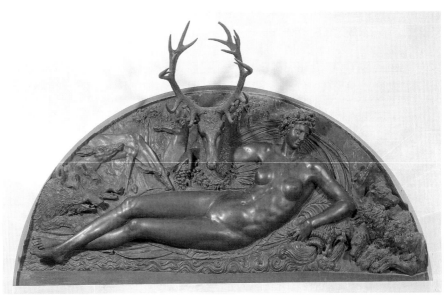

11. Cellini, *Nymph of Fontainebleau*. Paris, Louvre (Photo: Réunion des Musées Nationaux/Art Resource).

path. Neptune's gesture with his trident, moreover, is strikingly close to Ovid's description, and in light of the poem, we might read Earth's gesture, which in the first place indicates her fertility, as one also indicating fright (Fig. 6).[32] The gesture explains both why she opens "the way" for the water and what results from its entrance. Impregnation and birth are collapsed into a single event.

One final detail that corroborates a reading of Cellini's setting as that of a salt-bed is the boat that, when the saltcellar was in use, would seem to be carrying the salt away from the land. As Bernard Palissy explains:

> On account of their size, large ships cannot come near the shore: hence those who sell salt bring in small boats that enter into the flat, coming as close as they can to the salt they have sold; they drop anchor, and thus the said salt is brought first to the small boat, then that boat is led to the ship to unload.[33]

Inasmuch as Cellini's boat exposes the salt it contains, it might be taken to be a ship of the kind Palissy mentions. Too large to come all the way to land, it is anchored just offshore. Loaded with salt and directed out to sea, it suggests that the site behind it is one of salt production.

Setting out to personify the actions that, according to Aristotle and Pliny, take place in salt-beds, Cellini may have found that Ovid offered a way to do this with economy and wit (*con sale*). The texts adduced so far, however, account only for the elements included (according to the *Autobiography*) in Cellini's original wax model, the one he designed for the Cardinal of Ferrara in Rome. The object Cellini executed in France, the one that now resides in Vienna, seems to have depended heavily upon this, especially in the details of the upper part. It also, however, included an elaborate base unmentioned in Cellini's description of his original conceit. He describes this base for the first time when he writes of making the final version of the work for King Francis:

> I set the work upon a black ebony base. It was of a fitting size, and it had a bit of a neck, in which I arranged four gold figures, made in high relief. These figured Night, Day, Dusk, and Dawn. There were also four other figures of the same size, made to represent the four principal winds. These were worked up with as much finish as you can imagine.[34]

If the wax model made in Rome can be understood as a *dichiarazione* of the making of salt – both in the sense of a naturalist explanation of the elements that generate salinity, and as a more mechanical illustration of what Pliny called *salinae* – the actual table ornament that Cellini produced a few years later in

France requires further comment. Why, in changing a cardinal's saltcellar to a king's, would Cellini add the features he did?

In considering this question, a passage from Cicero's *De Natura Deorum*, one in which salt-production figures, is particularly suggestive:

> But how great is the benevolence of nature, in giving birth to such an abundance and variety of delicious articles of food, and that not at one season only of the year, so that we have continually the delights of both novelty and plenty! How seasonable moreover and how wholesome not for the human race alone but also for the animal species and for all things which grow from the land is her gift of the Etesian winds! Their breath moderates the excessive heat of summer, and they also guide our ships across the sea upon a swift and steady course. Many instances must be passed over, and yet many are to be told. For it is impossible to recount the conveniences afforded by rivers, the ebb and flow of the tides of the sea, the mountains clothed with forests, the salt-beds lying far inland from the sea-coast, the copious stores of health-giving medicines that the earth contains, and all the countless arts necessary for livelihood and for life. Again the alternation of day and night contributes to the preservation of living creatures by affording one time for activity and another for repose. Thus every line of reasoning goes to prove that all things in this world of ours are marvelously governed by divine intelligence and wisdom for the safety and preservation of all.[35]

With Cellini's object in mind, it is striking that Cicero lists *salinae*, "salt-beds," as one of nature's important gifts.[36] The collection Cellini assembles in the *Saltcellar*, however, is also remarkably close to Cicero's remaining inventory. Cellini's Earth, to begin, is a suitable rendering of Cicero's Nature; her gesture suggests lactation, and abundant and various things spring forth beneath her. The Temple beside her (Fig. 3) resembles nothing so much as Cellini's own idea for Fontainebleau's Porte Dorée, with the reclining *Nymph of Fontainebleau* above it: this both underscores the erotic impulse that drives the forces of nature and reinforces the idea that the Earth is a "source."[37] The pepper-filled edifice not only (like the salamander behind it) suggests heat, and thus generation, but also, by containing a condiment, literalizes the notion that nature, here the Earth, produces "delicious articles of food." The four puffy-cheeked faces, which look like winds, but which Cellini also refers to as figures of Spring, Summer, Autumn, and Winter, illustrate the yearly cycle that promotes the earth's bounty.[38] The artist's curious double identification of these characters depends on the idea that specific winds cause or accompany specific seasons, an idea upon which Cicero's paean also relies. Cellini's Sea, we have seen, is a flowing tide. His Earth, posed, he tells us himself, "to figure the mountains and the planes," is consonant with the mountainous terrain Cicero mentions.[39] Then there are the four figures Cellini calls *Notte, Giorno, Graprusco,* and *Aurora*

12. Cellini, *Saltcellar* (detail: Dawn).

(Figs. 12–15). The fact that these are unmistakably derived from Michelangelo's sculptures in the New Sacristy in San Lorenzo in Florence has led to some confusion, for the identities of Cellini's figures do not quite correspond to those of Michelangelo. The male who averts his eyes from a small gold sun (Fig. 13) must be Day, *Giorno*, even though he is based on the figure by Michelangelo standardly labeled as Dusk. The male with the streaked gold sunset behind him (Fig. 14), accordingly, must be Dusk, *Graprusco* (*Cresposcolo*), even though he is derived from Michelangelo's Day.[40] In Cellini's circle of figures, (presumably) unlike Michelangelo's, the Times appear in order. Turned counterclockwise (as astrological clocks move), the *Saltcellar* presents Dawn, Day, Dusk, Night.[41] This is significant, for the perimeter of the *Saltcellar* consequently captures the cycle Cicero calls the "alternation of day and night," and even illustrates, with its personifications, the moments of "activity" and "repose" he describes.[42]

Between these figures are eight sets of instruments – scythes, forks, picks, spades, a bow with arrows, an anchor, tridents, oars, a sail, and musical instruments. Pope-Hennessy noticed that these correspond largely, but not

13. Cellini, *Saltcellar* (detail: Day).

perfectly, to the object's topical division of earth and sea;[43] Prater called them "attributes of human occupations."[44] It is probably more accurate, however, to say that they represent "arts," in the sense of *arti*, or *artes*, skills or crafts exemplifying the fabricative branch of what Aristotle would have called "practical philosophy." The escutscheons include the attributes of *navigatio*, the primary art of the sea; *agricultura* and *venatio/armatura*, the corresponding arts of the land; and *musica*, the harmony, or composition, or principle of binding, that holds everything together.[45] As a group, they stand as apt tokens of what Cicero calls "the arts necessary for livelihood and for life."[46] The actual arts selected, moreover, must amplify the conjunction of earth and water at the center of the object. As the author Cellini's contemporaries would have known as Hermes Trismegistus writes in the *Asclepius*:

> I mean to speak not about water and earth, those two of the four elements that nature has made subject to humans, but about what humans make of those elements or in them – agriculture, pasturage, building, harbors, navigation, social intercourse, reciprocal exchange – the strongest bond

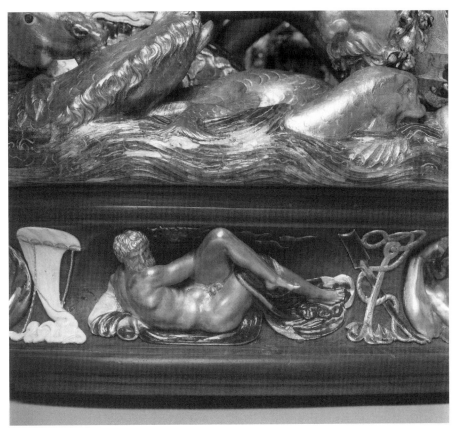

14. Cellini, *Saltcellar* (detail: Dusk).

among humans or between humanity and the parts of the world that
are water and earth. Learning the arts and sciences and using them
preserves this earthly part of the world; god willed it that the world
would be incomplete without them.[47]

Hermes allows that signs of the arts of the sort Cellini includes would remind
the viewer that water and earth already point to culture, knowledge, and mas-
tery. And Hermes's further proposal that the use of the human arts constitutes
the fulfillment of God's will comes very close to Cicero's own point – that
winds, time, and salt-beds all present evidence for a specific kind of argument.

That argument, at least as it appears in Lucilius's monologue in the second
book of *De Natura Deorum*, is a case for divine providence. The ekphrasis from
Cicero quoted above aims to instantiate the belief that the wonderful variety
of things seen in the world in fact betrays a purposeful cause. In the manner
of Kant's later "physiotheological" proof of the existence of God, it maintains
that the nature of the world implies something about the nature of its creator.[48]
The production of salt, like the movement of ships and the regularly changing

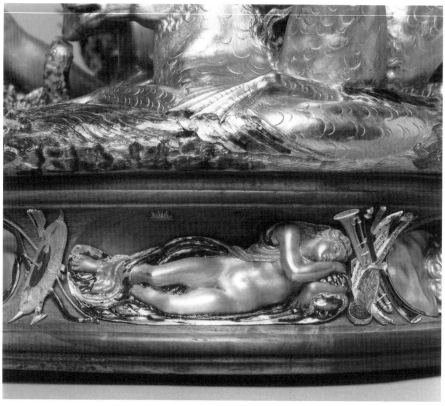

15. Cellini, *Saltcellar* (detail: Night).

times of day, prove the world to be marvelously administered, *admirabiliter administrari*.

Faced with the task of modifying the work from a cardinal's salt to a king's, the incorporation of a providential theme would have been fitting. Providence had traditionally been attributed to Roman Emperors, and was consequently cele-brated on ancient coins.[49] Many of these survived, inspiring self-aggrandizing moderns to adopt the virtue for themselves.[50] A number of French tracts predating Cellini's work name providence among King Francis's virtues in particular.[51] Coming to the saltcellar from a background in numismatics, it is easy to imagine that Cellini would have been attuned to such imagery.

The Ciceronian conception of providence (*prouidentia*) conflated the notion of managerial forethought (typified in good agricultural planning) with the older Greek idea of *pronoia*, literal foresight.[52] The attributes of Providence, accordingly, could include a rudder (for its capacity to steer presciently in the face of fortune) or a cornucopia (for the provision it effects).[53] Signifi-cantly, Cellini's *Saltcellar* includes both. The concept of providence had also entered the literature of art. Alberti, for one, argued that temples originated as

an acknowledgment that all the persons of a city, like all the particulars of any form, derive their inclinations from the providence of an omnipotent and good God.[54] Lomazzo appealed to a similar idea, describing God and Nature as providential intellects that comprehended the infinite particulars of the world they produced.[55] Francesco de' Vieri explicitly compared God's providence to human *artefice*.[56] Cellini's contemporary Basilio Lapi found a somewhat different appeal in the concept, invoking it when observing how nature's order provided means for transforming materials from one state into another.[57] While Cellini does not explicitly discuss providence anywhere in his own writings,[58] the concept nevertheless opens new possibilities for thinking about the artist's work, and more specifically, about the nature of the intelligence that the *Saltcellar* involves.

In the world picture of Cicero's Lucilius – which counts among the most elaborate discussions of providence in the classical tradition – it is intelligence that holds everything together:

> Every natural object that is not a homogeneous and simple substance, but rather a complex and composite one, must contain within it some ruling principle, for example in man the mind, in the lower animals something resembling the mind.[59]

While such an idea was not uniquely Ciceronian – Lapi, for instance, quotes Aristotle as saying that "all the operations of nature are operations of an intelligence," and Vieri refers to comments by Plato to the same effect – the argument of *De Natura Deorum* is particularly illuminating, both for its association of intelligence with *composition*, and for its discussion of the principle of intelligence within the framework of mythologized natural history.[60] Lucilius's comment is germane to the *Saltcellar* insofar as Cellini's imagery is an imagery *about* compositeness, and about the nature of the gods he brings together. According to Lucilius, composition happens because minds unite things, and such a view offers one possible clarification for Cellini's own use of personifications. Showing the Sea's movements and Earth's productions to be presided over by deities is one way of indicating the role of a knowing control behind the actions of those elements. Lucilius himself notes that divinities "pervade the substance of the several elements, Ceres permeating earth, Neptune the sea."[61] Cellini's Earth and Sea might be seen as the *genii* in charge of their elements.

Also central to Lucilius's argument is the notion that the world, in this condition, is like an artwork:

> If the structures of the world in all its parts is such that it could not have been better whether in point of utility or beauty, let us consider whether this is the result of chance, or whether on the contrary the parts of the world are in such a condition that they could not possibly

have cohered together if they were not controlled by intelligence and by divine providence. If then the products of nature are better than those of art, and if art produces nothing without reason, nature too cannot be deemed to be without reason. When you see a statue or a painting, you recognize the exercise of art; when you observe from a distance the course of a ship, you do not hesitate to assume that its motion is guided by reason and by art; when you look at a sun-dial or a water-work, you infer that it tells the time by art and not by chance; how then can it be consistent to suppose that the world, which includes both the works of art in question, the craftsmen who made them, and everything else besides, can be devoid of purpose and of reason?[62]

Lucilius enjoins the reader to think of artworks in terms of their origins. In part, he wants us to reason analogically: if a painting or sculpture manifests a governing rationale, so must the world, which is no less coherent. In part, he wants us to accept a particular ontology of human artifice: The very fact that art can come about, that the craftsman makes his clock and that it turns out to tick, proves the accommodation of human creators to the world; art-making itself points to the presence of an ur-intelligence. The argument is, in effect, a postulation of design. Just as an artwork originates with a plan (here we can think of Cellini's model for the *Saltcellar*, which he calls a *disegno*), so must nature itself: "the nature of the world itself, which encloses and contains all things in its embrace, is styled by Zeno not merely "craftsmanlike" but actually "a craftsman," whose foresight plans out the work to serve its use and purpose in every detail."[63]

The *Saltcellar* would evince Providence insofar as its coherence, its assemblage of working parts, constitutes proof of its maker's existence and intelligence. And for an artist like Cellini, who thought of the world as a "beautiful machine," we might take it to involve another, more qualitative, issue as well.[64] Providence implies not only rational artistry, but also excellence; as Plato writes, God saw to it that "his work would be, of its nature, most beautiful and good."[65] The result of providence is that things work in the best possible way, that parts do what they should, fulfilling a purpose.[66] Providence gives functionalism an aesthetic dimension; as Lucilius puts it, the chief aim of providence is "consummate beauty and embellishment of every kind."[67] One infers the existence of intelligence behind the world not only by reason, but also through one's experience of marvel. The exclamatory style of the passage that mentions *salinae* aims to demonstrate what Lucilius states more objectively elsewhere, that the beauty of creation is itself convincing evidence of providence.[68]

In the *Saltcellar*, Cellini asserts value on a naturalist analogy. The making of salt, an operation at the center of the "arts" of land and sea, shows the good that nature's own order allows. We might, considering one final passage from Lucilius's monologue, note his encomium to the hands: "What clever servants

for a great variety of arts are the hands which nature has bestowed on man!" As examples of the hands' arts, Lucilius names not only painting, modeling, and carving, but also music playing, agriculture, temple building, and navigation – the very activities alluded to in the *Saltcellar*.[69]

One of the things that seems remarkable about Cellini's *Saltcellar*, compared to others made in his day, is its symmetrical conception – the object might seem strikingly modern, in fact, just for including both salt and pepper. The inclusion of both condiments adds to the impression that Cellini has created a miniature world. Giving the user both salt and pepper, Cellini combines West and East, white and black, the land's yield with the sea's.[70] In the exhibited piece, nevertheless, the salt would have been the focus of particular attention. Calling his work a *saliera*, or even a *sale*, Cellini's designation acknowledges only one of its offerings. For practical but perhaps also other reasons, moreover, salt, but not pepper, would have been in evidence in the work's completed state: with the pepper hidden beneath the temple's lid, only the salt would be presented as one of the object's apparent materials. For the goldsmith, finally, there is reason to think that salt, more than pepper, would have held particular significance.

A Ciceronian reading of the piece might identify the production of salt as its premier art, the production toward which the whole world-machine is directed. A cognate idea can be followed up in Pliny, for Pliny's comments on salt open with the observation that "all salt is either made or born."[71] In the chapter this introduces, Pliny first describes "born salts," the salts that nature herself makes, spontaneously. What happens in salt-beds is treated only in the second half of the chapter; for Pliny, salt production does not count as a natural work, but as a human art. In Landino's Italian translation of Pliny, the edition that Cellini was most likely to have known, the key transition between the story of how nature makes salt and that of how man does reads as follows:

> Il sale fatto per arte e di molte ragioni. Molto sene fa nelle saliere met-tendovi acqua marina non sanza acqua dolce, ma la piova l'aiuta assai, ma sopra tutto il moto del sole, perche altrimenti non si secca.

> There are many ways in which salt is made with art. Much of it is made in *saliere*, putting ocean water there with fresh water, and rainwater helps, too, and above all the motion of the sun, for otherwise it does not dry.[72]

Announcing that salt can be made "by art," Landino's Pliny launches immedi-ately into a discussion of salt-beds, and of the operation that Cellini may well

be depicting. Suggestively, he renders what Pliny's Latin calls *salinae* not with the available Italian cognate *saline*, but rather with the word *saliere*, the standard Italian term for *saltcellars*. Thinking in Italian, Cellini could quite literally have associated his *saliera* with the kind of salt-bed that Pliny describes.

Like Cicero's, Pliny's terms suggest how salt-making exemplifies the human capacity to replicate nature's intelligence. As Leonardo Fiorauanti proposed a few years later, the separation of salt from water illustrates the marvel of "natural artifice" (artificio naturale).[73] The final stanzas in one of Cellini's own poems refer to the same process:

> Quel giorno che lasciò la bella spoglia
> l'etterno Re per noi spenta sul Legno,
> più del viver divenne il morir caro.
> Ché in lei cangiò sapor non men che soglia
> salso umor che conduca arte od ingegno
> per un dolce terren levar l'amaro.
>
> On that day when the eternal King left us his beautiful remains, dead on the cross, death became more dear than life. For the flavor in it changed no less than does the salty liquid, which art or ingenuity conducts through a sweet earth, to take away its bitterness.[74]

Both the *arte* and the *ingegno* to which the poem refers would have been of specific interest to the goldsmith. For one thing, they bear directly on the matter of composing and recomposing metals, core operations for an artist who distills, gilds, and fuses his materials.[75] Palissy, for example, writes succinctly: "I could say nothing of metals, other than that their matter is a salt dissolved and liquefied in common waters."[76] The remark is not eccentric; Cinquecento writers commonly conceived of metals and salts in related ways. Giovanni Braccesco, for instance, attributed to Geber the idea that metals could be generated from salts.[77] Andrea Cesalpino, conversely, discussed the "art" of changing metallic bodies into salts.[78] And most famously, Paracelsus named salt as one of the three "primaries," of which all metals (and for that matter, all things) were composed.[79]

Cellini's *Saltcellar*, furthermore, is not made exclusively of precious metals. Many of its surfaces are covered with enamel, that is, with colored glass. This is of general interest as far as Cellini's imagery is concerned, since the ancient Greek authorities on chemistry had held that glass, like salt, was a composite of earth and water. By the sixteenth century, moreover, it was standardly recognized that glass included salt as its primary constituent. It is not surprising that an artist like Palissy, who began his career as a glassmaker, should end up writing discourses on salt; as he remarks, "without salt it would be impossible to make any kind of glass."[80] One could, with the metallurgist Vannoccio Biringuccio, speak of "glass salt":

Another artificial salt is made that some call "glass salt" and others "sal alkali." It is made from lye gotten from the ashes of an herb called saltwort or soda . . . Drying it, they obtain the aforesaid salt for making glass; for this reason it is commonly called glass salt.[81]

Made *from* salt, glass was also *like* salt, inasmuch as its very existence illustrated human ingenuity. Biringuccio compared it to the materials he designated as "semi-minerals" (*mezzi minerali*):

Under the same justification that I spoke to you in the preceding chapter of crystal and some other gems, I can now, much better and with much greater justification, tell you about glass, since glass is one of the effects and one of the proper fruits of the art of fire. Every product found inside the earth is either stone or metal or one of the semi-minerals. Glass, as is apparent, resembles each of these, even if it is dependent, in every respect, on art. It seems to me that, before beginning my discussion of the arts themselves, I should discuss this most beautiful composition, mixed by art, and that I should group this composition with semi-minerals. Thus, in this chapter, I will write about it not as a semi-mineral *per se*, nor quite as a metal, but rather as a fusible material, one almost made a mineral by art and by the power and virtue of fire, one born from the speculation of good and wise alchemists. As a result of their experiments, glass imitates the metals on the one hand and the transparency and splendor of gems on the other. It is, without question, a very beautiful thing, one that should not be left buried in silence. . . . [82]

For Biringuccio, the "artfulness" of glass had several aspects. To begin, its existence depended on fire. It was a "fruit of art"; without human intervention, it could not exist. This origin, in turn, allowed it a curious place within the natural order. Fusible, it should be a metal. Transparent and shining, it should be a gem. In the end, it could only really be regarded as a *composito mexcolato con larte*; it was a *mezzo minerale* not only because its artifice made it fall short of authenticity (it was half mineral, *quasi fatta minerale*), but also because its final being was chimerical, half metal and half gem. The very existence of glass, for Biringuccio, suggested art's power to imitate through experimental composition:

Art is that which, through many experiments, and by adding or subtracting as its inventors saw fit, gave [glass] its being. As can be seen, the ancients have given us lodestone, niter, crystal, and various lustrous stones, and the moderns, in imitating them, have, it seems to me, done so much that one can hardly believe it possible to go further with this art.[83]

The conception of art presented here, a willful adding and subtracting, evokes Renaissance *paragoni* comparing competing artistic practices (the clay modeler adds, the marble sculptor subtracts). For Biringuccio, the more flexible, experimental art that pyrotechnicians employ subsumes both techniques; its

results, however, are to be judged in the same terms of realistic effect as were Zeuxis's grapes or Parhassius's curtain.[84] On the one hand, making glass demonstrated the artist's *potestas audendi*, the Horatian license to create through novel hybridization.[85] Just as Cellini could make "mostri maritimi," fish-horses (themselves a combination of the terrestrial and the aquatic) that he could not observe in nature, so could he use glass, the fusion of earth and water he invents from nature's givens. On the other, the creation of glass employed the means of science for the ends of naturalism. As Biringuccio writes: "The manual art of the goldsmith shares much with that of the alchemist, for it often makes a thing appear other than it is."[86] Like perspective, or *sfumatura*, the science of modern glassmaking defeated the ancients with the sophistication of its illusion, its products convincing gem-like appearance.

Cellini takes up related themes in his own writings.

> Here I don't want to discuss the way in which enamels are made, because that is a great art unto itself, which was already practiced by the ancients, and discovered by sophistic men. And as far as we know, there is also one sort of transparent red enamel which the ancients did not know about. It is said that this enamel was discovered by an alchemist who was a goldsmith. And recounting the little that is known about this, they say that this alchemist had put together a certain composition, trying to make gold, and when he had finished making his work, beyond the material that remained in his crucible there was a sediment of the most beautiful glass that had ever been seen. Consequently, the goldsmith began experimenting with it, mixing it with other enamels, and with the greatest difficulty and much time, in the end he discovered the way [to reproduce it]. This enamel is more beautiful than any of the others, and among goldsmiths it is known as "smalto roggio," and in France, "rogia chlero," inasmuch as its name is a French word, which means "clear red," that is, transparent red.[87]

Cellini never returned to his promised discussion of the art of making glass, but this passage alone leaves no doubt that this art, too, is one that goldsmiths have practiced. Cellini, like Biringuccio, views glass-making as a practice both ancient and modern, a practice sanctioned by the classical past, but expanded, through experimentation, to include results that rendered the ancients obsolete. He, too, associates glass with artifice and composition. Invented by "sophists," its nature is to deceive.

According to Cellini, glass was discovered by accident; he believes glass to have been the by-product of an operation tailored to another purpose.[88] This origin is relevant to the *Saltcellar*, for it underscores the relationship between glass and the other products generated from the same kind of operation. The *Saltcellar* includes a collection of siblings (metal, glass, salt), a family of materials related through common parentage. In this regard, we might think again of the

term *saliera*, which refers both to the narrow zone where the earth traps water *in* Cellini's object and to the object as such, or of the term *sale*, which refers both to an object like Cellini's and to the material such an object fictionally makes. If Pliny allows that Cellini's *saliera* could represent the *saliere* that engineers make at the zones where the earth and sea meet, Cellini's remarks now allow the converse as well. His *saliera*, as a collection of by-products, can show the variety of things (metal, glass, salt, saltcellars) that are made by the process it depicts.

Cellini has more to say about his *smalto roggio*. Once you have nearly completed your enamel work, he instructs the apprentice, and when you have fired the enamel so that it settles into its place, you then make a hotter fire:

> and when it is in its "season," put your work into it, firing it as is fitting for enamel and gold. Then remove it quickly, and have one of your boys ready with a bellows in hand. As soon as you pull the work from the fire, he must blast it with wind, and with that wind cool it. And one does this to the enamel when among it there is that *smalto roggio*, about which we talked earlier. The nature of this enamel is such that, at this last firing, while the others run, it does something beyond running, namely, from red it turns to yellow, so yellow that one could not tell it from gold. In our art, this is called "opening."[89]

Cellini's account of the conversion of red (liquid) enamel into gold evokes that material's particular history as the by-product of an alchemical quest.[90] Just as red glass resulted from the pursuit of gold, so can it be itself employed in that pursuit.[91] The transformation of enamel into gold (and later, back into enamel) returns to Biringuccio's topic of glass and imitation. One of the things art can do, for Biringuccio as well as for Cellini, is create materials that, while not natural, nevertheless resemble natural things. Through art, the goldsmith can turn salt into something that looks like a gem; through more art, he can turn this gem-like material into something that looks like gold. And all of this is possible not just because of the artificer's eye for superficial resemblance, but because the goldsmith knows that all three materials – salt, glass, and gold – are creatable through the composition, decomposition, and recomposition of two primary ingredients, water and earth. As the various materials of the *Saltcellar* come to appear ever more closely related, the machine itself begins to serve as a model of a material (call it a *sale*), the making and unmaking of which is the basis of Cellini's work.

If Cellini's comments about glass support a reading of the *Saltcellar* as a particular kind of composition, they also orient a way of thinking about the act of composing behind it. This involved, in the first place, an act of separation.

Cellini's description, quoted above, of making an oval form, then dividing it into earth and sea, may be reminiscent of God's own acts in *Genesis* of establishing the firmament, then separating it into land and water.[92] The modern artificer's fashioning of the world might be connoted alone by the object's oval shape – a shape generated by Renaissance cosmographers' projections from the globe, and, later, by Keplerian renderings of the universe.[93] In *Genesis*, too, the worldmaker's creation is regulated by a cycle of day and night, and there, too, the divided, well-ordered form is finally said to be good. All of this adds to the *Saltcellar*'s implication of the artist's divine providence.

Yet it is also instructive to look a bit more at Cellini's work with glass, considering not only the varying states of Cellini's *smalto roggio*, but also the status of the material he calls "acqua marina" (seawater):

> I almost forgot to mention an enamel called "seawater." This seawater is a most beautiful color, and it can be used on gold as well as on silver.[94]

It is fitting that Cellini calls this glass "water," not only because its color is the color of the sea, but also because glass was defined, in Cellini's day, by its potential liquidity. Biringuccio's classification of glass as a "fusible" material echoes a taxonomy that dates at least to Plato:

> Regarding bodies composed of both earth and water: so long as water, compressed by force, fills the empty spaces in the earth, those spaces will hold, and no water from outside will be able to penetrate and melt them. The motions of fire, however, penetrate water, just as water penetrates the empty spaces of the earth. And since fire affects water in the same way that it affects bronze, it causes the liquefaction of common bodies. Such things have fewer parts water than earth, just as the family of things called "glass" do, and all stones that are called "fusible."[95]

Plato thought that glass was a porous earthen body, infused with particles of water and liable to be melted. While it needn't be imagined that Cellini understood the dissolution of glass in just these terms, the premise and result of the process Plato described are relevant. Glass melts, Plato thought, because it (like salt) consists partly of water. And melting as such was not to be understood so much as the transformation of the hardness of the earth, as the revelation and manipulation of the water the interpenetrates it. The melting of glass is the discovery of water, and the effecting of its fluidity.

In the *Trattati*, Cellini writes the following:

> Enameling is like painting; you liquefy one sort of painting with oil and the other with water, and in painting with enamels, you liquefy with fire.[96]

Cellini understands the application of enamel to be an act of painting just because it involves turning a colored substance into liquid, then applying it to

the work. The enamel painter is the artist who causes the waters of glass to flow. This operation of enamel painting, Cellini consequently warns, is one that requires experience and knowledge. Different enamels "run" in different ways, and the artist must learn their habits:

> Before the goldsmith prepares to enamel the work, he should take a little plate of gold or silver and, on this, place all of the enamels he has to work with. Using his graver, he should make a number of shallow hollows on the plate, as many as he has enamels. Then he should crush each a bit so that they can be tested. This allows him to see which run more or less easily. It is necessary that all of the enamels run at the same pace, for when one is slow, and another fast, they impede each other, and nothing can be brought to perfection.[97]

By the time he turns to enameling the piece, the artist must know exactly what to expect from his enamels' movements. And even then, he must control these carefully:

> Take the work with your tongs, and bring it near to the mouth of the furnace, holding it close enough that it begins to absorb the heat. Little by little, as you see it becoming hot, put the work into the middle of the furnace, taking the greatest care that as the enamel starts to move, you do not let it run away.[98]

As in the testing stage, the crucial issue here is the control of movement. Painting with enamels, one must make them run (*correre*) but not let them escape (*scorrere*). This background orients another perspective on Cellini's actual use of "acqua marina" in his object, where it renders, appropriately, the Sea's water. Liquefying his blue enamel and running it into its place, Cellini's action might parallel the Sea's own: Unreining his horses, he makes his subject (water) flow, and sends it into Earth's openings to effect his composition. While making his waters run, however, he must also keep the reins in hand. Like Neptune, who gestures with his trident and points his right index finger, he must indicate precisely where the monsters he has released are to go. It is the double action of unleashing and guiding that makes composing, as painting, possible.

It is striking how, at the moment of Cellini's transformation from medal-maker to monumental sculptor, the control of liquids appears as a prominent theme in his works. Noting the verve with which Cellini portrays waters in his major bronze works of the 1540s (*the Nymph of Fontainebleau*, the *Perseus and Medusa* group, the *Andromeda* relief), it is worth remembering that it was his mastery of "waters," his expertise at the forge, that let Cellini enter more prestigious professional territory. The next chapter will have more to say about how Cellini's work as a goldsmith lay the ground for his undertakings as a bronze sculptor, and about the importance of this vocation to at least one of his watery details. What should be stressed here, however, is that the *Saltcellar*

is the first work in which Cellini alluded visually to the ways in which artistic creation involved, in some respect, the control of water. In Cellini's graphically erotic incorporation of Ovid's scene, where the earth "flings open wide a way for the waters" and the branches of the sea enter her, the movement of water and the copulation it effects are presented as a type of generation.[99] From one perspective, this might look like a show of knowledge, an anatomy or genealogy of salt. From another, it might look like the collapse of the two kinds of salt Pliny allows: "All salts are either made or born." As Gabriello Cesano, the first viewer of Cellini's model, allegedly pronounced, Benvenuto "wanted to show his children here."[100] The coupling of earth and sea, the fusion of materials, bears a salt, a salt that might be the artwork itself as much as the consumable condiment it holds.

Cellini loaded the final version of his *Saltcellar* with the emblems of its intended recipient, King Francis I.[101] As the idea of providence already allows that an absolute monarch might play the part of the presiding intelligence, it is possible to take the work's heraldic details – golden *F*'s, fleurs-de-lis, a salamander – to shore up this role. Inasmuch as the earth's "Temple" somewhat resembles a triumphal arch, and as Cellini's *Trattati* eventually describe Neptune's chariot as "a conch, that is, a maritime shell, made in triumphal form," it could be argued that the work projects the king as the ruler of the cosmos.[102]

Cellini's later language, however, tends to multiply, rather than secure, the meanings of his work; the fit between the descriptions Cellini wrote at the end of his life (nearly two decades after he had last seen the work) and the actual *Saltcellar* he made for Francis is not straightforward. When Cellini, in the mid-1560s, first mentioned the triumphal Neptune, he was changing the description he had twice previously given of the work. At the time, Cellini was watching the erection of Bartolommeo Ammannati's colossal marble *Neptune* (Fig. 16) opposite his *Perseus* in the Piazza della Signoria in Florence. That Cellini claims his *Saltcellar* invention involved *Nettuno* (rather than *Mare*), that he describes this Neptune's form as "triumphal," that he remembers the four "cavalli maritimi" to have participated in the work's triumphal form (like the four horses that draw a triumphal carriage), that he comes to assert that Neptune was accompanied by *mostri marini* (the same designation that Raffaello Borghini, for one, would use to identify the tritons at the feet of Ammannati's *Neptune*) – all of the these things may, quite intentionally, give the misleading impression that Cellini had long anticipated Ammannati's *concetto*.[103]

Even the manifest triumphal elements that the work does include, moreover, should be interpreted carefully. For one thing, the invention of those elements seems to have preceded Cellini's royal patronage. The final *Saltcellar* may bear

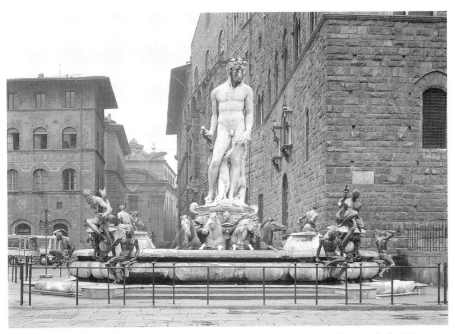

16. Bartolommeo Ammannati, *Neptune Fountain*. Florence, Piazza della Signoria (photo: Scala/Art Resource).

unmistakable signs of being *for* the king, but Cellini himself indicates that its presumed triumphal elements were already in place while the work was meant for Cardinal Ippolito. The addition of heraldry allows the projection of royal rule, but it does not erase the other projections that preexisted it. If the *Saltcellar* does incorporate a triumphal imagery, moreover, it seems significant that imagery is not disposed in the manner of a procession, of the linear movement of a single honored figure. Rather, it is organized as a cycle of reciprocal conquests: The Sea may release his horses and invade the Earth, but the Earth herself, flanked by her attribute of the "triumphal" temple, makes a standard gesture of domination by treading on the Sea's foot. Whatever Cellini's description of the *Saltcellar's* narrative, in fact, the naïve viewer would be hard-pressed to know which of the two figures is the conquering one, the answer likely depending on the side from which the object is viewed. And this aspect of the object's triumphal imagery – the possibility it offers of spinning through an alternating series of triumphs – may well suggest a naturalist reading, as much as a political one. Cicero, we have seen, claims that all compositions must have one "ruling principle"; Agricola claims that salt is formed when earth overcomes water, or water overcomes earth. The ideas of both of these thinkers ultimately descend from Aristotle, who maintains in both the *Physics* and the *Metaphysics* that every *compositum* involves the imposition of form on matter.[104] The Aristotelian account of composition need not be our guiding one – Biringuccio's *composito*

mexcolato, Lapi's *comistione*, and the alchemist's *copulatio* are but three of the available contemporary conceptions of the natural composite that avoid a narrative of conquest. If either Earth or Sea can be viewed as dominant, however, it can be viewed as dominant *vis-a-vis* the other. And such a motif, as later chapters will argue in greater detail, might well flatter the work's maker as much as its possessor.

On this score, it is worth noting how Cellini's *Vita* positions the *Saltcellar* in its account of the artist's days at Fontainebleau. There, Cellini characterizes the gift of the *Saltcellar* as an illustration of the limitations, rather than of the expanse, of the king's authority:

> [The King said to me,] "I remember having expressly commanded you to make for me twelve silver statues. That was all I wanted. You decided to make for me a saltcellar, vases, busts, doorways, and so many other things, that I am overwhelmed, seeing how you've abandoned all of my own desires, and attended to satisfying only your own."[105]

In retrospect, Cellini wanted the *Saltcellar* to remind the reader of the contests, as much as of the collaborations, that had taken place between artist and patron. And in speculating on the cosmic territory the *Saltcellar's* allegory represents, it is significant to note the degree to which the imagery *itself* was subject to dispute. As Cellini's writings leave it, the control of the *Saltcellar* is an open question.

Perhaps, in the end, the *Saltcellar* should be imagined in action. Rotated, or rolled on its wheels across the king's dinner table, its emblazoned scene of nature could let the work stand as an image of the kingdom *in nuce*, a miniature of the realm in which its depicted events transpired. Yet as Francis and his *virtuosi* served themselves of the salt, discussing the work as they literally picked the brains of Cellini's portrayed head, they would also have enacted a salty Italian expression: *pigliare il sale*, "to acquire knowledge," to learn.[106] If the work was (as Cellini's stories about it imply) a conversation piece, then the conversation it would have prompted was one that would include such topics as elemental union, hydrodynamics, geology, and alchemy. The intelligence the work represented comprehended the principles of those discourses, and in turn, it comprehended the way science contributed to the making of a *saliera*. In such a conversation, it would have been Cellini's intelligence that shone. The work initiated by an invitation to Cellini to demonstrate his *inventione* and *opera* terminated as a visualization of those very capacities.

TWO

Casting, Blood, and Bronze

> Oh, would that by my father's arts I might restore the nations,
> and, like my father, infuse breath into the molded clay!
>
> – Ovid, Met. I.363–4

*I*n retrospect, Cellini's *Saltcellar* seems decisive for all that the artist did after-
ward. Though its completion represents something of a watershed – after the
mid-1540s, such works would no longer be Cellini's pride – the judgment and
the skills he employed in making the golden object were crucial for the turn
of his Florentine career. Nowhere is this more evident than in the centerpiece
of his later *Life*, his account of the casting of the *Perseus* (Fig. 17).[1] Here is
the best-known moment in all of Cellini's writings: The artist rises from his
deathbed, overcomes the treachery of his assistants, quenches the fire that is
consuming the roof of his house, battles even the lightning directed at him
from the heavens, tosses dinner plates into the forge, and brings his statue to
life. The story, within Cellini's writings, is among his most mindfully fantas-
tic, and the line between its history and its fiction is difficult to draw. It is
revealing, nevertheless, to approach the episode in terms of what has come
before, reading it as the narrative of a goldsmith. Whatever else it is, Cellini's
tale is in the first place the account of a technical process, a demonstration of
his knowledge of how metals work. It is a version of a narrative that appears
also in the *Trattati* and a sequence of events that duplicates facts found in the
metallurgical literature of its time. Even its hyperbole, whatever the detail, is
specific in its aim: The account argues that Cellini could cast, and it argues that
casting, as an act, was heroic. Such arguments both reflect Cellini's origins and
show what he was becoming.

There are no other stories like Cellini's, and one of the reasons for this
is that few sculptors attempted to oversee the casting of works made from
their designs. Pomponius Gauricus tells us that Donatello never cast anything

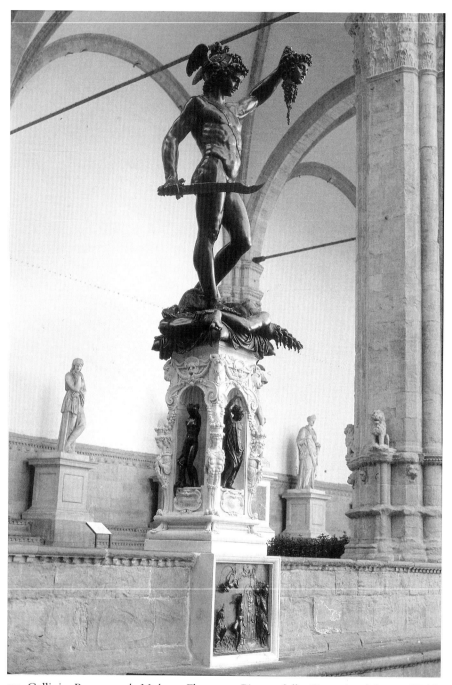

17. Cellini, *Perseus and Medusa*. Florence, Piazza della Signoria. (photo: Wolf–Dietrich Löhr).

himself, and Donatello specialists have accepted his statement as largely true.[2] We know that Antonio Lombardo subcontracted with local bell-casters for the pouring of his bronzes in Padua.[3] When Jacopo Sansovino began making bronzes in Venice, he, too, relied exclusively on experts.[4] Tribolo, having designed a 10-foot satyr, had it poured by Zanobi Portigiani.[5] Even Leonardo da Vinci, who was fascinated enough with the technological problems casting involved to draw furnaces and molds, probably never went beyond the modeling stage of the operation.[6] Letters indicate that when the critical moment arrived, his patron, Ludovico Sforza, sent to Florence for help with the founding; contemporaries report that Michelangelo later mocked Leonardo for drawing things he couldn't make.[7] Michelangelo, in turn, had his own opportunity to illustrate the principle: "I did not have very good fortune," he wrote of the casting of the *Julius II* in Bologna in 1507, "but this was because Master Bernardino, either out of ignorance or out of misfortune, did not [pour] the material well."[8] Leonardo's Florentine pupil Rustici, as it happened, had better luck; two years after the failure of the *Julius*, the same Bernardino (a cannon-maker from Milan) succeeded in pouring the figures for the Florentine baptistery.[9]

As a rule, sculptors were not casters, and the usual practice underwrites a number of the common prejudices in Renaissance sculpture theory. Alberti, for example, distinguishes between the *fictor* (modeler) and the *faber* (founder).[10] Gauricus puts the matter still more sharply, drawing a rigid distinction between what he calls *ductoria* (modeling) and *fusoria* (founding). While *ductoria*, he explains, requires invention and imitation, proportion and perspective, *fusoria* is, at best, merely technical, and at worse, disreputable (*infamis*). The actions involved are ideally executed by two different persons; they certainly do not overlap in their required competencies. The sum of the two is what Gauricus refers to as a *duplex ratio*: It is a cloven procedure, a two-faced art.[11] In view of such arguments, Cellini's pages become exceptional both as literature and as history. It is remarkable, in fact, that Cellini should even *want* to be known as a caster; the desire itself asks for explanation.

Such an explanation might be sought in Cellini's professional background. For while Gauricus and Alberti illuminate the attitudes of a figure like Michelangelo, neither writer, in dividing sculpting from casting, seems to have thought about the biographies of goldsmiths. As Cellini's own *Saltcellar* attests, the art of the goldsmith was closely bound up with the art of the forge. And this, at least to follow the record in Italy, bears on large-scale work as well. Michelozzo, who may have cast the statue of *Baldassare Coscia* for the baptistery, and who later made bells, regularly identified himself as an *aurifex* or *orafo* in notarized documents.[12] Pollaiuolo signed the metal tomb of Sixtus IV "OPUS ANTONI[I] POLAIOLI[I]/FIORENTINI[I] ARG[ENTI] AUR[I]/PICT[URAE] AERE CLARI/AN[NO] DOM[INI] MCCLXXXXIII" (this is the work of the Florentine Antonio Pollaiuolo,

famous for silver, gold, painting, and bronze).[13] Bartolomeo Bellano, who was trained in his father's goldsmith shop, was later assigned both to design and to pour the bronzes for the choir of the Santo in Padua. His signature on his now lost portrait of Paul II in Perugia is even more to the point than Pollaiuolo's: "HOC BELLANUS OPUS PATAVUS CONFLAVIT HABENTI/IN TERRIS PAULO MAXIMA JURA DEI." (Bellano from Padua cast this work to be held in the land of Paul by the high ruling of God.)[14] One of the best founders before Cellini was apparently Lorenzo Ghiberti, whose *St. John* for Orsanmichele impressed his patrons enough that they required him to make his *Matthew* as big or bigger, and to cast it in a maximum of two pieces.[15] While doing works like these, Ghiberti affiliated himself, *pace* Vasari, with the *Arte della Seta* (the silk guild, to which all goldsmiths belonged); documents describe him, too, as an *orafo*.[16]

The point here is that the compulsion to cast a bronze statue is far less surprising coming from the maker of a saltcellar than it would be from, say, the maker of a marble *Pietà*.[17] Cellini's own writings make this perfectly clear. The *Trattati*, for example, which end with a celebration of the monumental achievement of his late sculptures, begin with a genealogy of Florentine goldsmithery: Brunelleschi, Ghiberti, Donatello, Mantegna, Desiderio da Settignano, Verocchio, Martin Schongauer, Albrecht Dürer, and Marcantonio Raimondi, Cellini suggests, all worked in the same field. In his technical discussions, Cellini never divides modeling and casting into separate chapters; rather, he collapses them under common headings like "Cardinal's Seals" and "How to Fashion Vessels of Gold and Silver." When he sketches his taxonomy of *disegno*, he groups bronze-casting and goldsmithery together as a single art. When his discussions turn autobiographical, he does not restrict design to modeling, but rather exaggerates his importance as a caster.

This is not to say that the goldsmith was inherently equipped to take on large works. Cellini, no less than Michelangelo and Leonardo, always relied on specialists when it came time to pour. In France, he learned from the competent team of founders the king had assembled, studying the bronze reproductions made from Primaticcio's models after the antique,[18] listening to the expert *lavoranti* who came to work in his shop,[19] diligently watching the making of bronze harnesses for horses and mules.[20] His showpieces at the end of this were the *Nymph of Fontainebleau* (Fig. 11) and the other bronzes for the Porte Dorée. Though Cellini himself was not responsible for casting these, the works must at least have allowed him to participate in the making of bronzes on a scale unlike anything possible in his Italian days.[21] He observed the process, and recorded its steps. By 1545, when Cellini came back to Florence, he was ready to begin a series of experiments of increasing difficulty. First came the small plaquette of a dog, the one today displayed on the upper floor of the Bargello. He made this, he said, "per provare la terra," to test the

18. Cellini, *Portrait of Duke Cosimo I.* Florence, Museo Nazionale del Bargello (photo: Hirmer).

earth, referring to the material out of which he would make both his form and his negatives, the soil that had to receive the molten bronze.[22] Cellini, who had probably never cast anything in Florence, was experimenting on a familiar scale. One year later, in the autumn of 1546, the bronze bust of Cosimo (Fig. 18) had been poured.[23] Cellini boasted, "had I finished the work to the feet, it would have been 5 braccia high, but as it is it is half that size, and it is all of my doing"[24] – but this is not quite true. Cellini's records indicate that, several months before the bust was cast, the bell-founder Zanobi di Pagno Portigiani had come into his service. Between June 17 and October 17, Zanobi received regular payments from Cellini. The *Autobiography* states that Cellini cast the bust using Zanobi's furnace, not yet having one of his own[25]; reading this passage, Goethe imagined the marvel with which "the bellcaster watched his ringing bronze transformed into meaningful shapes."[26] Who, though, was truly here in audience? Cellini's account books note that Zanobi was paid "for his services in founding, forming, and cleaning the metal."[27] There is no evidence that the payments were for anything less than Zanobi's personal help at every stage of the process, and it might be noted how much such a bust – an enormous, thick, campanulate cast with a hollow core – would

benefit from bell technology for its accomplishment. What's more, Cellini continued to rely on expert guidance even when he began his real giants.[28] Working this time in his own studio, he recruited the services not of a bell-founder, but of the brothers Zanobi and Alessandro Lastricati. The Lastricati were cannon-makers, but had experience working with figural sculptures as well.[29] The two were on Cellini's payroll both in June 1548, when he cast the *Medusa*,[30] and in the winter of 1549, when he cast the *Perseus*.[31] It is none other than this Alessandro, in fact, who gets to speak important lines in Cellini's later narration of the event: when Cellini is awakened in the night to the news that the casting of the *Perseus* has failed, the former cannon-maker chastises him: "You see, Benvenuto, you wanted to undertake something that art does not allow."[32] Here, too, Cellini's reconstruction of the events should be read with some suspicion.[33]

What Lastricati's reminder does suggest is that, even in Cellini's shop, sculpting and casting could be thought to involve distinct areas of expertise. Cellini's claims are overstated, and his review of just what he had done is no doubt inaccurate. To question the facts of the *Autobiography* or the *Treatises*, however, it is necessary also to observe their argument. By casting his own work, Cellini suggests, he was violating professional boundaries. Through what his story, at least, staged as a battle, the artist annexed a neighboring competency, assembling for himself a vocation that would live up to the examples of the great goldsmiths that preceded him. Hence, the choreography of Cellini's most famous scene: The artist first removes himself from the affair, going to bed and leaving the work's completion to his "master founders and manual laborers and farmworkers and shop employees."[34] They fail, allowing the protagonist to burst into the workshop and save the work from death. The casting is, as it was with Michelangelo before him, a scene of *virtù* confronting *fortuna*, this time with the artist triumphant. The pour, Cellini insists, is his. He makes the complete execution of the cast the feature activity of the studio he commands, and he declares his responsibility for it through the final moments.[35]

Cellini's writings thus provide a vector for his own earlier small-scale metalwork. They reveal the path that Cellini thought goldsmithery provided, even required, for his advance to monumental sculpture. And those writings, consequently, look very different from the essays on the medium penned by contemporaries. Unlike Gauricus, for example, Cellini claimed that founding, no less than modeling, must be *ingenious*. Aware that his schemes placed new demands on the skills of experienced founders, his comments exploited the tensions between idea and execution that his initiatives implied. Writing that "[his] workers understood [his] method, which was very different from that of other masters in the profession," he acknowledged, backhandedly, that the casting had to be collaborative, even as he preserved a claim for the novelty of his task.[36] In the spirit of Leonardo da Vinci and Guglielmo della Porta, Cellini

proved the design and operation of furnaces and channeling apparatuses to be a scene for Daedalan originality.[37]

In a similar vein, Cellini relied on founding, and not just forming, when articulating his most ambitious imitative claims. For the Michelangelesque marble sculptor, the prime exercise of design was the extraction of a composition from a single hunk of stone. Cellini appreciated this challenge. Commissioned for the Loggia, his *Perseus* had to stand before Michelangelo's *David*, the century's most enviable posting of the feat; in his *Treatise on Sculpture*, he attacks sculptors who, having planned badly, are forced to "piece together their figures."[38] While planning the *Perseus*, Cellini undertook his own first two marble sculptures, both as complicated arrangements discovered in single blocks. Because bronze is not carved, Cellini could not think of the *Perseus* as a matter of recognizing the form in the stone. The act of metallic fusion, however, offered Cellini a way to emulate the accomplishment of a monumental piece without joins. Transposing the demand for material unity into a technical problem well-known to professional casters – that of managing the single pour[39] – Cellini rejected the safer and more practical option of casting the *Perseus* in sections (as the casters of Donatello's *Judith* and of his own *Nymph* had done), intentionally making the operation more difficult.[40] When he came subsequently to describe his feat, he conveniently suppressed the fact that not only the blood from Medusa's head, but also the wings on Perseus's feet and head had been made separately. Cellini presented the achievement of his cast as one that happened in a single gesture, and thereby both likened his achievement to that of the greatest stonecutters, and set the standards for a different kind of figurative work.

The design of both figure and apparatus, Cellini thought, could reframe the aesthetic of the large, freestanding, unpieced sculpture. Casting could, for one thing, allow Cellini to confront the most visible technical difficulty of marble sculpture, that of raising an arm holding something in its hand without letting it break. In stone, the effort was that of competing with the block's physical strength, extending a cantilevered piece from the core as dramatically as possible.[41] With a one-piece cast, this could be converted into the difficulty of leading the metallic flow through the entire mold without interruption. In his *Autobiography*, Cellini gives us the following conversation with his patron:

> The Duke said, "Now, tell me, Benvenuto, how is it possible that this beautiful head of Medusa, which is way up there in Perseus's hand, can ever come out [in your cast]?
> I responded without hesitation, "Now look here, my Lord, if your most illustrious excellency had the knowledge of art which he claims to have, he would not be afraid, as he says he is, that the beautiful head would not come out. Rather, he would be afraid for the right foot, which is way down there, and a bit displaced.[42]

49

The exchange, written after the fact, is almost certainly a fiction, but it pursues an important point. The duke's ignorance (as Cellini would have it) lies in the fact that he has been trained only to appreciate marble: By habit, he looks at what is raised in the hand. Cellini's lesson is on how to see the difficulties of *his* art. The lifted marble arm is trumped by the extended bronze foot, and the legible signs of his predecessors' greatness are translated from results of cutting to results of casting.

Cellini's domestication of the defining challenges of his competitors' fields likewise dramatized his very use of the furnace. Here, the paramount vantage was not a problem of design *per se*, but rather a mythical notion bound to the cast itself. The pourer of metals, Cellini discovered, could do something no stonecutter could: He could explain just how he spirited his figures. At the deciding moment in the *Autobiography*'s scene, as Cellini recounts the outcome of the almost disastrous clotting of the metal, he narrates as follows:

> I had [my assistants] get a half cake of tin, one which weighed about 60 pounds, and I cast it [*lo gittai*] into the clot in the furnace. This, with help from the fire and from stirring with iron bars and pokers, became liquid in a few minutes. Once I saw that I had resuscitated the dead, against the belief of all of those idiots, so much vigor returned to me that I no longer felt any fever or fear of death.[43]

Much has been written on Cellini's account of this revivification, but what has not been emphasized is that when Cellini says he has raised the dead, he is not speaking of his sculpture at all, but only of the bronze itself. His assistants' betrayal is to let the metal clot, his salvation is to make it remelt. Cellini rejoices even before the metal enters the channels. Later, once it has moved, he repeats the idea

> as everyone saw that my bronze had so perfectly been made liquid, and that my form was filled, they all helped and obeyed me with spirit and joy, and I ran about commanding and helping, calling out: "O Christ, how with your immense *virtù* you resuscitated from the dead, and climbed gloriously to Heaven!"[44]

Only the second time he brings up revival, with the invocation to Christ, does Cellini refer more generally to the enlivening of the sculpture itself. And even here, he preserves the original resuscitation: The assistants are cheered, first, because they see that the bronze has liquefied.

The idea that bronze could be brought to life is not something Cellini made up. It draws on conceptions about metals that he would have understood as both ancient and contemporary, scientific assumptions about their nature, their origins, and their potential. Fundamental here is the ancient Greek belief, questioned but never fully rejected in the Renaissance, that

the primary ingredient in metals was watery, and that metals formed when waters (or waters-to-be) became trapped in the earth and congealed.[45] One implication of this, for sixteenth-century readers, was that the "natural" state of metals was not quite solid, but rather "unctuous." Acknowledging this hydrous basis of metals, sixteenth-century metallurgists could not overlook what Aristotle said about water itself: "There is moisture in the earth, spirit in that moisture, and life-heat in all of those things, such that all, in some way, are charged with soul."[46] While neo-Aristotelians argued over the details of the generative process the philosopher described, none disputed the idea that metals, originating with water, were animated. As the sixteenth-century metallurgist Giorgius Agricola summed up: "Aristotle says that the material of metals is not mere water, but rather a water found in some sentiment and passion."[47] Aristotle's association of metal, liquidity, and spirit suggested that the hard metals of the world were found at the edge of a living, liquid state.

The previous chapter argued that Cellini had learned the basics of Aristotelian theories of generation while a goldsmith: his *Saltcellar* shows the combination of earth and water responsible for salinity, and rehearses a similar principle of origination. By the time Cellini came to write about his casting of the *Perseus* decades later, he would have been able to think through (and express) such ideas in even more refined ways. He might, for instance, have considered the writings he knew by his friend Antonio Allegretti. With art, Allegretti explains, one can "dissolve perfected metals, disposing them, or rather forcing them, to turn back into water, for water is their first material, that from which they were created and made."[48] Allegretti's lines, like Cellini's own, not only remember the Aristotelian etiology but also reverse it, finding in metals' watery constitution a prime challenge: if the origins of metals require that there be a spirit within, experience showed that that spirit could be witnessed. A dilettante alchemist like Allegretti, getting this far, would have gone a few steps further:

> [Metal is] a hard and dense material holding within it that living spirit which infuses all created things [*che a le create cose infonde*] and which alone gives them life, motion, and sense. It cannot show its forces unless its hot and lively virtue is quickly freed from where it lies, encumbered[49]

If one could witness the spirit of metals, Allegretti thought, then one should be able to isolate it. And if one indeed could isolate it, then one should be able to capture it and harness its virtue.

Allegretti's conjoining of movement, liquidity, heat, and life in metals is representative of the kind of naturalist understanding and language Cellini would have had available when contemplating his own challenges and accomplishments.[50] Of interest here, moreover, is not only the literature of

alchemy, but also that of pyrotechnics. Witness especially Biringuccio's handling of the theme:

> [Alchemists want to] separate spirits from bodies [of metal], and would return them there at will, as if they were daggers taken from their sheaths. I would believe that it is possible, with the will of fire, to extract those substances in things that are called spirits and to reduce them into vapors. But I will not believe that, once extracted, they can be returned there, for such an effect would be nothing other than a knowledge of how to resuscitate the dead.[51]

Biringuccio neatly describes the venture of metallic respiriting, even as he emphasizes its unrealizability. He makes light of alchemists, just as elsewhere he mocks those who "believe that even outside a woman's body one can generate and form a man or any other animal with flesh, bones, and sinews, and can animate him with a spirit."[52] That his remarks should appear in a book on casting is telling, and their place invites us to think further about the way Cellini brings similar language into his own story.

Had Cellini viewed the vain exercises Biringuccio was imagining, perhaps he too would have denounced them. As a goldsmith-*cum*-sculptor, however, Cellini's perspective on the business was different. Occupied, like every other artist of his time, with the question of how to give his figures life and motion, Cellini could not have overlooked the suggestiveness in what we have seen Allegretti call the "infusion" of one's "created things." From Biringuccio's sense that the vain alchemical dream of restoring spirits lay dangerously close to his very practical business of casting, it would be but a small step to change the emphasis of the analogy. When the bronze clot melts, it shimmers with life. And the larger enterprise Cellini describes presents a schema in which such life could be made, then imported into a body.[53] Poured into the statue, the metal exsuscitates it. Cellini's vocation, unlike Biringuccio's, could let him treat the founding of statues as a *fulfillment* of the impossible alchemical assignment.

Both in the *Autobiography* and elsewhere, Cellini plays out this plot against a background of God's own acts:

> Quel immortal divin Creator degno
> diè l'alme a noi, simil al suo valore;
> poi le vestì di questo bel furore,
> qual fe' di terra, e non d'ombra o disegno.[54]

> That worthy immortal divine Creator gave us souls, in likeness to his virtue, then clothed them with this beautiful furor, which he made of earth, and not of shadow or design.

Note the sequence of creation here. God started with the soul, then he clothed it [*le vestì*] in clay. To those who have been following Cellini's repeated

descriptions of what the bronze-maker does, this will sound familiar: After making the *anima* (the "soul," or core form) for his *Perseus*, Cellini writes, he "clothed this with those earths" that he had prepared (*io vestivo il mio Perseo di quelle terre che io avevo acconce*). Knowing that God made his first man of *terra*, it is fair to wonder whether God, doing so, was exemplifying the modeler's or the founder's art.[55]

Elsewhere, Cellini suggests that God's sculpting paradigm includes not only the work of clothing, but also that of infusing:

> Dio fe' il prim'uom di terra, e poi l'accese
> coll'immortal suo spirto, vivo e santo;
> e gli diè 'l mondo in guardia tutto quanto;
> poi 'n virgin vaso a rivederlo scese.[56]

> God made the first man of earth, then lit him with his immortal spirit, living and holy. He gave him the whole world to watch over, then, to see him again, redescended into the virgin vessel.

God's figure here, as previously, is of *terra*, earth or clay, the same material with which Cellini works, both when forming models and when forming molds. The poem itself goes on to make this analogy, repeating its story of God's career by summarizing Cellini's: "Fe' Perseo Benvenuto, e Cristo in croce" (Benvenuto made Perseus, and Christ on the cross). The truncated verb *fe'* is identical with that of the poem's opening, as is the sequence: Cellini, like God, made his first man, then he made his savior. The argument here is a variation on a familiar *paragone* theme: Sculpture defeats painting because God sculpted.[57] Cellini's novelty is to insist that the ultimate sculpting gesture is the addition of, as the poem says, a *spirto vivo*. This makes his argument suitable not only as a case for the superiority of work in *terra*, but also as an apology for casting. Cellini's resuscitation, first of his bronze, then of his statue, schematically repeats the bringing of the first man to life.

At points, Cellini makes the autobiographical element in these arguments explicit:

> . . . [il] gran Fattore
> s'accese 'l lume mio,
> Sia 'l Benvenuto, disse 'l mio buon Giove.[58]

God, the great Maker, gave spark to Cellini, then named him, just as he had done once before with Adam. But crucial this time is the last phrase, where Cellini refers to God as "Jove." In Cellini's time, *Giove* could be used generally as a classicizing designation for the singular generator of humanity, and Cellini uses the name elsewhere in specifically Christian contexts.[59] In this case, however, *mio buon Giove* has a second obvious reference as well, for there was but one sculpture of Jove by Cellini in Florence, and it was on public display (Fig. 19).

19. Cellini, *Perseus* (detail: Jupiter). Florence, Bargello (photo: author).

This was, of course, the mythological father of Perseus; Cellini had advertised this geniture on the front of his statue in the piazza, and the comparison was not missed.

Cellini's friend Agnolo Bronzino, in fact, underscored the importance of Perseus's parentage to Cellini's own creation myth. In one of the poems about the statue he sent to Cellini, Bronzino begins by addressing not the Perseus/Medusa pair, but rather the statuettes of baby Perseus and his mother Danaë, which, like the Jupiter, appear in the socle of Cellini's monument (Fig. 20):

> Ardea Venere bella; e lui ch'in pioggia
> D'oro cangiasti, Amor, che tanto puoi,
> Chiedeva; ond'egli a' dolci preghi tuoi
> Le scese in grembo, ov ogni grazia poggia.[60]

Beautiful Venus burned, seeking him [Jupiter] whom you, Love (who can do so much), changed into a shower of gold. Then, answering your

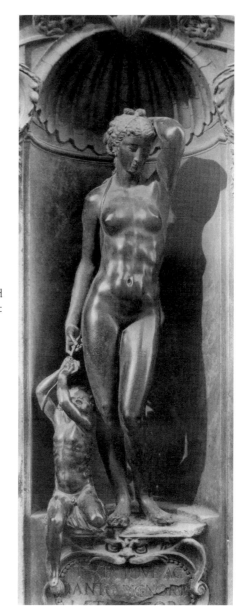

20. Cellini, *Perseus* (detail: Danaë and Perseino). Florence, Bargello (photo: Kunsthistorisches Institut).

sweet prayers, he descended down into her womb, where every grace is posed.

In Bronzino's tale, Danaë burns for Jupiter until Love makes the god himself turn into a shower of gold that fills Danaë's body. The wordplay is dense, for Bronzino identifies Cellini's woman not as Danaë but as Venus – and by implication, Cellini's child not as Perseino, but as Cupid/Love. The child Cellini makes for the niche is thus treated both as the desire that causes Jupiter's

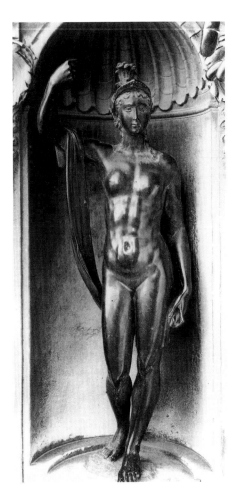

21. Cellini, *Perseus* (detail: Minerva). Florence, Bargello (photo: Kunsthistorisches Institut).

transformation and the warm result of Danaë's fulfillment, the actual burning within her body and the child sprung from it, now at her side. Looking to the other face of Cellini's pedestal, Bronzino then addresses Minerva (Fig. 21):

> Starete, disse, omai, Minerva in terra;
> E fe' d'entrambi un sol giovin, chall'ali
> E al tronco Gorgon, Perseo dimostri.
> E quinci appar divina agli occhi nostri
> L'opra, che il bene e la bellezza serra,
> Suprema gloria de' tuoi dolci mali.

He said, "you will remain, Minerva, on earth," and he made from the couple a single young man whom you show to be Perseus, with the wings and with the truncated Gorgon. And so the work, which encloses the good and the beautiful, appears divine to our eyes, the supreme glory of your sweet pains.

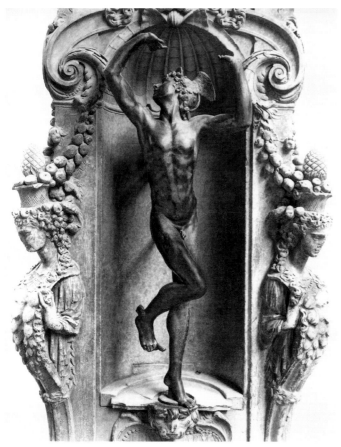

22. Cellini, *Perseus* (detail: Mercury). Florence, Bargello (photo: Kunsthistorisches Institut).

At the moment Minerva, the protectress of art and of alchemy, enters the poem, the agency of Perseus's creation is shifted from the conjunction Love–Jupiter–Danaë to Cellini alone. The *bellezza* of the boy is no longer just Danaë's gift to Perseus, but is an aspect of the *opra*. The "sweet pains" of Danaë's [Love's] desire for Jupiter are now Cellini's own, becoming the labor of love that is his work. Especially interesting is how these final lines allow a rereading of the unmistakably Petrarchan stanza that precedes them. Describing Danaë's heat as Jupiter's gold enters her, Bronzino writes:

> Ma come avvien s'a fuoco esca s'appoggia
> O qual di neve al Sol, quaggiù fra noi
> S'accese e strusse al caldo seno; e poi
> Seco s'unio viepiù che pietra in loggia.

> But as it happens if tinder rests in fire, or snow in the sun, so down here among us [the gold] was lit and melted in the hot womb, and then united with it more tightly than stones in the loggia.

How literally is Bronzino imagining Cellini's repetition of Jupiter and Danaë's act? When the fire burns, Minerva arrives, and a statue appears. Are we, then, directed to think specifically about Cellini's heated filling of the body with his own golden metal?[61]

Poetic inventions like Bronzino's illustrate the kinds of creation myths the *Perseus* allowed, and Cellini's own later refashioning of his art indicates how important it was that this creation took place, so to speak, within the womb of earth.[62] Making a man will have to go beyond giving him a form in clay; it must also involve ignition. If the making of the first man is to be emulated, one cannot just shape bodies, one must also, Prometheus-like, inspirit them.[63] Cellini's stories of casting are consistent with his poetry insofar as the marvel of Cellini's *fusione* is its capacity for *infusione*. Once liquefied metals are understood as living, the pouring of them into the armed mold could reproduce the archetypal act of life-giving. This lets Cellini hold his casting up to painting, just as he would hold it up to marble sculpture. Conversely, the poetry inflects Cellini's technical vocabulary. The earthen mold has an *anima*, an inner form that determines its shape, and an *ossatura*, a steel "skeleton" that holds it together. The infusion goes into its *bocca*, its mouth.[64] Describing his preparations of the mold in which he would cast the *Medusa*, Cellini writes: "I made the iron skeleton, and then made her form out of earth, as in anatomy."[65]

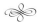

Part of what Cellini sought to demonstrate, with his *Perseus*, was that the making of metal sculptures could be as impressive as the making of stone ones. This demonstration depended on a poetics of process that Cellini had developed years earlier; in obvious ways, the copulative thematic in the *Perseus* follows on that of the *Saltcellar*. The context of the *Perseus* assignment, however, also required a redefinition of what it was that the statue-maker did, one that made room for, even required, the divine powers other artists assumed. This is significant not only for the literature that ultimately accumulated around the work, but also for the statue's very form. As the imagery of the *Saltcellar* expounds on the mode of composition by which the work itself was produced, so too does the imagery of the *Perseus*. As the founder's art figured in the substance the *Saltcellar* notionally manufactured, so does the caster's art figure in the feature of the *Perseus* that was, perhaps, that work's greatest marvel: the blood emerging from Medusa's head and neck (Figs. 17, 23, and 24).

The *Perseus and Medusa* was hailed, from the moment it was made, as *una cosa rara*, and its blood was arguably its most singular wonder.[66] With its implausible volume, the blood breached everything Cellini knew of human physiology, and voided his tireless insistence on anatomical accuracy. With its vivid rush, it contravened the determined self-containment of his hero's pose, and focused

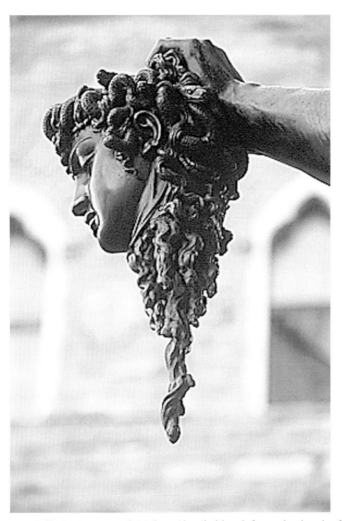

23. Cellini, *Perseus and Medusa* (detail: blood from the head of Medusa). Florence, Piazza della Signoria (photo: Wolf-Dietrich Löhr).

Cellini's figures into two points of convulsive animation. The statue's first viewers were overwhelmed: "I cannot get enough," wrote Bernardetto Minerbetti in 1552, "of watching the blood that pours impetuously from [Medusa's] trunk. This, although it is metal, seems nonetheless to be real, and it drives others away out of fear that they will be soaked with it."[67]

Knowing about the harsh rule of the statue's patron, Duke Cosimo I, and remembering the violent history of its site, Florence's Piazza della Signoria, most recent viewers have found Cellini's "impetuous pour" to be simply gruesome. The submission of Medusa to Perseus's blade has reminded them of real bodies that met similar or worse fates in Cellini's Florence, and the hero's triumphant act has accordingly seemed the very identity of political tyranny.[68] Contemporary evidence, however, suggests that such a visceral reaction is but one of the

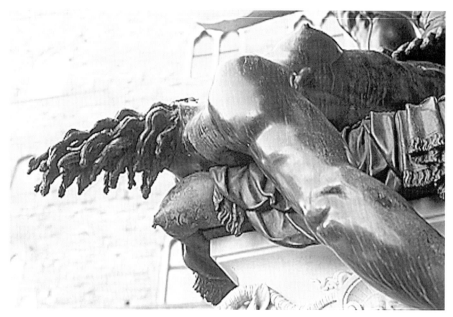

24. Cellini, *Perseus and Medusa* (detail: blood from the body of Medusa). Florence, Piazza della Signoria (photo: Wolf-Dietrich Löhr).

responses the blood might provoke, and it is a historically narrow one at that. The first admirers of the blood were not all admirers of Duke Cosimo, and they did not couch their praise as praise of Cosimo's rigor. They did not assume that Perseus's violence manifested Cosimo's, nor that it was addressed exclusively to the duke's enemies. They allowed it a more complicated role.

The possibilities for this role are bound up with the story of how and why blood entered the program of the Perseus in the first place. Cellini tells us that the duke initially required "just a Perseus" (solo un Perseo), "a statue of Perseus three braccia high, with the head of Medusa in hand, and nothing more."[69] This basic motif, as Karla Langedijk first recognized, was already current in the imagery of Cosimo's predecessor, Alessandro I. The similarity both of Cosimo's limited request and of Cellini's initial presentation model (Fig. 25) to the (bloodless) picture of Perseus on a metal coined by Francesco del Prato a few years earlier may indicate that, even before speaking with his new artist, Cosimo was imagining what might be done with a monumental display of Medusa's head.[70] The decision – also, we should presume, Cosimo's – to commission this as a work of bronze rather than marble must have had its own attractions.[71] Culturally, Cosimo's bronze would revive a classic Florentine material that had lapsed for decades; technologically, it would demonstrate his regime's premier pyrotechnic capacities. In 1544, the year before the work was begun, Varchi was already writing that Cosimo's "knowledge and study of metals resplend[ed] among his virtues."[72] A new metal *Perseus* in the Ducal Square could state much the same thing, making science an implicit factor

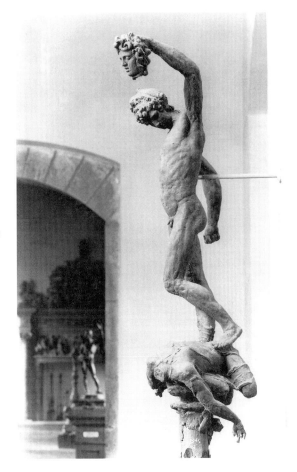

25. Cellini, Wax *modello* for *Perseus and Medusa*. Florence, Bargello (photo: Kunsthistorisches Institut).

in the rebirth of art that Cosimo's new order allowed.[73] The ideal place for such a work, finally, all but awaited its arrival. As Niccolo Martelli, writing in 1546, put it, "The people will look at [the Perseus] with amazement [when it is] on the platform of his Excellency's piazza, in the other archway of the Loggia, beside the one with Donatello's Judith. This space has been empty, and virtually reserved until now for the invention, [come] from the fateful stars, into the mind of our famous Duke; it will adorn the realm with all that metal, nature, art, contrivanu, rule, and style can make."[74]

Cosimo, it would seem, had calculated the combination of Perseus subject, bronze medium, and public site. Neither what the sources reveal about these calculations, nor other evidence, however, contradicts a further claim Cellini himself twice makes: The ultimate additions of the body of Medusa, the marble base on which the figures stand, and that base's ornaments could all be distinguished from Cosimo's first idea; all exceeded Cosimo's original desires.[75] Inasmuch as at least one of these assertions appears in a letter meant

to be read by the Duke, it may well be that the amplification of the *Perseus* was indeed urged by the artist – presumably with the support and advice of Varchi, then director of Florence's academy and Cellini's close friend; we know, at the very least, that Varchi eventually authored the four inscriptions on the statue's base.[76] An expanded project, Cellini and Varchi would both have recognized, could meet Cosimo's desire for a display of *metallo, arte,* and *ingegno* in even more concrete ways; it could also, however, fulfill that wish in terms of newly specific interest to the artist.

By changing the composition to include not only Perseus's petrifying display of Medusa's head but also the beheading itself, the point in the story of Perseus that the composition would *de facto* illustrate shifted. Set neither over the sea (as del Prato's medal was) nor in the realm of Atlas (where Ovid's Perseus "held out from his left hand the ghastly Medusa head"), the notional setting became the land of the Gorgons, and the time the moment when "[Perseus] severed [Medusa's] head from her neck, and from the blood of the mother swift-winged Pegasus and his brother sprang."[77] In the new scene, that is, blood was not gratuitous; it multiplied the myths to which the new sculpture was keyed. Initiating the birth of the winged Pegasus, the blood could synecdochally invoke Pegasus's own eventual role in originating poetry: "From the blood of the Gorgon was born Pegasus, who is interpreted as *fame*; he produced with his foot the Castalian fount or the Pegaseum, [and he is interpreted as fame because] virtue, overcoming all, wins itself noble renown."[78] The blood, anticipating the flow of the Hippocrene waters, linked the act of virtue to its glorification. Through mythographic logics, its flow could become the origin of art itself, the principle that glorious deeds mandate their artistic celebration, and thus the very justification of both Cosimo's commission and Cellini's work. As one later sixteenth-century writer explained, referring to the imagery on Cellini's own earlier medal of Pegasus, "virtuous action makes the fountains of glory and praise spring forth."[79] And when Cellini himself points out that "valorous and wise poets," recognizing the *virtù* of his sculpture, "covered its base with Latin and Italian verses," he reminds us that the spilling of Medusa's bronze blood did indeed result in poetry and fame.[80]

Beyond its symbolic promotion of Cosimo and his executor Cellini as new founders of the arts, moreover, the blood reinforced what Martelli, like Cellini himself, specified as the primary challenge of the artist's assignment – to make a match for Donatello's *Judith and Holofernes* (Fig. 26), the work that then stood in the Loggia's westernmost archway, and that had long been the Piazza Ducale's unique work of bronze.[81] Consider Giorgio Vasari's description of the *Judith*, written in the very years the blood was being designed:

> The exterior simplicity in Judith's habit and countenance manifestly reveal what is inside, the great mind of that Woman, and the aid of God;

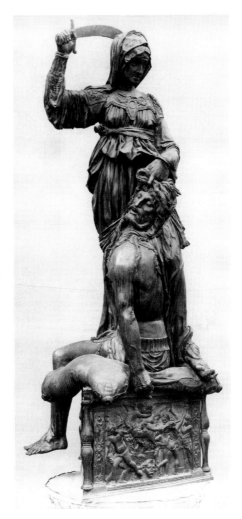

26. Donatello, *Judith and Holofernes.*
Florence, Palazzo Vecchio (photo:
Alinari/Art Resource).

in the same way, the air of Holofernes reveals wine, sleep, and the death
in his members, which, having lost their spirits, show themselves to be
cold and cascading[82]

Holofernes's limbs are *cascanti,* Vasari writes, because they have lost their spir-
its. Having been struck once already with Judith's sword, the giant's life has
retreated from his extremities; on the verge of death, warmth lasts only in his
heart.[83] As nearly every writer on Cellini's *Medusa,* in turn, insists, the sequel
to Holofernes would make dying even more vivid, realizing the loss of spirits
as the pour of blood. "Perseo miro," an anonymous sonneteer thus celebrated,
"e sotto a lui caduto/Il spirto e 'l corpo prezioso e caro/di Medusa." (I gaze
upon Perseus, and upon what is fallen beneath him, the spirit and body, pre-
cious and dear, of Medusa.)[84] In syntax and conceit, the line steers away from
both the impetuousness of the pour and its equine destiny. At issue, rather,

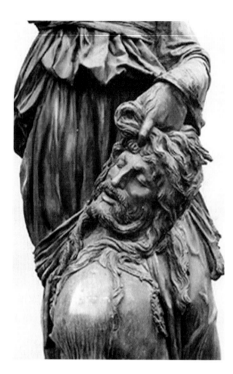

27. Donatello, *Holofernes* (detail: head of Holofernes).

is the statue's antithesis between containment and privation, between a hero great with his possessing soul and a victim from which *spirto* is being tapped. Francesco Bocchi's terms are even closer to Vasari's: "Medusa's body is . . . dead and cascading [*cascante*]; it makes wholly manifest how flesh and bones deprived of spirit are disposed."[85] Cellini himself offered this description:

> Qualche saggio di me Perseo pur mostra
> in alto ha 'l testio e 'l crudel ferro tinto,
> sotto ha 'l cadavro e non di spirto privo.[86]

> Perseus shows some evidence of me: above, he holds aloft the head and the cruel, colored [blood-stained] sword; beneath he has the cadaver, not bereft of spirit.

Medusa is a cadaver, as good as dead, even if her life, like Holofernes', has not quite vanished. As her muscles contract and her heart gives its final beat, she comes to her end. The body's distortion updates Donatello's cascading loss, while the blood presents the spirit's own desperate motion. Cellini's poem, like those of his contemporaries, looks beyond the point of Ovid's story; the key topic is rather the depletion of corporeal vitality. With its second body, the sculpture explores the relationship of exhaustion and beauty; with its blood, it reveals what life drains from the face and from the limbs (Figs. 27 and 28).

There are, in short, at least two available historical explanations for the incorporation of the blood into the program of the *Perseus*, one involving the

28. Cellini, *Perseus and Medusa* (detail: head of Medusa).

narrative that blood entailed, the other involving the sculptural inheritance it claimed. In both cases, the advent of the blood not only served Cosimo's purposes, but also facilitated the individuation of Cellini's own role as Florence's new star bronze-maker. The means both Cellini and his viewers offer for addressing the blood directly, moreover, repay still further attention. Between his adaptation of Donatello's emptying body and his gloss on the means of his own sculptural execution, Cellini's antithesis of the full and the vacant became all the more material.

Although [the blood] is metal, Minerbetti says, *its seems to be real*. On the surface of it, the remark may be nothing more that a spin on the common topos of the *signa spirantia*. What invites pause, however, is Minerbetti's intuition that it should be precisely with the blood that Cellini's metal became most real. Such a remark, however casually it was made, could, in Cellini's time, have been amplified along many lines. Mining experts would have observed that metal formed in "veins" in the earth, "almost like the veins of blood in the bodies of animals."[87] The alchemist whom Cellini asked for an explanation of mining must have commented on this.[88] Aristotelian pneumatology, furthermore, offered homophonic accounts of the origins of human blood (hence spirit and life) and of metals; both were infusions of water into earth. One could,

as Agricola did, make the point by quoting Timocles: "silver is the soul and the blood of mortals."[89] Alchemists, on the other hand, might have pointed to the theories of metallic etiology according to which metals were generated of "seeds" and blood, just as people were. "Whoever claims that vapor is the material of metals, says nothing other than he who calls the material of birth the blood of the male and the female, whence seeds are generated."[90] "Menstruum" (*mestruo*), a solvent in which metals dissolved, was a standard ingredient in sixteenth-century attempts at metallic transmutation.[91] And Biringuccio, citing proof of antimony's proximity to metals, noted that a "bloody liquor" could be extracted from it.[92]

Equally interesting, on this point, is Cellini's own poetry. In 1559, on learning of Vincenzo Danti's triple failure in attempting to cast the statue of *Hercules and Antaeus* for the garden fountain of the Medici villa at Castello, Cellini wrote a series of sonnets at Danti's expense. Most of these pun on the word *gettare*, comparing Danti's miscasting to Hercules's own tossing away of Antaeus. But one sonnet in particular ends with more curious lines:

> Voi che nel mondo pur gittar volete
> o roba o sangue o pregiati metalli,
> per tornar gloriosi al fiume Lete;
> gittai nel fier 'lion, pria in fra i galli
> se ben' feci 'l mio premio vi sapete
> brutto è 'l creder saper, poi far tre falli.[93]

[O] you who desire, while in the world, to pour money, or blood, or prized metals, to return glorious to the river Lethe – I cast in proud Florence [in '*lion*: Ilium / home of the Marzocco] and earlier among the Gauls[*i galli*: Gauls /Cocks]; If I did well, [now] you know my reward. It is a sad thing for one to believe that he knows how to do things well, and then to make three mistakes.

Readers have long found these stanzas difficult. In Cellini's Florence, the river Lethe could not have been mentioned without awareness that Dante placed it at the top of Purgatory; nevertheless, Cellini's clarification that the return to Lethe is glorious, as well as his implication that the return was allowed through the champion's worldly deeds, distances us from the passive suffering that a rigorously Purgatorial scene would require. Cellini's specification that one *returns* to Lethe sooner evokes Virgil's and Plato's stories of how, after death, the river purges the spirit so that that spirit can reenter the body reborn. The protagonist who, while in the world, casts blood and metals, qualifies for immortality. This affects the interpretation of the deeds at the center of the poem. "Pouring blood" can mean shedding blood, and can thus be a labor that is redemptive, or redeemable; elsewhere Cellini insists that work on his marble Christ was the contrary of "casting away his hours" on vain activities.[94]

Situating *sangue* between *roba* and *pregiati metalli*, the pun in this case invites a comparison between the suffering of bloodletting and the sculptor's work.[95] As Michelangelo allegedly remarked to Ammannati, "In my works, I shit blood."[96] Adolfo Mabellini, by contrast, has taken "pouring blood" to mean spilling others' blood; to *gettar sangue* is to do violence. It is, of course, easy to imagine an unrepentant double murderer like Cellini intending such a sense; the virtue rewarded in this respect, too, brings Cellini close to Plato's or Virgil's spirits.[97] Perseus is surely meant to be "glorious" as he spills Medusa's blood.

For whatever opacity remains, the poem binds blood and metals, and does so in ways that implicate both the imagery of the Perseus, and the sculptural act behind it. If the third line, "per tornar gloriosi al fiume Lete," is allowed to set the parameters for the gloss on what precedes it, these conjunctions will contribute to one conception of sculptural *virtù*. This conception, however, might also be questioned, by looking more critically at the form in which the sonnet has appeared ever since its first publication in the nineteenth century.[98] The poem exists in one draft. It was never intended for print, and was never even rewritten so as to make it presentable to others. In the manuscript, it happens, we find that the original third line of the stanza was not "per tornar gloriosi al fiume lete," but rather "non vi mettete à far se non sapete." Cellini, perhaps attempting to make his conceit sound more erudite, changed his mind about how to conclude the stanza. It is tempting to think that the first two lines were written with the draft's deleted conclusion, rather than the one known today, in mind. Left intact, the original nugget of the stanza would have been simpler and more grammatical: "You who desire, while in the world, to pour money, or blood, or prized metals, don't begin if you don't know how." Such a remark highlights the second face of the central pun, the reference to the enterprise of metal casting at which Danti failed. Blood and precious metals, in this case, could betoken each other interchangeably: One can found with the blood of the earth, and one can throw one's mettle into the task.

To return to Cellini's statue, and to the effusion that Minerbetti so admired: The poets imply that Cellini, assigned to undertake a monumental bronze response to Donatello's *Judith and Holofernes*, had studied in particular his predecessor's depiction of lost spirits; in his Medusa, Cellini imitated Donatello's own drained figure, but portrayed those spirits directly. Cellini gave the spirits a medium in metal, and as such attempted to meet the poetic expectation that his bodies, like Donatello's, be infused. Exposing blood, he demonstrated just what infused the body, and he illustrated how that essence could move across the container's threshold. The *metal* of this blood, moreover, could seem, to one with Cellini's science, especially resonant as the carrier of the infusing spirits. Rendering liquidity *in metal* effectively recalled spirits already there. By the same token, the status of his bodies as infused was naturalized by descriptions of the act that generated them, the act of pouring that

Cellini took to be the center of the founder's profession. Ultimately, the terms of metallurgy allowed the artist to corroborate his fulfillment of the assigned aesthetic of infusion. The fictive blood, as liquid metal, could, in retrospect, record the spirits that Cellini had literally poured into the sculpture. Retold, the act of turning real bronze into the fictive insides of Medusa could illustrate the process of turning real bronze into the real insides of the statue's *ossatura*, or *corpo*. Cellini cast blood.

Such a reading is enriched by the other ways that the statue has, in the recent literature, been framed. Kathleen Weil-Garris Brandt, for example, encourages a closer look at the base on which the *Perseus* stands: Developing a suggestion from Christof Thoenes, she proposes that this socle be read as an altar. The idea is a powerful one; comparison with Renaissance representations of Roman altars leaves little doubt that Cellini had such a form in mind. On this basis, Brandt describes the pedestal as "an altar to the Olympian gods who protect the Medicean 'son of Jove,' now Duke Cosimo I."[99] Although the poems of Bronzino and others treat the statuettes Cellini includes on the base as Perseus's creators, as much as his protectors, and caution against limiting the figures to a statement of Medicean genealogy, much speaks for the kernel of Brandt's proposal: The base is dedicated to the gods it contains. Such dedicated altars, after all, play a prominent role in the story of Perseus. Having rescued Andromeda, Ovid writes,

> Perseus builds to three gods three altars of turf, the left to Mercury, the right to thee, O warlike maid, and the central one to Jove. To Minerva he slays a cow, a young bullock to the winged god, and a bull to three, thou greatest of gods.[100]

It is suggestive that Cellini's altar includes all three of the figures on Ovid's (Fig. 22). The artist could thus well be alluding to a specific detail from the Perseus narrative, one he could have known not just from texts, but also from other images, for instance, the etching designed by his friend Giulio Romano (Fig. 29). If, as Brandt implies, Cellini intends his base to *function* as an altar (and not merely to incorporate classicizing, but contentless, shapes), then the object's role as a base becomes more consequential. The viewer might think, for example, about what *should* be on an altar: As Cellini certainly knew, Medusa occupies the space of immolation, the space of *fire*.[101] Viewed against contemporary representations of pagan rites, Medusa's blood could well seem to pour in the midst of a notional heat. Related considerations highlight the effect, vis-à-vis the base, of Perseus's own gesture. It is intriguing to consider whether Cellini looked carefully at, for instance, the *Pygmalion and Galatea* by his friend Bronzino (Fig. 30), whether he thought about the relation of sacrifice to the sculptor's own act of transformation, about how life comes to be given through fire and death.[102] An argument in this direction could draw

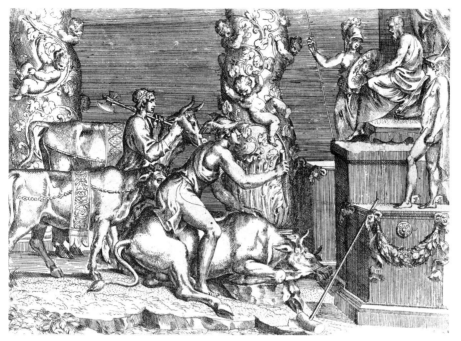

29. Battista del Moro, *Perseus Sacrificing to Jupiter.* Vienna, Albertina.

on Mircea Eliade's classic studies of the role of blood sacrifice in metal casting, and specifically on his thesis that "life can only be engendered from another life that has been immolated." Metempsychosis, the transfer of life from one being to another, is an almost primordial strategy in metal forging; Eliade's discussion of the importance of animal and human oblations in various cultures' founding rituals offers a way to normalize Cellini's own act of creation.[103]

To expand the scope of this reading in a different way, it is helpful to consider John Shearman's observation that Michelangelo's *David* and Baccio Bandinelli's *Hercules* can be read as having been enfolded into the *Perseus*'s fiction. Cellini's group realized a subject that thematized the petrifaction of the beholder in a material that was perspicuously *not* stone, and it occupied an architectural plot on which two gigantic marble works seemed to gaze (Fig. 31). The opportunity was extraordinary: Perseus could seem to transform his two stone predecessors into the first and lasting evidence of his own petrifying weapon.[104] Shearman does not discuss just how Cellini hoped to make this gorgonization operate, how the artist could make plain that his sculpture was more than stone. But if we can now say that it is through infusion that bronze exceeds marble, then we can infer that it is precisely the blood that guarantees the whole effect. It is its warmth, its red life, that differentiates Cellini's bronze from its petrified companions[105]: Ovid himself narrates that when Perseus held up

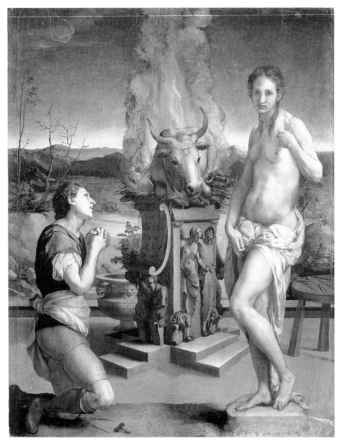

30. Bronzino, *Pygmalion and Galatea*. Florence, Galleria degli Uffizi
(photo: Scala/Art Resource).

Medusa's head, he made his opponents into "stone without blood" (*silicem sine sanguine*).[106] Cellini's bronze triumphs over its stone predecessors because the blood of the medium implies a state of life that marble cannot, and because a calculated circuit of mythical birth and death provides for it a spirit that marble, in its face, can only lose.[107]

Between the comments of poets, the features with which Cellini amplified his work, and the setting the statue had to enter, perspectives accumulate that allow Cellini's sculpture to be read in much the way that he himself read Vincenzo Danti's: His image of *virtù* becomes an allegory of casting. By now it is tempting to see Perseus's gesture as the heroic (as Hercules' was the pathetic) pouring of metallic-blood/spirited-metal into the place where the monument should or does stand. One further piece of evidence, however, remains to be addressed. There is, it turns out, another document that bears directly on the

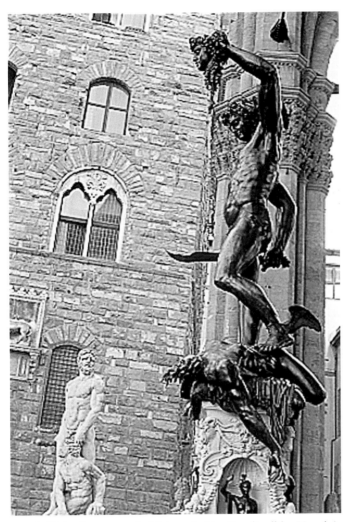

31. Cellini, *Perseus and Medusa* (with Bandinelli's *Hercules*).
Florence, Piazza della Signoria (photo: Wolf-Dietrich Löhr).

blood, one that complicates its role in the statue and its relation to Cellini's
own background: surprisingly, Cellini gives his blood a name.

In the accounts preserved of the weighing of pieces of the monument cast
subsequently to the *Perseus*, we learn of a *Merchurio*, a *Danae*, a *Perseino*, four
alie (wings), and two *gorgoni di Medusa*.[108] All but the last of these items present
no problem; they can be readily identified with components in Cellini's assem-
blage. The *due gorgoni*, however, have long remained something of a mystery.
Given that the Perseus figures were not the only metalworks Cellini had un-
derway at the time of the record, it might be guessed that the document
records more miscellaneous pieces. As there is also evidence that Cellini ex-
ecuted components for his monument that were ultimately omitted, it might

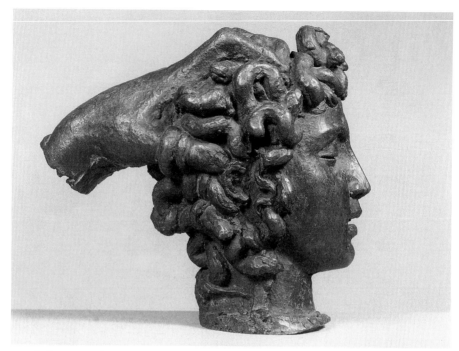

32. Cellini, *Head of Medusa*. London, Victoria and Albert Museum (photo: Art Resource).

seem possible, alternatively, that these *gorgoni* were extra Gorgons Cellini once intended for the statue.[109] Eugène Plon, in fact, the only Cellini specialist to comment on the phrase, was certain that the *gorgoni* were independently cast Medusa heads.[110]

Unknown to Plon, however, was a second, more specific, document of the weighing. From this it becomes clear that Cellini made not just any Gorgons, but the *gorgoni del collo e della testa della medusa* (*gorgoni* of the neck and of the head of Medusa).[111] The document leaves no doubt: The *gorgoni* are exactly the two blood formations that hang from Medusa's two parts. This raises new considerations. How, to begin, should Cellini's actual making of the blood now be reconstructed? The Medusa was cast in June 1548, the Perseus in the winter of 1549, but the pieces mentioned here were cast only in the summer of 1552.[112] Cellini thus seems to have rendered the blood independently, designing it as a piece on its own, turning to it only after he had seen how the figures themselves would look in cleaned condition. Such a scenario, perhaps, helps make sense of another small work from Cellini's hand, the mysterious bronze study of Medusa's head, which came to light in 1964, and which resides today in the Victoria and Albert Museum (Fig. 32). The function of this piece, datable on the basis of thermoluminescent tests to Cellini's lifetime,[113] and presumably identical with the "testa di Medusa di bronzo" listed in the inventory of Cellini's studio on his death in 1571,[114] has, for decades, been a matter for debate. One

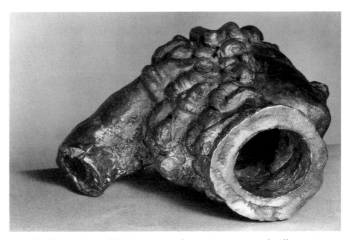

33. Cellini, *Head of Medusa*. London, Victoria and Albert Museum.

largely overlooked clue, however, may be the treatment of the work's neck, where the metal has been polished to form a fairly even plane (Fig. 33). This termination, it turns out, is remarkably similar to that which Cellini used with the larger work as well, where it served to create a sort of joint, into which the blood could be fitted. What the Victoria and Albert piece may thus represent is a ca. 1549 study for the head of Medusa – one, that is, made before the *gorgoni* had been modeled. The piece reminds us of the physical independence of the *gorgoni* from the monumental cast, reminds us of the fact that the *gorgoni* themselves were separate (and later) problems of design.

The date of the reference to the *gorgoni* provides evidence about the sequence of Cellini's work on the *Perseus*, and may help us imagine how he thought about his different pieces. To discuss Cellini's actual treatment of the blood, however, it is also necessary to tackle the philological issues raised by the documents' terminology. From modern Italian, it might be expected that Cellini's word *gorgoni* is the plural of *gorgone*, Gorgon. In Cellini's time, too, the word *gorgone* was familiar enough; to mention a Gorgon was to speak of a member of Medusa's family, of the person of Medusa herself, or even (as Plon knew) of her head in isolation.[115] However, no version of, or commentary on, the Medusa story, nor any dictionary entry, early or recent, seems to allow the word *gorgone* to designate blood. What, then, are Cellini's items? One possibility is raised by Niccolò Tommaseo and Bernardo Bellini's 1869 *Dizionario della lingua italiana*, which remarks that the plural *gorgonii* names not Gorgons as such, but rather a particular family of polyps – *gorgonii* are *corals*.[116] Tommaseo and Bellini give no source or example for this usage, but their word is very close to a term that Cellini could have found in Pliny's *Natural History*, namely *gorgonia* (Latin *gorgonia*, English *gorgonian*), the term for a red coral "so named because it is converted into the hardness of stone." The Italian version of Agricola's scientific

writings, published two years before the Cellini documents in question were drawn up, spotlights and explains Pliny's word:

> [Coral] has also been called gorgonian, because the poets imagine that the gorgons were converted into stone. Thus Pliny, writing about gems, says these words: "gorgonian is, in effect, nothing other than coral, and the reason for this name is that gorgonian is transformed, converted into the hardness of stone."[117]

Surprisingly, Agricola glosses Pliny's definition not with reference to the petrifying power of Medusa's face, but rather with the assertion that gorgons themselves, like gorgonian corals, rigidify.[118] Cellini's term *gorgoni* accordingly requires us to consider the possibility that *Medusa's* metal not only flows but also hardens.[119]

For this, it is instructive to return to Ovid's telling of the Perseus story. Now, though, the crucial passage concerns not the beheading of Medusa, but rather the rescue of Andromeda:

> Having killed the dragon, Perseus came down from the rock and sat on the bank of the sea to wash himself, for he was soaked with the dragon's blood. As he did this, the head of Medusa got in his way, so he set it on the ground. So that the head did not crack, Perseus gathered some seaborne sticks of wood to set it on, and put them on the ground. Immediately those sticks hardened as stone does, and from the blood of the head they became vermilion. It is thus that coral is made, and this was the first coral. Seeing this, and the death of the dragon, the sea-nymphs marveled greatly. And as Perseus entered the water, the nymphs came to the bank, took those corals and disseminated them through the sea, where they immediately began to grow. Because of this, there is now an abundance of coral in the world.[120]

The quotation comes from the earliest published Italian translation of the *Metamorphoses*, penned by Giovanni Bonsignore in the fourteenth century, and first printed in 1497. Bonsignore's version of the story, like those that follow his, modifies several significant details of Ovid's Latin.[121] Ovid, as it happens, did not even mention blood, specifying that seaweed was petrified at Medusa's *touch*, transformed through the *vis monstri*.[122] The early Italian versions, in contrast, do not name the cause of the petrifaction at all, but do explain that once coral hardened, Medusa's blood made it red.

That Cellini has blood itself become coral may indicate that he knew such a translation of Ovid; that he omits seaweed as an ingredient, however, makes his own metamorphosis one of a new sort. In part, his variation depends upon his having located the generation of coral in the scene of Perseus's confrontation with Medusa, rather than Andromeda. What is striking, though, is how, in

departing from Ovid's Andromeda tale, the sum of Cellini's details approaches not only the earlier moment in Ovid's narrative, but also some ideas from Pliny. In the *Natural History*, it is not the gorgon that petrifies, but the removal of the coral-to-be from its native marine conditions: Soft in the water, coral becomes hard only when it meets air. Pliny also has this to say about it:

> Coral is like a shrub in shape, and it is green in color. Its berries, while underneath the water, are white and soft, but when plucked they become hard and red, and have the shape and size of common cornel berries. They say that if corals are touched while they are alive, they immediately turn to stone. Expecting this, collectors pull them out with nets, or they lop them off with sharp blades. It is on account of this, they say, that the thing is called 'coral.'[123]

The passage is suggestive, inasmuch as Cellini, like Pliny, has coral become coral only when it is cut. If Cellini knew his Ovid not from translations but rather (or also) from Raphael Regius's popular Latin edition, he would have found the commentary referring him directly to Pliny's discussion.[124] And if Cellini read one of the many available editions of the *Storia Naturale*, then he knew Pliny's etymological hypothesis – *curalius* (probably because of the Greek κειρειν, to cut, shear) is so named for the way it is collected.[125] Cinquecento Italian editions render Pliny's *acer ferramentus* as *un tagliente ferro*. Cellini takes this in the most literal sense; to underscore the capabilities of Perseus's *ferro*, he provides the hero with a sword of iron.[126]

It might be expected that Cellini, who claims to have once passed every day of an entire month on a beach, collecting "the most beautiful and rare pebbles, snails and seashells,"[127] would have been interested in coral for its visual properties alone. This he would have had in common with his patron, who, like other European princes, avidly sought coral as a marvelous *objet*.[128] In his profession, Cellini must have known goldsmiths who had mounted coral in brilliant settings; perhaps he had done the same himself. Coral, in sum, was precious – a point emphasized, among others, by Vasari, whose *Perseus and Andromeda* for Francesco I's *studiolo* (Fig. 34) puts the coral (like Cellini's, more decisively blood-shaped than Ovid's text requires) in the company of pearl-bedecked nymphs, Minerva's sparkling shield, and the hero's own ermine-fringed boots. Originally, this painting designated and commented on objects hidden behind it, objects that very likely included gorgonian.[129] Looking from Vasari's coral to Cellini's, the latter might even seem to exemplify what is sometimes described as his goldsmith's aesthetic; it agrees with the monstrous heads on the hilt of the sword, the dragon finial on the helmet, and the extraordinary fineness of the Medusa head itself. It is as if Cellini has turned the whole statue into a colossal setting for the marvelous coral, calculating how best to show its qualities to the piazza.

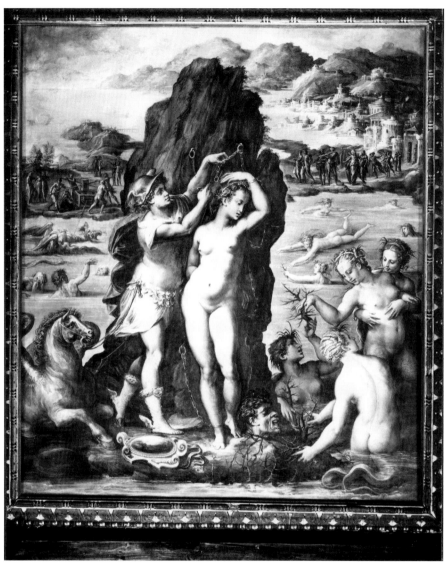

34. Giorgio Vasari, *Perseus Liberating Andromeda*. Florence, Palazzo Vecchio (photo: Alinari/Art Resource).

Both Cellini and Cosimo would also have been fascinated by the transformative properties Ovid and Pliny attribute to the substance. As Philippe Morel has demonstrated, coral is a meaningful participant in Renaissance grottoes, where its behavior likens it to *spugna*, the dripping ooze that covers the walls and ceilings. Coral was a "juice apt to become stone" (*sugo atto a diventar pietra*); it, like *spugna*, seemed to harden before the viewer's eyes. Morel compares the generation of coral to that of rocks, stressing that the fundamental process in its generation is one of glutination.[130] Such a view works well with Cellini's

gorgoni: He renders a material with traces of its past as a moving current of liquid, and a present in the coagulated stillness of metallic stone.

Beyond Morel's account, it might be stressed that in the sixteenth century, many thought that coral began as a plant. Its nativity thus involves not only a process of solidification, but also one of preservation; coral's vegetative virtues remain within, and consequently allow the gem to function as an apotropaion, as a medicine, and even, ideally, as a philosopher's stone.[131] This adds a Plinian dimension to the *collecting* of coral; Medusa's blood should be seen not merely as the product of Cellini's inspired fantasy, but also as an ornament central to his patron's interests. Recognizing coral, and knowing its potency, the viewer must take even the *Perseus*'s propagandistic intentions to involve more than menacing would-be rebels with beheading, or recording the violent appropriation of the piazza's space; the naturalist view of coral lets the statue illustrate transformation as much as butchery.[132] Perseus's gesture, allowably more benign that it is now usually said to be, involves the conversion of the rough into the fine, the dangerous into the valuable. The outstretched arm offers coral to the ducal city, to which its bearer has guaranteed safety. The coral constitutes both a claim for the richness of the arts that accompany the keeping of peace and a reassuring amulet of protection from the hero that has guaranteed it.[133] It is the gorgon, as much as the beholder, that is transformed: From the pride that threatens to upset civic calm, Medusa becomes the object that both arises from and guarantees that pride's removal, the petrified prize of Perseus's blade.

All of this assumes, of course, that Cellini's accounting note is sufficient to demonstrate that coral is what we see. His actual rendering might seem more equivocal. The main stalk of blood reaching from Medusa's head, perhaps, will appear to have grown rather than fallen, stretching a knobby trunk into space, twisting like a vine (Fig. 23). And perhaps Minerbetti should not have been worried about being soaked with the blood from Medusa's body: It has stopped the outward trajectory of its spray and has turned downward, dangling for perpetuity in bauble-tipped strands (Fig. 24). Maybe these ends, like the small globules that hide within, are to be taken as the berries Pliny mentions, white when under water, red and hard when brought into the air. All of the blood that emerges from both head and body moves in individualized serpentine stems, and its surprising volume may, as well, suggest its vegetative state: Compare especially the amount of blood we see coming from the head with the size of its container.

At the same time, incontrovertible features of coral are absent. Its forms are not branched, and, having probably been gilded, it lacks the telltale blood-red color. Its hang fairly reproduces what might be expected of liquids drawn by gravity; from the head the substance moves straight to the ground, from the body it curves downward as well. There is, furthermore, the difference,

already remarked, between Cellini's scene and the narratives of coral generation that are its presumed sources. More suspiciously, there is the ineluctable fact that not one of Cellini's contemporaries, a number of whom we have already heard commenting on the blood, mention recognizing it as gorgonian. For Minerbetti, the blood "seems to be real"; for the poet Pagano Pagani "a true wave of blood flows from the neck."[134] Even Cellini, as we have seen, later refers to the blood in terms consonant with his viewers' descriptions. If the artist wants us to see coral, he wants us to see it at the threshold of its existence, at the moment when it stops being blood. Ovid and Pliny cue us to read this backward, from the coral toward its source.[135] But we could just as well approach the transformation from the other side, starting with blood. Blood itself, after all, is nothing less than a "nutrient in potential," a substance ready to change into other substances as soon as it enters the right conditions. As Varchi asserted while lecturing on blood just two years before the *Perseus* was begun, blood even contains an ingredient called *cambio*, so-named because blood is changed and transformed as it moves from one environment to the next.[136] Is what we see, then, better described as coral that was blood, or rather coral-to-be, the *aptness* of blood to become coral?

Either way, taking coral to be the *end* of Cellini's blood requires an understanding of it as something more than infusion revealed. To say that blood can become coral is to say that it can itself be rendered; as a *medium*, it not only bears spirit, but it also accepts form. Blood, writes Galen, "is like the statuary's wax, a single uniform matter, subjected to the artificer."[137] Molding blood in wax, Cellini proved the simile. And casting metal after this wax, Cellini found not just shape, but also value. His medium becomes vivid: In its featured preciousness, and in its aptness to form, the blood-*cum*-coral is as functional a token of *bronze* as any Cellini could have offered. The coral emphasizes that Cellini's blood is *dear*, and comments on the marvelous goldsmith's object into which it is made. We come back to Cellini's punning phrase on the pouring of "sangue o pregiati metalli" and to the anonymous viewer's description of the spirit and body of Medusa, *prezioso e caro*. If the rendering of metal into blood could, through poetic and alchemical discourses, typologically fulfill the quest of bringing metal into spirit, then rendering that blood as coral, making it simultaneously congealed and precious, brings the achievement full circle. Cast, the metal hardens into immortal life.

THREE

The *Ars Apollinea* and the Mastery of Marble

> The arts have this difference, too, from the sciences: that they
> are divided and separated from one another, such that one can
> be a master of one without knowledge of any of the others.[1]
> – Benedetto Varchi

*T*he series of goldsmiths' biographies with which Cellini begins his *Trattati* implicitly affiliate the artist with a narrow tradition of Florentine statue-making, a tradition that included such masters as Ghiberti, Verocchio, and Pollaiuolo, but left out every artist who came to specialize in marble-carving. In tallying this lineage, Cellini must have known that it was into the history of precious metalwork that the *Perseus*, the public work to which he had committed a decade of his energies, most obviously fit. Such a sense would have been heightened by the inclusion of the bronze statuettes in the work's base, by the addition of a neo-Ghibertian relief facing the Piazza, and, as the previous chapter has argued, by the connotations of much of the work's imagery.

This is not to deny that metallurgic performances could be pitched so as to liken them to productions in stone. So much, at least, must have been involved in Cellini's comments about the *Perseus*'s raised arm, or in his insistence on the one-piece cast. But a venerable legacy of sculptural thought – one dating at least to Pliny and surviving, in legal form, in the regulations of the guild system – would sooner divide statues according to their materials than compare them on the analogy of their difficulties. An artist as deeply interested in teaching as Cellini could not have missed the fact that he had not trained in the manner of Michelangelo, Bandinelli, or even Donatello, the artists whom, if only by way of his assigned setting, Cellini inherited as interlocutors. There was no avoiding the question of just where it was that Cellini's work belonged. To put the *Perseus* in the broader context of Cellini's Florentine career, accordingly, it is necessary not only to imagine the kind of argument that could be made on

the *Perseus*'s behalf, but also to address the kind of skepticism that such a work would inevitably have elicited.

Consider two witnesses. In book two of *Il Riposo*, Raffaello Borghini's 1584 dialogue on the arts of Florence, talk turns to the *statue di piazza*. The speakers first discuss Michelangelo's *David* (installed 1504), Bandinelli's *Hercules* (completed 1534), and Ammannati's *Neptune* (completed 1575), debating the success of each sculpture's anatomy, proportions, and attitude. Having concluded their remarks on the figures along the Piazza's east side, the participants then look south (Fig. 35) to the Loggia de' Lanzi, the colossal stage that held Cellini's *Perseus* (completed 1554), Donatello's *Judith* (reinstalled 1582), and Giambologna's *Rape of a Sabine* (completed 1583). Before proceeding, however, Rudolfo Sirigatto, one of the speakers, finds it necessary to remind the group of the boundaries of their topic:

> There are no more figures in the piazza that we can talk about but the beautiful group by Giambologna, for it is not our intention to speak of bronzes.[2]

A discussion that seemed, to this point, to be only incidentally about medium is suddenly revealed to have depended entirely upon it. Sirigatto's earlier opinion that the awkwardness observable in the *David*'s shoulders proved the limitations of the block Michelangelo sculpted betokens Borghini's otherwise implicit assumption that even the iconographic and stylistic questions on which the dialogue focuses would be considerably different if the work at issue were not marble. The conversation moves without further remark to the *Sabine*, and heeding Sirigatto's reminder, the speakers focus exclusively on the marble group that is the monument's main element; in five pages of argument, no one so much as mentions the prominent, sophisticated bronze relief on the front of the monument. Just as the earlier description of Ammannati's *Neptune* fountain had given almost no attention to marvelous bronze characters that populate its border, and just as the larger discussion had entirely ignored the *Perseus* and the *Judith*, so here does the debate reinforce Borghini's belief in the fundamental difference, and inferiority, of bronze as a medium.

Thirty years earlier, in a poem about the *Perseus*, Cellini's friend Antonio Allegretti offered a slightly more favorable view of what the bronze-maker might achieve:

> Once, my Cellini, the world celebrated Polignotus, Zeuxis, and Apelles among painters, and praised Phidias and Praxiteles in marble. Now in both [painting and marble sculpture] it celebrates Buonarruoti. Bronze has been lauded and famous, for ancient works and new, but your Perseus defeats all of these, and makes them seem cold and motionless.[3]

Allegretti recognized that Cellini's work in France had positioned him to become Florence's, if not Italy's, premier *bronzista*; he invokes the chill of the

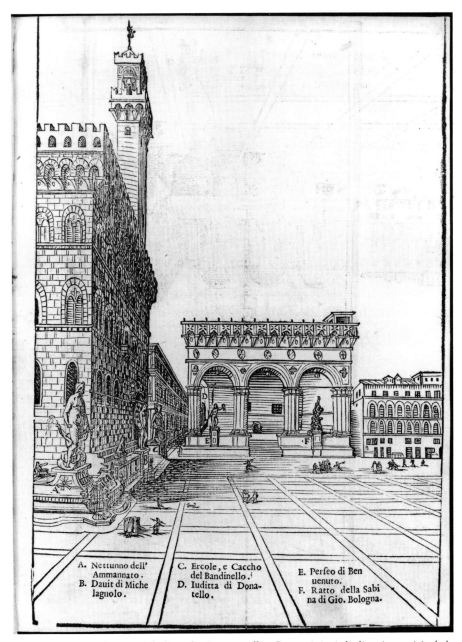

A. Nettunno dell'
 Ammannato.
B. Dauit di Miche
 laguolo.

C. Ercole, e Caccho
 del Bandinello.
D. Iuditta di Dona-
 tello.

E. Perfeo di Ben
 uenuto.
F. Ratto della Sabi
 na di Gio. Bologna.

35. Frontispiece from Michelangelo Sermartelli, *Composizioni di diversi autori in lode del ritratto della sabina*. New Haven, Beinecke Rare Book and Manuscript Library.

"Medusa effect," and he describes the success of the *Perseus* as a conquest. But a conquest of what? Although the *Perseus* freezes its competitors, gorgonizes them, makes them like stone, it does not triumph over *actual* stones – that is for Michelangelo alone to do. Allegretti lets Cellini imitate

Michelangelo's accomplishment within a medium, but segregates his productions from Michelangelo's. Cellini's mastery is to be limited to a field in which Allegretti names no predecessor.

For both Borghini and Allegretti, Michelangelo's excellence is excellence in marble; their statements block, with different degrees of sympathy, the possibility of emulating Michelangelo in any other material. It is easy to see how Michelangelo's own practice, which eschewed virtually all sculptural material other than white Cararra stone, might itself have seemed to support such a view.[4] And it consequently comes as little surprise to find that, whatever his hopes for the *Perseus*, Cellini was not satisfied working only in metal. Hearing Cosimo's idea for the *Perseus* for the first time, Cellini did not promote himself on the basis of his demonstrable experience in France; rather, he asserted that,

> desirous to show in this marvelous school that, after leaving it, I had labored in another profession than that for which the school knew me, I responded to my Duke that I would gladly make him a great statue in that beautiful piazza, in marble or in bronze.[5]

Conceiving his return to Florence as the opportunity to demonstrate his professional expansion, Cellini offered to show his prowess as a stone-worker.

Cosimo probably knew that Cellini had no experience with the marble chisel, and he opted to keep Cellini working on metal; the artist was to make "just a Perseus."[6] This decision, however, seems only to have goaded Cellini. First, pressing the commission, Cellini made not only the bronze statue, but also, beneath it, a "great base of marble," elaborately carved with figures and emblems.[7] Then, having been commissioned by the Duke to make a portrait of him in bronze, Cellini not only turned this out, but also began a reproduction of it in marble.[8] On the side, he accepted the task of restoring an antique marble figure for the Duke, and in addition carved two independent statues. Later, he would also spend his own limited funds to buy himself more marble, so that he could continue working it.[9]

The autobiography leads the reader to believe that Cellini's campaign against the Duke's initial inclinations was achieving its goal. The artist writes:

> While I was working [on the *Perseus*], the Duke came to see me, and many times he told me, "Set aside that bronze for a while, and work a bit on marble, so that I can watch you." I immediately picked up the marble chisels and worked away with confidence.[10]

There is, however, cause for suspicion. Cellini's claims about his confident handling and Cosimo's encouragement disguise the real labor Cellini's beginnings as a marble sculptor must have entailed. Of the five works of marble that Cellini's studio undertook for Cosimo in the late 1540s, four remained in the *bottega*

at the artist's death in 1571.[11] Cosimo accepted the fifth (the restored marble *Ganymede*), but balked at paying for it. Nor does the Duke seem to have offered payment for the most beautiful Cellini marble that ended up in his hands, the Escorial *Crucifix*.[12] There is no evidence that Cellini ever executed a marble sculpture on commission.[13]

Only the sponsored time of his work on the *Perseus* and the guidance of the *scarpellini* who ostensibly worked for him, it can be inferred, allowed Cellini to learn to carve. And it is not even likely that Cellini himself was responsible for all of the works that now generally go under his name. His account books, for instance, reveal that he paid Willem de Tetrode and Francesco del Tadda, two talented marble-workers then in his shop, to carve the marble base for the *Perseus*. Tetrode also worked on the now-lost bust of Duchess Eleanora, and it is likely he, rather than Cellini, who carried out the *Ganymede*.[14] In comparison with the God-like powers Cellini attributes to himself in his creation of the *Perseus*, the artist's comments about one work he did make, the *Apollo and Hyacinth* now in the Bargello Museum (Fig. 36), barely disguise his embarrassment:

> As I heard everything cracking, I regretted many times ever having begun to work on it. I got what I could out of [the marble], namely the Apollo and Hyacinth which one can still see, unfinished, in my workshop.[15]

The comment may well describe Cellini's experience with his very first marble statue. With the *Apollo*, the 48-year-old metal-worker was attempting to redefine himself as a master of the profession his rivals had been working at since they were children. From a technical point of view, the result has long been viewed as one of the artist's weakest pieces; put in the context of his professional history, however, it becomes one of his most interesting.

As Cellini himself acknowledged, the marble sculptor's virtuosity was measured by the facility and invention with which he discovered a complex, multi-figured composition in a single given piece of stone.[16] More than one reader has suspected that when Cellini writes that he got what he could out of the block, he directs attention to the fact that he *did* manage to realize a two-figure design. With this recognition, however, has come the assumption that this task so occupied Cellini that it overcame his capacity to find for the work a satisfying subject. At best, that subject has been considered a compromise – because the scene of Hyacinth turned into a flower "had no sculptural possibilities," Cellini invented a scene of tender exchange between Apollo and his beloved instead.[17] At worst, the subject has seemed an infelicitous, ad hoc, and even nonsensical idea adopted in the face of the difficulties marble presented: "The figure of Hyacinth, sunk to its knees and seemingly helpless, its lower legs stuck to the ground, was only added as a support at the back, allowing the figure of Apollo to present himself frontally the viewer." There is no narrative

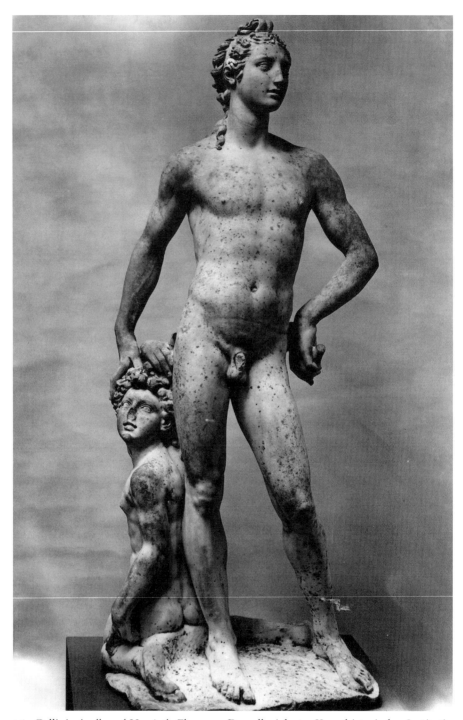

36. Cellini, *Apollo and Hyacinth*. Florence, Bargello (photo: Kunsthistorisches Institut).

or thematic rationale to Hyacinth's presence; Apollo's and Hyacinth's gestures "establish only the most superficial connection between the two figures."[18]

It is possible to look at the sculpture in other ways. Technically, after all, Cellini's Hyacinth was not really "added" to anything; it was of a piece with his Apollo. Moreover, the fact that Hyacinth's pose serves statical ends, absorbing some of the weight that would otherwise have to be carried by Apollo's thin legs, logically implies nothing about the accident or purpose in the choice of a subject for the work. Could Cellini not have selected his characters in acknowledgment of the exigencies of a stable two-figure composition, rather than in spite of them?

An answer to this might be available if we approach the imagery of the *Apollo* in the context of Cellini's professional trajectory. For the subject of the *Apollo,* it can be argued, is precisely Cellini's art. Its statement enfolds the terms of artistic success and failure that Cellini, coming for the first time to marble, imagined for the piece. The *Apollo* is a polemical work, and its polemic is bent on proving Cellini's knowledge and control of the medium that threatened to isolate his sculptural domain.

A helpful way to begin thinking about the questions asked above is to consider Cellini's *Apollo and Hyacinth* as a *type*, defining the genre to which it belongs. A number of accepted and familiar categories of imagery – the multifigure monolith, the triumph – might, for this, seem productive points of departure. It may be, nevertheless, that another category is still more illuminating than these, one that I will, for the moment, term "master–subject sculptures."

It will be necessary to justify this label and to elaborate its range of reference. Provisionally, however, the name can be taken to describe compositions such as Michelangelo's *Victory*, or Cellini's own *Perseus*, in which one figure is shown to have "mastered" another. Formally, the genre relies on a vertical hierarchy, wherein an upper figure is implied to be a victor, and a lower figure is implied to be his or her victim. Historically, its roots are in medieval *psychomachia* oppositions, which, in the wake of Donatello's *Judith and Holofernes* and under the auspices of absolutist patronage, were transformed to include political, as much as moral, topics.[19] To contend that Cellini's *Apollo* also belongs to this genre will be to imagine that the artist, facing his marble block, looked at the way its contours suggested figures with some sort of convincing postural relationship. It will be to imagine, further, that Cellini's actual discovery of figures reflected his awareness that earlier sculptors had turned vertical blocks into compositions combining a standing figure with a sitting or kneeling one,

where the combination implied that the upper figure had *overcome* the lower. Explicating Cellini's sculpture in terms of this alleged genre, in turn, will amount to showing how its characters perform these assigned parts.

For such a demonstration, it is crucial to observe that Cellini's *Apollo and Hyacinth*, like Donatello's *Judith and Holofernes*, Bandinelli's *Hercules and Cacus*, and the many Renaissance representations of David and Samson, can be taken to cast its two players as killer and killed. Such a schema, in fact, helps explain Cellini's one remarkable divergence from the formats of his predecessors: Whereas Donatello, Bandinelli, and Michelangelo all have the standing figure use its left hand to take the victim's head, Cellini has Apollo take Hyacinth with his right. Cellini's reversal of the typical orientation, his theatrical placement of Apollo's right hand, may well be intended to evoke Apollo's cry to Hyacinth in Book Ten of the *Metamorphoses*: "My right hand is the cause of your end; I am the author of your death."[20] Cellini himself, as we shall see, alludes to the story of Hyacinth only once in his writing, using it to illustrate the wound that Apollo deals.

It is of immediate interest, moreover, that Cellini's work not only continues an existing format or schema, but also, with its choice of characters, reformulates that schema, and thus the master–subject genre as such. The mastery that Cellini attributes to Apollo, unlike that represented by his predecessors, relies on what Ernst Kantorowicz has called Apollo's "double function."[21] In Cellini's imagery, the master has the capacity not only to injure, but also to heal.

Apollo's role as a healer was familiar from a number of authorities, including Virgil, Ovid, and Petrarch; Ovid even goes so far as to call medicine Apollo's invention.[22] It was, in Cellini's time, a familiar topos that Apollo's nature was two-fold. As Macrobius summarized, "some hold that the sun is called Apollo as destructive ($\alpha\pi o\lambda\lambda\acute{v}\nu\tau\alpha$) of life; for it kills and destroys living creatures when it sends a pestilence among them in time of immoderate heat." This, Macrobius explained, "is why statues of Apollo are equipped with a bow and arrows, the arrows being understood to represent the force of the sun's rays." Yet Apollo's rays, Macrobius continued, were also beneficent: "Power to heal is attributed to Apollo because the heat of the sun, if it is temperate, puts to flight all diseases." This provided an alternative etymology – "[Apollo] is thought to be so named as the god who drives away ($\alpha\pi\epsilon\lambda\alpha\acute{v}\nu o\nu\tau\alpha$) diseases" – as well as an alternative iconography: "Since [the sun] is constantly a source of health and more rarely a cause of pestilence, statues of Apollo represent the god with arrows and a bow in his left hand and with the Graces in his right, because his [right] hand is slower to harm and readier to heal."[23] Significantly, Cellini's friend Benedetto Varchi knew Macrobius's discussion, and he reviewed it in a 1545 lecture. Some authorities, Varchi noted, traced Apollo's name to the Greek 'Aπόλλιν, "to kill," justifying this with reference to Apollo's *saette* (arrows), "which are nothing other than solar rays." Others linked the name to 'Aπαλλάττιν, "to

free." He concluded that the two etymologies, "although contrary, nevertheless complemented one another," for "since Apollo is nothing other than the sun, he can equally murder and conserve."[24]

The two aspects of Apollo's power are easily translated into an erotic key like that of the Hyacinth story. Cellini, in fact, seems to rely on just this potential in one of his own sonnets:

> O Febo, tu sai ben che la prima arte
> fé quella ch'ogniun dicie esser più sana,
> perché l'amar l'un l'altro è cosa umana,
> poi vie più dolcie le virtù diparte.
>
> La tua fugacie Dafne mal comparte
> col bel Diacinto tuo la piaga insana,
> che pel suo grande error si sta lontana,
> e fiori e fronde a molte gente sparte.
>
> A chi le dia ormai più non ti curi,
> c'hai sol concesso le saette e l'arco,
> la cetra; né vuo' mai ch'altri tel furi.
>
> Mi son quei parvoletti acerbi e duri,
> che 'l tempo e lor mi han già di forze scarco:
> mie terza fiamma è est'ampli alberghi oscuri.

Oh Phoebus, you know well that the first art did that which all agree is healthiest, for reciprocal love is a human thing, and it distributes even sweeter virtues. Your fleeing Daphne unhappily shares the never-healing [lit., "insane"] wound with your beautiful Hyacinth, she who, for great error, keeps to herself, away from all, and who shares her flowers and fronds with many people. Worry no longer over whom she may give such things, for you alone have given away the arrows, the bow and the lyre; nor do you want anyone to steal them from you. Those little boys are sour and harsh to me, for they, along with time, have drained me of my strength; my third flame is in this great dark dwelling place.[25]

Though the poem is one of Cellini's most impenetrable, a few lines invite attention here. The references in the last stanza to harsh *parvoletti* and dark dwelling places suggest that the poem was written in 1557, after Duke Cosimo had had Cellini imprisoned for sodomy. This, in turn, may inflect what comes before: Although all of the editors of this poem have supposed that "la prima arte" is poetry, the phrase may be more metaphorical, perhaps in key with Cellini's reference elsewhere to sodomy as "una così nobile arte."[26] The antitheses drawn between the first two stanzas include one between "healthy" and "unhealthy" (or even sane and insane) loves, but also, apparently, one between lovers that are healthy, and lovers that Apollo kills. Of interest, in any case, is Cellini's apostrophe to Apollo and his specification that Apollo alone distributes the lyre

and the arrows. That Cellini would be thinking of Apollo's role in the invention of lyric would make sense under the circumstances, when Cellini, locked in darkness, could do little but write: Wholly within the lyric tradition of channeling torments into artistic expression, imprisonment here becomes poetry's condition.[27] That Cellini's Apollo also works with the bow sooner evokes the tradition elaborated by Macrobius and Varchi, one to which Cellini himself would later return.

More specific descriptions of the relationship between Cellini's two marble figures, however, are needed. A good place to begin is Ovid's *Metamorphoses*, which would have been for Cellini the most familiar version of the story. In this, there is exactly one moment when Apollo touches Hyacinth. This is the moment when Hyacinth, having been struck by the discus Apollo threw, begins to die:

> The god [Apollo] suffers as much as the boy does; like the wounded boy, he becomes deathly white, and he takes [Hyacinth's] broken body into his arms. Now he warms him, now he sadly he dries the wound and the living blood, now, with the virtue of potent herbs, he holds back the fleeing vital breath. Herbs and spells, however, are to no avail; the rough wound is lethal. Just as in the garden, when a violet or a lily or a poppy is struck and broken, such that it remains attached to its living stem, and, drained of strength, nods its heavy head, can no longer sustain itself, and with its tip stares at the green ground, so, close to death, does one see [Hyacinth's] beautiful face fall. Its vigor gone, it becomes a burden to its own neck, and it drops languidly back upon his nude shoulders.[28]

Ovid's passage attributes to the respective characters two simultaneous actions. Apollo, attending to Hyacinth's (head) wound, applies heat and herbs, the elements of his medicine. Hyacinth, meanwhile, transforms, coming to resemble a flower. It might seem that these lines, better than any others, account for the behaviors Cellini uses to identify his figures. The body of Cellini's Hyacinth, like Ovid's, appears flower-*like* in its disposition. His legs, pinned motionless to the ground, seem to spread like roots. His trunk and head rise like a stem and blossom. Apollo, meanwhile, stands where Ovid places him, by the dying Hyacinth's side. The god's hand, responsible for all that has happened, lays on Hyacinth's head.

In testing such a reading, it should be noted that Cellini's work appeared precisely at the moment when these metaphoric aspects of Ovid's text were being rediscovered. Camillo Cautio's exactly contemporary translation of Book Ten, the first Italian translation of the verses since the 1520s, was also the first to desist from abbreviating Ovid's plot into a moralizing encapsulation, and to give a just impression of the figurative language of the Latin original. The

same kind of attention would govern all Ovid translations from the 1540s on. It should also be noted that Cellini himself had already revealed his own interests in anthropomorphizing natural phenomena in the manner of simile. Just a few years before, he had arranged the legs of the two facing, reclining figures in his *Saltcellar* to illustrate how the branches of the sea enter the mountainous earth. In Cellini's description of this work, as in Ovid's of Hyacinth, human bodies act out nature's processes.

If Ovid's text gives some sense of what Cellini's characters are doing, however, it also helps highlight Cellini's departures from the standard narrative. The sculpture, for instance, gives no indication of the tragic centerpiece of Ovid's tale – the failure of Apollo's medicine. Cellini's Hyacinth, who has no obvious wound, does not obviously wilt, but rather turns upward and toward Apollo in the manner of a blossom seeking light. This may reinforce the floriform aspect of the boy, as well as the impression that the Sun-God is delivering a notional heat, but it also complicates the sense of Hyacinth's death. Perhaps this death, begun with a collapse in the manner Ovid describes, has been partially reversed; the sculpture could reflect Macrobius's idea that sunlight has the capacity to heal. Or perhaps, for the sake of personification, the details of the death have been hung onto Ovid's subsequent description of Apollo's effectiveness, his ultimate creation, from Hyacinth's corpse, of a real flower called "hyacinth." Or perhaps, more abstractly, the death, and its qualification, embody Apollo's double function: The hand that applies medicine is the same hand that, "the cause of Hyacinth's end," brought Hyacinth to require medical treatment in the first place.

Ovid's diction, in any case, raises the topic of art-making. The Latin text, which describes Apollo's application of medicine as the use of his *artes*, continues a leitmotif that runs through the entire episode, and sustains an extended characterization of Apollo's actions as manifestations of his creative power. His lethal discus throw, Ovid writes, "fell hard and heavy to the earth, impressing a sign there with strength and art."[29] When, upon making this artful sign in the earth, the discus then bounced into Hyacinth, Apollo cries "I am the author of your death."[30] Having struck his beloved, Apollo first applies his medical arts, then turns the boy's draining blood into a flower, promising "you will remain fixed in my heart, and always on my lips. My lyre sounding to you, my verses will sing your beauty and your name. Thus, born as a new flower, you will bear the sign of my laments."[31] Making this lyric, transmuting Hyacinth into an eternal expression of himself, Apollo even goes as far as to write on him, inscribing letters into his form: "[Apollo] wanted to inscribe his laments and his

sadness on the purple leaves, and so the funereal note was sculpted."[32] When the transformation is complete, when Hyacinth has changed from mortal into immortal, from memory to art, from self-identity to mimesis, Ovid's Phoebus celebrates himself as the "author of [Hyacinth's] honor."[33]

Any sixteenth-century reader might have noticed these details. Apollo was the god who presided over the Muses at Parnassus, the one who inspired Dante to write the *Paradiso*, the one who, losing Daphne, invented the poet's laurels; the Hyacinth story merely expanded on Apollo's role as the source and the governor of the arts.[34] The lyric aspects of the myth, moreover, should have resonated with Cellini in particular, for he was not only a member of Florence's literary academy, but also, as his poetry and criminal record attest, a lover of young boys.[35] No aspect of Apollo's aptitudes, however, would have interested the sculptor and his circle more than what Ovid elsewhere termed the *ars Apollinea*, the "Apollonian art" of medicine.[36] In light of Cellini's arrangement, the gesture of Apollo's hand, laid upon Hyacinth's head, invites further reflection.

Just before Cellini began making the *Apollo*, Varchi had made the art of medicine a central topic in his *Lezione sopra la maggioranza delle arti*. Following Aristotle's use of medicine as a test case for the examination of the similarities and differences between the arts and sciences, Varchi argued at length what Aristotle had only left implicit, that medicine fell into the same category of operation as sculpture – both were "arts," as opposed to "sciences" or "virtues." Contemplating the hierarchy of the arts, and invoking Galen, Varchi held that medicine outranked all others on account of its nonreliance on force or strength:

> Among the arts there are some, to follow Galen's distinction, that are vile and undignified, such as those which are applied with the forces and efforts of the body – what the Greeks, designating "operating with the hands," call *chirugicas*, that is, manual. There are other arts that are honorable and liberal, among which, he [Galen] places above all, medicine, rhetoric, music, geometry, astronomy, arithmetic, dialectic, grammar, and the knowledge of law. Nor does he preclude that, among these, one places sculpture and painting, for although they exercise the hands, they do not principally require the exertion [*forze*] of the body.[37]

In this passage, Varchi pursues a somewhat blurry distinction between sculpture and the "manual" arts, complicating the view we have already seen Leonardo express, that the labors of sculpture compromised its liberal status.[38] In contrast to earlier writers, Varchi allows both that an art like sculpture, which uses the hands, might look honorable, and that an art like medicine, the paradigmatic liberal art, might not compromise its rank should it use hands as well.

Varchi also maintains the artistic superiority of medicine on grounds of its objectives and materials:

> Medicine is the most worthy and noble of the arts because it has the most noble and worthy end, namely, as we stated above, that of preserving health where it exists, and inducing it where it is missing. To this argument is to be added another, that of medicine's subject [*subbietto*], which is far greater than all others, man being infinitely more perfect than all other mortal things.[39]

The argument here depends upon Aristotle's teleological definition of the arts, exemplified in his statement that, inasmuch as

> there are many operations, arts, and sciences, it happens as well that there are many ends: thus in medicine the end is health, in the art of building ships the end is the ship, in the military art the end is victory, and in the art of governing one's house the end is wealth.[40]

In contrast to virtues, which contain their excellencies within their very practice, Aristotle held that arts like medicine were distinguished for locating their success or failure in their results. Varchi expands on this by introducing the concept of art's "subject": Art, for Varchi, has not only an objective, but also a terrain, and this terrain is a crucial qualitative concern, determining the art's rank. The artist whose art is applied to better stuff, Varchi contends, is the better artist. However curious Varchi's proposal seems, it would likely have appealed to artists in his audience, for it corresponded with the order of nobility that Michelangelo and his admirers had impressed on the visual arts. It was a precept of the moment, for example, that only the human body was a subject worthy of artists' work. Following Varchi, it could be argued that the artist of the *Apollo*, by eliminating everything but the human body from his work, likened himself to the doctor, and ensured his own elevation. It is relevant, on this point, that Cellini, like his contemporaries, was fascinated with anatomy, and apt to discuss Michelangelo's work in terms of anatomical *scienza*.[41]

Varchi was a friend of Cellini. He would have been a crucial resource for Cellini's more abstract notions about what art-making amounted to, and in particular for any sense of the importance of the medical paradigm to those notions. He was not, however, Cellini's only instructor. No less important to the sculptor would have been Guido Guidi, another friend from Cellini's youth who was, it happened, physician to King Francis I during the sculptor's own tenure at Fontainebleau, and physician to Duke Cosimo during Cellini's residence in Florence.[42] Guidi, like Varchi, commented extensively on medicine and art. Whereas Varchi, however, took it largely for granted that medicine counted as an art, and concerned himself with how arts ranked against one another, Guidi, a practicing doctor, devoted more attention to the actual ways

in which medicine might be artful. Thus, he developed Aristotle's suggestion that medicine was a *productive* practice:

> Some [arts] are contained within their own execution, and result in no other work; others leave, along with their own execution, a made work, more perfect than the execution that was directed towards it. Wrestling, the skillful playing of games, the flute, and the cithara consist of action, or execution, alone, and their perfection consists in their own execution. Painting, the art of sculpture, and the art of architecture leave a work at the end of their execution. Medicine, when it makes a health which remains after its execution, ought to be numbered among those arts which do not have their end in their doing, but which are rather directed to the work that is to be left behind.[43]

Guidi contended that the doctor's work, like the sculptor's, is a work of man-ufacture. When a doctor operates, he creates *opere*. This means that medicine must be viewed in terms of a field or scope as determined by medium:

> The art of sculpting, which is manifold, has one common end. The end is the sculpture or the statue, and this can be seen to be a single end, even though one artificer casts statues with founded bronze, another forms them in wax, another cuts them out of marble or other stones. If occasionally the same man effects all of these things, we do not for that reason hold that these many arts are different among themselves. The same reasoning holds for health, towards which many arts are directed, while medicine applies strictly to the human body. From this it is clear what is the subject of medicine [*quid sit subjectum medicinae*]: it is not health, nor is it man; rather, it is the human body. In the same way the material of one art differs from that of others, be it stone, or wood, or any metal.[44]

Like Varchi, Guidi was concerned with what artists work *on*, although he described medicine's operation in more explicitly fabricative terms than Varchi did. Unlike Varchi, who took the *subbietto* of medicine to be "man" generally, Guidi maintained that medicine's true *subiectus* was the actual body. Elsewhere, he stated more concretely what this subject amounted to:

> [W]hen anything is generated, a new substance is effected that was not there before. This is neither material, nor form, but what is composed of both . . . The same goes for the practice of the arts: what is effected is neither a statue, nor bronze, but a bronze statue. The material that is subjected [*subijcitur*] already exists, it is not generated; one makes a composite of the material and the shape that it receives.[45]

Medicine, then, is an art that creates forms and compositions when applied to the human body. On this point, Varchi would have agreed; he goes so far as

to say that doctors sometimes inform bodies with a beauty "as much natural as artificial."[46]

Cellini probably would have been familiar with basic medical ideas from the time he was a child – the only surviving piece of writing by his father, one which Cellini saved for his entire life, was a sonnet on medicine.[47] Cellini's own writings, moreover, indicate both that he was conversant with Varchi's and Guido's ideas about medicine, and that those ideas bore on his conception of his art. In a poem addressed to Varchi, the sculptor fondly evokes their discussions together:

> Posandomi oggi alquanto nel mio nido,
> dal greve ferro più che 'l dover lasso,
> pensando al tempo a dietro e quel che io passo,
> né so ancor dove io me stesso guido.
> Sol un pensier più alto in ch'io mi fido,
> che tutti meco girno al mortal passo:
> però disposto io son venirmi a spasso
> vosco a cena, signor, con quel gran Guido.
> Voi di Cristo, poi di Platone e quello
> Aristotil che 'nfra più dotti ha 'l vanto,
> d'Ipocrate e Galen, man di natura,
> ragionar sentirò: io di scarpello,
> d'argento, d'oro e bronzi, in fin che 'ntanto
> il dolce cibo i pensier vani oscura.[48]

Relaxing somewhat in my nest today, exhausted from [my work with] the heavy iron [chisel] more than I should be, and reflecting on the time that is past and that I live, I do not yet know where I take myself. There is only one higher thought I trust: that all, together with me, turn towards the moral pass. Therefore, I'm pleased to come to dinner to relax with you, sir, and with the great Guido. I will listen as you speak of Christ, of Plato, of Aristotle (who, among many wise men, is most extolled), of Hippocrates and of Galen (the hand of nature), and I will speak of the chisel, of silver, gold and bronze, until the sweet food [and the food for thought] gradually obscures our vain thoughts.

The poem, which reads like a witty response to a dinner invitation, indicates that, *da Varchi*, conversation moved freely from the topic of medicine to that of art-making.[49] Several turns of phrase, moreover, deserve closer attention. That Cellini writes of the *ferro* and of the *scarpello* indicates that his own contributions to these discussions drew on his expertise not in modeling or in casting, but in *carving*. And that Galen wins the pseudonym *man di natura* (hand of nature) suggests that Cellini viewed medicine both as a "manual" practice (Varchi's point taken) and as the engineered deployment of nature's own powers. The spirit of the phrase is close to that of Varchi's own writings,

which present medicine as a *ministra della natura*, distinguishing it from such "unnatural" practices as architecture, practices that "make things that only art alone can make."[50] The phrase is also one that suits Cellini's Apollo: The god's medicine is as natural in its effect as is the sun, when directed to an anemic flower.

As far as Cellini's sculpture is concerned, the importance of this discourse lies in its treatment of medicine as a form of artistic mastery, one that "subjects" the body through the use of the hand. Following the paradigm for the medical art laid out by Varchi and Guidi, we might now view Apollo's overcoming of Hyacinth not only as the indication that Apollo is Hyacinth's killer, but also as the demonstration that he is Hyacinth's restorer – two antithetical possibilities that both implicate artistry. Such an argument is born out further in Cellini's most elaborate use of Apollo, the seal he later designed for Florence's Accademia del Disegno (Fig. 37). The seal includes the only other image of Apollo Cellini ever made, and the pose of the seal's figure closely resembles that of the earlier statue. In the later work, the image is coupled with a commentary, in which Cellini promotes Apollo as the academy's protector with the following explanation:

> After that great flood that covered all the earth, when the water had returned to its places, there remained a dense fog that prevented the earth from germinating. But the sun, by the virtue of its rays, wounded the fog so badly that it retracted. Thus, the Ancients figured Apollo with the bow and arrows with which he wounded the serpent Python (as they named that dense fog). I have accordingly put this into my design, for it seemed to me that this Accademia del Disegno of ours was worthy of this beautiful emblem: just as design is the true Lantern of all of the actions that men of all professions undertake, so is design of two sorts, the first, that which one makes in one's Imagination, the second, that which one demonstrates in lines. This has made man so ardent that he aims to compete with great father Apollo: [Apollo] made the plants and the grasses and the flowers and the Animals, all marvelous things and ornaments of the earth, grow, while man, with his design, built on this earth the great cities with their stupendous palaces, theaters, temples, towers, loggias, houses and bridges, then adorned all of these things with beautiful figures of animals in marble and in metal, and decorated the internal parts of his marvelous edifices with paintings, and ornamented himself with jewels and with gold – all of this he did with the artifice of his marvelous design. And since this Apollo is [man's] true Master, it seemed to me for this reason that he should be our Emblem.[51]

Although Cellini's later drawing shows Apollo and Python, not Apollo and Hyacinth, its conception of the hero is suggestive in a number of regards. It

37. Cellini, Design for the Seal of the Accademia del Disegno. Munich, Staatliche Graphische Sammlung.

identifies Apollo with Duke Cosimo, linking his capacity for murder with his role as a patron of the arts. It casts Cellini himself more as the Duke's executor than as his victim. As such, the seal demonstrates the flexibility with which different parts could be assumed; nevertheless, it preserves the violence

95

in Apollo's defining act. More pertinent to the imagery of the statue is the way in which the drawing construes the Sun-God's power as the power both to destroy and to nourish – the advent of the flower, and consequently of art, is contingent upon Apollo's potentially (but not essentially) murderous emanations. The seal allows not only that both aspects of this power might be legible in its different effects, but also that the positive and the negative might be results of a single luminous phenomenon. The seal characterizes this single phenomenon, the sequential purging of fog and encouragement of growth, as *artificio*: just as the complex disposition of Hyacinth, dying and blossoming, indexes various aspects of Apollo's *ars*, so does a single light, sustained, bring about a sequence of effects in the postdiluvian world. As the agent of this artifice, Cellini writes, Apollo is the artist's "true Master."

Cellini's choice of characters was not entirely unique. Three years before Cellini made his seal, a book by Giovanbattista della Porta had explicated the execution of the misty monster as an allegory of the "artful application of natural agents to one's proper and fitting subjects [*suggetti*]."[52] "Python and Phoebus," wrote Della Porta,

> stand for the two principal things that you use in such occupations, things which need to be recognized in artificial as well as in natural works – namely, the subject [*suggetto*], or, we want to say, the material, and the Agent. If one of these must be operated upon, the other must operate.[53]

He goes on to explain, with more specific reference to the action of the story, that

> nature, when it is able, withdraws from bad things the best thing it can with the force of celestial heat, and transmutes those bad things into animals, introducing spirit and life into them, in such a way so as to offend neither those things which already live, nor the operations of things [that are already] perfect.[54]

Della Porta's exposition of the story relies on the logic of alchemy; his terms, nevertheless, are fitting to both of Cellini's own conceits. Making explicit the equation of *materia* and *suggetto*, Della Porta's image offers a useful comparison for the subjections Cellini's own Apollo accomplishes, and for Cellini's specification that Apollo is a *Maestro*. His explanation of Apollo's victory illustrates the kinds of connections between Apollo's killing and art-making that were available to Cellini. Especially suggestive is his description of Apollo's *forza*, "cavando delle cose cattiva quel meglio ch'ella possa." This is similar to what Cellini, at roughly the same moment, was writing about his accomplishment with the block he was forced to work with when making his own Hyacinth: "ne cavai quel che io potetti."

To this point, the chapter has been considering Cellini's *Apollo* mostly within a literary context. Working with the terms of "master" and "subject," it has argued that Ovid's text, contemporary medicine, sculpture theory, and Cellini's own poetics all contribute to a reading of his statue that views Apollonian artifice as the work's basic topic. This alone might seem reason enough to suggest that Cellini's *Apollo* bespeaks the artist's own sculptural concerns, that Cellini's interest in depicting a master who makes flowering artworks responds to the professional circumstances of the sculptor in 1540s Florence. It might be inferred that, coming at the new project of stonework from a background in metallurgy, Cellini thought of his task as an alchemist would, imagining the "reduction" of the imperfect products nature placed before him "to true and perfect health."[55] Perhaps there are broader *paragone* issues at stake: Marco Boschini would later compare the act of painting undertaken by Titian, Cellini's contemporary, to the work of a doctor.[56] Or perhaps, keeping the tradition of Cellini's new medium in mind, the better comparison is the flame-like form that so occupied Michelangelo; Cellini could be emulating the master's burning away of cold, obscuring surfaces to expose the purged and perfected figures beneath.

Before settling on any of these conjectures, however, the relationship between form, medium, and genre needs to be considered more closely. Earlier, the chapter defined the master–subject sculpture as one that standardly involved a standing victor and a collapsed victim, and it suggested that the genre could be pursued in various materials. For what follows, it is now also significant to note that when master–subject sculptures were made in marble, they normally had an additional requirement: The lower figure had to stabilize the upper one. This added a technical dimension to the iconographic standards of the genre – if the discovery of multiple figures in a single block was a virtual *sine qua non* of marble sculpture in Cellini's day, the master–subject form, with its pillar and brace, emerged as a conventional way to enable this.

As master and subject, the two carved elements had plausible relative functions as characters, not just as blocks. Fictionally, the lower figure would be there for the sake of the upper figure's identity, and not because the upper figure, being made of marble, might otherwise topple. With this effect of purposefulness, master–subject sculptures let artists accommodate a principle articulated in different ways by Galen, Michelangelo, and others, that the success of an artwork should be measured by the degree to which it made the viewer see artifice more than material.[57] All of the members of this genre thus potentially raised the topic of art's confrontation with the recalcitrance of material. In the case of Cellini's *Apollo and Hyacinth*, however, this confrontation not only guided the work's compositional strategy, but also accounted for its

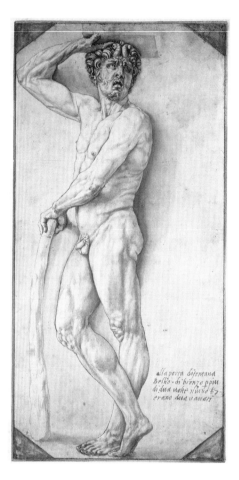

38. Cellini, *Satyr*. Washington, National Gallery of Art, Woodner Collection (photo © 2000 Board of Trustees, National Gallery of Art).

membership in the genre. Apollo earns the title of "Maestro" precisely because of the artifice with which he killed or healed his subjects. Hyacinth, similarly, might be a *subjectus* either because of his lyric death, or because medicine and sunlight, through *ars*, submitted the body to the form of health. With the *Apollo*, Cellini identified the generic topic of master–subject with the generic aim of conspicuous *artistic* mastery.

The terms for such an identification were ones with which Cellini was accustomed to thinking both before and beyond his work on the *Apollo*. At Fontainebleau, for example, Cellini's design for the Porte Dorée comprised a colossal Nymph, the genius of the site (Fig. 11); two Victories, each bearing torches; the king's emblematic salamander, flanked by these; and two armed monsters, serving as caryatids (Fig. 38); all incorporated into a kind of triumphal arch, and all supplementing frescoes by Primaticcio that showed Hercules's enslavement to Omphale. Any one of the Porte's elements might have evoked the theme of subjugation,[58] and Cellini's autobiography suggests how such a theme could, in turn, evoke his own artistry. Discussing the studies he made for

the Nymph in the overdoor, and the model (Katherine Scelau) who posed for her, Cellini writes:

> I made her remain in great discomfort hour after hour, and remaining in this discomfort caused her great pain, and to the same degree brought me delight, for she had the most beautiful form and brought me the greatest honor.[59]

As Nancy Vickers has argued, Cellini's comment extends the interpersonal dynamics of the workshop into the field of figuration.[60] The body of the Nymph in the relief records the master's assertion of control over his model and assistant; her suffering is his honor. Where the *Autobiography* asserts Cellini's dominion in the realm of modeling, furthermore, other writings stage it in relation to other operations. The most remarkable of these is probably Cellini's *Discourse On the Principles and on the Way to Teach the Art of Drawing*, most of which explains how the student might "reduce" his subject by memorizing the order of its bones. In framing his discussion, Cellini connects his proposed curriculum to a vision of how the young draftsman might establish psychological supremacy over his material, becoming, through his studies, sovereign over both himself and his subject. Because, as Cellini puts it, "the most important thing in all of the most noble arts, for those who want to defeat and dominate them, consists in nothing other than taking spirit over them," the student should never begin by drawing something that sets him trembling, but should rather start with something he can immediately conquer (a simple, weapon-like bone, for example).[61] An implication of the discourse is that the works resulting from its principles – a works like Cellini's own *Nymph*, or *Hyacinth*, which demonstrate the artist's comprehension of the nude – inherently illustrate the mastery over bodies that the artist has achieved.

The mastery illustrated through Cellini's sculptures could be founded on the doctor's understanding of the body, the studio chief's right to pose the *garzone*, or the modeler's surety in twisting wax limbs into fitting shapes.[62] Regarding the *Apollo and Hyacinth* in particular, however, the matter is complicated by the work's actual composition. As previous scholars have argued, this composition is not just generic – its arrangement of a proud standing figure positioning his hand over the head of the kneeling figure he has killed – depends upon and responds to a master–subject sculpture by Cellini's most despised personal antagonist, the *Hercules and Cacus* of Baccio Bandinelli (Fig. 39).[63] As such, the work cannot be understood apart from the rivalry between the two men.[64] Before, during, and after Cellini's work on the *Apollo*, Bandinelli was doing everything in his power to discredit and hinder Cellini's sculptural practice. As Cellini prepared to unveil his colossal *Perseus*, Bandinelli wrote to Duke Cosimo that Cellini, having no *disegno*, should be restricted to chasing other sculptors' reliefs.[65] When one of Cellini's pupils sought work in Rome,

39. Baccio Bandinelli, *Hercules and Cacus*. Florence, Piazza della Signoria (photo: Alinari/Art Resource).

he wrote back to his teacher that this was impossible, "thanks to a certain master Dante, a sculptor who used to work with the cavalier Bandinello."[66] Bandinelli impeded even Cellini's acquisition of materials: As *provveditore* of the Cathedral Works, he had charge of virtually all the marble distributed to the city's artists.[67] The very block in which the *Apollo* was carved was one that Cosimo forced Bandinelli to give Cellini.[68] The difficulties that that stone brought Cellini were difficulties Bandinelli had ensured.

The *Apollo* could easily be read as an anticipation, in negative, of the detailed savaging of Bandinelli's *Hercules* that Cellini would later include in his writing. Whereas in Bandinelli's face, "if you removed all the hair, there'd be nothing left but a thin squash not big enough for a brain," Cellini worked with a beardless figure, and drew the hair away from the forehead to reveal his *bel volto*.[69] Neutralizing the figure's facial expression, Cellini avoided the scowl that made Hercules seem a *lionbue*. Cellini stripped the figure of his ludicrous muscles, and rendered a slim youth in place of Bandinelli's older strongman. In

the figure's stance, Cellini indicated clearly, as Bandinelli had not, how the legs bear the weight of the torso to which they were connected. Placing the victim behind, rather than in front of the killer, he avoided the technical difficulty that had forced Bandinelli to lean his Hercules forward, "the greatest and most excruciating mistake that those plebe-masters make." With Apollo's swung hip, finally, he made evident the figure's *grazia*, the lack of which he faulted Bandinelli for repeatedly.[70]

The *Apollo*'s rebuke of the *Hercules*, however, is not merely a formal one; it also raises questions about the nature of the mastery that is the subject of the work. Varchi, we have seen, distinguished both medicine and sculpture from more exertive, "forceful" uses of the hand. Della Porta, meanwhile, specified that Apollo's strength lay in "the force of celestial heat." The mastery Apollo exemplifies, these texts imply, is a mastery that does not require "le forze del corpo." And Apollo's mastery consequently contrasts dramatically with the mode of mastery exemplified by Hercules, for the latter's subduing of Cacus counted among the Labors which, in Italian, were called his "Forze." The contrast gains resonance when we realize how crucial such terms were for the derision of the statue. Vasari, for instance, wrote of the model for Bandinelli's *Hercules* as follows:

> Hercules, having clamped Cacus's head between two stones with his knee, uses his left arm to clench him with great force, holding him down between crouching knees in a pose of affliction. He demonstrates Cacus's suffering and Hercules's violence and weight above him, which make every tiny muscle throughout his body burst.[71]

Vasari perceived Bandinelli's objective as the magnification of corporeal strength. The physical pressures the two figures exert, meeting an ungiving stone resistance, permeated the bodies of the characters to the point that they threatened to explode. As for the marble version that followed this, Vasari implied that Bandinelli worsened an already bad work by trying to intensify this effect still more:

> Imagining that the air did not flatter [the statue], making the muscles seem too weak, [Bandinelli] had a new screen rebuilt around it, climbed with his chisels back upon it, and carved out the muscles more crudely than they had been in the first place.[72]

Overcarved or overinflated, Bandinelli's muscles were, for Vasari, the bathetic feature of his work; Vasari travestied Bandinelli's style for its absurd pursuit of mass and force. Cellini must have remembered this, for he himself later compared the figure to a bag of melons. But he also made other, related jokes on the work:

Fiesol e Settignan, Pinzedimonte
voglion che sia da più d'un fiorentino;
solo scultore e pittore Angel divino;
quel Bandinel copiò sol Leoconte.[73]

Fiesole, Settignano, and Pinzidimonte all want to be more than a Flo-
rentine. The Divine Angel [Michelangelo] is the singular sculptor and
painter; Bandinelli only copied Laocoön.

The remark, which denies that the works of Bandinelli (whose father had a villa
at Pinzidimonte) follow the principles of Michelangelo (the "divine Angel,"
whose name Cellini uses to betoken the standard of Florentine art), alludes to
Bandinelli's own beginnings as a marble sculptor, when he copied the *Laocoön*
(Fig. 40) for Cardinal Giulio de' Medici (later Pope Clement VII).[74] Invoking
this work as he does here, some three decades after Bandinelli's *Laocoön* was
completed, Cellini's comments hit a larger target than the copy alone. To say
in the 1550s that Bandinelli "only copied Laocoön" was to say that everything
Bandinelli *ever made* looked like the Laocoön; "Laocoön" libeled Bandinelli's
style *tout court*. The *Hercules*, that is, was a sort of Laocoön – as another satirist of
the work, possibly thinking of the snake-bitten Trojan priest, reported, "some
say that [Hercules] has been poisoned, as he seems to have swelled up in every
part."[75]

At issue here is the place of force in sculpture, and the *Apollo*'s challenge
to the *Hercules* might be followed through a number of different discourses.
With Bandinelli's style linked to that of the *Laocoön*, for instance, the *Apollo*
might seem to criticize Bandinelli's vision of the antique.[76] As Cellini and
his audience knew, the *Laocoön* had been brought, in 1506, to the sculpture
court of the Vatican Palace in Rome, where it became the counterpart to the
Pope's second most famous statue, the *Apollo Belvedere* (Fig. 41). The hairstyle,
if not the whole physique of Cellini's *Apollo*, recall the work's more famous
predecessor. This raises the possibility that Cellini was attempting to ground
his own figural manner with reference to an ancient prototype, pursuing an
Apollonian, as opposed to Herculean, figural form.

As Cellini's poetic reference to the "Angel divino" makes clear, more-
over, the imitation or rejection of the *Laocoön* as a sculptural guide also bore
on both sculptors' claims to the artistic legacy of Michelangelo in Florence.
Bandinelli's *Hercules* had been recarved from a block Michelangelo himself had
once worked on, and it had been erected by Cosimo's predecessor as a pendant
to Michelangelo's *David* in the Piazza della Signoria (Fig. 42).[77] The general
posture of Cellini's *Apollo*, and especially its gaze – which is directed in the
distance rather than at his beloved – suggests that it, too, aims to be a sequel to
Michelangelo's statue, albeit a sequel of a different kind. Similarly, when Cellini
later writes of Michelangelo's sculptures that "the most beautiful muscles put

40. Baccio Bandinelli, *Laocoön*. Florence, Uffizi (photo: Alinari/Art Resource).

well in their places have not done him so much honor as his showing of the
bones," his tendentious denial that Michelangelo's style was muscular may well
have had Bandinelli's competing profile of it in mind.[78]

Perhaps the most interesting aspect of Cellini's contest, however, is its con-
ception of the marble medium per se. For Cellini voiced ideas not only about
the conventions of marble sculpture, but also about the nature of its material. In
the chapter in his *Treatise on Sculpture* dedicated to "Making Figures in Marble
and in Other Stones," Cellini (helped, perhaps, by his editor, Spini) explained

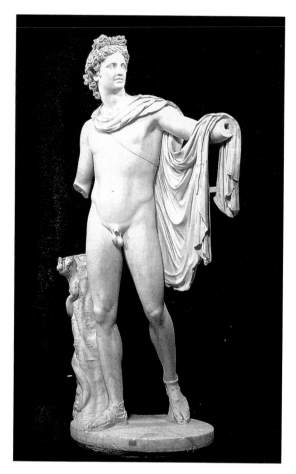

41. *Apollo Belvedere.* Vatican (photo: Scala/Art Resource).

where marbles come from. Marbles, he recounted, were compounds of earth and water, generated through the agency of the sun:

> their creation is brought about with thick, unctuous, packed earth, commixed with water. The earth becomes mud, and the mud is reduced to stone by means of the sun's rays.[79]

While this might remind us of the Python story, and consequently of Della Porta's allegory, Cellini momentarily discounts the relevance of the etiology to the actual problem of cutting stone. The knowledge is more useful, it seems, for an understanding of why stones have different qualities:

> the nearer the region to the East and to the Equator – as India and Ethiopia are – the finer and more precious are the stones that are generated. Conversely, the more distant the mud is from the sun, the less bright and fine are the stones that are born.[80]

42. Michelangelo, *David*. Florence, Accademia (photo: Alinari/Art Resource).

Marbles, Cellini points out, can be classified by their relative degrees of hardness and preciousness, that is, by how long the sun has acted on them, cooking them toward perfection. The classification, then, is ultimately an aesthetic matter: The actions of the sun leave visible traces on the marbles they make. Harder and more perfect sorts of stones, Cellini observes, have "a thick grain with certain lusters next to one another." Inferior stones' grains, by contrast, are weaker; they are both physically softer and visually less bright.[81] The second-most-perfect marble is Parian marble, with a color "more flesh-like than white." Lesser stones have spotted grains, and these are the "most difficult to work, as chisels of whatever sort are eaten by the said impurities." They are also unreliable:

> Sometimes marbles are streaked by one of these spots, and these [marbles] easily deceive the Artificer, for on the outside they are covered with a splendid skin, while on the inside they conceal such blemishes as to render the work ugly and graceless.[82]

The best stones, the stones that allow the best artworks, were those with which the Sun itself has taken the most time.

Cellini preferred Italian marble to the limestone he saw his contemporaries using in France, for limestone was "turbid," while marble was "candido," bright,

luminescent.[83] The only attraction of limestone was that, being softer, it was easier to work than marble, and once worked and exposed, it would "with time take on a hardness almost like that of marble, especially on its surface."[84] With limestone, apparently, the artist could interrupt the hardening of the stone while he did his work, then give it back over to nature to finish.[85] Cellini seems to have thought, however, that the gains in softness were not worth the loss in brightness. Candor – a quality which the sixteenth-century naturalist Andrea Cesalpino also remarked as marble's characteristic feature[86] – was crucial to the stone's potential. If, as the artist stated in a letter contemporary with the *Apollo*, "the difference between painting and sculpture is the same as the difference between the shadow and that which makes a shadow," then sculpture should be linked with light, not darkness.[87]

The pertinence of these ideas to Cellini's actual practice is evident in the work he held to be his greatest achievement in the medium, the *Christ* he made for his never completed tomb (Fig. 43). Cellini claims that he made this work in order to see whether, "with the force of my art, I could outdo my predecessors."[88] The subject for it, he explains elsewhere, came to him in a vision:

> The sun appeared to me without its rays, just like a bath of the purist melted gold. While I considered this great thing, I saw the middle of this sun begin to swell, and the form of this swelling grow, until suddenly it turned into a crucified Christ, made of the same thing as the sun was. His benign face was more graceful than human *ingegno* can begin to imagine, and while I considered this thing, I cried out "Miracles! Miracles!"[89]

The balance of calculated invention and authentic memory in Cellini's story is open to debate. The earliest record of the vision appears in the testament Cellini wrote almost fifteen years after the fact; in this testament, and in later writings, the vision serves Cellini as a means of attributing a divine origin to his conception of the sculpture. It can safely be said, moreover, that certain details of Cellini's vision depend on his reading of Dante. In the first canto of the *Paradiso*, for instance, Dante describes watching the sun turn into liquid metal (in Dante's case, boiling iron).[90] And in the fourteenth canto, the narrator of the *Paradiso*, like Cellini, has a vision of Christ:

> Qui vince la memoria mia lo 'ngegno;
> ché quella croce lampeggiava Cristo,
> sì ch'io non so trovare essempro degno;
> ma chi prende sua croce e segue Cristo,
> ancor mi scuserà di quel ch'io lasso,
> vedendo in quell'albor balenar Cristo.[91]

> Here my memory overcomes my *ingegno*, for that cross illuminated Christ in such a way that I cannot describe it. Whoever bears his cross and

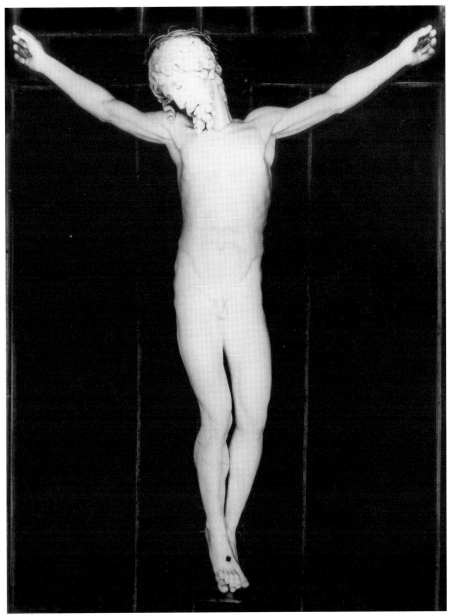

43. Cellini, *Crucifix*. Real Monasterio de San Lorenzo de El Escorial (photo: Kunsthistorisches Institut).

> follows Christ will forgive me for what I fail to say, having seen Christ
> glow with such brightness.

That Cellini knew these lines can hardly be doubted, for Varchi referred him to them in a consolatory poem he sent the artist.[92] Like Dante's, Cellini's text describes his vision as overwhelming; both writers remark that the image of Christ

exceeds their *ingegno*. The words the two authors do manage, furthermore, are themselves telling, for the single quality they both stress is *luminousness*. This is particularly suggestive in view of Cellini's remarkable composition, which he describes as a *bianchissimo* Christ attached to a *nerissima* cross.[93] It may well be that Cellini thought sculpture could achieve the visual effect that, according to Dante, words could only fall short of. Using the black cross to set off the white marble's splendor, Cellini uses the candor of the marble – the traces of the sun's action – to present the vision of a body *made out of* the sun.

On grounds of Cellini's writings alone, it could thus be claimed that Cellini's *Crucifix* relies on a traditional association between Christ and the Sun.[94] Cellini's interest in the association, however, is also suggested by the fact that his later drawing of Apollo (Fig. 37) attempts to approximate the mode of painting that his later discourse *On the art of disegno* would term "dipingere di chiaro e scuro."[95] Though the discourse was penned around the time Cellini drew the Apollo, the artist's own interest in *chiaroscuro* seems to date precisely to the time of his first thoughts on his *Crucifix*. According to the original August 1555 testament, the tomb was to include, above the *Crucifix*, a white marble tondo depicting the Madonna and Child contemplating "the very Crucifix made by Cellini's hand" *(el medesimo crucifisso fatto di mano di [Cellini])*. In a codicil to the testament, added a month later, Cellini changed his mind, specifying that the tondo should be executed "in fresco with yellow paint and without the diversion of other colors; this [manner of working in] pure color is called *chiaro e scuro* painting."[96] The substitution might suggest that Cellini associated the tondo with light, and more specifically, with the light of the boiling sun. And when, in the end, the *Crucifix* proved to be the only element of the tomb Cellini completed, this piece itself seems to have become the heir to his earlier interest in chiaroscuro imagery. It, like the *Perseus,* constitutes a link between his sculptural interests of the early 1550s, and his later academic writings.

Cellini's motivations for making the *Crucifix,* sixteen years after the alleged dream and a decade before his conception of the seal, almost certainly include both his new Florentine milieu's culture of *Dantismo*, and the fact that Bandinelli himself had turned to the subject of the *Corpus Cristi* (Fig. 44). In 1552, just two years before the first notice of Cellini's plans, Bandinelli unveiled a statue of *Christ* in the choir of the Florence cathedral. The work was instantly lampooned by Cellini's friends. Bernardo Minerbetti scolded that the figure was too massive (*grasso*), representing a Christ with large muscles, rather than one properly gaunt from hunger and thirst. Alfonso de' Pazzi wrote that the figure looked more like a beaten soldier than like Christ, and encouraged Bandinelli to stick to making Laocoöns. Antonfrancesco Grazzini compared the work to a river god, like the others implying that it was indecorously bulky. Both Grazzini and Pazzi also derided the work for being a *gigante*, a particularly telling charge inasmuch as it categorized the *Christ* as a colossus – as an over-scaled,

44. Bandinelli, *Dead Christ Held by Angel*. Florence, Santa Croce (photo: Alinari/Art Resource).

over-audacious and over-virile sculpture in the manner of Michelangelo's *David* and Bandinelli's own *Hercules*.[97] The comments are uniformly disparaging, but they are also useful, for they indicate how contemporaries understood Bandinelli's aesthetic strategy. Above all, it would seem, Bandinelli exploited the mass of the stone, conveying force as physicality, diminishing the viewer over whom the marble would tower.

With its force expressed in this way, the statue's *whiteness* entered among the features that satirists could turn against it. When Pazzi, for instance, calls Bandinelli's *Christ* "*U' fante grosso, biancho, unico e bello*" (a great white infantry-man, singular and beautiful), the charge is that the artist is too concerned to prove his virtuosity with a colossal monolith.[98] Pazzi suggests that the whiteness of the colossus interfered with or contradicted the intended depiction; as Raffaello Borghini said of another figure from the same Bandinelli project, "it shows the material more than the art."[99] A related joke appears in an anonymous, unpublished satire on the *Hercules*: "*E s'io son stato Baccio scarpellino, / Non è che 'l mio Gigante non sia bello, / E bianco, e biondo com'un ermellino*" (and if I was Baccio the stonecutter, it's not the case that my giant wasn't beautiful, white and blond like an ermine).[100] When Bartolommeo Ammannati unveiled the sequel to the *Hercules* that Bandinelli had begun — the Piazza della Signoria's *Neptune* — contemporaries referred to it economically as the *biancone* ("the big white thing").[101]

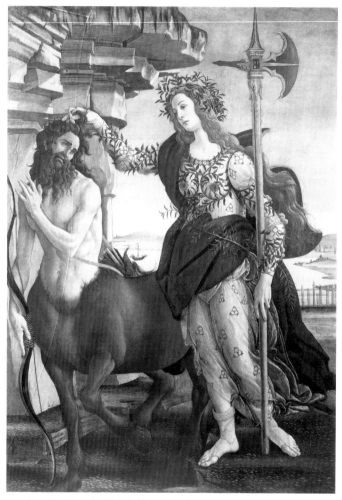

45. Sandro Botticelli, *Pallas and the Centaur.* Florence, Uffizi (photo: Alinari/Art Resource).

Viewers from Cellini's time to ours have suggested that, unlike Bandinelli, Cellini never proved particularly adept at working on a monumental scale.[102] Having been given a small, thin slab to work with, moreover, Cellini could not have attempted a colossus even if he had wanted to. But the small stone also had its advantages, for in compelling him to seek different channels for aesthetic force, its limitations actually helped him to circumvent some of the colossus's dangers. Not constrained to work with the physically large characters that were suited to physically large stones, Cellini could start with subjects more congenial to what he considered to be the stone's properties. Specifically, he could embrace the candor left in the stone by its natural history of solar artifice, incorporating that into his scenes. In the case of the *Crucifix*, he used chiaroscuro to embody his subject's radiant awesomeness. In the case of the

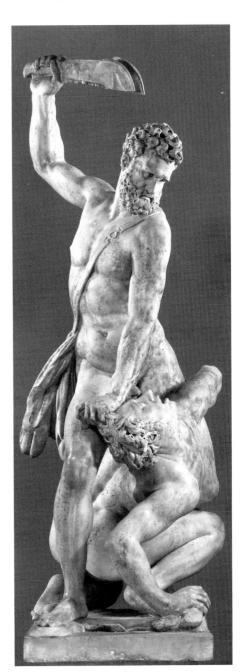

46. Giambologna, *Samson and a Philistine.* London, Victoria and Albert Museum.

Apollo, he used the model of solar artifice itself: Here, as in Cellini's account of marble generation, whiteness signals a move toward perfection. The Sun, his master, applies an artifice that kills to transform, that overcomes to make resplendent. In contrast to Bandinelli's whiteness, which drew the boundary of material and art, Cellini's candor collapsed the two together.

47. Michelangelo, *Creation of Adam*. Vatican, Sistene Chapel (photo: Alinari/Art Resource).

Cellini's *Apollo* follows Bandinelli's *Hercules* far enough to qualify as a member of the master-subject genre, but its solar subject effects a reconception of the mastery at that genre's center. Consider, once again, the curious gesture of Apollo's right hand. Holding Hyacinth at the hair, this gesture vaguely evokes a conventional triumphal gesture, where one figure indicates the subjugation of another by taking him or her by the locks (Figs. 26, 45, and 46). At the same time, however, it also resembles gestures of creation or incarnation, approximating, for example, the hand of God that touches the child Christ in Michelangelo's *Creation of Adam* (Fig. 47) or that of the angel that ends Elizabeth's barrenness in Pellegrino Tibaldi's *Annunciation of the Conception of St. John the Baptist* (Fig. 48).[103] In Cellini's work, the polyvalence of this hand is consistent with what I have been describing as Apollo's double function; the hand both kills and heals. The "force" of this hand is thus qualitatively different from that of Hercules. Whereas Hercules subjugates with physical strength, Apollo uses disembodied light. With this force as a means to mastery, and with the evidence of this force emanating from the stone itself, Cellini obviated muscles as a figural requirement. The signs of force, the artwork's explanation of how its force works, no longer required metaphors of corporeal power. Indeed, dependence on such strength would have seemed coarse and brutish: The application of strength alone could only reduce its object, it could not effect beauty, or infuse the figure with the spirit that let it flourish.

48. Pellegrino Tibaldi, *Annunciation of the Conception of St. John the Baptist*. Bologna, San Giacomo Maggiore (photo: Scala/Art Resource).

This opens the work to political readings, and we should question whether it can really be said, as one recent commentator has maintained, that the *Apollo* had "no patronage significance."[104] In the first place, it cannot be ruled out that Cellini intended to give the work, when complete, to Duke Cosimo.[105] It is

easy to imagine the *Apollo* installed in Cosimo's gardens at Castello, for which numerous marble works were being commissioned, and for which medical subjects could be especially topical.[106] Like Cellini's own later writings, moreover, the work drafts Apollo as a role the Duke could easily play. Cellini's later seal identifies Cosimo with Apollo explicitly: "Apollo è sol la luc' / Cosmo è principio à la gran scuola, e' Duce." A sculpture by Domenico Poggini, derived from Cellini's, shows Apollo with Cosimo's astrological emblem, the Capricorn, in Hyacinth's place.[107] If Cellini's *Apollo,* moreover, is indeed an agent of *artes,* then it also supports a familiar pun on his patron's name, making Apollo, so to speak, one of the "Medici."[108] Medicine, on this reading, would overlap not only sculpture, but also statecraft: Aristotle compared not only the artist but also the legislator to the doctor; Macrobius called Apollo the "patron of public health."[109] In this regard, it might be noted that what Apollo makes is a flower, and thus potentially a play on the name of Cosimo's city (Flor-ence), as well as on the tradition of Medici floral iconography (one need only think of Botticelli's *Primavera* and *Birth of Venus*). Ovid, it could be added, claimed that the hyacinth resembles nothing so much as a lily; as a type of fleur-de-lis, Cellini's Hyacinth could assume an almost heraldic quality. In the context of Cellini's own contemporary thought about his patronage, the work might even be compared with his portrait of Cosimo, in which eagles biting the Duke's nipples suggest the patron's function as Cellini's, and Florence's, nourisher (Fig. 18).[110]

This does not mean, of course, that the *Apollo*'s iconography is narrowly Medicean. As is often the case with Cellini, personal imagery overlaps political subject matter. The artist's comments about chiseling in the presence of the Duke show that the work was self-serving, but not private; it was a performance executed under the eyes of the court. The *Apollo*'s imagery develops Cellini's own persona as much as it does Cosimo's. We might compare it, for instance, to the same artist's *Narcissus* (Fig. 49), a nearly contemporary marble which, like the *Apollo*, has a boy reaching or losing the flower of his youth as he touches his hand to his head and grows into a blossom. An allusion in a contemporary letter suggests that Cellini conceived this work with the knowledge that Alberti had attributed to Narcissus the invention of painting. It is consonant, then, with Cellini's later seal in representing the creation of art as the creation of flowers.[111] Even the civic allusions of the *Apollo*, if they are present, enfold Cellini as much as Cosimo. Cellini tells us, for instance, that Florence was named after one of *his* forebears, an imperial soldier named "Fiorino da Cellino," who helped found the city.[112] And in Cellini's remarkable coat of arms, possibly invented for his brother's tomb in the early 1530s but certainly redrawn for his own sake in the late 1550s (Fig. 50), a lion extends a paw to touch, or hold, or support, a fleur-de-lis.[113] With its combination of Marzocco and lily, the drawing seems to arrogate a civic symbolism for Cellini's personal use. Appearing amidst a

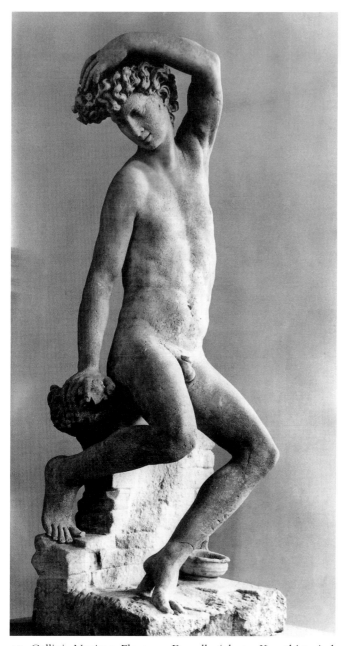

49. Cellini, *Narcissus.* Florence, Bargello (photo: Kunsthistorisches Institut).

series of works linking hand to flower, it seems less a family memorial and more an advertisement of what the artist's civic status might amount to.[114]

We return to our opening image of Cellini's duel, chisel in hand, with the new marble block. Given the technical challenge to make multifigure sculpture

50. Cellini, *Cellini Family Coat of Arms*. Florence, Biblioteca Nazionale.

and a genre of imagery through which to address it, Cellini confronted the question of how to generate aesthetic force in marble. His answer was to display the workings of Apollonian power, and this answer, in turn, was the first step toward the definition and defense of his own sculptural *maniera*. If Apollo's artifice is taken to indicate something of Cellini's own, then Cellini's

style becomes decorous evidence of the kind of artistic mastery the work itself promotes. Apollo's brightness is his *vis artis*, the splendor of the rays that transforms his subjects. Hyacinth's death is his immortalization, the reception of aura that accompanies his artistic apotheosis. Cellini's profile of mastery as artistry thus rejected the aesthetics and the politics of one sculptural regime and promoted another. Making Apollo a Master *qua* artist, Cellini invites the viewer to reflect on the various modes of mastery a patron, or artist, might promote. Artful mastery becomes the alternative to another, more vicious, mastery. Profiling his art as mastery, conversely, Cellini lets his *Apollo* read as a claim about his own artistic competence. Implying victory over both the stone itself and the dominant mode of Florentine marble sculpture, the *Apollo* asserts a new field for Cellini's own artistic force, the command of a field beyond that of the metal-worker.

The Design of Virtue

Sculpture is an art by which one represents worthy persons, with an aim of keeping the virtue and the glory of the those persons alive in the memory of men . . . [1]

– Francesco de' Vieri

*I*n the last two centuries of Cellini criticism, aesthetic judgments of the artist's work have seemed inextricable from moral ones. Some writers, all but apologizing for their subject, have denounced him: Cellini was "a little man, made of jealousy, rancor, and mean interests,"[2] "violent, arrogant, self-assertive," "possessed by intense, absorbing egotism,"[3] "capable . . . of ways of living which are perhaps better left unmentioned,"[4] a "reprobate."[5] Others, turning Cellini's life into novels and opera, have made no excuses for their admiration. Goethe, for one, attached an appendix "On Morals, Art, and Technique" to his edition of Cellini's writings, and singled out the artist for his "susceptibility to both sensual and ethical beauty."[6] "The image of moral perfection, an unreachable thing," Goethe maintained, "floats perpetually before our hero's eyes."[7]

If these opinions about Cellini's values reveal as much about their authors as about Cellini himself, the question of how Cellini's ethics bore on his art does, nevertheless, have a historical dimension. In the first line of his autobiography, Cellini asked to be judged for what he had done that "resembles the virtues" – that was, as Goethe put it, *tugendähnlich* – and nearly all of the hundreds of pages he wrote subsequently are dedicated to presenting his case.[8] If his writings are not always analytically rigorous, Cellini nevertheless betrays throughout strong feelings about which kinds of actions were good ones, and which were not. If his almost theatrical display of virtue has had an impact on the later biographical literature ostensibly responding to Cellini's art, rather than to his morals, even this may be appropriate, for high on Cellini's own list of defensible pursuits was the practice of art itself.

What was "virtue" in Cellini's day? A useful definition is provided by one of Cellini's antagonists, Vincenzo Borghini:

> *Virtù*, to follow the common use of the term, is a very general thing: it seems that *virtuoso* and *virtù* denotes any good thing conjoined with excellence, and that it pertains to many things. It pertains not only to the affections of the spirit, to justice, to prudence, and to other moral things, but also to intellectual habits, such as the sciences. It refers, moreover, not only to these things, but also to practices – thus one calls *virtuoso* a chaste man and a temperate one, a philosopher and a wise man, an architect and a musician. The familiar phrase *imparare or darsi alle virtù* means 'to learn some art of *ingegno*,' such as letters, music, etc. . . . [9]

No foe to the pretensions of artists was more outspoken than Borghini; the author of these words was the same man who condemned any "vile artificer" who aspired to nobility, the same man who mocked Cellini himself for comparing himself to the soldier.[10] All the more telling, consequently, is Borghini's own acknowledgment that the concept of *virtù* provided grounds for admiring the moral exemplarity of artists. To follow Borghini, *virtù* was the common denominator between the artist and the saint, the philosopher and the hero. So long as one was doing something that was inherently good in the first place – philosophy, for example, or music – *virtù* could be achieved simply by doing it extremely well.

Borghini was not alone in his belief that art-making was a potentially virtuous activity, or even in suggesting that *virtù* offered the basis for thinking about the relationship between the artist and the holy man. Cellini himself claims that, once he had seen his vision of the Sun-Christ and made a model after it in wax, God outfitted him with a kind of aureole:

> Ever since I saw that thing, there has remained with me a splendor – a most marvelous thing! – above my head. This is visible to every person I've ever wanted to show it to, which hasn't been very many.[11]

Cellini goes on to say that his aura was less visible in Italy and in France, because in Italy the air is mistier – a comment that may prefigure the emblematic use he would eventually make of Apollo and Python. More obviously, however, the glow above Cellini's head is a halo, both a proof of his redemption and a manifestation of the brilliance that radiated from his brains. In figuring his glowing Christ, Cellini partakes of him, acquiring some of his subject's own virtues.

Remarkably, a very similar conceit is pursued in an unpublished poem, written to Cellini while the artist, imprisoned later in Florence, was wishing he could work on the marble *Crucifix*:

> Chi entrar' vuole inelprofondo abisso
> Diben' potere almondo dimonstrare

Bisognia, Compar' mio, come te fare
 A ben' rapresentar un' Crocifisso.
Preso, e leghato, e poscia inprigion' misso
 E uscirne per burla, e ritornare
 Preda di birri battere, e stratiare
 E 'l cervel' delle spine haver' trafisso.
Poi quelle man' che lo scarpel' d'amore
 Maneggian' e 'l martel' divera fede
 Inpreda date all'otio, e al dolore
Poscia elevato l'uno, e l'altro piede
 Dall'opre virtuose ch'ai nel core.
Cosi ch' gl'andian' dietro Cristo chiede.
 In tal modo si vede
La vera effigie è 'l vero alto messia
A cui non fu dolor' mai pari o fia.
 Dipoi che questo sia
Non per tua colpa, ma per premio dato,
All'innocentia, e non a 'l tuo peccato.[12]

Whoever wishes to enter the deep abyss and so to be able to demonstrate to the world how – must, my friend, do as you do – to represent a Crucifix well. Taken and bound and then thrown into prison, and exiting for mockery, and returning, prey to the beating and tearing of soldiers, and having your head pierced with thorns, then having those hands, which managed the chisel of love and the hammer of true faith, given to otium, and to suffering, then having one, then the other foot lifted away from the virtuous works that you have in your heart – it is this that following Christ requires. In this manner we see that the true effigy is the true exalted Messiah, whom suffering never equaled and never will, for all of this was given to you not for your fault, and not for your sin, but as a prize for your innocence.

The poem's conceit turns on the puns introduced in the first stanza, the verb *representar'* suggesting both "to produce" and "to act as," and its object *Crucifisso* thus suggesting either the marble Crucifix that Cellini makes or the crucified man that Cellini becomes. As the second stanza evokes the Passion, and the third the tools that the sculptor loses in his own imprisonment, the lines that follow keep both of these meanings in play, so that by the time line 13 refers to the sufferer's *virtuose opre*, these works must be both Christ's and Cellini's. Cellini's artistic work, the poet suggests, becomes a kind of sacrament; his chisel expresses his love, his hammer his faith. If Cellini himself allows that the act of modeling Christ in wax beatifies him, his friend adds that the same is true for the more physical labors of stonecutting.[13]

 The first three chapters of this book have suggested a number of ways in which Cellini, through the exercise of his artistry, aimed to be virtuous.

Following Cellini as he competed with the poets he called *virtuosi*, as he performed a miraculous resurrection, and as he contested the values of good political imagery, these chapters have suggested that Cellini prompted his viewers to consider just what it was that let sculptural works, and their makers, be admired. The present chapter aims to provide something of a framework for these issues. Focusing on Cellini's most direct statements about the relationship between art and virtue, it will show that Cellini had very definite ideas about how it was that the sculptor managed to act well. Sculpting was good, we will see Cellini explain, because it followed *disegno*.

When we think about the emergence of *disegno* as a central term in late sixteenth-century art theory, we often think of a concept that granted a new kind of transcendental intelligence to its users.[14] Hence, for Erwin Panofsky, the invention of *disegno* as an artistic principle was a manifestation of Renaissance idealism, giving artists access to something like Platonic forms.[15] For Wolfgang Kemp, *disegno* supported a new form of political absolutism, conferring dominion over a designed world to the mind of the individual.[16] And most recently, Robert Williams has suggested that *disegno* constituted a *metatechne*, offering what he calls the "superintendency" of all knowledge, artistic and otherwise.[17]

A decisive prompt to view *disegno* in this manner is a comment by Giorgio Vasari, one which is quoted repeatedly in the literature, and which anchors virtually all of these studies. *Disegno,* Vasari writes, "withdraws from many things a universal judgment, similar to the form or idea of all the things in nature."[18] This definition, which posits an origin in *disegno* for everything under the sun, is a powerful one, both in its philosophical boldness and in its advantageous position in the preface to Vasari's *Lives*, the success of which not even its confident author could have foreseen.

This explanation of *disegno*, however, was not the normative one in Italy, nor even in Vasari's Florence, and it does not deserve its place as our standard definition of the term.[19] Cellini, it turns out, is a particularly good source for a competing view, one he articulates explicitly in the 1560s, and which implicitly guided his most important sculptural undertakings from two decades earlier. For Cellini, *disegno* did not allow upward withdrawal, but rather invested conduct, including especially the conducting of art, with cause, purpose, and meaning. *Disegno* was, for him, not the end of knowledge, but the means to virtue; it made his art significant not just as a form or idea, but as a work.[20]

The terms with which Cellini would have us approach his conception of design can best be introduced by looking at the series of sketches the artist made

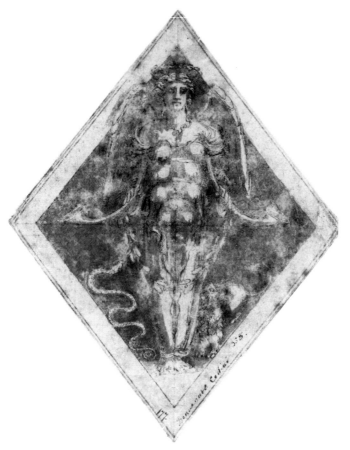

51. Cellini, Design for the Seal of the Accademia del Disegno. Munich, Staatliche Graphische Sammlung.

in 1564 (Figs. 51 and 52), proposing a new seal for Florence's recently founded Accademia del Disegno. The Academy was seeking an emblem to replace the now outdated winged bull of its predecessor institution, an idea manifesting "the most beautiful caprices and the most extravagant and beautiful fantasies that one could imagine," and Cellini's sheets duly offered a set of allegorical chimera that would economically state the Academy's universal value and mission.[21] While his proposals were not, in the end, accepted (no agreement on a seal was reached, in fact, until 1597, long after Cellini's death), his conceits, nevertheless, have come to be counted among Cellini's most important (and therewith the sixteenth century's most representative) definitions of *disegno*.

Cellini's seals have been compared with Vasari's definition because they refer at one point to a design "which is made in the imagination." This seems to conform to Vasari's sense that design is a noumenon, a plan of the things the artist would imitate available to him as pure thought, even before he sits down

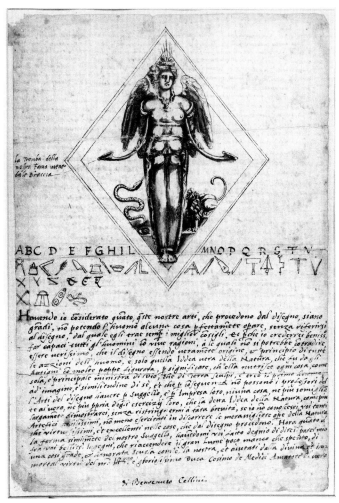

52. Cellini, Design for the Seal of the Accademia del Disegno. London: British Museum. © The British Museum.

to draw or to model. Yet notice how Cellini's remark appears:

> *Disegno* is the true lantern of all the actions that men of every profession
> do, such that *disegno* is of two kinds, the first, that which one makes in
> the Imagination, the second, drawn from that, that which one makes
> with lines.[22]

Cellini describes the *disegno* in imagination not to make an epistemological point, but rather to clarify a thesis about human action. That *disegno* is both what is imagined and what is drawn from the imagination is important not because it ties an executed product to a more abstract idea, but because it illustrates the role design plays in every significant endeavor.[23] And it is such a

claim about *action* that emerges as the leitmotif of Cellini's entire series of seals. In its most elaborated version, his explanation is this:

> Having considered how much these arts of ours which proceed from design are great (man not being able to operate perfectly without referring to his designs, from which he always takes the best counsels), and believing myself to be able to convince all men with vivid reasonings, which one could not deny to be most true, that design is truly the origin and principle of all of the actions of man, and the single true "Iddea della Natura," which was figured by the ancients with many breasts to signify that she, as the single and principle minister of God (who sculpted with earth and created the first man in his image and likeness) nourishes everything – [I have] consequently [concluded that] the professors of the arts of design could not have, for their seal and impresa, anything more similar to the truth, nor more proper to their exercises, than the said Iddea della Natura. This I would demonstrate at greater length, without restraining myself to such brevity, did I not know all of you most noble Artificers to be no less exercised in discussing the marvelous works of nature than you are virtuous and excellent in [enacting all] things which proceed from design.[24]

The opening words of the passage key the discussion of *disegno* to that of greatness; *disegno*, Cellini asserts, is nothing less than the source of artistic excellence. The last words circle back to seal the thought: Artificers who proceed from *disegno* will be *virtuosissimi et eccellenti*. Between these two theses, Cellini wanders through an explanation of how greatness and virtue, beginning from *disegno*, are reached. From *disegno*, he explains, men take the counsels (*consigli*) that guide their operations; from *disegno*, men access the *Iddea della natura* (the nature goddess / the idea of nature), thus becoming capable of making art from the same principles with which God himself worked when he "sculpted and created" the first artwork, man himself.[25] The *Iddea della natura* (in the form of Diana of Ephesus, the picture on the seal) should serve as the Academy's symbol because it figures design's role as absolute origin; it is this *Iddea* that enables the reenactment of God's works. At the center of the statement is a crucial definition – *disegno* [*è*] *veramente origine e principio di tutte le azzioni dell'huomo*. It is this part of the argument that Cellini reiterates elsewhere: The sun-god Apollo can stand for *disegno* because "disegno is the true lantern of all the actions that men do"; the many-breasted Diana of Ephesus can stand for *disegno* because "*disegno . . .* is the true mother of all man's actions."[26]

Cellini's proposal was intended to be broad in scope, and the comments involve assumptions about the relation between theory and practice, art and nature, the artist and the divine.[27] Rhetorically, however, the principal topic in the statement is *virtù*; Cellini attempts to define virtue in such a way that

the artist can achieve it. To talk about *disegno*, Cellini wants to claim, is to talk about human undertaking; the discourse to which *disegno* is native is that of ethics. Inasmuch as *disegno* is the defining feature of the new Academy, Cellini effectively claims, artists, as much as any other professionals in society, are positioned to exercise virtue.

The materials for Cellini's conception of his virtuous profession come in part from Aristotle's *Nicomachean Ethics*. He chooses, for instance, to circumscribe art not as a kind of *thing*, but rather as a kind of labor. Art is an *opera*, an *esercizio*. This gives Cellini's *arte* much the sense the same term has in Bernardo Segni's 1550 Italian translation of the *Ethics*, where it renders the Latin *ars*:

> Just as it is with the flautist, with the statue-maker, with every artificer, and with all those who undertake some operation [*operatione*], that the being and the quality of their arts [*arti*] and operations [*operationi*] consists in their works [*opere*], so is this the case with every man in whatever office is proper to him.[28]

Like Aristotle, Cellini approaches statuary in terms of works, as the realization or fulfillment of the operations proper to the sculptor's office. And when Cellini's terminology eventually contradicts Aristotle's claims that "art has to do with making, not with action,"[29] it does this by folding "action" into the language of "operation" Aristotle himself had already provided. Cellini's view here might be compared to that of his contemporary Francesco de' Vieri, who in 1568 took up the same issue of art and its ends with which Varchi and Guidi had also wrestled:

> It is true that, with regard to their manner of operating in material, externally and outside of themselves – their manner, that is, of acting on something that is not identical with the actor – [painting and sculpture] are absolutely arts. But with regard to the end with respect to which they take their name and with respect to which they make judgments about things, they should be counted among the sciences [*dottrine*], which draw on the moral and the active in order to operate with an aim of moving themselves in imitation of the virtuous operations of praiseworthy men.[30]

Acknowledging Aristotle's supposition that a logic of "ends" helped to define the relationship between arts and sciences, Vieri nevertheless suggests that Aristotle's further premise – that arts, because they are factive, deal only with ends outside of the actor – was unsound. The *process* of making art, Vieri points out, requires judgment, and this requirement imbues that process with a kind of "internal" end, regardless of what the hands ultimately do. Vieri's response to the *Ethics* effectively rejects Aristotle's reduction of the art to production in order to emphasize another point Aristotle makes – that art, being an operation,

requires *consiglio*, a *ministra*:

> Counsel pertains to things that we can put into execution . . . it does not pertain to exact disciplines, to those that can be sufficiently mastered, such as that of letters – one does not seek counsel about the way in which one should write the characters. Rather, one consults about all the things that can be done by us, and that we do not always do in the same way, such as the art of medicine, and the art of earning money, and the art of navigating . . . We seek counsel more in the arts than we do in the sciences, because in the arts we have more doubts.[31]

Aristotle maintains that art is counsel's true field. Undertaking something of which the result is as yet unseen, art requires guidance. And when Cellini explains that counsel leads design from that which "is made in the Imagination" to that which "is demonstrated with lines," this resembles one of Aristotle's central examples:

> [E]ach person having, first of all, presupposed some end, he considers how, and by what means, he can pursue it. And once he sees how he can pursue it, he considers the means by which he can pursue it most effectively, and best. If he can reach his end by one means only, he then considers how he can reach it by that one, and [how he can reach] that one by some other, until he arrives at the first cause [*cagion' prima*], which is the last thing to be found. And so it appears, to each who takes counsel [*si consiglia*], that he is attempting something and resolving it in the way just described, no differently than happens when one draws lines [*non altrimenti ché avviene nella disegnatione delle linee*].[32]

Aristotle is presumably referring to the drawing of geometrical, rather than human, figures. His allowance that something called *disegnatione* best exemplifies what it looks like for virtue to follow counsel, however, may well have seemed pertinent to other graphic practices as well. Cellini, in any case, wants to charge *disegno* by investing it with a similar exemplary function.

Such a claim about art and virtue would have been an especially topical one for the seals. The charter of the new Accademia del Disegno specified as a primary criterion for membership that artists must be *virtuosi*, and this had to be manifest both in character (as virtuousness) and in art (as virtuosity).[33] Cellini's seal designs, which promote artistic operation as a paradigmatic virtuous action, justify and explain the academy's admission standards. That only *virtuosi* should be admitted to the Accademia del Disegno is, in Cellini's terms, an all but tautological rule, for only those with *disegno* can be virtuous.

Cellini would have been encouraged in such a claim by his knowledge of other writers on the arts. Most important among these was his close friend

Varchi, who was himself an advocate for the relevance of ancient Greek, and especially Aristotelian, philosophy to the modern arts. In Varchi's most famous statements about the visual arts, his 1547 *Lezzioni sopra la pittura et scultura*, in fact, he uses the *Nicomachean Ethics* as his primary authority in explaining the difference between art and science, between the active and contemplative faculties. Citing the *Ethics*, Varchi not only claims that the "end" of the arts is to operate, but also invokes "the very words of Aristotle in the third book of the Ethics" to stress the importance of *consiglio*: "The arts take counsel and deliberate, and often they do this more than the sciences do."[34] Again with reference to Aristotle's *Ethics*, he claimed that "the arts and the virtues are very similar in this regard: both appear through exercises, through doing things."[35] Even Cellini's designation of *disegno* as an "origin" and "principle" may have come directly from Varchi, who calls *disegno* the *principio* of the arts, and who writes that "*disegno* is the origin, the source, and the mother of [both painting and sculpture]."[36]

Cellini's seal designs thus raise two complementary questions, both of which involve what might be called the accessibility of virtue. First, what kind of a virtue could a practicing artist in Cellini's time appreciate; what, from the perspective of a particular profession, would virtue look like? Second, what in the particular task of the artist was suited to the pursuit of virtue – how could one be virtuous within a profession, and how would the pursuit of virtue give profession itself a form? In order to evaluate what Cellini's answers to these questions included, we must look not only at the pithy theories about art that his seals ultimately aim to be, but also at the works they purport to govern. In the late 1540s, while Varchi was first formulating the terminology of artistic action Cellini later drew on, Cellini's own profession was not writing, but designing sculpture; in fact, he was charged with nothing less than making a timely icon of virtue – the *Perseus* – to go in his city's most prominent civic square. If Cellini's ultimate claim is that the art of design must be virtuous, it is here that that claim must be measured, for the *Perseus* is not only the clearest standard of virtue Cellini ever offered, but also the first work on which Cellini's emblem of *disegno*, the "Iddea della natura," appears (see Fig. 19).[37] How do the key features of Cellini's representation of virtue anticipate his language of art (including the language that the *disegno* allegories in turn employ)? If, as has been argued, Cellini's reflections on his art are also reflections on virtue, to what degree is the converse true? Answers to these questions might begin with the *Perseus*, and more specifically, with the bronze relief of *Perseus Rescuing Andromeda* (Fig. 53), which Cellini made for the front of the sculpture. For the relief's dynamic incorporates a conception of action that suggests the very connection Cellini's seals attempt to forge: that between facture and ethics, between *arte* and *virtù*.

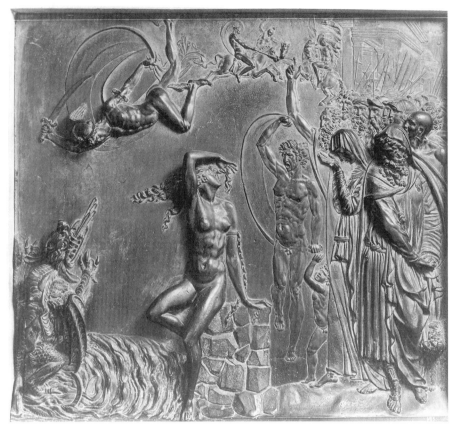

53. Cellini, *Liberation of Andromeda*. Florence, Bargello (photo: Biblioteca Hertziana, Rome).

Cellini's *storia* of Andromeda (as he refers to the relief) draws on the moment in Ovid's *Metamorphoses* when Perseus (above left), flying over Ethiopia, interrupts his journey to rescue Andromeda (center), whose parents, Cepheus and Cassiopeia (right foreground) have sacrificed her to the dragon Cetus (below left). Executed in the highest relief, the key players are easy enough to identify, and if the composition also includes a number of peculiar details, there is reason to agree with those recent scholars who have argued that virtue is the topic that everything else amplifies.[38] Such a reading is supported, to begin, by the interpretations of the story offered in both of the vernacular versions of Ovid in print at the time Cellini began the relief. The first of these, that of Giovanni Bonsignore, appended this commentary to his translation:

> We could interpret the monster morally, as well as the fact that Perseus
> has wings: one interprets him, namely, as the virtuous man with angelic

54. Cellini, *Liberation of Andromeda* (detail: Perseus).

feathers. I interpret the monster to be the demon which is filled with all vices, which are the death of virtue . . . [39]

The second, that of Agostini, agreed with his predecessor that Perseus stood for the *huomo virtuoso*, and added:

One could also interpret the monster morally, as the enemy of nature, which, although well entrenched, is always driven away, and in every undertaking against virtue ends up losing.[40]

Flying with the winged sandals (*talaria*) given him by Mercury, Bonsignore's Perseus becomes God's agent, an alter ego of St. Michael, who turns the defeat of a dragon into a triumph over everything diabolic. Agostini, revising the allegory, replaces the divine representative with a "natural" one. Both commentators agree, however, that the episode's antithesis is fundamentally a moral one, a polarity between virtue and what hinders it.[41] Inasmuch as Cellini's own depiction of the scene is built around the threat to, and consequent rescue of, the maiden, it invites similar terms of reading.

Merely granting that Cellini's *Perseus* is supposed to exemplify virtue, however, does little to engage the work itself. What, in Cellini's depiction of Perseus, is the viewer to understand virtue to consist in? More fundamentally: What, in the relief, is Perseus's action (Fig. 54)?[42] Evidently, Cellini gives the viewer the moment when Perseus, flying over Ethiopia, catches his first sight of Andromeda, who stupefies him: "Her eyes held his, and from them an arrow pierced him with light, and as its fire ran through his veins, he almost forgot to flap his wings."[43] Yet Cellini also seems to illustrate a second scene, one that

should have happened later, in which the hero, having fallen for Andromeda, spoken with her father, and accepted the mission to slay Cetus, "took sword in hand, and, with fiery heart, vigorously flew towards [the monster]."[44] A crucial difficulty in Cellini's relief is that Perseus's movement encompasses at least two distinct moments of his ardor. The billowing cape and drawn sword suggest downward acceleration and preparation to strike, but this is elided with, or preceded by, a seemingly simultaneous *halting* of motion. Perseus flies, but he also twists away from his trajectory, focusing his attention on his fiancée's plight. To get at Cellini's sense of virtue, we must account for the double sense of Cellini's Perseus.

A first pass at this double sense might be to conjecture that Cellini has in fact reconfigured the traditional narrative by setting Perseus's entire action in reference to Andromeda. Ovid's own words might offer one description of this reconfiguration, for his poem identifies Andromeda as Perseus's *pretium et causa laboris*, the prize and the cause of his labor. As the bride Perseus wins with the kingdom he saves, Andromeda is the compensation for what he does; she is also, however, his work's reason, and as such she is linked to what he does even before he does it. The Latin *causa* allows Andromeda to be subsumed into Perseus's act to varying degrees: Her figure could be read, for instance, as the living beauty *for whom* Perseus kills the dragon, or, alternatively, as a personification of the motivation *out of which* he acts, the very embodiment of his inducement. It is this second possibility, importantly, toward which Agostini tends in his commentary on the story:

> We interpret Calliope [sic], Andromeda's mother, as *superbia*, and Andromeda, who was bound to the rock, as the noble mind [*la mente nobile*], which, through superbia, was taken and removed from God, and given to the demon. We take Perseus to be virtue, which takes the noble and divine mind for its wife, and unties and frees it from diabolic hands with its beautiful and healing words.[45]

In the most well-known versions of the classical myth, Juno had Cetus sent to terrorize Cepheus's kingdom because Andromeda's mother had boasted of her beauty; that Agostini turns the whole episode into a fable of pride and its punishment, then, exploits a moralizing element that is, to a degree, already there. Less obviously cued by Ovid, however, is the way in which Agostini, beginning with this, collapses the whole incident into the collective aspects of a single exercise of virtue: Through *superbia*, the mind is separated from God; through virtue, alternatively, it is connected. The mind that is liberated from diabolical menace is the very mind that sin jeopardized; strung between bodies, Andromeda is everyman's mind, noble or enslaved, depending on whether she is linked to the acts of her mother or to those of her husband. The act of virtue, for Agostini, is not the killing of the monster so much as the marriage itself,

Perseus's union with noble mind, which, in turn, equips virtue with its crucial attribute. If Perseus can speak his beautiful words, it is because Mercury, the god of eloquence, has outfitted him to do so; it is also, however, because a noble mind now guides him – Perseus frees Andromeda *with* his words because speaking beautifully *is* an act with mind.

Whether or not they would have found Agostini's allegorical reading compelling, an Aristotelian like Varchi and Varchian like Cellini would have found nothing strange in the suggestion that *mente* (mind, intelligence, knowledge, acknowledgment, attentiveness) was indispensable to virtue. Aristotle, for instance, writes that

> the good man does [*opera*] what he ought, because every mind [*mente*] wants for itself what is best and the virtuous man [*il virtuoso*] obeys the mind[46]

Mente, is, for Aristotle, one of the fundamental causal principles that moves the world, and is moreover a decisive one for ethics, as it is the one cause linked to human agency.[47] He treats *mente* as the spur to what he calls *elettione*, and explains that election, in turn, is a necessary condition for moral action:

> There can be no election without *mente* and without consideration, nor without moral appetite. Without *mente*, and without habit, one can do neither good nor evil actions. But *mente* moves nothing but that which it moves for some end, and which is operative. As such, this [*mente*] rules the productive faculty [*la fattiva*].[48]

Mente, as the first mover behind a virtuous operation, begins to look very much like what Ovid calls a labor's cause. And while it might be reckless to put too much Aristotelian weight on Ovid's turn of phrase, it is worth observing that the iconography of virtue that Varchi and Cellini knew from Agostini is, in one telling way, consistent with the Aristotelian context in which virtue would inevitably have been theorized: The Italian Ovid and the Italian Aristotle agree that virtue, to be virtue, begins with "mind." Bernardo Segni, Aristotle's Italian commentator, in fact, comes close to saying what Agostini says of Perseus and Andromeda: "Virtue saves the principle – and this is the *mente* – and Vice destroys it."[49]

We know, furthermore, that *mente* was to be a specific consideration in Cellini's *Perseus* project. Even before the relief was conceived, it had been decided that, above the Andromeda *storia*, on the four sides of the base of the statue, were to be four niches, each containing the figure of a mythological character who contributed one aspect to Perseus's formation. In Varchi's and Cellini's original plan, at least, those characters were to assume their significance from the role they played in the classic story – Jupiter and Danaë would appear because they were Perseus's parents, Minerva and Mercury because they

armed Perseus with the weapons he used to slay both Medusa and Cetus. Each figure would "speak" a Latin couplet, written in the first person and inscribed (in a mouth) below. These inscriptions would give sense to the attitude the corresponding figures had adopted: Jupiter, shown brandishing a thunderbolt, would promise to avenge all wrongs done to his son; Mercury, taking flight, would explain that he is ascending to heaven; Danaë, bowing her head, would accept the exile imposed upon her.[50] And each figure, it might finally be inferred, would be responsible for one thing on which Perseus's virtue depends: From Mercury, for example, Perseus would take eloquence (hence the "*belle & salutifere parole*" Agostini mentions), from Danaë he would inherit beauty.[51]

Such an allegorically explicit division of a figure into the qualities of which his virtue was composed was unprecedented in Renaissance sculpture, and it reveals the level of philosophical complexity with which Cellini and Varchi (who, at the very least, composed the four figures' inscriptions) wanted to approach the project.[52] Most relevant for present purposes is the figure of Minerva. Standing at attention and armed with a spear, she indicates her own contribution to Perseus's formation: "That you may be victorious, I, your chaste sister, give you this shield" (*Quo vincas Clypeum do tibi casta soror*). The shield, readers of the Perseus story would know, was the operative instrument in the ruse that allowed Perseus to defeat the Gorgons; this, along with its provenance from the goddess of wisdom, linked the shield generally with Perseus's intelligence.[53] In the same key, a mythographical tradition stemming from Fulgentius interpreted the gift as the gift of divine wisdom.[54] And several suggestions for alternative inscriptions to go on the *Perseus*, preserved among Cellini's papers in the Biblioteca Riccardiana in Florence, gloss it with similar specificity. One of these is a variant by Varchi himself: "I give you [this] shield, as I once gave you mind and spirit" (*Do clypeum, quae iam mentem animumque dedi*).[55] Two others, both slightly longer, come from Pietro Angelio da Barga: "Having been born from the head of Jupiter, I graciously imparted to [my] brother a mind, so that he might be knowing, [and] a shield, so that he might be strong" (*Nata Iovis cerebro tribui gratissima Fratri / Qua sapiat mentem, quo valeat Clypeum*), and "I, his sister, gave Perseus counsel and the fell shield, that he might overthrow this monster with his able hand" (*Consilium, saevamque dedi, soror, aegida persei / ut monstrum hic valida sterneret ille manu*).[56] All of these proposed inscriptions agree with the one ultimately selected in making Minerva's gifts her *raison d'être* within the work; the Riccardiana lines, however, also suggest what these gifts would contribute to Perseus's action – a god-given "mente" or "consilium" or "animus" would guide his work and strengthen his hand.

If, in the end, Cellini and Varchi rejected the possibility of explicitly naming Minerva's more abstract function on the statue (thus leaving the role Agostini assigned to Andromeda potentially in play), the existence and agreement of

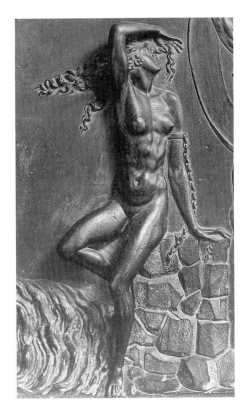

55. Cellini, *Liberation of Andromeda* (detail: Andromeda).

the verses demonstrate that at least two of Cellini's contemporaries understood Perseus's virtue to depend on *mente*. Returning to the Perseus of the relief, who is shown both bearing the shield and attending Andromeda, it might now be said that Perseus is stopped, diverted from a headlong dive, because the engagement of mind, the acquiring of counsel, is a defining part of Perseus's virtue in particular, and, in Aristotelian terms at least, any virtuous action as such; conversely, he is in action because only in the *opera* can virtue be realized.

This begins to indicate how the relief anticipates Cellini's later thoughts on *disegno*, for as Aristotle himself points out, *mente* rules the human faculty for production. Ovid's own text already suggests how having Perseus's mind on Andromeda might amount to thinking about sculpture:

> Seeing the beautiful woman, tied, as I have said, beside the sea, Perseus would have believed her to be a statue . . . [57]

Even beyond the highly suggestive fact that Cellini chose to portray exactly this moment in Ovid's narrative, there is much to encourage the viewer to read Andromeda as a specifically sculptural thought. Unlike most representations of the liberation of Andromeda, Cellini's scene has the victim chained to an edifice (Fig. 55). While the structure is polyvalent in type – Hirthe called

the structure "a wall," Plon saw a "rock," Corwegh a "cliff" – what can be said of it concretely is that it is *artificed*, built in what would have been understood as a "rustic style," and thereby loaded, as Cellini would have known, with art theoretical connotations.[58] Cellini's rustication, which is of perfect Serlian decorum, affiliates the combination of figure and base with Cellini's own contemporary sculptures in the round (Fig. 49), and lets the structure read as one of Cellini's typically rocky pedestals. Serving as the support for a sacrificial victim, moreover, it is equally legible as an altar; in this respect, it repeats in miniature the socle of the *Perseus* itself, directly above it.[59] No less indicative is the way Cellini positions Andromeda within the space of the scene more broadly. As is well-known, Cellini was one of the earliest promoters of sculpture "von allen Seiten gleich schön," or, as he put it, sculpture that had from eight to one hundred distinct viewpoints from which it could be seen to advantage.[60] What has not been remarked is that in the Andromeda relief, Cellini deploys just such an arrangement of multiple viewers. While Perseus and the dragon see one side of her figure, the nude male to her left (on which more later) *orbits around* her, running in a clockwise circle, keeping his eyes on her in the process. The crowd beyond, furthermore, is arranged in a calculated repetition of this orbit, going so far as to include a dog that leans out around the rest of the characters to get a better view. If Ovid suggested that Andromeda look sculptural, Cellini accommodated her to his own sculptural norms.

Writers around Cellini, moreover, were prepared to use the very language we have been looking at to discuss Cellini's work on the *Perseus*. Consider Giulio Stufa's verse on the monument:

> Descendens olim superis Cellinus ab astris,
> Vidit, et huc visum Persea mente tulit.
> Quem mox, cum, iussu Cosmi Ducis inclyti in arte
> Finxisset quot sint, quot fuerint superat.[61]

> Cellini, once descending from the stars, saw a vision, and carried this vision of Perseus in his mind. This, as soon as it was contrived (by the order of Duke Cosimo, famous in art), superseded all that is and all that has been.

What is striking about the poem, in light of the present discussion, is not just that it structures Cellini's act with the same term of *mente* that constituted Perseus's own virtue, but that it does so with a description of an action that is remarkably like Perseus's own. Presumably, this poem was among those that "valorous and wise poets" attached to the base of the *Perseus* at its unveiling in 1554.[62] This context is evocative, for when Stufa's words are imagined actually affixed to or beside Cellini's relief, his presentation of Cellini's brilliant making of the Perseus as a descent from heaven begins to resemble Perseus's own movement. That Perseus interrupted a *downward* flight on encountering

Andromeda departs from Ovid's narrative of the hero crossing her land. One thing this notion suggests (especially with Jupiter standing above) is that Perseus's rescue is a god-given solution to a god-given plight.[63] The deed Stufa's poem describes, however, that of the actualization of mind in the work, may also offer further connotations for relief.[64]

More must be said about how figurations of virtue could underwrite metonymic readings of the sculpture, treating its maker as the work's true protagonist.[65] First, however, it is necessary to look further at the body of Cellini's *Perseus*. For this, some terms made available in a lecture on "furor" by one of Varchi's successors at the ducal literary academy, Lorenzo Giacomini Thebalducci, may be helpful. In the course of his discussion, Giacomini brings up the subject of attention:

> We presuppose that just as the hand, in order to operate with strength, tenses [*tende*] the sinews and makes a certain force and concentration of spirits, and just as the eye, when it fixates [*affisa*], similarly makes, so to speak, such an "intention" [*intentione*], so do the internal parts that know, whenever they want to operate attentively [*attentamente*], collect and fortify themselves, calling many spirits back to themselves.[66]

Relying on its etymological connection with *tendere*, "to tense," Giacomini wants to exploit the literal possibilities in the term *intendere*, "to see," "to understand," "to have in mind." Unpacking the "tension" in "intention," Giacomini points out that the eyes can undergo the same effect of concentration as the hand, collecting spirits into a single focus. What is common in these two processes, according to Giacomini, in turn constitutes a model that pictures knowing itself; this knowing, conceived as "attentive operating," effectively sublates the hand's operation and the eye's sight.

The pertinence of such a word family to the designing of the body can be argued by adducing a famous drawing by Michelangelo, the so-called *Archers* now at Windsor Castle (Fig. 56). The drawing presents a myriad of interpretative difficulties, beginning with attribution; William Wallace, for one, has suggested that in its original form, the drawing omitted not only the bows one imagines the figures to be bending, but also the arrows, the target, and the sleeping cupid at the lower right.[67] The conceit of the drawing may be related to an idea the artist expressed in a famous poem about painting the Sistine Ceiling, where he connects the deformation of his judgment to the fact that, in painting the ceiling, he must stretch his body like a bow.[68] Still more useful in explaining the Windsor drawing, however, is a passage David Summers has highlighted in the *Nicomachean Ethics*, in which Aristotle offers a metaphor for the use of "right reason":

> In all of the habits described above, as indeed in all others, there is a certain target [*signum*], towards which he who has reason, taking aim,

56. Michelangelo, *Archers*. The Royal Collection © 2001, Her Majesty Queen Elizabeth II.

> tenses and relaxes [*intendit atque remittit*]. There is a certain terminus in the middle [*terminis mediocritatum*], which we aver to be between excess and deficiency . . . [69]

Summers discusses the importance of Aristotle's promotion of the middle course for the art theory of Michelangelo and his contemporaries, but the metaphor of tension and relaxation this requires is also of interest. Picturing a bending, or "in-tending," suits Aristotle's purposes because good action must "tend" toward one thing, as opposed to another: As Donato Acciaiuoli puts it in his gloss on the metaphor, "right reason is that which sights the target [*signum*] at which we should aim [*tendere*]."[70] This metaphoric action is of further interest insofar as the terms it depends upon, *signum* and *tendere*, both translate aspects of design. Machiavelli, for instance, uses the word *disegno* and its cognate *disegnare* in his own rewriting of the metaphor:

> A prudent man ought always to follow the trails tread by great men, and to imitate those who have been most excellent, such that, if your virtue does not reach theirs, at least it catches some scent of it. Do as prudent archers do when, it seeming to them that the place they aim [*disegnono*] to hit is too distant, they place their aim a bit higher than the targeted place, not so as to reach such a height with their bows, but rather to reach, with such a high sight, their design [*disegno*].[71]

Machiavelli, unlike Aristotle, makes virtue explicitly a matter of imitation;[72] his *disegnare* means, at once, "to aim" and "to imitate."[73] Michelangelo's drawing

may involve a similar pun, thus illustrating the way having a *disegno* results in an intention, which in turn amounts to a physical act, of which designing figures, *disegnare*, counted as a premier example. If contemporaries were attuned to such word play, it could explain why the drawing (whether Michelangelo or a later sixteenth-century artist completed it) finally makes the archers' target explicit with a *term*. This is, in the first place, the "terminus" at which Aristotle says actors should aim, but it is also, in Machiavelli's idiom, the present *disegno* of their acts.[74] It could equally account for another feature of the drawing that has long puzzled commentators, the fact that the archers seem to be drawing their bows left-handed. Taking the absence of the bows to be purposeful, and invoking the pun on *disegnare*, it might now be proposed that the figures are not left-handed at all; rather, they are reaching forward with their rights, their actual "drawing" hands. The same vocabulary, finally, would explain why Cellini's "iddea della natura," which aims at defining *disegno*, takes the form of a term: It is the *terminus*, or *disegno*, that is design's imitative target, and hence beginning: "In actions, the end is the origin."[75]

Added to Giacomini's association of physiological and cognitive "intention," this extends the interpretative possibilities of the sculptures under consideration. If Giacomini, and perhaps Aristotle as well, imagine understanding to look like the tensing of muscles, then there are grounds to ask as well whether a figure like Cellini's *Perseus*, twisted by his vision of Andromeda, similarly experiences "intention." This is, it happens, precisely the word Agostini employed in his translation of Ovid's narrative:

> Quando Perseo la cagion uera intese
> che ignuda la tenea legata al sasso
> d'ira e disdegno, e di pieta si accese.

> When Perseus perceived [intese] the true reason why Andromeda was bound nude to the rock, he was set alight with anger, with disdain and with compassion.[76]

For Agostini, Perseus "intends" a *cagione*, a reason or cause, which results in what contemporaries would have called an *affetto*, an expression or effect – Perseus's *ira*, *disdegno*, and *pietà* are the *affetti* produced by his apprehension of his *cagione*. If, as has been suggested, Cellini's scene evokes the moment in Ovid when Perseus, stupefied, "almost forgot to flap his wings," it captures an analogous process. Although Perseus is in the air, that is, he is not exactly, or not only, flying; rather, he is turning to fixate in accompaniment or response to his intention of Andromeda. Perseus reads as operating between rest and motion, bereft of agency yet tensed. Whether Andromeda now distracts his downward course with her beauty, or whether, having already stopped him, she now motivates him to raise his sword and continue, her (dis)animating

force is made plain. As Perseus's heart literally goes out to her, she, as *mente* or *causa laboris*, represents the impulse that originates act.[77]

All of this suggests how the representation of action might bring in tow the representation of knowledge, or intelligence. And the relevance of this conjunction to that between *virtù* and *mente* emerges more fully when we view Cellini's relief not only against the artist's own contemporary work, but also against the setting of its exhibition. Cellini's own remarks acknowledge how much heed he took of the sculptures that already stood in the Piazza della Signoria at the time he made his *Perseus*. These included Michelangelo's *David* (Fig. 42) and Donatello's *Judith and Holofernes* (Fig. 26), both of which he had been admiring since the time he was a child, as well as Baccio Bandinelli's *Hercules and Cacus* (Fig. 39), for which Cellini had deep contempt. In accounting for Cellini's interest in the place of mind in virtue, then, it cannot be overlooked that the *David*, like the *Andromeda*, shows not the moment of victory, not the traditional triumphal swagger over Goliath's head, but rather an earlier moment, that in which the boy, seeing Goliath, lifts his sling, sizes up his opponent, and takes aim. Michelangelo offered a monumental example of how *perception* might be turned into a heroic act, enlisting the whole body for its purpose.[78] From the perspective of the Andromeda relief, Michelangelo's heroizing of David's perception, or intention, begins to look like a strategy for showing how virtue depends upon the presence of mind. A similar possibility arises with regard to Donatello's *Judith*, for contemporary viewers, as we have seen, could read both inner and outer guidance in her face: "The exterior simplicity in Judith's habit and countenance manifestly reveal what is inside, the great mind of that Woman."[79] Like Perseus, Vasari's *Judith* does not simply move her sword into action; more than this, she *is* moved.[80] And while such a dynamic, in realizing a convincing *affetto*, contributes to the naturalism for which Donatello was admired, no less does that same chain reaction underwrite Judith's virtue – Judith does not just triumph over evil; more than this, she executes an action that follows (from) a good cause.[81] Donatello added cause to victory as an attribute of virtue; Michelangelo preserved the cause and suppressed the victory; Cellini, finally, makes cause explicit, embodying it. This line of interpretation accounts as well for Cellini's report of what bothered viewers about Bandinelli's statue: "It does not pay attention to what it is doing" (*la non bada a quel che la fà*).[82] It also brings us back to the question of how, dependent on *mente*, *virtù* could amount to the carrying out of a *disegno*: Michelangelo, at least, was prepared to compare David's act to his own: *Davicte cholla fromba / e io chollarcho / Michelagniolo* (David with his sling / and I with my bow / Michelangelo).[83]

In the context of the Piazza, furthermore, what succeeded the *Perseus* is even more telling than what came before. In 1584, Giovanni Bologna, Cellini's most important Florentine follower, unveiled his *compimento* (his pendant, or more

57. Giambologna, *Rape of a Sabine.* Florence, Piazza della Signoria (photo: Wolf-Dietrich Löhr).

literally, "completion") to the *Perseus*, replacing the *Judith* in the Loggia de' Lanzi's eastern archway with a marble sculpture on the *Perseus*'s scale (Fig. 57).[84] If the story Raffaelo Borghini recorded of the event is to be believed, Giambologna at first displayed the work without identifying its subject:

> ... goaded by the spur of virtue, [Giambologna] set out to show the world that he knew how to make not only ordinary statues, but also many together, and the most difficult that could be done, and that he knew where all the of art of making nudes lay (showing deficient agedness, robust youth, and feminine refinement). Thus he depicted, only to show the excellency of art, and without attaching any *historia*, a proud youth abducting a most beautiful maiden from a weak old man [*un giovane fiero, che bellissima fanciulla à debil vecchio rapisse*]; and this marvelous work,

having been brought almost to completion, was seen by his Highness our Grandduke Francesco Medici, who, admiring its beauty, decided that it should be placed in the spot we now see it. And since figures aren't brought out in public without a name, [Francesco] asked Giambologna to come up with some speakable invention for his work; and someone (I don't know who) said to him, that his work was well made to follow [*seguitar*] the *historia* of Perseus by Benvenuto, which he would have created with the ravished Andromeda wife of Perseus, with the abductor Fineus her uncle, and with her old father Cepheus.[85]

Giambologna's original invention lacked an *historia*, and this lack opened the possibility that Giambologna had followed Cellini, for at least two of his character types (those potentially legible as Cepheus and Andromeda) matched two of the leads in the *Perseus*. Of course, the absence of story did not entail the absence of action, and all of those who argued about the identities of Giambologna's characters nevertheless agreed on what they were doing: Giambologna's scene showed, in essence, one man's victory over another, where that victory consisted in the "rape," or abduction, of a woman.[86] Borghini was not eccentric in arguing that just this action constituted Giambologna's "art." As a sonnet by Bernardo Davanzati, 'Sopra il Talassio di Giambologna Scultore,' reads:

> Tenera verginella have in sul petto
> E nelle braccia giovin f[i]ero ardente,
> Che strider e sguizar si vede, e sente
> Vinto dal senso il ver' dell'intelletto.
> Altri d'antico gelo il cor ristretto
> Da terra mira il suo danno presente.
> Io veggio ben' com' ingegnosamente
> Ricopre illustre velo alto concetto.
> Quest'opra, eterna Idea, e simulacro
> E gloria della bella arte divina,
> Da far' tutti stancar' gl'ottimi Artisti,
> È, Giambologna mio, la tua Sabina.
> Tu se il Talassio; il lungo studio e macro
> È il vecchio padre à cui tu la rapisti.

The proud, ardent young man has the tender virgin on his chest and in his arms; we see her crying and squirming, and we feel the truth of the intellect conquered by sense. The other, his heart clenched by ancient freeze, gazes from the earth upon his present damage; I see clearly how ingeniously the illustrious veil covers the high concept. This work, the eternal Idea, simulacrum and glory of the beautiful divine art, such that all great artists are exhausted – this, my Giambologna, is your Sabine. You are Talassius, and the old father is the long and tiring study from whom you steal her.[87]

The lack of an *historia* let Giambologna's *Sabine* empty out into moral allegory: The viewer could treat the soldier's loss of self-control in the presence of beauty as an image of the agencies involved in the conjunction of mind and body.[88] Davanzati's vocabulary is, in part, Platonic: Approaching the sculpture in terms of an "eternal Idea" and its simulacrum recalls the famous discussion of art in Book 10 of the *Republic*, and the description of the "tenera verginella" quotes the *Phaedrus*, where Plato uses this phrase to describe the soul that is "ravished" when the Muses inspire furor.[89] For Davanzati, Talassius seems as much to receive the Sabine from above, as to take her from below. The "ottimi artisti" who fall exhausted at their divine work, meanwhile, must include Michelangelo, for Varchi had made famous that writer's poem on love and sculpture, *Non ha l'ottimo artista alcun concetto*, just a few years before. With the *Perseus* standing in view, moreover, the schema the new poem provides rings with a different familiarity, resembling both Agostini's moral allegory of masculine *virtù* and feminine *mente*, and his rhymed union of *ardere* and *intendere*. Davanzati's Giambologna, like Cellini, would seem – against all linguistic conventions – to gender *disegno* female, identifying her with the heroic male artist's mover. Viewed against Cellini's *storia*, in fact, the poem may seem to suggest that Giambologna has, in essence, recycled the triangle of young man taking young woman from old man that Cellini, rendering Perseus, his fiancée, and her father in high relief, had already identified as the *virtuoso*'s structuring conflict.[90]

Giambologna's statue could support Davanzati's metonymic reading, in part, because of the role it gave to *ardor*.[91] Other viewers called this "furor"; hence, Giambologna's own protector and patron, Bernardo Vecchietti, identified the characters as "oppressed debilitated agedness, virile young furor, and the spoil [*ratto*] of the pure light virgin."[92] It might be asked whether this profile, too, cannot be matched to Cellini. We have already seen how Agostini not only named Perseus's ardor, but linked it to his "intention." To this description, now turning again to Perseus's second sense, might be added another line from Agostini, who allows that Perseus, too, might be in a furor: Perseus "climbed to the sky with open wings, then descended with furor onto the back [of the monster]" (con l'ale aperte uerso il ciel saliua / poi con furor adosso gli tornaua).[93] What emerges if, encouraged by Giambologna's *arte* (and the *virtù* that goaded it), we isolate this aspect of Perseus's act?

The first thing that happens is that the dragon no longer seems to be Perseus's only antagonist: Appearing on the right of the scene, entering between the damsel and her kin, is a second villain as well, this one in the form of a terrifying nude man (Fig. 58).[94] The detail, which incorporates an unmistakable reference to a print after Michelangelo that at least some believed to show the

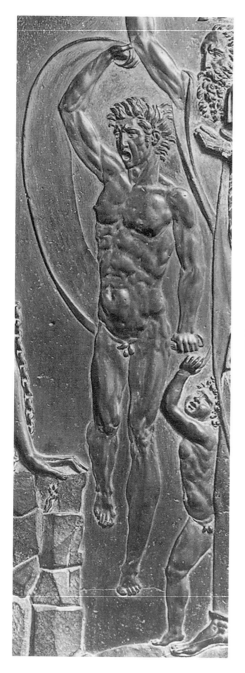

58. Cellini, *Liberation of Andromeda* (detail: Furor).

face of *furia* (Fig. 59), has only the sketchiest basis in Ovid.[95] Some scholars have inferred that the man must be Phineus, Andromeda's uncle and, at the time of her sacrifice, fiancé, who upon her rescue became Perseus's enemy.[96] Borghini's story about the *Sabine* demonstrates Phineus's prominence in contemporaries' ideas of the Perseus story, and Ovid himself describes Phineus

59. Antonio Salamanca after Michelangelo, *Viso di Furia*. London, British Museum. © The British Museum.

"furying" at Perseus.[97] This reading, however, entails some narrative confusion, inasmuch as Ovid has Phineus make his angry appearance only much later in the Perseus story, at the banquet where Cepheus is celebrating his daughter's new engagement. A more useful textual source, it might seem, is Virgil's *Aeneid*, which famously describes "impious Furor, sitting on savage arms, his hands fast bound behind with a hundred brazen knots," who roars "in the ghastliness of blood-stained lips" when war ends and peace returns.[98] Cellini knew the passage, for he had depicted it himself on an earlier medal (Fig. 60).[99] Yet the very existence of the medal also makes plain the degree to which Furor's place in the *Andromeda* abandons the Virgilian scenario: In contrast to the traditional image of Furor bound and conquered, this Furor races into the scene, fully unleashed. In light of this, and given the specific context of the Perseus story, a third literary image becomes suggestive, this one from the *Astronomicon* of Marcus Manilius.[100] Manilius, like Ovid, tells the story of Andromeda's rescue, placing this in the context of an etiology of the constellation Andromeda, telling of how Perseus's deed precipitated Andromeda's placement in the heavens, and characterizing the effects she has on those below. Describing "the man whose birth coincides with the rising of

143

60. Cellini, Verso of Portrait Medal of Clement VII: *Peace and Furor*. London, Victoria and Albert Museum.

Andromeda," Manilius writes of an

> Attendent and guard of harsh imprisonments, standing proudly by as the mothers of the wretched lie prostrate on his threshold, and as the fathers long through the night to receive their children's last kisses, and to take into their own marrow their children's spirit. The image of the executioner comes bringing death, with pyres alight and sword ready drawn. He lives on his executions, and is, in short, a man who could have watched when Andromeda hung bound to the rock.[101]

Could this be the figure who threatens Cellini's prisoner as well, unsympathetic to the laments of her parents nearby?

Whatever should count as a textual source of the figure, the more relevant matter here is the collection of attributes that the various attempts to match the figure to a text highlight: his face, his nudity, the speed that his flurrying cape implies. The minimal sum of these details, like those of the Michelangelo print from which they are derived, is a figure *di furia*, a figure "in a fury." And what is remarkable about this is that this aspect of the figure, its condition of fury, appears to be shared, at least partially, by Perseus himself. Perseus all but doubles the furious arrival on Andromeda's other side, and the billow of his cape shows him to be no less ardent: To John Pope-Hennessy, at least, the two figures appeared so similar as to be identifiable as multiple representations of a single character.[102] Even if Pope-Hennessy's interpretation is not convincing, his impression encourages the question of whether the relief itself does not prompt the viewer to make his inference, to reflect on the co-presence and confrontation of two furies.

Various sixteenth-century ideas about furor help here. Cellini's French contemporary Pontus de Tyard, for instance, claimed that one could distinguish between *furie* and *fureur*, and he carefully segregated, persons who "lose themselves in anger, and without being in the least irritated, indifferently assail all those whom they find before them," from those who, experiencing the elevation of the soul from the body, find their *intention* "all detained by thoughts of the thing desired."[103] Slightly later, Giordano Bruno would write that all *furori* could be reduced to two kinds: Those which bring about "blindness, stupidity, and irrational impetuosity, which tend towards savage insanity" and those which cause "a certain divine abstraction," which, "with the fire of desire and the breath of intention [*soffio dell'intenzione*]," make its subjects "become better than ordinary men," "principle artificers and executors."[104] These distinctions, which depend both on Plato's discussions of poetic frenzy[105] and on Cicero's contrast between *furia* and *insania*,[106] help term the relief's antithesis of responses to Andromeda: spiritual absorption and blind madness, the engagement of virtuous mind and its loss into "diabolic" hands,[107] illuminated "pietà" and the blankness of the unmoved executioner.

Cellini's own words show how well aware he was of the various uses to which a language of fury/furor could be put. His earliest known poem, from 1539–40, contrapposes the casting of *impio furore* from Heaven with the artist's own access to divine light, and thereby his capacity to sculpt:

> S'i' potessi, Signor, mostrarvi il vero
> del lume eterno, in questa bassa vita,
> qual'ho da Dio, in voi vie più gradita
> saria mia fede, che d'ogni alto impero.
> Ahi! se 'l credessi il gran Pastor del chiero,
> che Dio s'è mostro in sua gloria infinita,
> qual mai vide alma, pria che partita
> da questo basso regno, aspro e sincero;
> Le porte di Iustizia sacre e sante
> sbarrar vedresti, e 'l tristo impio furore
> cader legato, e al ciel mandar le voce.
> S'i' avessi luce, ahi lasso; almen le piante
> sculpir del Ciel potessi il gran valore.
> Non saria il mio gran mal sì greve croce.[108]

If, my Lord, I could show you the truth of the eternal light that I, in my base life, received from God, you would have more trust in me than in any great monarch. Alas! If the great Pastor of the church believed that God had shown himself to me in his infinite glory in such a way as no other soul, before leaving this base, bitter and sincere realm has ever seen, then you would see the sacred and holy doors of Justice open

wide, and the villainous, impious furor fall bound, crying to Heaven. If I had light, alas, I would be able to sculpt the great valor of Heaven's designs, and this heavy cross would no longer be my torment.

The only manuscript evidence of the poem is Cellini's *Vita*, which not only repeats its verses, but also claims that Cellini wrote them while recording, in wax, the vision that he had of the crucified Christ emerging from the molten sun. There is reason to believe that the whole event, including that of the poem's composition, was retrospectively refashioned when Cellini penned the *Autobiography* in the late 1550s. For one thing, the plea of the last line sounds similar to the *suppliche* Cellini had recently submitted to Duke Cosimo, asking that he be freed from prison so that he might work on his marble Crucifix. That Crucifix, as we have seen, itself allegedly derived from the vision to which this poem, too, now refers. As Cellini was writing this, he may still have hoped that the Crucifix would be hung above his tomb. In the 1555 codicil to the testament specifying this arrangement, moreover, Cellini stipulated that, beside his tomb, accompanying his marble Crucifix, his executors were to display the wax model on which the Crucifix was based.[109] While, as we have seen, Cellini's contemporaries could liken his work on his marble to the Passion of Christ, Cellini himself seemed to associate sculpting with salvation. To make the wax *disegno* was to have contact with the divine, to act with the light of Heaven, and to defeat the fury of his tormentors.

In a later discourse, Cellini applies the concept of "furor" to the act of sculpture:

> A valiant painter such as Michelangelo would complete a painting of a life-size nude, with all of the study and virtue that could be worked into it, and the longest this would take him is one week – many times, I saw him make an entire nude, finished with all the diligence that art requires, in the space of a day. I, however, do not want to restrict myself to such a short time, because there are certain furors that sometimes come to the men who are his most virtuous equals.[110]

Cellini's comment, which is germane to the *Andromeda* relief for its association of *furori* with *virtù*, may be the first instance in Renaissance literature of transferring *furor poeticus* to the art of sculpture. His deployment of furor to defend the *slowness* of his work, moreover, is especially remarkable; it contrasts dramatically with the sixteenth century's most famous description of sculptural furor, Blaise de Vigenère's allegedly eyewitness, but ultimately implausible, description of how the sixty-year-old Michelangelo would "strike more chips from a very hard marble in one quarter hour than three young stonecutters would have been able to do in three or four," knocking away pieces "four fingers thick," and going at the marble "with such impetuosity and fury" that the

writer feared "the whole work would go to pieces."[111] Both Blaise's credibility as a witness and Cellini's account of the furious dilation of his own labor must be accepted with caution. The context in which the latter appears, Cellini's discourse *Sopra l'arte del disegno*, suggests that he has the controversial pedagogy of the new Academy in mind; presumably, he aims not only at defending the virtues of his own sculptural exercise (on the basis of its reinedness, its divine cause), but also at rebuking the ideas and practice of his arch-enemy, Giorgio Vasari, who prided himself on his painterly *speed* in painting.[112] The comment, moreover, must be reconciled with Cellini's other ideas about the place of furor in sculpture, most notably his story of the casting of his *Perseus*, in which he describes himself as *infuriato*, running about the studio and beating on his assistants in a *diabolico furore*.[113] The slow, prospective furor of *disegno* would seem to be distinguishable from the quick, reactive furor of casting.

Turning back to the *Andromeda* relief, a concept of "furor" may help account for Perseus's action. It is in attempting to explain furor, we have seen, that Giacomini, Pontus, and Bruno all reach for the term "intention." Employing Cellini's own assertion that furor leads to slowness, such a concept may now provide the link between Perseus's two senses: his disanimation and his impulse to attack. As intention, furor circulates: In one direction, it alienates the spirit, effecting muscular concentration, winding and halting its subject; in the other, its inspiration guides its subject's follow-through, motivating his deed. Figured *against* an antithetical possession, the infuriation that, unable to respond to beauty, brings disaster on a populace, furor comes to dissect and explain virtue itself. The opposition, at its most general level, provides a scope for a pictorial dynamics that includes more than just motion (Perseus is, after all, tensed, if not still); the artist must seek an action that overcomes vanity, must conceive a doing that escapes blind frenzy or spiritless animal-like mechanics. In context, however, the opposition also reflects Cellini's particular situation. Modeling, molding, casting, filing, and polishing pieces that could take months, if not years, to perfect, faced with patrons eager for completed products and rivals who could cover walls with paint in much less time, the sculptor could be well-served by a theory of *disegno* that justified slow action for the sake of beauty.

The case of Giambologna's *Sabines* demonstrates how such imagery allowed poets to read the artist into his hero's virtue; as "viril giovin furor" becomes a figure for the artist himself, the artistic act takes on virtuous form.[114] In light of Cellini's own pursuit of *Tugendähnlichkeit*, his *arte*, no less than his theory, might also be one after the look of *virtuosità*. The *Andromeda* relief presented Cellini with a conjunction of circumstances that gave this search focus: a story about the undertaking of action for the sake of beauty, a body of commentary that isolated intention and virtue as that story's allegorical aims, an intellectual

environment geared to viewing art-making within an ethical framework, and a tradition of sculptural practice prepared to treat images in metonymic terms. As he conceived a picture of virtue for his city, each of its terms gave his own action an example, until Perseus's virtuous work became Cellini's artistic design, the cause behind his own imitation. Can we also say, with Goethe, the converse? Do the sculptures we have seen, reflecting their maker's labors, also propose that virtue must be artful? As David aims, and Perseus follows his mind, and Talassius walks with Idea, all good action begins to look like the execution of design.

CONCLUSION

Cellini's Example

*I*n the essay attached to his translation of the *Vita*, Goethe proposed that Cellini be regarded as the "representative of his century."[1] Writing this, Goethe can hardly have meant to deny that Cellini was in many ways *unlike* his contemporaries – the very fact that he translated Cellini's long story betrays the degree to which he took Cellini to be exceptional. What the comment rather recommends is that, in evaluating the importance of Cellini's writings, we look not only to what they indicate about the character and temperament of the individual behind them, but also to the perspective they offer on those who worked around and after him, more shadowy figures who left no comparable documents. The present book has argued that Cellini's *oeuvre* – literary and artistic – allows some considerations about what, in Cellini's time, constituted the art of sculpture. In the spirit of Goethe's remark, it might be useful to conclude with a look at what this book's Cellini, accordingly, is representative *of*.

One way to pose this question is to ask about the historical consequence of Cellini's works, about their actual importance for his contemporaries and successors. Such a query might begin with a second look at the technical possibilities the *Perseus* defined, the model it provided for public works in bronze. Cellini's successful execution of the *Perseus* set a benchmark for an entire generation of metal statue-makers. Hardly had the metal cooled when one of Cellini's old antagonists, Leone Leoni, attempted to emulate Cellini's feat with his own monumental one-piece cast in Milan.[2] To the south, in Rome, Guglielmo della Porta would shortly thereafter invoke Cellini's *Perseus* as his single comparandum when accounting for the quality of his colossal portrait of Pope Paul III.[3] Before the end of the decade, artists as far away as Munich would make a variation on the *Perseus* (with Medusa's spirits now made into drinking water) as the centerpiece for a courtyard in Duke Wilhelm V's Residence (Fig. 61). This *Perseus*, designed by Friedrich Sustris, and modeled by Hubert Gerhard, proved that Italian metallurgic mastery was equalled on the other side of the Alps.[4]

61. Hubert Gerhard and Friedrich Sustris, *Perseus*. Munich, Residenz (photo: Foto Marburg/Art Resource).

In Florence and elsewhere, attempts to demonstrate such expertise became a matter of professional pride. Five years after the unveiling of Cellini's statue, Vincenzo Danti, another sculptor trained as a goldsmith, attempted, and failed, his own monumental cast, the *Hercules and Antaeus* designed for the Medici Villa at Castello. Cellini, observing the disaster, immediately wrote a series of satirical poems reminding their common audience, and patron, that no one could yet compete with him. Giambologna, who unlike Danti had arrived in Florence in time to watch the unveiling of the *Perseus*, meanwhile labored to add metallurgic skills to the repertoire of stone-working talents he had brought with him from Flanders and Rome.[5] After five years of practice on the small forge that had been set up in the house of his patron Bernardo Vecchietti,[6] and at just the moment when Bartolommeo Ammannati took over the repouring of Danti's statue, Giambologna tackled his own first large bronze figure, the

Bacchus that now stands at the end of Florence's Borgo San Jacopo. Scholars have rightly viewed the *Bacchus* as a work made in response to the *Perseus*;[7] what has not been sufficiently stressed is the degree to which that work shows Giambologna competing with his contemporaries to step into the professional niche the aging Cellini had left vacant. Before his own death, Giambologna's studio would produce dozens of large bronze sculptures; with his great pupil Adriaen de Vries, the marvelous challenge of the one-piece cast would survive well into the next century.[8]

The question of who cast such works implicated both the occupation of the sculptor, and the way those occupations were represented, for as Cellini's imagery and poetry demonstrate, metallurgic knowledge might not only be enacted, but also depicted. It is telling, for example, that one of Danti's few surviving poems (the others are epideictic verses in praise of Cellini) is a sonnet satirizing alchemy. When Danti is found writing "more wood and more coals did I burn in vain than that most ancient Sicilian smith fired in Aetna," it is impossible not to think of his own personal mishaps as a caster, including both the repeated disasters he encountered with the *Hercules and Anteus* and those that arose with the relief panels on which he worked in the same years.[9] Together, Danti's and Cellini's poetics of casting in turn provide the seeds for the astonishing references to the act of the pour that appear in the inventions of De Vries – a depiction of bellows, the mechanical breath of the casting operation; an allusion to alloys, the compounding of his statues; the repeated exposure of sprues, the pipes through which spirited metal flowed into, and air out of, bronze bodies.[10] More generally, we might think about the vogue for Mercury imagery that originated with the Cellini and Giambologna workshops (Figs. 22 and 62).[11] Among Mercury's charges was the realm of metallurgy; his flight, for alchemists and founders, symbolized the state of liquidity or "volatility" achieved when metals were brought to the forge.[12] In Giambologna's Medici *Mercury*, and in the *Mercury* by Sustris and Gerhard that still faces the *Perseus* in the Munich courtyard, this flight is nothing other than the end of the quasi-divine breath that generates it.

The accomplishments of Cellini with the most immediate and visible international impact seem to have been in the field of metalwork. It is also intriguing, however, to follow the momentum of the broader battle over sculptural manner fought between Bandinelli and Cellini in Florence. For young sculptors of the succeeding generation, hearing the Academy's discussions and looking to the works of Michelangelo for illustrations of what was being said, the interpretative questions that the manner of those works raised could not have been avoided. Those encountering Cellini in the 1560s would have known his attempts, in writing, to distinguish between Michelangelo's interest in bones and his adversary's favoring of muscles. They would have heard of his similarly polemical proposal for the Academy's obsequies of Michelangelo, centered on

62. Giambologna, *Medici Mercury*. Florence, Bargello (photo: Alinari/Art Resource).

a catafalque topped with a great *skeleton*.[13] These distinctions between the muscular and the skeletal amounted to a dissection of Michelangelo's style, an unfolding of that style into two alternative sculptural modes. It is tempting, in viewing the aftermath of this contest, to seek out the ways later Florentines dealt with the antithesis. Ammannati, in his *Neptune* fountain (Fig. 16), includes an unmistakably Bandinellian colossus as its centerpiece – an apt, if

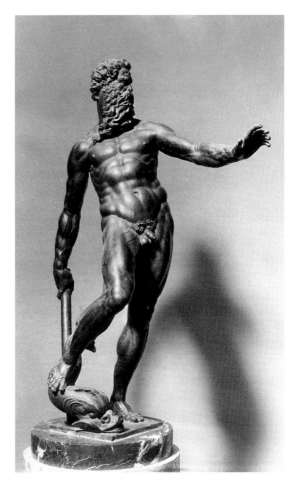

63. Giambologna, bronze cast after a study for *Neptune Fountain*. Bologna, Museo Civico (photo: Alinari/Art Resource).

unavoidable choice, given that the project arose with Bandinelli's own attempt to add a brother to his *Hercules* in the Piazza. Yet along the perimeter of his fountain, Ammannati also includes a series of bronze figures, so different in style from the centerpiece that some have doubted Ammannati's authorship of the ensemble. If we follow the convincing case laid out in the recent literature, and accept that Ammannati designed and oversaw all of the figures, the question remains of why Ammannati opted, within a single work, for so sharp a stylistic contrast.[14] Can the answer not simply be that the material, the physical types, and even the erotic postures of the sea creatures attempt to balance the great Bandinellian marble with a series of Cellinian bronzes? Along similar lines, it is tempting to view the work of a sculptor like Giambologna as a sort of middle path between the poles Cellini and Bandinelli came to represent. Formally, what is most remarkable about a figure like Giambologna's *Neptune* (Fig. 63) is its harmonization of strength and grace, its success at meeting the

colossus's requirement of mass while informing that mass with a light, supple pose. Could it be this reconciliation of Cellini's and Bandinelli's manners that, by the seventeenth century, allowed Giambologna to be described as "Corinthian," representing neither the *forte* Athenian style of Michelangelo, nor the delicate, Apollonian manner of Praxiteles?[15]

All of these questions have to do with Cellini's significance for the history of ideas, with the way his legacy affected later artists' thought. To return to Goethe's comment about representativeness, however, Cellini's importance needs to be considered from another, less causal and more diagnostic angle as well. As the introduction to this book suggested, the study of Cellini may prove most informative where the artist seems to work with a standard idea, to present a view on a topic of shared interest. If the fact that he wrote so much and so vividly makes him irresistible as a source, the question arises of just what Cellini might be a source *for*. Answering this may require the historian to bracket the chronological account, and to test Cellini's exemplarity. Cellini's role in the history of art, that is, may prove most significant when his work is treated as a perspective, rather than as an origin.

The point can be made with reference to the *Saltcellar*. Michael Baxandall's path-breaking book *Giotto and the Orators*, along with the studies it inspired, have made it easy to assume that when Early Modern artists thought about composition, they normally did so on the model of rhetoric. The possibility Cellini presents of a more scientific or alchemical notion of composition, one that begins with actual materials, and that centers on the processes to which the artist submits them, may also bear on a broader range of works. It might point, for example, to a particular brand of "monster," what Giambattista Della Porta, in discussing "natural magic," called a "commixtion," less the chimerae authorized by Horace and attacked by Vitruvius, and more the laboratory products that scientists bore in their studies.[16] Art, on this model, might emerge as a kind of cookery; salt becomes the common denominator to more than one kind of recipe book.[17]

Similarly illuminating is Cellini's vision of infusion. The idea that sculpture involved not only the shaping of a material, but also the charging of it with life seems to be a timeless one. It appears everywhere from the legend of the Golem to the story of Frankenstein; it is central to the Hermetic texts that were fundamental for Early Modern occult thinking,[18] and, according to Ernst Kris and Otto Kurz, it has analogues even in ancient Babylonian myths.[19] Cellini's desire to bestow his works with life could be compared with those of many contemporaries, from the modelers who, as Baldinucci claimed of Giambologna, "finished their works with their breath," to the fountain-designers whose figures exhaled water. In rendering his spirits as blood, however, Cellini's work also raises the broader issue of artistic *incarnation*, a sort of animation that sculptors were not alone in pursuing. When Marco Boschini writes of how Titian

would add to his paintings "some smears of red, like drops of blood, to invigo-rate the feeling of the surface,"[20] he suggests that there might be a Cinquecento origin for one manner of enlivening pictures, a manner still of interest a century later. When Caravaggio signs his *Beheading of St. John the Baptist* in the prophet's blood, when Rubens enfleshes, and bloodies, an ancient statue of Seneca in painting,[21] when Guido Reni distinguishes living from dead Innocents with red highlights,[22] these artists, like Cellini, use a medium of blood to emulate God's original acts.

As far as marble sculpture per se goes, it can be instructive to consider what kind of continuity might exist between Cellini and his successors. It is unlikely, for instance, that Bernini knew Cellini's *Apollo*, or his *Christ*, or even his published ideas about the generation of marbles. Yet Bernini's own early *Apollo and Daphne* is the closest thing Italy offers in the way of a sequel to Cellini's use of marble. Here, too, the sun god is an agent that both kills and perfects, turning his victim into a plant-like form, creating unmatched wonder with that plant's growing leaves. Here too there is a meditation on the intersection between the sculptor's poetics (Apollo and Bernini make of Daphne laurel for their own crowns) and the work of the hand (Daphne is transformed with a touch).[23] And here too there is the possibility that Apollo, as the figure of light, might just embody the sculptor's project *tout court*. One need look no further than Bernini's Roman chapels to see his Cellinian intuition that the candor of marble, its solar saturation, lends it especially well to the depiction of the visionary. In Bernini, as in Cellini, light has a transformative power, but its potential also inheres in the very materials that are shaped. The larger lesson of Cellini's work in and writing about stone is that the materials of sculpture themselves have a history. Their properties are not essences to be excavated, but qualities to be discovered or invented.

A similar principle holds for the sculptural act. Though it depends upon conventional and highly habitualized techniques, it also takes shape, in large measure, as a product of the imagination. Witness the theory of *disegno* repre-sented by Cellini's seals for the Florentine academy. Those theories, this book has argued, reflect a sculptural tradition that tied an understanding of design to a conception of virtue. The foregoing discussion focused above all on the work in Florence's Piazza della Signoria; it pointed out, for example, that the literature generated around Giambologna's *Sabine* show Cellini's associations still to be in place. What was not pursued is the usefulness of Cellini's state-ments for thinking about art outside of Florence, and beyond his century. In 1604, Federico Zuccaro was still prepared to draw the attention of the artists and patrons in his audience to what he termed *disegno morale,* a design that served, as he put it, as the *causa di ogni virtù*.[24] For statements like this, and like his more famous claim that *disegno* "is a concept formed in our mind that enables us to operate practically, in conformance with what is intended,"

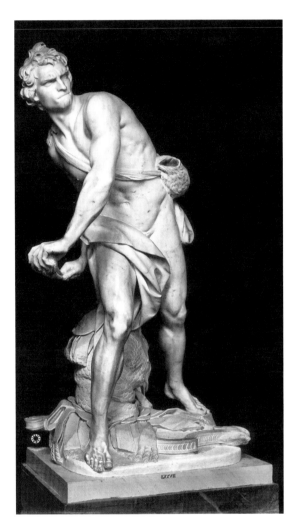

64. Bernini, *David*. Rome, Galleria Borghese (photo: Alinari/Art Resource).

Zuccaro, like Cellini before him, turned to the ideas in Aristotle's *Ethics*.[25] It is possible that Cellini and Varchi provided the impetus for Zuccaro's development of Aristotle's sketchy remarks into an explicit art theory. Even if this is the case, though, it may be more illuminating to look at the matter another way around: Whatever its sources, Zuccaro's seventeenth-century Roman publication shows that the kinds of connections Cellini draws continued to matter to later, and more distant, thinkers. Might they also bear on, for example, De Vries's variations on Giambologna's abductions, in which the woman, now equipped with a bow, seems to lecture her bearer?[26] And what of, once again, the young Gianlorenzo Bernini? Hans Kauffmann has related the sculptor's *David* (Fig. 64) to Picinellus's contemporary discussion of the Biblical hero's victory; that victory, Picinellus specified, was one achieved "not with size but

with virtue."[27] The view is consistent with one expressed in Jacopo Fabri's commentary to Aristotle's *Ethics*, a text that (like Ripa's later *Iconologia*) used David as an example of fortitude:

> David, the fearless unarmed boy, confronts the giant, swollen with hooked breast plate, and with numerous weapons. The nude [boy] takes the armed man by surprise, and beheads the man he has overcome. Look how much the *virtue of the noble mind*, cultivated by God, and unbroken courage ought to be helpful for the one who, always master of his virtues and very brave in all things, takes inspiration from on high."[28]

Such discussions illuminate the way in which Bernini's sculpture represents a partisan reading of the *David* Michelangelo had made, at virtually the same age, one century earlier. In contrast to the take on the *David* offered by Bandinelli's pendant to it – a pendant which, as we have seen, was faulted for its over-emphasis on physical force and for its failure to link attention and action – Bernini, like Cellini, makes *mind* the real origin of his figure's virtue.[29] If Michelangelo offered a monumental example of how the act of perception might be heroic, Bernini figured in the round what Cellini had pursued through allegory and relief sculpture: a demonstration of how the body of the hero might follow the purpose of a *conception*. Bernini's earliest biographers relate that the sculptor, in designing the countenance of the *David*, studied his own face in the mirror. We might consequently ask whether the sculpture involves a new twist on the Florentine practice of sculptural metonymy. In the case of both Cellini's *Perseus* and Giambologna's *Sabine*, contemporary poets read the artist into his hero's virtue; in the case of Michelangelo's *David*, the artist himself drew the comparison. A variation on these conceits may be involved in Domenico Bernini's account of his father's sculpture, in which the description of David's gesture – "he is in the act of unleashing the blow (*colpo*) against the giant Goliath" – echoes in the sculptor's self-referential insistence that "in his youth, he never missed a blow."[30] The control of the blow is a fair description of sculptural *disegno* – for what else should that be than having an idea of where to strike?

If Cellini's conception of *disegno* interprets a broader sculptural practice, no less might be said of Cellini's thinking on sculptural mastery. We have seen Cellini assert that "in all of the most noble arts, the most important thing, for the artist who wants to conquer and dominate them, consists in nothing other than taking spirit over them."[31] Cellini was writing here about the practice of drawing, but the idea that an artist might want to "conquer and dominate" an art has a wider relevance. These pages have argued, for example, that Cellini expressed his control of materials through an imagery of violence. The florid forms that result in his *Hyacinth* make this violence seem rather benign – as benign, perhaps, as Agricola's suggestion that salt is born when earth conquers

65. Leone Leoni, *Charles V and Furor.* Madrid, Prado.

water or water conquers earth. Other aspects of Cellini's approach to his media, however, are decidedly less kindly. The *Perseus* allows that the water exhumed from the forge's metal might double the blood extracted from a victim's body; this offers a different, but no less concrete, image of how subjugation, artistic or otherwise, might amount to "taking spirit." Cellini's approach to figuration, moreover, allows the dispensing of the alchemical allegory altogether. The sculptor describes his *Medusa* as a *femmina scontorta*,[32] a phrase that assimilates the figure to a more comprehensive range of victory imagery – Leone Leoni, for one, also describes the sweating figure of Furor beneath his Charles V (Fig. 65) as *contorta*.[33] Can works that bear such descriptions not exemplify Antonfrancesco Doni's definition of *disegno*, as "the act of putting one's power into operation"[34]?

When Cellini enumerates the different "manners of work," that goldsmithery comprises,[35] when he, like Vasari, divides *disegno* into constituent

parts, he may seem the perfect embodiment of the absolute artist, the universal man, the expert who comprehends – and thus controls – many arts.[36] To emphasize Cellini's *virtù*, or his mastery, however, is also to let him stand for something other than absolutism, namely, a vision of artistry that emphasizes the fact, and resonance, of process. However much Cellini may have pursued something that looks like control, it cannot be said that, in doing this, he hoped to transcend technique. As Cellini insists repeatedly, there could be no superintendency in detachment, no comprehension apart from the acts of sculpture. No doubt it was important to Cellini that sculpture seem not only a matter of doing, but also a matter of thinking about what is done – the *Saltcellar,* the *Perseus,* and the late seal designs all, in various ways, feature the artist's intelligence, or mind. Rather than concluding from this, however, that sculpture has become a liberal art – an art, that is, that is by definition not mechanical – Cellini's art and writing suggest that the kind of practical reason that the Aristotelian tradition had long associated with the mechanical arts is the kind of thinking that really matters. Like the Machiavellian archer, the thinking artist must operate empirically, extemporaneously.[37] Metallurgy, with its experience and experiment, casting, with its *ingegnose* responses to the difficulties of engineering, marble carving, with its resourceful handling of unmalleable blocks, design, with its counseled action – all of these domains require an expert who devises and reacts, recognizing circumstance and inventing solutions as the situation asks. Just as Cellini denies that operation is somehow at odds with contemplation, so does he question the worth of speculation to no effect. Cellini's frequent diatribes against what he calls *parole al vento* represent a two-fold challenge. For the sculptor, the words require that reflection yields works. For his latter day audience, they demand that an account of theory also be an account of art.

Cellini's own sculptures seem bound to the cunning voice of their maker's *Autobiography* because those sculptures are about performance, about the invention or discovery of an executive agency. Each of Cellini's genres, each of his fields, sets parameters for the artist's self-realization: The fields ground the work that imagination will outfit, and they anchor the metaphors and the myths that will give the work meaning. One implication of this is that Cellini's modernity has to do not only with his manner of stepping back from his work, of explaining to others what that work is like, but also with his manner of entering into it, of generating meaning in work itself. If texts like the *Trattati* demonstrate anything, it is that *techne* itself can be exalted.

Late in his life, in the margin of a sheet, Cellini wrote, insistently,

Avevo mostro almondo
Avevo mostro almondo.[38]

This insatiable desire to show, to show the world, to show his art, is in no small part what makes Cellini so terrible. Violent, vain, and misogynistic, his art, like his writing, makes him the foil of modern morality, and thus, perhaps, of modern art. For all of his meanness, however, Cellini is dismissed to our own detriment, for with his egregious self-display, he serves as a representative as no other can. In his arrogance and virtue, he gives the words and images for sculpting in his time.

APPENDIX

On the Authorship of the Bargello
Marble *Ganymede*

*D*espite the fact that Cellini documented his productions better than most artists of his time, controversies remain concerning his authorship of various works. At the height of his career, the decade beginning in 1545, Cellini maintained a large workshop that included a number of the best sculptural talents in Florence. Both the scope and the requirements of his projects during this period precluded him from executing them all personally, and the relevant documents confirm that he had assistants working on his sculptures at just about every stage of their making. Questions arise even with works that fall under the broad rubric of *disegni*, since the surviving drawings that can be attributed safely to Cellini differ so dramatically in manner.[1] Although recent commentators (including this writer) have accepted the small bronze *Perseus* now in the Bargello as an autograph Cellini work, there is no real evidence that speaks against the possibility that it is a later cast after a lost Cellini *bozzetto*, or even a reduction of the monumental *Perseus* executed completely outside of his shop. The modeling differs from the secure Cellini *bronzetti*, the base looks to be a later addition, and the gilded details suggest the maker's familiarity with the finished state of the colossal bronze work.[2] The bronze *Neptune* in the North Carolina Museum of Art, which Valentiner first connected to Cellini's proposed project for the Piazza della Signoria fountain, is no more secure.[3]

The authorship problem with the most significance for this book, however, involves the distinction of Cellini's hand from that of Willem de Tetrode, known in Italy by the name Guglielmo Fiammingo. Cellini scholars have almost entirely neglected Tetrode's activity in Cellini's shop; Tetrode scholars, meanwhile, have inadequately dealt with the information that the Cellini documents provide.[4] At the crux of the issue is the marble *Ganymede* now in the Bargello (Fig. 66): While one group counts this among Cellini's most intimate and personally symbolic creations, the other maintains that it is not by Cellini at all, and that it may in fact be Tetrode's only surviving marble statue. Inasmuch

66. Cellini and Willem de Tetrode, *Ganymede*. Florence, Bargello (photo: Kunsthistorisches Institut).

as the present study grants the *Ganymede* a severely qualified significance in its account of Cellini's development as a marble sculptor, the question requires attention.

The verifiable circumstances are these: On 19 October 1562, a Fleming exiting a tavern in Rome was assaulted with rocks by another Fleming. In his deposition, the former gave his name as *Magister Guillelmus q. Danielis*, and attributed the fight to enmities formed three years previously, while he had been working on a "studiolo" in Pitigliano.[5] Four months earlier, on 25 June 1562, one "Guglielmo scultore fiamingho" wrote from Rome to Grand Duke Cosimo I in Florence, seeking work. In the letter, he claimed that he had worked previously on a "scrittoio" in Petigliano [sic].[6] Finally, Vasari's 1568 *Life of Guglielmo della Porta* singles out, as a Della Porta *creato*, one "Guglielmo Tedesco," who had also distinguished himself in making a "studio" with sculptures copied after the antique and "piccoline di bronzo," which the Count of Pitigliano had subsequently given to Grand Duke Cosimo.[7] As the only Flemish bronze-maker with a father named Daniel known to have been active in Italy during these years is Willem Danielsz., it has been inferred that Tetrode is the Guglielmo who authored the Pitigliano studiolo.[8] This studiolo was subsequently disassembled, but a number of the figures Vasari mentions it containing seem to correspond to entries in sixteenth-century Medici inventories identifying objects held today in the Bargello. These figures have formed the core of the surviving Tetrode corpus.[9]

The difficulties arise with another comment Guglielmo makes in his 1562 letter to Cosimo. He writes

> Già circa anni 13 sono che io Guilelmo, fiamingo, stetti qui in Fiorenza, et racconciai per Vostra Illustrissima Eccellenza un ganimede di marmo anticho, che al presente, come intendo, si trova a Piti, il quale, per quanto mi fu riferto, non dispiacque a V. I. E.

> It was about 13 years ago that I, Guilelmo Fiamingo, resided there in Florence, and I mended for your Most Illustrious Excellency an antique marble Ganymede, which at present, I hear, is to be found in the Pitti Palace. The work, it has been reported to me, did not displease you.

This chronology places Guglielmo in Florence in 1549, and Cellini's account books establish that Guglielmo was, in 1549, a member of his studio. In the last months of that year, "Guglielmo Fiamingo scultore" began making the four masks and Capricorn heads on the base of the *Perseus*. While one record comments that Guglielmo was in Cellini's bottega precisely to work on the *Perseus*, another notes that he also worked on the (now lost) marble bust of Duchess Eleanora. It would seem that Guglielmo, while with Cellini in 1549, worked especially as a marble carver – an interesting enough revelation, given that the only works he is known to have made in the two decades following

were in bronze. The account books also establish March 1550 as the date when the marble *Ganymede* Cellini had volunteered to restore for Duke Cosimo was finally prepared for delivery.[10] In a 1570 letter, Cellini mentions that the same *Ganymede* was then in the Pitti Palace.[11]

So far, all of the indications are that Tetrode made the *Ganymede*. The matter, however, turns out to be more complicated. Cellini never mentions Guglielmo's name in connection with the *Ganymede*; by the 1560s, in fact, he was claiming credit for making it himself. Moreover, a document published by Carpani nearly two centuries ago specifies that in February 1546, "Benvenuto restaurò una figurina antica, per il Duca Cosimo, dell'altezza di braccia uno e mezzo, alla quale ha rifatto la testa, le braccia, e i piedi." (Benvenuto restored for Duke Cosimo a small antique figure 1 1/2 braccia in height, for which he re-made the head, the arms and the feet.)[12] Both the height of this figure, and the description of the restored parts, correspond to the Bargello marble. The indicated date is some two and a half years before Guglielmo joined Cellini's shop.

These facts, nevertheless, have to be viewed in conjunction with other considerations. For one thing, Cellini typically (and especially in his letters) claims a greater role in his studio productions than he likely had. This is not merely attributable to the writer's penchant for exaggeration; it also suited the purpose of the letters, which sought outstanding payments for works Cellini's studio had produced. Cellini himself had covered the cost of materials and hired the hands to help work them; it would have been conventional to designate the work, as he designates the *Perseus* itself, as his. As for the Carpani document, even if the date is reliable, it is telling that the notice makes no reference to the presence of the new sculpture's most elaborate elements: the eagle and the base. The generic reference to a "figura antica," rather than to a "Ganymede," in fact, may suggest that the key attributes had not yet been added. This could indicate that, in 1546, the work was, as yet, simply incomplete, which would not be surprising, given that it was only turned over to its patron four years later. Since the Bargello *Ganymede* requires the unmentioned restored parts in order to stand, and since those parts are physically continuous with the acknowledged elements of the restoration, the evidentiary value of the document is questionable. Perhaps the perfect tense of the verb *restaurò* should be doubted, and the document interpreted to indicate only that the piece was underway. In this case, there would be no unequivocal information about the state of the work's advancement when Tetrode (presumably) began attending to it. It should be noted that Cellini's *Autobiography* includes a scene in which Cellini promises the Duke that he will restore the work, but no scene in which he actually works on it.

It may be helpful as well to evaluate Cellini's own capabilities at the time of his alleged restoration of the piece. The only two secure Cellini marble works from the late 1540s are the *Apollo* and the *Narcissus*. While the damaged

condition of these sculptures limits the degree to which they can ground a discussion of Cellini's early marble style, they do both appear to lack the fine, hard-edged detail that characterizes all of the restored portions of the *Ganymede*. The wavy locks that typify all three of the marbles Cellini certainly carried out himself (the *Apollo, Narcissus,* and *Christ*) have little in common with *Ganymede*'s ringlets, which appear rather to have been made in imitation of the bronze hair on the *Perseus* itself. The faceted quality of the *Ganymede*'s base differs notably from the clawed chiseling visible in Cellini's approach to the similar problem of rustication presented by the *Narcissus.*

Evaluating the work against the evidence of Tetrode's own oeuvre involves particular difficulties. While Tetrode is known to have made marble sculptures in Delft several decades later, none of these works survive; his productions from his time with Cellini are in fact his only secure works in stone. The crisp ornamentation of the *Perseus* base might indicate that precision marble work was precisely Tetrode's specialty in these years, but between the capricorn heads and the *Ganymede*, there is little to compare. If, as has long been suspected, Tetrode entered the Cellini workshop in his early- to mid-twenties, there may well be earlier marble works by the artist yet to discover. In the absence of further visual evidence, however, we are limited to what the documents suggest. In view of these, it is tempting to take Tetrode at his word, and to place the execution (after Cellini's design) of the *Ganymede* among his very earliest works.

The entries in Cellini's account books pertaining to "Guglielmo Fiammingo" can be summarized as follows:

1. BRF 2788, fol. 3r records a total payment of ∇ 85.6.15.2 to "ghuglielmo fiammingo scultore" for having worked "insullopera delpreseo" between 20 August 1548 and 21 June 1550. BRF 2787, fol. 27r, lists the same amount paid to "ghugljelmo fiamjngho scultore . . . per avere lavorato insullopera delperseo."

 The same folio of BRF 2788 records a total payment of ∇ 35.5.19.8 to "ghuglielmo orefice fiamjngo" for "tante sua opere date inlavorare allopera delpreseo" between 10 October 1549 and 27 July 1550. The same folio in BRF 2787 confirms this in all the particulars as well.

 These memoranda refer to total payments over the given period, and the separate entries suggest that two different accounts are being tallied. The fact that the two names, in each book, are distinguished as "scultore" and "orefice," may suggest that the two Guglielmi are different persons. Since the information in BRF 2787 (which was compiled in 1560) simply repeats the information in BRF 2788, and since the figures here must record totals summed elsewhere, this is not, in itself, conclusive; but see no. 4, below.

2. BRF 2788, fol. 3v records that "ghuglielmo fiammingo scultore" was paid a further ∇ 5.5.0.0 on 28 September 1551 "che tornorno allavorare insullabasa delpreseo e per sue opere." This information is copied into BRF 2787, fol. 28r. Presumably, it records the payments made to the sculptor after the end of the first summary, i.e., payment beginning sometime after 21 June 1550.

3. BRF 2788, fol. 8r records provisions made to Cellini by Duke Cosimo for three *garzoni* at a rate of four scudi per garzone per month. A "ghuglielmo fiammingo" was among the three. The payments run from August 1548 through February 1549/50, with a two-month lapse in the winter of 1548–1549.

 BRF 2788, fol. 10r seems to confirm that this garzone was the "scultore," as it notes that "Ghugljelmo fiammjngo scultore" "vene astare alavorare conesso mecho" on 20 August 1548 for a salary of four scudi per month. In the margin, it is noted that Cellini settled with Guglielmo on what he had been owed through the first of July 1549. Following this is a list of payments running from July through September 1549. Then it is noted that Guglielmo is content with what he was paid through 2 October, on which date they came to a new agreement. Effective immediately, Guglielmo was no longer to be salaried, but to be paid by the *giornata* at a rate of $2^1/_2$ giuli. By 15 March of the following year (fol. 11r), Guglielmo had worked a total of $105^1/_2$ *giornate*, and had received ∇ 25.2.14.8 (this exceeds the provisions Cellini had received for the *garzone* from Cosimo).

4. BRF 2788, fol. 12r, records the following: "Gugljelmo orafo fiamjngo venne alavorare mecho per insino aldi 10 dottobre 1549 e facemmo merchato insieme della saljera che mela douessi bene finjre di cesellare quanto alben lavorare sapa viene e mj douessi rinettare iquatro puttjnj coilor dalfinj che vanno per ilpiede di essa ellemaschere ella venere ejo gljelavevo adare gettate dargento eper sua fattura di detta finjta opera gljo adare scudi ventj dj moneta dacordo—∇ 20.0—"

 And beneath this: "detta saljera non si finj e fu pagato per quello che fece epero si chancella." A list of payments follow, running from 20 October 1549 through 28 January 1549/50, totaling ∇ 14.3.3.4: Fol. 14r records a new agreement made on 1 February 1549/50: "Ghugljelmo orafo fiamjngo adj primo dj febrajo 1549 afatto mecho nuovo achordo in firenze detto dj afinjrmj la saljera lavora per lpregio dj dua carlinj elgiorno in sinoche sia finjta ladetta opera."

 Beneath this: "detta saljera non si finj e fu pagato per quello che fece epero si cancella."

 And following, payments to the *orafo* made between 1 February and 27 July, totaling £146.3.4.

Directly after this, Cellini records that, on 28 September 1551, "rjcomjncjo allavorare in sulla testa della duchessa et piu aldetto scudi dua doro abuonchonto enon abjamo fatto alchunpatto se non pagarlo sicondo fara." The new plan didn't work out for long: "et adj 29 dottobre £25 per suo resto diche aveva lavorato mecho indetto tempo eper nonlo potere tenere non avendo danarj dal ducha lolasciaj." For his work on the bust, Guglielmo received a total of 48 lire.

Meanwhile, fol. 13r records that "Ghuljelmo fiamjingo scultore a fatto patto mecho adj 31 ottobre 1549 di farmj 4 maschere e 4 teste di caprjcorno quale sono comincjate nella mja basa delpreseo le maschere sono sotto le zanne cioe sotto epiedj delle figure · le teste del capricorno sono in su canti sopra la idêa della natura esiamo dacordo inelle dette maschere eteste a dua scudi luna per laltra doro che sono scudi sedicj ildetto acordo epatto presente maestro antonio intagljatore dellopera che ora lavora in casa mja e dj tanto sa afar creditore—∇ 17.1.0.0."

That Guglielmo was to be paid for the Capricorns and masks by the head suggests that this payment was to be over and above what he was receiving for his *giornate*. Following this record, there appears a list of payments running through 9 May 1550, totaling ∇ 15.6.6.8.

Fol. 17v records payments to "ghugljelmo scultore" from 12 April through June 1550, totaling ∇ 17.2.18.0.

For a number of reasons, these are the most significant entries. They record something of the appearance of a new *Saltcellar* Cellini had underway in Florence (elsewhere, we learn that he was making this for the Cardinal of Ravenna)[13]: It would include a Venus (thus drawing attention, again, to the sea's generative powers), masks, and putti riding dolphins. The entries also name the multibreasted figures on the corners of the *Perseus* base as images of the "idea della natura," the same figure that would later appear in Cellini's Academy seal. Finally, the entries specify the date of Guglielmo *orafo*'s arrival in Cellini's shop, one that does not correspond to the recorded date of arrival of "Guglielmo scultore." On this basis, it would seem safe to conjecture that there were indeed two Guglielmi fiamminghi in Cellini's shop in 1549, a sculptor who was working on marble projects, and a goldsmith who was assigned to metalworks. Inasmuch as Tetrode's 1562 letter specifies that it was a *marble* Ganymede that he mended, it seems reasonable to identify him as the "scultore" rather than the "orafo," even if this is surprising given what we know of Tetrode's later activity. Such a hypothesis would also account for the fact that "Guglielmo scultore" seems to have been receiving money for unspecified work in addition to the contracted rate for the masks and Capricorn heads.

Notes

The completion of the final manuscript for this book, in the fall of 2000, coincided both with the completed restoration of Cellini's *Perseus* and with the artist's 500th birthday, events that occasioned a boom in Cellini scholarship and series of conferences on his work. Over the course of the year, at conferences in Ferrara, Florence, Frankfurt, London, and New York, scholars from various fields delivered almost fifty papers on or relating to Cellini. As I write this, plans are underway for the publication of at least two independent volumes of essays from these conferences. Because the conference participants, at the time they delivered their papers, were able to consult neither the present manuscript, nor, in some cases, the dissertation from which it developed, and as these authors' papers were, likewise, unavailable to me in advance, I have incorporated few responses to their findings in the present book. I would like to advise the reader, nevertheless, that a number of these papers raise points that bear on the arguments pursued here, and to recommend, in this regard, that the reader consult the forthcoming studies by Denise Allen, by Marco Collareta, and by Beth Holman on Cellini's goldsmithery; by Horst Bredekamp on Cellini's violence; by Peter Meller on the *Centaur*, attributed to Cellini, in the collection of Michael Hall; by Charles Avery on Cellini's candleholders for Francis I; by John Shearman and by Ulrike Müller-Hofstede on the sculptures in the Piazza della Signoria; by Alessandro Nova and by Gerhard Wolf on Cellini's *Narcissus*; by Patricia Reilly on Cellini's *Discorsi*; by Paolo Rossi on Cellini's *Trattati*; by Kathleen Weil-Garris Brandt and by Victoria von Flemming on Cellini's designs for the seals of the Accademia del Disegno; by Matthias Winner on Cellini's *Crucifix*; and by Klaus Herding and by Tom Willette on the reception of Cellini in the eighteenth and nineteenth centuries. (My own essays in these volumes will treat Cellini's studio, and his coat of arms). In cases where the information or ideas in as yet unpublished papers required me to change or qualify an existing argument, I have made every effort to indicate my debt in a footnote.

Regarding the notes themselves, I have, wherever possible, cited primary sources in editions to which the relevant readers could presumably have had access. Unless otherwise indicated, all translations are mine. Praise for any renderings that the reader finds particularly elegant should go to Larry Kim and Eric Dugdale, who improved my Latin translations, and to Mary Pardo and Dino Cervigni, who improved the Italian ones. Blame for all infelicities, and for all translation errors, should come only to me.

Introduction

1. See Farago, 256–7: "Tra la pittura e la scultura non trovo altra diferentia se non che lo scultore conduce le sue opere con maggior faticha di corpo ch'el pittore, ed il pittore conduce l'opere sue con maggior faticha di mente. Provassi così esser vero, con ciò sia che

lo scultore nel fare la sua opera fa per forza di braccia et di percussione a consumare il marmo od altra pietra superchia che eccede la figura, che dentro a quella si rinchiude, con essercitio meccanichissimo accompagnato spesse volte da gran sudore composto di polvere e convertito in fango..." (The only difference I find between painting and sculpture is that the sculptor conducts his work with greater bodily fatigue and the painter conducts his work with greater mental fatigue. You can prove that this is true because when the sculptor makes his work he consumes the marble and other stone covering in excess of the figure enclosed within by effort of his arm and by percussion, which is a highly mechanical exercise, often accompanied by great amounts of sweat composed of dust and converted into mud.) The argument is close to a theme in Lucian, *Somnium* 6–14; I am grateful to Kathleen Weil-Garris Brandt for this reference.

2. The description of Rubens at the easel comes from Otto Sperling, who describes the artist simultaneously painting, dictating a letter, answering questions from his guests, and listening to the Tacitus recital; see Hymans, also Rooses, II, 156. For Leonardo's comments, see Farago, 257.

3. Barocchi 1973, I, 560:

 N.... dimmi, come ti fecero gl'antichi figurare la Scultura e la Pittura?

 A. Finsero alcuni la Pittura una femina vestita molto ornatamente, con varie acconciature, tutta allegra et adornata per tutto di diversi e varii fiori, tutta ridente.

 N. E la Scultura?

 A. Pure una femina, ma differente assai, tanto nella forma quanto nell'abito, considerato il variare che fa l'uno essercizio dall'altro; perché in verità il lavorare in pittura e molto piacevolissimo modo, e l'operare in scultura è aspro, duro, faticoso e colmo d'ogni austerità.

 (N: Tell me, how did the ancients have you figure Sculpture and Painting?

 A: Some of them depicted Painting as a woman, very ornately dressed, with variously arranged hair, the whole thing cheerful, and decorated with different kinds of flowers, all of it delightful.

 N: And Sculpture?

 A: Her, too, as a woman, but rather different, as much in form as in dress, considering the difference of the one exercise and the other; for in truth, working in painting is a most pleasant thing, and operating in sculpture is bitter, hard, exhausting, and complete with every kind of severity.)

4. See Zuccaro's *Origine e progresso dell'academia del disegno* in Zuccaro, 40.

5. The explanation of the turban was first proposed by Steinmann 1913, 17. For Leonardo's mockery of the sculptor, who "with his face caked and all floured with marble dust...looks like a baker," see Farago, 257.

6. See Scholten, 187–9.

7. Ferrero, 594.

8. A recent and useful short biography of Cellini is that of Capretti. The most reliable surveys of his work are those of Pope-Hennessy, Camesasca, and Avery-Barbaglia.

9. Guasti (17) reports that Benvenuto's father, Giovanni Cellini, built the scaffolding Leonardo used while painting his *Battle of Anghiari*; a document published by Gaye (II, 455–62) records that Giovanni was also on the 1504 commission that deliberated the placement of Michelangelo's *David*. Cellini must have been introduced to both artists as a young child.

10. See the summary of the documents and bibliography in Cust, 182–3, n. 2.

11. A surviving medal sometimes identified with this design is a matter of debate. The most recent discussion of the problem (with further bibliography) is that of Rudolf-Alexander Schülte in his entry in Brink-Hornbostel, 198; see also Pope-Hennessy 1985 and Avery 1986, who accept the medal illustrated in Brink as Cellini's, and Radcliffe 1988, who does not.

12. Cellini's report that the Cardinal intervened with the Pope on his behalf is corroborated by other documentation; see the summary in Cust, II, 79, n. 1.

13. For the circumstances of this, see Cole 1998.

14. See the discussion in Chapter 1 below.

15. See the discussion in Cole 2001b, with further references.

16. Cellini defends his absence in a letter; see Tassi, 357–8. For an informed discussion of the circumstances, see esp. Kennedy.

17. On Cellini's last venture as a goldsmith, see esp. Trento, 83–8.

18. Cellini mentions reading Giovanni Villani twice in his autobiography; see Ferrero, 60, 340. The inventory made at his death includes just one book, a "Dante in penna"; see Tassi, 256, no. 93.

19. A helpful introduction to Cellini's poetry is Gallucci 2000. For Cellini's exchange with Battiferri, see Milanesi 1857, 355–6. For Cellini's poem to Molza, see Ferrero, 909. For the literary culture around Cellini, see also Parker.

20. See esp. the exchanges with Antonfrancesco Grazzini, discussed in Cole 2001b.

21. For Lasca's praise of Cellini, see Verzone, 50. Cellini reports Varchi's satisfaction with his "simplice discorso"; see Guasti, 1–2. For Cellini as a *Dantista*, see Guglielminetti, 309–54, as well as the *postille* in BRF 1009, fol. 3r: "Benvenuto Cellinj quando era in Parigi si abbattè a un Giudice che auendo innanzi le parti che faceuano gran fracasso, per chetarle disse a una di q[ue]lli intro alterato, queste parole, Paì, paì, sathan, alè, paì, cio è cheto, cheto col Diauolo, ua uia, cheto. E ricordatosi di questo luogo di Dante, tenne per certo che Pluto per poter meglio attender à sì nuoua cosa che uno uiuente col uero corpo fusse in inferno; uolesse racchetare il romore che per l'ordinario i Diauoli fanno, e dicesse loro quelle parole in lingua Franzese. E cosi correggeua Benuenuto uomo acutissimo questo testo. Domandandogli io, Perche parlasse Pluto a' suoj Diauoli piu in Franzese che in altro linguaggio, Rispose chj Diauol lo sa? forse fu capriccio di Dante, per usar questa uarietà, come in moltj luoghi usa parole Latine, Prouenzalj, Ebbree, e altre. E nota, che a' Franzesi *αι* facit é. E pronunziano pe pe Sathan, pe pe Sathan ale pè che è il uerso di Dante." The fullest and most helpful discussion of this document is Gallucci 2000, which does not, however, acknowledge its earlier presentation in the present author's doctoral dissertation.

22. For this, and for further suggestions of the literature Cellini knew, see Rossi 1998.

23. The Alberti allusion was first recognized by Nordhoff; see her discussion, 205–14. For Cellini on Serlio and Leonardo, see Ferrero, 818–20.

24. See Cellini's admiring comments on his father's compositions, Ferrero, 68. Latin poems on the *Perseus* are published by Tassi, 482–93.

25. The most recent and convenient edition of Cellini's collected writings is Ferrero's, and I shall refer mostly to that when quoting Cellini. It should be noted, however, that much basic philological and editorial work on Cellini remains to be done. Most of the *ricordi*, many of the letters, and a few fragments of poetry remain unpublished. Of the works that have been published, only the *Vita* and the *Trattati* have appeared in adequate critical editions. For the original orthography and errata of the *Vita*, consult the Bacci edition. The volumes published by Carpani, Tassi, and Guasti contain the most important collections of supplementary documentary material. The best scholarly English version is, in my opinion, that of Cust, which will soon appear in a new edition by Paolo Rossi. Regarding the *Trattati*, it should be noted that every edition for the last century and a half, including Ashbee's English translation, is based on a manuscript preserved in the Biblioteca Marciana in Venice. This manuscript is not in Cellini's hand; it appears to be a presentation copy of an original that no longer exists. To what degree Cellini himself was responsible for the significant differences that exist between this manuscript and the version of the *Trattati*, edited by Gherardo Spini, that Cellini saw published in 1568, is a matter for speculation. For the problem, see the discussion in Milanesi 1857.

26. Goethe, 497: "Bestimmter jedoch zeigt er sich als Repräsentanten der Künstlerklasse, durch die Allgemeinheit seines Talents."

27. Burckhardt, 203.

28. Ferrero, 813–4.

29. Ibid., 594.

30. Ibid., 131.

31. Ibid., 112.

32. Ibid., 317–8.

33. Ibid., 122–6.

34. Ibid., 172–3.

35. Ferrero, 114–5.

36. Pope-Hennessy, 13. On Pope-Hennessy's premise, see the remarks in Penny 1986, 14.

37. For evidence of Cellini's manipulations of fact, see esp. Rossi 1994 and 1998. For the *Vita* as literature, see esp. Biagi; Goldberg; Cervigni; Arnaldi; and Mirollo, 72–98.

38. Ferrero, 593–4: "veduto come mai nessuno si sia messo a scrivere i bellissimi segreti e mirabili modi che sono innella grand'arte dell'oreficeria, i quali non stava bene a scriverli né a filosofi né ad altre sorte di uomini, se non a quegli che sono della stessa proffessione, e perché una tal cosa non abbia mai mosso nessun altro uomo, forse la causa è stata che quegli non essere stati tanto animosi al ben dire, sì come e' sono stati al ben fare pronti. Avendo io considerato un tale errore di tali uomini, e io, per non stare in cotal peccato, mi sono messo arditamente a una cotale bella impresa . . . " (Seeing that no one has ever set himself to writing down the most beautiful secrets and marvelous modes that the great art of goldsmithery comprises, being that neither philosophers nor other sorts of men are suited to writing these things unless they be persons of the profession; and because such a thing has never moved any other man, perhaps because they were not as spirited to speak as they were ready to act, I, having considered such an error on the part of such men, and in order not to remain myself in such a sin, ardently set myself to this fine undertaking.)

39. See Ferrero, 373, and Chapter 1 below.

40. Ferrero, 948: "Feci Perseo, o Dio, com'ogni uom vede, / e piacque a chi io lo feci e a tutto 'l mondo: / e' libri a tal virtù han questo pondo. . . . Gli occhi e la grazia e 'l dilicato volto / di quel libro a me tanto amato e caro, / legge oscura a chi mal iudizio adopra." (I made Perseus, O God, as every man sees, and it pleased him for whom I made it, and all the world: works [*lit.*, 'books'] of such virtue have this weight. . . . The eyes and the grace and the delicate face of this work [*lit.*, 'book'], so beloved and dear to me, are an obscure law to those who use bad judgment.)

41. The relevance of the tools to Cellini's sense of sculpture as discourse was impressed on me by Robert Williams. The significance of the instruments Cellini includes in his alphabet has never been satisfactorily analyzed.

42. Notable exceptions include Larsson, Preimesberger 1985, Preimesberger 1986, and Bolland and Nagel.

43. For Cellini and the *paragone*, see Jacobs 1988 and Cole 2001b. Work on the *paragone* issues raised by the sculpture of the Piazza della Signoria in Florence is also underway by Ulrike Müller-Hofstede.

44. See Baxandall 1990, as well as the more cautionary comments in Kaufmann 1995, chapter 3. Standard references on the subject include Wittkower 1977 and Penny 1993.

45. One work of particular distinction is Butters; see also the excellent overview of the recent literature by Baker.

46. Calamandrei, 4: "Se non ci fosse la *Vita*, forse stenteremmo a riconoscerlo dagli altri manieristi del suo tempo . . . "

47. I am thinking here of the recent discussion by Daniel Arasse, who defends Robert Klein's proposal that Mannerism is nothing less than the "art of art"; see Arasse-Tönnesmann, esp. 12–15; and Klein. John Shearman, in a similar vein, has written that Mannerism amounts to "a shift in emphasis among the constituents of the function of a work of art: less devotional, practical, ceremonial, and more self-sufficient, or absolute; it is a tendency – widely but not universally approved – to reduce or elevate, according to the point of view, the function to that of simply being a work of art. The more Art the better." See Shearman 1967, 46.

48. Camille, esp. 341. For a related discussion, see Belting 1994, and the critique of Belting by Freedberg. Craig Hugh Smyth, in addition, has summarized what he describes as the nineteenth-century view of Mannerism as "art for art's sake instead of a higher purpose; hence, emptiness coupled with mere decorativeness"; see Smyth, 24.

49. At least as early as 1563, Michelangelo's paintings were being attacked for their preoccupation with "arte"; see Gilio, 94r: "Disse M. Silvio, hor dunque per capacita nostra cominciate a mostrarci di mano in mano i luoghi, ne quali egli [Michelangelo] piu de l'arte, che del vero s'è compiaciuto." Suggestive here, as well, is Charles Dempsey's argument that the Carracci reform of painting was responding to Tasso's call for an "art that hides art" (*l'arte che tutto fa, nullo si scopre*). See Dempsey 1986, esp. 244.

50. On the pursuit of fame, see Rubin, esp. 289–96.

51. On style as a commodity, see Baxandall 1972, 17–23; and Baxandall 1980, 95–122.

Chapter One: Salt, Composition, and the Goldsmith's Intelligence

1. Aphrodisias, 4: "Artificesque sapeintiores expertis esse censemus."

2. Palissy, I, 198: "Si je connoissois toutes les vertus des sels, je penserois faire des choses merveilleuses."

3. Vasari-Milanesi, II, 223.

4. Ibid., II, 264.

5. Ibid., II, 330.

6. Ibid., III, 254-5.

7. Ibid., III, 290-1: "Si accostò a quello per imparare i modi del maneggiare ed adoperare i colori; parendogli un'arte tanto differente dall'orefice, che, se egli non avesse così prestamente resoluto d'abbandonare quella prima in tutto, e' sarebbe forse stata ora che e' non avrebbe voluto esservisi voltato. Per la qual cosa, spronato dalla vergogna più che dall'utile, appresa in non molti mesi la pratica del colorire."

8. Vasari-Milanesi VI, 183: "Parevagli [Bandinelli] ancora strana cosa, che egli [Cellini] fusse così in un tratto di orefice riuscito scultore."

9. Calamandrei, 167: "Tutte le cose che sono ristrette in mezzo a questi cieli sono composte di quattro cose, né di piú né di manco, di modo che ogni cosa che fa l'huomo si viene a essere composta di queste quattro cose. Io truovo l'arte della schultura la prima, perché il nostro idDio fiece il primo huomo di schultura di terra colle sue propie divine et immortali mani. Di poi da questa naqque la maravigliosa et lasciva pittura. Appresso si trasse da queste la utilissima architettura. [D]appoi considerando l'huomo et conoscendosi lo essere signiore di tutte le cose terrene, [h]avendo ritrovati i metalli et infra questi i piú nobili, l'oro et l'argento, ancora di questi [egli] volle schulpirne statue et altre diverse forme di cose." (All of the things that are enclosed within these heavens are composed of four things, neither more nor fewer, such that everything that man makes turns out to be composed of these four things. I find the art of sculpture to be the first of these, since our God made the first man out of sculpture in earth with his own divine and immortal hands. Then, from this, was born marvelous and proud painting. Next, from these things, emerged most useful architecture. Finally, man considering things, and knowing himself

to be the lord of all terrestrial things, having discovered metals there, including the most noble ones, gold and silver, from these things too he wanted to sculpt statues and other diverse kinds of things.)

10. Ferrero, 96.

11. Meller, 16.

12. See esp. the use made of Cellini in Summers 1981 and in Kemp 1974.

13. This image of Cellini was the predominant one through the nineteenth century, when numerous works of goldsmithery were incorrectly attributed to him, and when his works in marble had not yet been recognized. Henri Focillon's *Benvenuto Cellini*, originally published in 1911, might be taken as the culmination of this literature. Pope-Hennessy rightly characterized Friedrich Kriegbaum's "Marmi di Benvenuto Cellini ritrovati," as "the first serious study of Cellini as a sculptor"; see Kriegbaum, as well as Pope-Hennessy, 309, n. 36.

14. Ferrero, 373: "Vedete, signori, di quanta importanza sono i figliuoli de' re e degl'imperatori, e quel maraviglioso splendore e divinità che in loro apparisce; niente di manco, se voi dimandate un povero umile pastorello, a chi gli ha più amore e più affezione, o a quei detti figliuoli o ai sua, per cosa certa dirà d'avere più amore ai sua figliuoli; però ancora io ho grande amore ai miei figliuoli che di questa mia professione partorisco: sicchè il primo che io vi mostrerrò, monsignore reverendissimo mio patrone, sarà mia opera e mia invenzione; perchè molte cose son belle da dire, che faccendole poi non s'accompagnano bene in opera."

15. Hope supports his suggestion that Cellini was interested only incidentally in the subject of the *Saltcellar* by remarking that Cellini "did not even bother to record that the man was Neptune and the woman Tellus." In the *Trattati*, however, Cellini does specify that the male character was "figurata per Nettuno"; see Ferrero, 688, and n. 102 below. In all of his descriptions of the work, moreover, Cellini is very specific that his figures represent *Mare* and *Terra*. The genders and functions of the figures in the object would suit these designations, and there is no reason to doubt Cellini's awareness of this. See n. 27 below, and, on the passage from the *Vita* discussed here, esp. Link-Heer.

16. In an article that appeared just as the manuscript for this book was going to press, Carsten-Peter Warncke suggested, in the spirit of Schlosser, that the *Saltcellar* represents the period's fascination with *concettismo*, but also that Cellini "kein Gelehrter war," having made the *Saltcellar* following "Allgemeinplätzen der Programmkunst." Warncke's general argument, though developed independently of the recent literature, seems largely compatible with the one pursued here, especially in its intriguing assertion that "Cellini's Entwurf und Modell verwirklichte sich nicht allein eine künstlerische, sondern erklärtermaßen eine spezifisch goldschmiedekünstlerische Absicht."

17. Ferrero, 373.

18. C.R. Ashbee's translation of Cellini's *Trattati*, for example, regularly refers to Cellini's *Saltcellar* as a "salt."

19. Prater; esp. 35.

20. Poeschke 1992, 209.

21. Aristotle, *Meteorology* 2.3. For an informative overview of ancient ideas about salt, see Blümner.

22. Cellini's contemporaries also continued to think about the geological and meteorological processes behind salt. Vannoccio Biringuccio's *Pirotechnia*, for example, includes a thoughtful overview of the Aristotelian tradition and its shortcomings:

> Io anchor vela diro per cosa ferma, essendo stato detto dal diuinissimo Aristotele & da altri valentissimi homini l'oppenion de quali come credo che sapiate e che li razzi solari, sieno che disecchino & abruciano certe parti dela terra & le eleuino in alto, quali poi cadendo in mare generano la sua salsedine, A lequali parole per esser dette da chi sonno non mi contra appongo, ma e ben vero che per le medesime ragioni non comprendo, perche tanti

laghi & acque ferme che sonno infra terra non diuentan come le marine salse, che per esser mancho quantita & non mancho sotto poste al poter de razzi solari, o quelle de Loceano, o quelle che son nel mar caspio, & tanti altri mari douerrebbeno anchor loro esser salse. Dipoi ancho non comprendo ben per che si troui in vn luogho dil mare esser piu salso che in vn altro. Per il che non pensando che tal cosa facilmente proceda da certa propria la natura di terra, cosi salsa, & che per esserne in molti luochi sotto laque marine lo dia tal salmacita, & questo mel fan dire molte ragioni, & massime quando mi metto auanti a gliochi dela mente tanti monti con tanti varii terreni, con tanti colori & sapori che son dale acque del mare vetati & recoperti, infra li quali non dubito che cosi come ancho ne sonno infra terra con miniere di sale parissimo che in mar anchor esser non ne possino. & di questo mene fa anchor tesimonio l'hauere inteso che in Cipri si caua peschando il sale nel fondo del mare fatto . . .

(I will, furthermore, recount to you, as a certain thing – it having been stated by the most divine Aristotle and by many other great men, the opinion of whom I believe you know – that solar rays are what dessicate and burn certain parts of the earth and lift them into the air, which subsequently, falling in the sea, generate its saltiness. I sustain these words, inasmuch as they were expressed by persons who do not contradict me. It is true, nevertheless, that I do not understand why, following the same reasoning, the many lakes and permanent bodies of water that are in the earth do not become salty like marine waters, since they are smaller and no less subject to the power of solar rays than are the waters of Ocean or of the Caspian Sea. Many other seas, moreover, ought also to be salty. I also do not understand very well why one finds more salt in one part of the sea than in another. For this reason, I do not think that the phenomenon proceeds simply from a certain nature proper to earth, namely, saltiness, for there are also many places under water that give it its salinity. This prompts me to cite many arguments, above all, when I imagine all of the many mountains and all of the various terrains, with so many colors and flavors, that are veiled and covered by sea waters, I don't doubt that there are some among them, just as there are some among the lands, with salt mines, since, just as there are salt mines in the earth, there couldn't be the same in the sea. To this, I have a witness from whom I've heard that in Cypress one extracts, by fishing, salt already made at the bottom of the sea . . .)

Biringuccio questions Aristotle's theory on empirical grounds, then offers an alternative that eliminates the need for Aristotle's meteorological loop. What is striking in Biringuccio's discussion, however, is how, even as he reconfigures the process, he maintains similar roles for Aristotle's two main players. For Biringuccio, as for Aristotle, the origins of salt are in the Earth's body: *proceda da certa propria natura di terra, cosi salsa*. And despite these origins, for Biringuccio, as for Aristotle, it is above all water that makes salt available. In place of Aristotle's rain, the liquid medium that brought salt into the sea, Biringuccio now looks at the sea itself, and at the sea's contact with the earth *beneath* it.

23. Albertus, 241.

24. Agricola, 16: "Quando un corpo terreno con uno humido si mescola; ò al contrario, quando uno humido con un terreno; tal che hora questo, hora quello, vinca l'un l'altro: Da quella prima maniera di commistione nascono i sapori de le acque . . . la materia dunque del sapore si è la terra e l'acqua."

25. Landino, 777: "Fannolo in Candia sanza acqua dolce mettendo solamente l'acqua salsa nelle saliere, & intorno all'Egitto si fa dell'acque marine che per se medesime corrono in terra, La qual credo che sia in humidita del Nilo."

26. Lucretius, too, refers to the process: "Et quo mista putes magis aspera laeuibus esse / Principijs, unde est Neptuni corpus acerbum: / Est ratio secernundi, seorsumque uidendi. / Humor dulcis ubi per terras crebrius idem / Percolatvr, ut in foueam fluat, ac mansuescat." (And to show you more clearly that there are rough elements mixed with smooth which produce Neptune's bitter body, there is a way to separate them, and to see

how the sweet water, when the same is filtered through earth several times, runs separately into a pit and loses its saltiness); see Lucretius, 70 (2.470–74), and for the English, Lucretius-Rouse.

27. Ferrero, 374: "Io feci una forma ovata di grandezza di più d'un mezzo braccio assai bene, quasi dua terzi, e sopra detta forma, sicondo che mostra il Mare abbracciarsi con la Terra, feci dua figure grande più d'un palmo assai bene, le quale stavano a sedere entrando colle gambe l'una nell'altra, sì come si vede certi rami di mare lunghi che entran nella terra . . ."

28. Ovid, 12 (1.278–84): "Nunc, ait, utendum: vires effundite vestras. / Sic opus est, aperite domos, ac mole remota / Fluminibus vestris totas immittite habenas. / Iusserat, hi redeunt, ac fontibus ora relaxant, / Et defrenato voluuntur in aequora cursu. / Ipse tridente suo terram percussit, at illa / Intremuit, motuque vias patefecit aquarum." My English follows Agostini's translation of the passage (6v): "Conuocati i fiumi nella sua casa Nettuno cosi gli comincio a parlare, o fiumi hoggi mai cominciate ad vsare le vostre forze, perche cosi bisogna & attendiate ad aprire le vostre case & allentate le redine a vostri corsi, poi che cosi fu comandato i detti fiumi con sfrenato corso entrarono nel mare, & allora Nettuno percosse la terra con la verga, laquale cosi percossa tremo, per loqual tremore fece la via alle acque & largo le vene."

29. *Met.* 1.302–5: ". . . silvasque tenent delphines et altis / incursant ramis agitataque robora pulsant." The present interpretation would be roughly the antithesis to Warncke's suggestion that Neptune's gesture depends on the famous *Quos ego* scene in Virgil's *Aeneid*, in which the sea god calms the waters and allays the flood tides. Warncke takes the presence of the four seahorses and three dolphins in the *Saltcellar* as a reference to the *quadrivium* and to *trivium*, to the seven liberal arts and to the seven virtues.

30. In his overview of the representation of Oceanus from antiquity to the eighteenth century, John Pinto notes that the Greeks understood "Ocean" to be a stream surrounding the earth. He points to sculptural examples of Oceanus that, following the idea of Oceanus as a stream, portray him as a reclining river god. If Cellini's "Mare" could be identified with "Ocean," this tradition would have significance for the pose Cellini gives his figure. See Pinto, esp. 225–7.

31. On statues of river gods more generally, see esp. ffolliott, 92.

32. Cellini writes that his Earth produced "tutti quei più belli animali" that surround her; see Ferrero, 444. Even beyond Aristotle's association of salt with bodily excretions, the production of salt can be connected with lactation: see, e.g., Virgil, *Georgics* 3.394; Pliny, *Nat. Hist.* 31.88.

33. Palissy, I, 206: "Par ce que les grans navires ne peuvent aprocher du bord, à cause de leur grandeur: parquoy ceux qui vendent du sel ameinent des petites barques qui entrent au dedans du platin le plus pres qu'ils peuvent du sel qui ils auront vendu, ils posent l'ancre, & ainsi l'on apporte ledit sel premierement en la barque, puis l'on meine la dite barque pour descharger dens le navire."

34. Ferrero, 444: "Aveva da poi posata questa ditta opera e investita in una basa d'ebano nero: era di una certa accomodata grossezza, e aveva un poco di goletta, nella quale io aveva compartito quattro figure d'oro, fatte di più che mezzo rilievo: questi si erano figurato la Notte, il Giorno, il Graprusco e l'Aurora. Ancora v'era quattro altre figure della medesima grandezza, fatte per i quattro venti principali, con tanta puletezza lavorate e parte ismaltate, quanto immaginar si possa."

35. Cicero, 101 H-I: "Sed illa quanta benignitas naturae, quod tam multa ad vescendum, tam varia, & tam iucunda gignit: neque ea vno tempore anni, vt semper & nouitate delectemur & copia. Quam tempestiuos autem dedit, quam salutares non modo hominum, sed etiam pecudum generi: iis denique omnibus quae oriuntur è terra, ventos Etesias, quorum flatu nimii temperantur calores, ab iisdem etiam maritimi cursus celeres & certi

deriguntur. Multa praetereunda sunt, & tamen multa dicuntur. Enumerari enim non pos-
sunt fluminum opportunitates, aestus maritimi multum accedentes & recedentes: montes
vestiti atque siluestres: salinae ab ora maritima remotissimae: medicamentorum salutarium
plenissimae terrae: artes denique innumerabiles ad victum & ad vitam necesariae. Iam diei
noctisque vicissitudo conseruat animantes, tribuens aliud agendi tempus, aliud quiescendi.
Sic vndique omni ratione concluditur, mente consilioque diuino omnia in hoc mundo,
ad salutem omnium conservationemque admirabiliter administrari." Throughout this chap-
ter, I cite the 1511 Paris edition of Cicero's Latin text. This is, however, very close to the
modern versions of the text, and I have been steered by Rackham's translation for my
quotations in English.

36. No vernacular version of *De Natura Deorum* was available at the time Cellini made the
Saltcellar. The Latin work, however, had gone through multiple editions in the preceding
decades, including the French one used here. Charles Schmidt has indicated that the work
was much in vogue at the time Cellini made the *Saltcellar*. While one can only speculate
about who, at Francis's court, might have introduced Cellini to the text, the mytholog-
ical density of the Fontainebleau visual vernacular encourages the assumption that artists
conversed regularly with experts on such matters. See Schmidt, esp. 96–7 and n. 1.

37. For the comparison between Cellini's portal and "tempietto," see Prater, 44–51.
Prater points out that the edifice resembles a triumphal arch. It might well be asked,
however, whether arch forms always signified triumph in the sixteenth century. Cellini
refers to the structure exclusively as a "temple," and its form can be compared with the
upper story of the "Temple of Janus" in the medal he had earlier made for Clement VII
(Fig. 59). Sebastiano Serlio's *Terzo Libro* presents the Temple of Janus under the rubric
of triumphal arches; see Serlio 102–3. Cellini knew Serlio in France, and he mentions
the presentation of one of Serlio's books (he doesn't specify which) to King Francis. The
erotic dimension of the Porte Dorée is evident in its use of satyrs as caryatids. See below,
pp. 98–9.

38. Ferrero, 689: "Avevo fatto nella grossezza del detto ovato un partimento di otto zone,
nelle quale avevo figurato la Primavera, la State, lo Autunno e il Verno."

39. Ibid., 688: "Le gambe del mastio e della femmina con bellissima grazia d'arte en-
travano l'una nell'altra, una stesa e l'altra raccolta, che figurava il monte e il piano della
terra." It is possible that Terra's mountainousness is associated with her productivity. It was
in mountains, after all, that salt would be mined. Cf. Biringuccio's vision of mountains
under the sea, giving water its various flavors; n. 22 above.

40. As David Summers has pointed out to me, Cellini's figure of *Night* seems related
not only to Michelangelo's prototype, but also to the antique Sleeping Cupid, examples of
which Cellini could have seen in Florence; see Bober, 51.

41. All four of Cellini's figures have more identifiable attributes and actions than do
Michelangelo's: Of the two women, one is sleeping, leaving no doubt that she is night; the
other, by reason of her gendered name, must be Aurora, which makes sense inasmuch as
she appears to waking, stretching, starting the day. Pope-Hennessy identifies the figures
differently in *Cellini*, 109–10; my captions agree with Scalini's.

42. It is conceivable that the position of Cellini's figure of *Day*, with its demonstration
of the sun's heat, is a thoughtful one, for it appears exactly beneath the point where the
flow of water meets land. With this arrangement, Cellini would complete the mechanism
necessary for the dessication of ocean water, and hence allow for the formation of usable
salt. Pliny describes the various ways heat has been used at salt pools: "In Caonia cuocono
l'acqua d'una fonte & rafreddendola fanno sale. Ma e pigro, & non pianco, in Gallia & in
Germania gettano l'acqua salsa in su legni ardenti." (In Chaonia they cook the water of a
spring, then chill it, making salt. This salt is insipid and not white. In Gaul and Germany,
they pour salty water on burning logs); see Landino, 778. As we have already seen, however,

Pliny reports that the "usual" method was simply to use the sun, "without which [saltwater] does not dry out."

43. Pope-Hennessy, 112.

44. Prater, 33.

45. For *navigatio*, *agricultura*, *venatio*, and *armatura* as arts, see Schlosser 1896; for *musica* as an "art," Kristeller. Composed in the manner of heraldic emblems, Cellini's own tiny groups of instruments illustrate an observation later made in 1585 by Vincenzo Borghini, that escutcheons typically comprise the "instruments of the arts" that were their bearers' first exercises. See Borghini 1990, 47: "Vedesi questo nobile costume di pigliarsi l'arme nel modo, che si è detto di sopra, esser dipoi venuto in declinazione (che non sempre stanno le cose nel medesimo tenore) e l'origine d'esse trasportata all'arti, avendo preso per arme molti gl'instrumenti di quell'arte, che fu loro primo esercizio . . . "

46. On the topic of "arts necessary to life," see Summers 1987, 236 ff.

47. Copenhaver, 71.

48. See Kurz–Kris, 54.

49. Mattingly gives numerous examples, with attributes including a rudder, cornucopia, and globe.

50. Two slightly later examples include Leone Leoni's Tomb for Gian Giacomo de' Medici in the Milan cathedral (begun 1560, designed under the guidance of Michelangelo), which pairs a figure that Vasari identified as Providence with one of Fame; and Alessandro Allori's Siena tapestry cartoon celebrating the Medicis' distribution of grain, which includes a figure that a contemporary document identifies as Providence. For the tomb, see Vasari-Milanese, 7, 540; for the tapestries, see Heikamp 1956, esp. Fig. 17 and document 57.

51. See the examples in Lecoq, 71, 78, 86, and 106.

52. Useful histories of the idea of providence include Parma and Martin. As a virtue that involved the anticipation of the future, and as a word that differed in spelling by only one letter, providence was often conflated with prudence. Ripa, 439, for example, identifies prudence as the source of providence. The 1531 Paris translation of Boccaccio's *Geneologiae Deorum* renders Boccaccio's Latin term *prouidentia* with the French *prudence*, and refers the reader to the discussions of Cicero and Boethius; see Boccaccio 1494, 10r, and Boccaccio 1531, 9r–v. See also Seznec, 94, 120, and Summers 1987, 266ff.

53. See, e.g., the description of Providence in Ripa, 439–41: "Il Timone, ci mostra ancora nel Mare adoprarsi providenza in molte occasioni, per acquistarne ricchezze, & fama, & ben spesso ancora solo per salvar la vita; Et la providenza regge il Timone di noi stessi, & dà speranza al viver nostro, il quale quasi nave in alto Mare, è sollevato, & scosso da tutte le bande da venti della fortuna." (The oar indicates to us further that providence is used at sea on many occasions, to acquire riches and fame, and often enough, to save lives. Providence also controls the oar of ourselves, and gives hope to our life, which, virtually a boat in the high seas, is lifted and shaken from every direction by the winds of fortune.) Compare Meller's comments about the ship in Cellini's *Saltcellar*: "Il motivo indica come questa uomo–nave, questa saliera animata che dirige la propria corsa, sia desiderosa di servire al tavolo del re." (The motif indicates how this man-ship, this animated salt that directs its own course, desires to serve at the table of the king); Meller, 14.

54. Alberti 1553, 7.1 (122r):

> Et pour mieux approuver leur dire, ilz mettent en faict que Saturne faisoit ces distributions ainsi, pource qu'on ne baille pas a vne beste l'administration d'vn troupeau, ains a quelque pasteur entendant bien sa charge, & que tout ainsi failloit il preposer sur les peuples vne autre certaine espece d'hommes laquelle excedast les communs en toute vertu & prudence. Voyla aucuns autres maintiennent que cela fust estably par la prouidence de Dieu tout puissant & tout bon, qui voullet qu'ainsi que les volentez des

particuliers ont leurs inclinations fatales du luy, pareillement les eussent tous peuples de citez.

Ce n'est donques pas de merueille si les muailles dans lesquelles s'assemblent & entre deffentent les humains, furent iadis consacrées aux dieux: & si quand les grans Capitaines auoient assiegé quelque ville, faisans leur effort de la prendre, pour n'estre veuz rien perpetrer contre le deu de la religion, ilz auec certains carmes ou inuocations sacrées euoquoyent les dieux tutelaires, autrement protecteurs de la communaulté, a ce que sans les offenser, ilz entrassent a main armée oultre les clostures estant commises en leur protection sauuegarde. Mais qui vouldroit doubter qu'vn temple ne soit sainct & sacré, tant pour plusieurs raisons, que singulierement pource que lon y adore deuotement le createur qui faict innumerables biens au gerre humain?"

I quote from the French edition to illustrate that the key term of "prouidence" was preserved in translation.

55. Lomazzo, 14: "Quantunque alcuna creatura celeste forsi possa esser capace d'intendere quelle cose particolari che attualmente sono create, & prodotte, nondimeno perchè non sono creati tanti particolari nel mondo, che non se ne possa produrre molto maggior numero, ilche solo dipende da la libertà di Dio, & da la sua prouidenza; perciò questa potenzialità, ò per dir più chiaro, i particolari tutti che sono stati creati & prodotti insieme con quelli che si ricreranno, & produranno nel mondo, solo possono essere da Iddio con la sua prescienza conosciuti. Et parte di questo accennaua Aristotile, quando diceua che i particolari erano noti à la natura; intendendo forsi del primo motore de la natura qual è l'istesso Iddio." (However much some celestial creature might perhaps be able to understand those particular things that are, at this moment, created and produced, nevertheless, because there are not so many particular things created in the world, that a much greater number of them could not be produced – this depending only on the God's freedom, and on his providence – for this reason, that potentiality, or to put it more clearly, all of the particular things that are created and produced, together with those that will be created and produced in the world, can only be known by God, with his prescience. Aristotle indicated part of this when he said that the particular things were known by nature, meaning perhaps the first mover of nature, which is God himself.) If Cellini, like Lomazzo, sees providence as a concept germane to art-making, his position is virtually the opposite: whereas Cellini's work suggests that the artist himself can aspire to a limited form of providence, Lomazzo denies this, contending that the artist's difference from the divine Creator requires him to begin from universals, rather than particulars. For Rubens's use of Providence in political triumphal imagery, and for Poussin's possible adaptation of this to an art-theoretical statement, see Posner, 200–3.

56. Vieri 1576, 32–3: "Se Dio hà de' mortali prouidenza, che eglino dirittamente adoperino (come dice Platone nel decimo libro della Republica; et ancora perche se questo non pacesse, sarebbe da meno di qual si voglia artefice, che diligente cura tiene dell'opere sue) bisogna, che gli huomini habbino gli Spiriti custodi." (If God has providence of mortals, so that they can operate directly (as Plato says in the tenth book of the Republic – and also, if Plato's word is not enough for you, because God would otherwise be lesser than the common artificer, who diligently guides his works), it is necessary that men have guardian spirits.)

57. See Basilio Lapi, "Dialogo de minerali et sua accessorij," BNCF Magl. 16, 36, 116r: De metalli intermedij. Cap[itol]o iij°.

S: Da poi che tu hai aperto la natura si un[iuersa]le come particular' de metalli, desiderrei mi dimostrassi di quelli che sono intermedij, et che lanatura sene serve a condurre detti metalli et quel che si cava doppo si fia extratto esso metallo.

N: Io non posso par non vadia dimano in mano dichiarando la natura di quelli quando la natura per sua provida ordinatione non vadia da extremo a extremo ma sempre con un

mezzo operi et conduca suo intento col qual mezzo coagula et coniunge quelli, et da
perfectione alla sua principiata mistura.

On Intermediate Metals. Chapter 3.

S: Since you have explicated both the universal and the particular nature of metals, I would
like you to teach me about those that are intermediate, and about what nature uses to
form these metals, and about what is brought forth, after that metal is extracted.

N: I cannot proceed but slowly, explaining the nature of those things, for nature, by her
provident ordering of things, does not go from extreme to extreme, but always works
with a means, and carries out her intention with that means; she coagulates and joins
those things, and gives perfection to the mixture she created.

58. See, however, the case Carlo del Bravo makes for Cellini's awareness of Stoic philos-
ophy: Del Bravo, 145–54.

59. Cicero, 94 F: "Omnem enim naturam necesse est, quae non solitaria sit neque
simplex, sed cum alio iuncta atque connexa habere aliquem in se principatum, vt in homine
mentem, in bellua quiddam simile mentis."

60. See Basilio Lapi, "Libro de minerali, et distillatione allo Illustrissimo et eccellen-
tissimo signor Duca di Firenze Cosimo de medici suo unico Patrone," BNCF Magl. 16,
36, 62v: "Onde disse A[ristotile] tutte le operatione della natura sono operatione della
intelligentie." Cf. *Physics* 199a. For Aristotle's comparison of natural and artificial order,
related comparisons in other sources, and their place in Cinquecento art theory; see esp.
Summers 1981, 311–17.

61. Cicero, 97 D: "Sed tamen his fabulis spretis ac repudiatis, deus pertinens per naturam
cuiusque rei, per terras Ceres, per maria Neptunus, alii per alia poterunt intelligi . . . "

62. Ibid., 98 D: "Quodsi omnes mundi partes ita constitutae sunt, vt neque ad vsum
meliores potuerint esse, neque ad speciem pulchriores, videamus vtrum ea fortuiata ne
sint, an eo statu, quo cohaerere nullo modo potuerint nisi sensu moderante, diuinaque
prouidentia. Si ergo meliora sunt ea quae natura quam illa quae arte profecta sunt, nec ars
efficit quicquam sine ratione, nec natura quidem rationis expers est habenda. Quid igitur
conuenit signum aut tabulam pictam quum aspexeris, scire adhibitam esse artem: quumque
procul cursum nauigii videris, non dubitare quin id ratione atque arte moueatur: aut cum
solarium, vel descriptum, aut ex aqua comtemplere, intellegere declarari horas arte non
casu: mundum autem, qui & has ipsas artes & earum artifices & cuncta conplectatur, consilii
et rationis esse expertem putare?"

63. Ibid., 96 E: "Ipsius vero mundi, qui omnia conplexu suo coercet & continet, natura
non artificiosa solum sed plane artifex ab eodem Zenone dicitur, consultrix et prouida
vtilitatum opportunitatumque omnium."

64. Ferrero, 822. On the saltcellar as a machine, see Prater, 82.

65. Plato, 6v (*Tim.* 30b): "Hac ratione mentem quidem animae, animam vero corpori
dedit, totumque ita mundem constituit, vt pulcherrimum natura opus optimumque foret."

66. We might be reminded, on this point, of Michael Baxandall's association of pictorial
quality with decorum, order, commensurateness, and coherence: "Positing an intentional
unity and cogency entails a value judgement." See Baxandall 1985, 120.

67. Cicero, 96 E: "Haec potissinum prouidet, & in his maxime est occupata. primum vt
mundus quam aptissimus sit ad permanendum. Deinde vt nulla re egeat. Maxume autem
vt in eo eximia pulchritudo sit, atque omnis ornatus."

68. Ibid., 98K–99A.

69. Ibid., 102K: "Quam vero aptas quamque multarum artium ministras manus, natura
homini dedit!"

70. On pepper, and its origins in India, see Cardanus, 416–17.

71. Landino, 776: "Ogni sale o si fa, o e nasce per se . . . "

72. Ibid., 777.

73. Fioravanti, 122v: "Tutte si riducono in due specie, cioè dolci, & salse. & in questo sta nascoso vn grandissimo secreto della maestà di Dio, del quale io son stato il primo a scoprirlo, & è questo, cioè. Fare l'acqua salata de mare dolce & salutifera sopra tutte l'altre acque del mondo. & questo l'ho scritto negli altri miei libri, doue ho scritto le nostre nuoue inuentioni, cioè nel Specchio di scientia vniuersale. & di essa acqua ho scoperto vn grandissimo secreto in essa, & è questo, che con artificio naturale, l'ho ridotta di tanta uirtu, che quasi suscita i morti, & conserua longamente i uiui; cosa che mai piu da nessuno è stato visto ne vdito." (All things can be reduced to two kinds, namely, sweet and salty. And in this there is hidden a great secret of God's majesty, which I was the first to discover, and it is this: how to turn the sea's saltwater sweet, and make it more salubrious than all of the other waters of the world. And I have written about this in my books, where I recorded my new inventions, that is, in the *Mirror of Universal Wisdom*. And regarding this water, I discovered a great secret in it, and it was this: that with natural artifice, I reduced it to such virtue, that it virtually revives the dead, and long preserves the living, a thing that has never been seen nor heard by anyone else.)

74. See Ferrero, 872–3. The sonnet is bound with the goldsmith's collected poetry in the Riccardiana, and though the manuscript is a fair copy in an unfamiliar hand on anomalous blue paper, all modern editors have agreed that he was its author.

75. Salt is a key ingredient or result in a number of Cellini's operations. He boils soldered filigree in saltwater, for instance, to remove borax; he soaks gold filigree in vinegar until salt forms on its surface; he uses salt to clean his foils. See, e.g., Ferrero, 611.

76. Palissy, I, 109–110: "Suyvent quoy je ne puis dire autre chose des metaux sinon que la matiere d'iceux est un sel dissoult & liquifié parmy les eaux comunes."

77. Bracesco, 9v: "Veggiamo che le ceneri & la calce, il sudore, la orina lo sputo, e lacqua del mare dal sole decotta, tengano in se alcuni sali, Et perciò io ho detto nel prin. del testamento, Che da ogni cosa combusta si puo fare il sale." (We see that ashes and lime, sweat, urine and spittle, and the water from the sea that has been decocted by the sun, retain in themselves various salts. And for this reason I have written, at the beginning of my testament, that salt can be made from everything that is combusted.)

78. Cesalpino, 39.

79. For a good precis of Paracelsus's view of salt, see Pagel, 82–103. For the reception of Paracelsus in France, see Debus. Debus finds that Paracelsian views did not become widespread in France until after 1560; if this is the case, then Cellini's independent isolation of salt as a model "artistic" maneuver is all the more remarkable.

80. Palissy, I, 215: "Sans le sel, il seroit impossible de faire aucune espece de verre."

81. Biringuccio, 36r: "Fassene vnaltro artificiale qual chiamano sal vetro, & chi sal alchali, & questo si fa di liscia fatta di cennere duna herba detta Gala, ouer Soda, & chi dice Dusnea, & chi Difelti, li piu chiamano questa cennere alume catina, con laquale si fa anchora il capitello per fare li savoni, et per disecchatione sene tra il detto sale per fare el vetro, onde e detto dal vulgo sal vetro."

82. Ibid., 41r-v: "Sotto il medesimo colore che vho detto nel capitolo auanti del cristallo & de alcune altre gioie. Posso molto meglio & con molta piu scusa dirui hora del vetro, come per esser vn de gli effetti & proprii frutti de larte del fuocho, Per che ogni produtto che si troua nele interiorita dela terra, o glie pietra, o glie metallo, o glie nel numero demezzi minerali. Questo come si vede somigli ogniuno, anchor che ogni sua dependentia venga da larte, & pero mi par auanti chio arriui al luocho proprio de larti douerui di questo bellissimo composito mexcolato con larte trattare & metterlo nel nu-mero de mezzi minerali. Et cosi in questo capitolo vi diro desso non come mezzo minerale proprio, ne anche come metallo, ma come materia fusibile & quasi fatta mineral da larte & dala potentia & virtu del fuocho, nata dale speculatione deli buoni ingegni alchimichi per

mezzo de quali in vna parte se imitato li metalli, in vn altra la diafanita & resplententia dele geme, certo cosa bellissima, & da non la douer lassar nel silentio sepulta."

83. Ibid., 41v: "Larte e quella che gli ha dato lessere con il molto isperimentare, & con la giognere & leuare come glie parso, perche come si vede gli antichi la calamita, el nitro, il cristallo, & varie pietre lucide vaggiognevano, li moderni imitandoli mi par che habbino tanto fatto che forse si puo credere che andar pocho piu la con questa arte si possa."

84. For the categorization of arts according to whether they are additive or subtractive, see Mendelsohn, 92 and n. 16.

85. On this, see Pfisterer 1996, also Summers 1981, 134.

86. Biringuccio, 135v: "Gran communicantia ha questa arte da l'opera manuale in fuore con li alchimisti, perche quel che non e ben spesso fa parere come si vede nel adattare delle gioie nel augumentare il colore a l'oro, & nel biancheggiare l'argento & ancho nel dorare le cose quali con effetto sonno d'argento, d'ottone, o di rame, & paiano d'oro, & cosi anchora quelle che non sonno le fanno parere di buono & fino argento."

87. Ferrero, 617–18: "Ancora io non voglio ragionare del modo che son fatti gli smalti, perchè quella si è una certa arte molto grande, la quale ancora la facevano gli antichi, et è stata trovata da uomini soffistichi; e per quello che noi possiamo ritrarre di vero, di quella sorte di smalto rosso trasparente gli antichi non avevano cognizione, e si dice che questo smalto fu trovato da uno archimista, il quale era orefice; e per quello poco che si ritrae, dicono che questo archimista aveva messo insieme una certa composizione cercando di fare oro, e quando gli ebbe finito di fare la sua opera, oltra alla materia del suo metallo restò in nel coreggiuolo una loppa di vetro rosso tanto bello, quanto ancor si vede; di modo che il detto orefice fece di esso sperienzia, accompagnandolo con gli altri smalti, e con gradissima difficultà e molto tempo al fine pure egli trovò il modo. Questo smalto si è il più bello di tutti gli altri, e si domanda in fra l'arte degli orefici smalto roggio, e in Francia si domanda *rogia chlero*, di modo che questo suo nome si è voce franzese, la quale vuol dire rosso chiaro, cioè trasparente."

88. Pliny also claims that the invention of glass was an accident; it was created, he writes, by saltpeter merchants who had built campfires on the sands of a shore. See *Nat. Hist.* 36.189.

89. Ferrero, 623: "E quando ei sieno nella loro stagione, metti dentro la tua opera, dandogli sicuramente un buon fuoco tanto, quanto comporta lo smalto e l'oro. Di poi subito tra' lo fuora, e fa' d'avere preparato un tuo garzone con un manticetto in mano, il quale subito che tu cavi l'opera del fornello, con grandissima prestezza le faccia vento, e con quel vento la freddi: e questo si fa a questa sorte di smalto, per esser in fra essi quallo smalto roggio, che noi abbiam parlato di sopra; la qual natura di smalto a questo ultimo fuoco se bene e' fa correre gli altri, a questo e' gli fa un altro effetto oltra al correre, la qual cosa si è che di rosso e' divien giallo, tanto giallo che egli non si discerne dall'oro: e questa voce in nell'arte si domando aprire."

90. Cellini's red liquor evokes the auriferous ruby elixir sought by alchemists. For a readable discussion of alchemical color theory, see Roberts, 55–63.

91. It is striking that, of the four times of day depicted on the *Saltcellar*, all of which wear an enamel garment, only the sun is cloaked in *smalto roggio*. Thematically, this makes sense: The color *roggio* is not just any red, but the red of the burning sun. As Dante writes, "Lo sol, che dietro fiammeggiavo roggio, / rotto m'era dinanzi a la figura, / ch'avea in me de' suoi raggi l'appoggio" (*Purgatorio* 3.16–18). That, in Cellini's little action, both the sun and the body of *Giorno* render heat and light in the medium of gold evokes *smalto roggio*'s own capacities. On Cellini's facination with the sun, see Chapter 3 below.

92. Ferrero, 688.

93. For this, see most recently Summers 1981, 434–5, and Preussner, esp. 46–52, both with further bibliography.

94. Ibid., 622: "Ma mi s'era scordato uno smalto che si domanda acqua marina; e quest'acqua marina si è color bellissimo e si adopera in oro sì bene come in argento." For what follows, compare the discussion in Pope-Hennessy, 112.

95. Plato, 19r (*Tim.* 61b): "Corpora ex aqua terraque composita vt aqua terrae inania[e] vi coarctata obstruat, sic prorsus se habent, ut aqua exterior influere per ea non possit, ideoque minime liquefaciat, sed ignis acquae meatus penetrans quemadmodum & aqua terrae inania[e]: atque ita aquam afficiens vt ignis aërem, communi corpori liquefactionis causam praebeat. Haec vero partium aquae minus habent quam terrae, quemadmodum vitri genus, & lapides illi qui fusiles appelantur."

96. Ferrero, 621: "Questo modo di smaltare si è come il dipingere: imperò le due sorte del dipignere si liquefanno una con l'olio e l'altra con l'acqua, dove questo modo del dipignere con gli smalti si liquefà col fuoco."

97. Cellini, 15v: "Prima che l'Orefice si prepari à smaltare l'opera si debbe pigliare una piastretta d'oro ò d'argento, et sopr'essa si debbono porre tutti gli smalti che si hanno à adoperare, facendo sopra la detta piastra tante cavernelle con una ciappola quanti saranno gli smalti, indi si pesta di tutti un poco per farne saggio, che serve à vedere qual sia più ò manco facile al correre, essendo necessario che tutti gli smalti corrino à un tratto, perche quando l'uno fusse tardo, et l'altro veloce s'impedirebbono l'un l'altro et nulla si condurrebbe à perfezione."

98. Ibid., 16r: "Poi che con le dette Molle sia presa si accosterà alla bocca del Fornello tenendovela tanto appresso che la cominci à pigliare il caldo, indi a poco à poco come si vede essere ben calda mettisi l'opera dentro al Forenello nel mezzo, havendo grandissim'avvertenza come lo Smalto comincia à muovere, di non lasciarlo scorrere affatto."

99. Salt is apposite to the theme of *copulatio* as well. As Palissy writes, "Il entretient l'amitié entre le male & la femelle: à cause de la viguer qu'il donne és parties génitalles: il aide à la generation: il donne voix aux creatures commes aux metaux." ([Salt] keeps up the affection between the male and the female because of the vigor that it gives to the genital parts. It helps in generation. It gives voice to all creatures and to all metals); see Palissy, I, 190. Lapi, BNCF Magl. 16, 36, 117v–118r, designates *copulatio* as the origin of "mezzi materiali": "Questa comistione di humori, e vapori produce una media natura che luno conlo altro extremo complecte, quando la provida natura non vadia in un tempo da no extremo a un altro se prima non empie, tutti e mezzi, e pero fu necessario facessi alchuni intermedij, per li quali si copulassj essi metalli liquefactibili con quelli non si liquefanno." (This commixtion of liquids and vapors produces a middle nature, which completes one and the other extreme. For provident nature does not go suddenly from one extreme to another without first completing both means, and thus it was necessary that she make some intermediates, by which liquifiable metals could copulate with non-liquifiable ones.) On copulation and metallurgy, see esp. Eliade, 53–64.

100. Ferrero, 375: "Benvenuto v'ha voluto mostrare de' sua figliuoli."

101. Prater conjectures, without evidence, that the King ordered the *Saltcellar* from Cellini as a counterpart to the tableware he had previously received from the artist. See Prater, 83.

102. Ferrero, 688: "Nettuno ... in su una cocchiglia, cioè un nicchio marittimo, fatto in forma di trionfo." The triumphal dimension to the work's program would have helped make it the fitting diplomatic gift it later became, and would have suited its eventual place in the *Kunstkammer* of Emperor Rudolph II. On the later travels of Cellini's *Saltcellar*, see Plon 1883, 172–6. On *naturalia*, the imperial theme, and Rudolph II's *Kunstkammer*, see Kaufmann 1978b.

103. This is not to deny the debt to Neptune imagery in Cellini's original image; the

presumed source in Ovid, in fact, suggests quite the contrary. The proposal here is rather that Cellini's shift in descriptive terms is comparable to other passages in his writings that imply or assert that he had anticipated the ideas of his rivals (see below, Chapter 3, n. 61). In the case of the Neptune, the opportunity was especially attractive, for the *Trattati* were to be published and read at court, and there was little chance that anyone reading the book would be able to compare Cellini's description to the actual object. On the affair, see the story and poems in Ferrero, 363–79, 890, 895–6, 923–32; Borghini's description of the fountain, Borghini 1584, 165; and Bush, 143–52.

104. For this sense of the term, its background, and its place in Cinquecento art theory, see Summers 1981, 299–300, Preimesberger 1986, 191, and Summers 1993.

105. Ferrero, 460.

106. See Tommaseo-Bellini's entry for "sale": "19. Pigliare il sale, *fig., si dice dell'Acquistare sapienza, o perizia di checchessia.* C. [Cors.] *Segret. fior. commed.* 2.4. Non dubitar, padron, credi che quale Di lor prestò gli orecchi alle impasciate, Ha già preso il sale (*ha capita la malizia*). [G.M.] *E tuttavia diciamo, per es.* Son tre mesi soli che è all'Università, ma ha già preso il sale degli scolari."

Chapter Two: Casting, Blood, and Bronze

1. It is evident that, in the writing of the manuscript, Cellini was particularly concerned with this passage. In the Biblioteca Laurenziana pages, it is precisely at the beginning of the story of the casting that Cellini took the pen back from his amanuensis, preferring to script the pages himself, with care.

2. Gauricus, 218. On this question, see esp. Semper, 316 ff; Janson 1941, 24–6, and 87; Janson 1957, 50; Caplow, I, 127–8. Lányi identified Giovanni di Jacopo degli Strozzi as the caster of Donatello's *Rossore*; Lányi, 9–23. It is also known that one Andrea dalle Caldiere cast both the horse of the Guattamelata and the majority of the bronzes for the altar in the Santo. Donatello may have been involved in the casting of some of his smaller pieces. See Gloria, 11, 13; Band, 43, doc. 2; and Janson 1957, 165, 167.

3. See Jestaz, 58–60 and *passim*.

4. Regarding Sansovino, Bruce Boucher vouches, "For his bronzes, a standard pattern emerges from the documentary records. After the definitive clay model had been fired, a gesso piece-mould could be made and a wax cast would be taken from it. At this stage, cleaning and alterations could be made, and here Sansovino would intervene, working directly in the wax and supervising his assistants. The wax cast would then be handed over to a professional founder for casting in bronze"; Boucher, I, 145.

5. Holderbaum, 336–43, 369–72.

6. On Leonardo and casting, see the documents in Beltrami, and fols 141–57 of Madrid Codex II, included in Reti. The large secondary literature on the topic includes, most recently, the collection of essays edited by Ahl; the articles by Ahl, Kirwin and Rush, Carlo Pedretti, and Virginia Bush have useful further bibliographies. In addition to the works they cite, see Somigli 1952, Pedretti, Cianchi, Hall, and Kemp 1981, 203–7.

7. See the Anonimo Gaddiano, in Beltrami, *Documenti*, 163; also Bush, 66.

8. Barocchi 1973, I, 391–2: "Non ò avuta troppa buona sorte, e questo è stato che maestro Bernardino, o per ignoranza o per disgrazia, non à ben fonduto la materia."

9. On Rustici and Bernardo da Milano, see Milanesi 1873; on the Bernardino d'Antonio dal Ponte di Milano who helped Michelangelo, see Milanesi 1875, 75, note 2; Gotti, I, 63; and Barocchi 1962, 390–3.

10. On the topic in Alberti, see Collareta.

11. Gauricus, 225, contends that casting enables one to melt valuables and pay armies, becoming indirectly responsible for the suffering and destruction brought by war. For

the continuation of related prejudices in the Florentine Academy, see Barzman 1985, esp. 222–38.

12. See esp. Caplow (as in n. 22), 50, 355–6.

13. For the inscription, and for contemporary references to Pollaiuolo's work on the tomb, see Ettlinger, 148.

14. Vasari-Milanese, II, 606, n. 3.

15. For the Ghiberti documents, see Doren, 26ff; also the summary in Krautheimer, 406, doc. 71.

16. See, e.g., Krautheimer, doc. 257.

17. See, however, Irving Lavin's discussion of Bandinelli's ambitions as a caster, to appear in the forthcoming acts from the 1999 CASVA conference on "Large Bronzes of the Renaissance," edited by Peta Motture.

18. See the document published by Cox-Rearick 1995, 465, n. 39.

19. See, e.g., Ferrero, 784: "Io ho visto in Parigi fare da quelli pratichi uomini le più mirabil cose che si possa immaginar al mondo . . ."

20. Ibid., 756.

21. Cellini contracted out the casting of both the *Nymph* and the two Victories for the portal, to Gilles Jordain and Pierre Villain. See the documents and discussion in Grodecki.

22. Ferrero, 753–4.

23. For the dating of this, see *Trento*, 56–8.

24. BRF 2788, 7r: "Allo Illusstrissimo signore duca cosimo de medicj a dj 17 dj febrajo 1547 ▽ cinquecento doro dj moneta sono per la mja fattura del rjtratto della sua testa di bronzo con parte del chorpo insino al belicho armato duna spoglia alantica con molto gran lavoro fu grandissima e dificile opera la grandezza sua esendo stata finjta insino a piedi saria figura dj 5 braccia ma chosi e meza e per mja fattura in tutto – ▽ 500"

25. Ferrero, 494.

26. Goethe, 495: "der Glockengießer sah mit Verwunderung sein tönendes Erz in bedeutende Gestalten verwandelt . . ."

27. BRF 2788, fol 2v: "Et adj 17 dottobre [1546] azanobj di pagnjo champannjo e fonditore ▽ undicj di moneta porto contanti per avere aiutato gittare latesta di bronzo di sua eccellenza e nettata eporre di terra tutto lopera del preseo echomjncjo aservjre sino adj 17 dgugnjo prossimo passato — ▽ 11.0"; and fol. 5r: "fa creditore eldetto zanobj per sua opere serujto a fondere e formare erjnettare dadj 11 dj Luglio 1546 sino adj 17 dottobre ▽ in tutto ▽ undicj dj moneta — ▽ 11.0."

28. Ferrero, 495: "E per essere questo getto cosa difficilissima, io non volsi mancare di tutte quelle diligenzie che avevo imparato . . ."

29. On the Lastricati, see Palagi, Spallanzani, Corti, Boström, and Butters.

30. BRF 2787, fol. 11 l: "Spese fatte e dafarsi per conto dellopere dj bronzo devon dare adj 3 dj Luglio [1548] ▽ 19.0.11.4 sono per piu spese fatte quando gittaj la medusa di bronzo epagatj a diverse persone cioe £22.20.0 a maestro lessandro e zanobj suo fratello – ▽ 3.1.10." See also Milanesi 1857, 249.

31. Milanesi 1857, 251.

32. Ferrero, 520: "Vedete, Benvenuto, voi vi volete mettere a fare una impresa, la quale mai nollo promette l'arte."

33. Elsewhere, Cellini warns his readers that the casting of statues should never be entrusted to *maestri d'artiglierie*, probably with the Lastricati in mind. See Milanesi 1857, 177; also Bush (as in n. 26), 59.

34. Ferrero, 518.

35. Here and in what follows, I argue for a perspective different from the one recently offered by Elisabeth Dalucas, who writes of Cellini: "Der Schöpfungsakt hat sich gänzlich

auf die Erfindung verschoben, auch wenn der Gussvorgang als ihr verlängerter Arm immer noch vom Schöpfer überwacht werden muss, um die Qualität des Konzeptes zu garantieren. Die Erschaffung der Figur stellt die eigentlich bildhauerische Tätigkeit dar, nicht der Guss." (The creative act has been shifted entirely into the invention [of the figure], even if the execution of the cast, as that act's extended arm, must still be supervised by the creator in order to ensure the quality of the product. The creation of the figure, not the cast, represents the true sculptural activity.) See Dalucas, 74–6.

36. Ferrero, 517.

37. For della Porta's claims about invention in casting, see his 1569 letter to Bartolommeo Ammannati, published by Gramberg, I, 122–8.

38. Ferrero, 790. On the relationship between the difficulty of the one-piece marble and the task of the giant-conquerer David it depicts, see esp. Seymour, Lavin 1993 and Lavin 1998 (all with further references).

39. See the Ghiberti documents as cited in n. 33 above. Leonardo, when planning the horse for his Sforza Monument, considered ways it might be made in one pour. For bell-casters and cannon-founders alike, furthermore, it was routine knowledge that, however monumental the work might be, it could have no joins. My argument here is merely that, in the emulative context of Cellini's *Perseus* assignment, he would have thought both about the specific *difficultà* his contemporaries admired in marble sculpture and about the history of bronze casts. For an excellent introduction to bells and bell-casting, see Motture. On bells as one-piece casts, see Biringuccio, Book 6, Chapter 12. Virginia Bush traces the interest in the one-piece cast back to Leonardo; see Bush (as in n. 26), esp. 59–61, as well as the discussions in Kemp 1981, Kirwin 1995 and 1997, and Dalucas.

40. For technical aspects of the *Judith*, see Bearzi. For the *Nymph*, see Grodecki.

41. The most pointed written description of this difficulty comes, surprisingly enough, from the painter Jacopo da Pontormo: "Una figura di scultura, fabricata a torno e da tutte le bande tonda e finita per tutto, con scarpelli e altri strumenti faticosi ritrovata in certi luoghi da non potere pensare in che modo si possa co' ferri entrarvi o finirvi, essendo pietra o cosa dura, che a fatica alla tenera terra sare' difficile, oltre alle difficultà d'un braccio in aria con qualche cosa in mano, difficile e sottile a condurla, che non si rompa..." (A sculptural figure, made in the round and finished on all sides and in every place with chisels and other taxing instruments, so worked in certain places that it is impossible to imagine how one could have entered there with chisels and finished the details, it being of stone or of another hard material – such a figure would, for the labor which brittle stone requires, be difficult: even beyond the difficulty of raising an arm with something held in its hand into the air, it would be difficult and subtle to carry out the work in such a way that it does not break.) See Barocchi 1973, I, 504.

42. Ferrero, 515.

43. Ferrero, 521: "Io feci pigliare un mezzo pane di stagno, il quale pesava in circa a 60 libbre, e lo gittai in sul migliaccio dentro alla fornace, il quale cone gli altri aiuti e di legne e di stuzzicare or co' ferri e or conne stanghe, in poco spazio di tempo e' divenne liquido. Or veduto di avere risuscitato un morto, contro al credere di tutti quegli ignoranti, e' mi tornò tanto vigore, che io non mi avvedevo se io avevo più febbre o più paura di morte."

44. Ferrero, 522: "[V]eduto ogniuno che 'l mio bronzo s'era benissimo fatto liquido, e che la mia forma si empieva, tutti animosamente e lieti mi aiutavano e ubbidivano; e io or qua e or là comandavo, aiutavo e dicevo: – O Dio, che con le tue immense virtù risuscitasti da e' merti, e glorioso te ne salisti al cielo!" For commentaries on the scene, see esp. Somigli 1958, 9ff., who examines the technical issues implied by Cellini's addition of *stagno* (i.e., *stagno inglese*, pewter) to his broth; also Maier, esp. 84–94; Gardner, and Orsino. Cellini claims that he caught a fever in the process of executing the cast: see Mircea Eliade's comments on forgers' transcendence of the human state through their own heat; Eliade, 80.

45. Plato, 17v–18r (*Tim.* 58d–59b): "Aquae genera duo sunt praecipua. Vnum humidum, alterum fusile Ex his vero quas aquas fusiles appellauimus, quod ex tenuissimus leuissimisque fit densissimum, vniforme, splendidum, flauumque, pretiosissima res est, aurum florescens per petram compactum est. Auri autem ramus propter densitatem durissimis & nigro praeterea colore suffusus Adamas appellatur. Sed quod auro proximas habet partes pluresque vna species continet, auro quoque densius, & terrenae partis paucae tenuisque particeps, adeo vt asperius duriusque sit, verum ex eo quòd interualla intrinsecus habet magna, leuius est, hoc genus nitentium concretarumque aquarum vnum est, atque aes nominatur." (There are chiefly two kinds of water, one liquid, the other fusible Of those that we have called fusible, the one produced from the finest and lightest matter is the densest. It is unique in form, brilliant and yellow, a most precious thing; it is blossoming gold, compacted by stone. One vein of gold, one most hard because of its density and, moreover, suffused with a black color, is called "adamant." But that which has parts close to gold includes several species; it is denser than any gold, and, sharing small and fine bits of earth, it is rougher and harder, yet because it has great hollows within it, is is actually lighter. This type of glittering, hard water is unique, and it is called "bronze.") Aristotle's extremely popular *Meteorologica*, which went through at least 14 editions between 1540 and 1560, classes metals similarly (378a and 389a). See, e.g., Aristotle 1564, 212v: "Aurum igitur & argentum, & aes, & stannum, & plumbum, & uitrum, & lapides multi nomine uacantes, ad aquam pertinent: omnia enim haec calore liquantur."

46. Aristotle 1545, 276v (762a): "Generantur autem in terra humoresque animalia & plantae, quoniam humor in terra, spiritus in humore, calor animalis in uniuerso inest, ita ut quodammodo plena sint animae omnia." Compare, for example, Palissy, 376: "Comme toutes especes de plantes, voire toutes choses animees sont en leur premiere essence de matieres liquides, semblablement toutes especes de pierres, metaux & mineraux sont formees de matieres liquides, en leur premiere essence." (See that all animate things, like all species of plants, are in their first essence liquid matter; similarly, all species of stones, metals and minerals are formed of liquid matter, in their first essence.) Soderini writes that water is the "anima delle ville e degli orti" (soul of cities and gardens); Soderini, 261, quoted by Rinaldi, 165. Francesco Vieri writes that "i Metalli siano sostanze composte di vapore humido & di natura d'acqua" (metals are substances composed of liquid vapor, and they are by nature made of water); Vieri 1581, 148.

47. Agricola, 66: "Aristotele . . . bene dice che non sia l'acqua pura la materia de' metalli, ma quella, che in qualche affetto e passione si truovi."

48. Allegretti, 85–6: "Quella parte mezzana riserbata / Riduce in acqua, con la qual poi solve / Gli metalli perfetti, e gli dispone / Anzi gli sforza a ritornare in acqua / Che la materia prima, sendo d'acqua / Creati e fatti." Cellini himself writes that when bronze melts, it 'turns into water (viene in acqua); see Ferrero, 779. On Allegretti's relationship with Cellini, see Gabriele's introduction, esp. 11 ff.

49. Ibid., 52: ". . . materia dura e densa, / Che tiene in sé rinchiuso il vivo spirito, / Ch'a le create cose infonde, e dona / Egli solo la vita, il moto e 'l senso / Dove mostrar le forze sue non puote / Se da pronta virtù vivace e calda / Fuor non e tratto ond'impedito giace."

50. As several scholars have suggested, there may even be an alchemical dimension to Cellini's writings. A poem in his hand refers to the pursuit of *oro potabile*, the elixir that could make the sick well and the old young; he seems to have been familiar with the hypothetical process by which one arrives at such gold; See Ferrero, 882, 617. See also the discussion above, pp. 36–7, on Cellini's belief that an enamel he used was invented by "an alchemist who was also a goldsmith." Allegretti asked Cellini to deliver his alchemical writings to Varchi, who also wrote on alchemy; see Gabriele, introduction to Allegretti, 11–14; also Prater, 100; Arnaldi, 19ff.; Kaufmann 1997; and Rossi 1998, esp. 63–4.

51. Biringuccio, 6r: "[Alchemisti] separano gli spiriti da corpi & a lor volontà vegli ritornano come se fussero il coltel dela lor guaina; creduto bene che quelle sustantie che nele cose si chiamano spiriti sia possibile con la violentia del fuocho cavarli e ridurli in vapori, ma cavati non crederò già che mai ve li ritornino che un tale effetto altro non sarebbe si non un saper far resuscitare i morti."

52. Ibid., 8r: "Et con questa & con molte altre ragioni vogliano che si creda che fuor del ventre feminile generar & formar si possa uno homo & ogni altro animale con carne & ossa & nervi & ancho animarlo di spirito."

53. Relevant, in this regard, is the story of Daedalus, who allegedly gave mobility and speech to his sculpture by filling it with liquid Mercury. See Kris-Kurz, esp. 66–9; and Bredekamp 1995 a, esp. 47–51. The Daedalus story is highlighted, among others, by Francesco de' Vieri; see Vieri 1586, 58. Cellini's animation is the inverse of Michelangelo's marble project, which was to enliven the figure by withdrawing it: ". . . per levar, donna, si pone / in pietra alpestra e dura una viva figura, / che là più cresce u' più la pietra scema . . ." ([I]t is by removing, lady, that one places in hard, alpine stone a living figure, which grows greater precisely where the stone grows less); Ryan, 140.

54. Ferrero, 971.

55. See Ferrero, 516. Cellini calls this earthen clothing a *tonaca* (tunic) and a *vesta* (coat); see Ferrero, 516, 755, 761. Vasari terms it a *cappa*, or cloak; see Vasari, 51.

56. Ferrero, 854.

57. For this theme in Cellini, see Mabellini, 42 ff. On divinity as a *paragone* topic, see Mendelsohn, 112ff.; and Farago, 73ff. On God as a smith, see Gramaccini, esp. 163.

58. Ferrero, 961.

59. Jupiter's role as animator of the world is stressed in Vieri 1586, 77: "Ma in verità è un solo, che è l'anima del mondo: questa in quanto viuifica, muoue, & gouerna la parte celeste, gioueuole col suo moto, & lume alle cose di quaggiù, & à noi si chiama Gioue, inquanto viuifica, muoue, & regge le creature di questo basso mondo, suggete al continuo flusso." (But in truth there is only one who is the spirit of the world; this spirit, inasmuch as it enlivens, moves, and sustains the celestial realm, which is, with its motion and light, in turn useful [*gioueuole*] to the things here below is called Jove [*Gioue*] by us, inasmuch as it enlivens, moves and sustains the creatures of this base world, subject to continual flux.)

60. Milanesi 1857, 405.

61. The conceit, with its procreative overtones, resembles one used by Andrea An- guli: "Lysippum doctumque volens superare Myronem / Sculptor, non duxit Persea, sed genuit. / Ipsum iterum genuit, viditque, Deoque replevit / Flatu iterum credens Juppiter esse suum." (The sculptor, wanting to outdo Lysippus and skilled Myron, did not model Perseus, but begot him. He then begot him a second time: he watched, and Ceres filled [Perseus] with breath, Jupiter believing him to be his own [son]); Tassi, 486. It is also close to one used by Michelangelo in a madrigal to Vittoria Colonna a few years earlier: "Non pur d'argento o d'oro / vinto dal foco esser po' piena aspetta, / vota d'opra prefetta, / la forma, che sol fratta il tragge fora; / tal io, col foco ancora / d'amor dentro ristoro / il desir voto di beltà infinita, / di coste' ch'i' adoro, anima e cor della mie fragil vita. / Alta donna e gradita / in me discende per sì brevi spazi, / c'a trarla fuor convien mi rompa e strazi." (It is not unique, the mould which, empty of the work of art, finally stands ready to be filled by silver or gold melted by fire, and then brings forth the work only by being sundered; I, also, through the fire of love, replenish the desire within me, empty of infinite beauty, with her whom I adore, soul and heart of my fragile life. This noble and dear lady descends into me through such narrow spaces that, for her to be brought forth, I too must be broken and shattered.) Note especially Michelangelo's treatment of the casting mold as a body, and his puns on *forma* and *anima*; Ryan, 140–1.

62. On Medusa as Earth, see Bonsignore, 27r: "Vediamo le allegorie di facti di Perseo

dico prima tanto vien a dir gorgon quanto che terra cioe gorgin agicos che vien a dire in greco terra & vene interpretato opera di la terra." (Regarding the allegories of the adventures of Perseus, I maintain, first, that to say *gorgone* is as much as to say *earth*, that is, *gorgin agricos*, which in Greek means "earth," and which is interpreted as the work of the earth.) Bonsignore's interpretation is recycled by Agostini, 45r. Also suggestive for the interpretation of Cellini's *Perseus* pursued here is an extraordinary 1953 article by A. A. Barb, who underscores the fact that Perseus's victim is, in the classical stories, pregnant, and who, from gnostic sources, argues that "the beheading is clearly a creative act"; see Barb, esp. 208ff. I am grateful to Clare Guest for this reference.

63. One viewer of the *Perseus* wrote: "Quod stupeant homines, viso uccisore Medusae, / Non est vipereum, quod gerat ille caput, Sed manus Artificis, quae tot iam saecula nobis, / Mortua, quae fuerant corpora, viva facit. / Igne lutum potuit sublato animare Prometheus: / Saxaque cum cara coniuge Deucalion: / Persea CELLINUS; sed siquis comporet unus / Hic vivit Perseus, mortua sunt reliqua." (What astonishes men when the killer of Medusa is viewed is not the serpent-bearing head that he presents, but the hand of the Artificer, which, [for the first time] after so many centuries, makes what were dead bodies come alive for us. Prometheus could animate clay with stolen fire, Deucalion, with his beloved spouse, could animate rocks; Cellini could animate Perseus; but anyone makes the comparison, [he will find that] Perseus alone lives, the others are dead); Tassi, III, 482. Reinhard Steiner cites this poem for different purposes; see Steiner, 69–71.

64. For the term *bocca*, see Ferrero, 764 and 766.

65. Ibid., 490: "Avevo fatto la sua ossatura di ferro: di poi fattala di terra, come di notomia." The hollow, "negative" form of this body, it might be argued, genders it female; this makes the overtly sexual perspective on the casting process which Bronzino's language allows even more apposite. On the role sexual violence plays in Cellini's art, see Vickers, Carroll, Even, and Johnson.

66. Della Porta's ca. 1574 records of his work on the tomb of Paul III suggest how the *Perseus* became the yardstick for later achievements. After specifying that his seated figure was seventeen palms high and forty palms in circumferance, and that it had cost of 8000 scudi, he observes that "La statua che a fato Benvenuto in fiorenza costa scudi dodecimila et è di mancho grandezza della sopra ditta et non eccede nell'altre qualità." See Gramberg, I, 105–6.

67. Bernardo Minerbetti, in a letter to Giorgio Vasari, Aug. 20, 1552, in Barocchi 1973, II, 1198–1200: "Dico che questa figura si vede nel volto una fierezza mirabile in una faccia dolcissima; el moto del braccio manco, che sostiene per e' crini la testa di Medusa, è cosa incredibile, che vedendola par che vivamente la mostri al mondo; et in quella testa si vede la morte negli ochi e nella bocca fare el suo crudele offizio. E quel che non posso saziarmi di guardare con stupore è el sangue, che impetuosamente esce del tronco, che, ancorché di metallo sia, par niente di meno tanto da dovero, che scaccia altrui per paura di essere insanguinato." Brandt comments on the letter, 411.

68. This interpretation of the *Perseus* has been the standard one at least since the influential monograph on the statue by Wolfgang Braunfels. Braunfels takes the statue to represent the "power and cleverness" of the sovereign, and he contends that it demonstrates "wie denn zu allen Zeiten das Volk niemand so stürmisch zu huldigen pflegte, als dem, der es unterdrückte" (how, as always, the people are wont to do homage to no one more than the one who oppresses them); see Braunfels 7. In a similar spirit, Mary McCarthy writes that "When Cosimo I installed himself as dictator, he ordered from Cellini the *Perseus and Medusa*, to commemorate the triumph of a restored despotism over democracy"; McCarthy, 22. More recently, Pope-Hennessy has associated the Perseus subject with "the dogma of the divinely inspired wisdom and ruthless heroism of . . . the Duke"; Pope-Hennessy, 168. Philippe Morel, citing Pope-Hennessy, has written

that "La tête présentée au public peut valoir comme une menace à l'endroit de ses [Cosimo's] ennemis, la libération d'Andromède comme une métaphore de la libération de Florence du monstre républicain." (The head presented to the public could serve as a threat to [Cosimo's] enemies, the rescue of Andromeda as a metaphor for the liberation of Florence from the republican monster); Morel 1996, 70, n. 6. The most forceful exponent of this view, however, is Volker Breidecker, who compares the scene Cellini shows to actual executions Cosimo staged and oversaw on the piazza, including the beheading of republican rebels in 1537; see Breidecker, 25ff. I am grateful to Rainer Donandt for this reference.

69. Cellini, letter to Bartolommeo Concino, in Tassi, 334–42. For a more extensive citation, see n. 75 below; see also Pope-Hennessy, 169.

70. For the medal and its connection to the statue, see Langedijk, I, 76. Also frequently cited as a visual source for Cellini is a statuette now in Hamburg; see Braunfels; also Brandt, 411, n. 181; and Pope-Hennessy, 168.

71. Cellini writes that when Cosimo first proposed the sculpture, he offered to make it either in bronze or in marble. See Ferrero, 474–5, and below, p. 82.

72. See Varchi 1827, 4, cited in Butters, I, 242 and II, 460.

73. Kirwin's recent book on Bernini suggests that the monumental bronze *Baldachin* the sculptor designed for Urban VIII could have brought to mind cannons, which were forged from the same materials and produced with the same technology. Although the context of Cosimo's commission and the circumstances of Cellini's studio leadership were in important ways different from those of Urban and Bernini, the gist of Kirwin's argument is suggestive with regard to the earlier work as well. The *Perseus*, unlike the *Baldachin*, was an image of violence; Cellini tells us that artillary masters helped him cast it (Ferrero, 769) and describes the fiery scene of its casting in language that evokes a battle. See Kirwin 1997, esp. chap. 2; also Kirwin 1995.

74. Niccolo Martelli, letter to Luigi Alamanni, Aug. 20, 1546, in Heikamp 1957: "Egli si vedrà con stupor delle genti nel rialto della Piazza di sua Eccza Illma nell'altro arco della Loggia di là dalla Giudetta di Donato, quasi luogo vacuo e privio riserbato fino a questo tempo, con l'invenzione nella idea del famoso Duca nostro, dalle fatali stelle per adornar la patria di quanto bello in metallo, natura, arte, ingegno, norma e stil può fare."

75. See esp. the letter Cellini sent to the duke's secretary, Bartolommeo Concino (as in n. 69): "Il mio Illustrissimo ed Eccellentissimo Signor Duca mi commisse, che io gli facessi un Statua di un Perseo di grandezza di tre braccia, colla testa di Medusa in mano, e non altro. Io lo feci di più di cinque braccia con la detta testa in mano, e di più con il corpo tutto di Medusa sotto i piedi; e gli feci quella gran basa di marmo con il Giove, e Mercurio, e Danae, e il Bambino, e Minerva, e di più la Storia di Andromeda, sì come si vede." (My most illustrious and excellent Lord Duke commissioned me to make a statue of Perseus, three *braccia* high, with the head of Medusa in hand, and nothing more. I made it more than five *braccia* high, with the said head in hand and, in addition, with the entire body of Medusa under his feet; I also made him that great marble base, with the Jupiter, Mercury, Danaë, the Baby [Perseus], and Minerva, and, in addition, the *storia* of Andromeda, as you see). In the *Autobiography*, Cellini narrates that the duke asked him to make "solo un Perseo," and that he returned several weeks later with a wax model; the Duke accepted the design, and it became the basis for the large statue; Ferrero, 475. If this wax *modelletto* is identical with the wax group in the Bargello (Fig. 25) – Cellini mentions only one, and this is the only one that survives – it can be inferred that the two-figure group had been accepted practically from the outset, and that the base (and blood), however implicitly now needed, were actually designed some time later. My inferences here follow those of Pope-Hennessy, 169.

76. For the inscriptions, see Tassi, 491–2, and Heikamp 1957, 145, and Chapter 3 below. Varchi's move to the duke's employ in Florence preceded Cellini's by two years, but the two

had been friends from at least the 1520s. Who initiated Varchi's participation in the *Perseus*, and how extensive that participation was, are matters for speculation; it may be that Varchi simply offered suggestions appropriate to an already established program, or he may have played a role in formulating the iconography. Varchi's personal interest in the sculpture is suggested by his academic lectures. When discussing the nature of sculpture in his now-famous *Sulla pittura e scultura*, he took as his example "un Perseo"; see Varchi 1859, II, 620. When he conducted his survey on the relative nobility of sculpture and painting, Cellini was one of the eight artists he invited to submit opinions. When the *Perseus* was unveiled in 1554, Varchi led the charge in writing encomiastic poems, composing at least two himself and having the longer versions of the Latin inscriptions translated into Italian. A poem by Bernardo Vecchietti, moreover, associates Varchi and Cellini explicitly in the mutual honor they do to Cosimo: "E come hor d'intagliarlo hà sol lo stile/Del Cellin grido, allor senza contesa / S'udirà; solo il VARCHI alto ne scrisse." (As now only Cellini's chisel/[style] may boast of carving him, so will it be heard without contest how noble Varchi alone wrote about him); Varchi 1555, 117. Later, Cellini sent both his poetry and his autobiography to Varchi, "so that it might feel, a bit, the the polish of [his] marvellous file." (che senta un poco la pulizia della vostra maravigliosa lima.) See the letter of May 2, 1559 in Ferrero, 985–6.

77. Ovid, 114 (4.785–6): "Eripuisse caput collo, pennisque fugacem / Pegason, & fratrem matris de sanguine natos."

78. "De sanguine autem Gorgonis natus est Pegasus, qui *fama* interpretatur; et pede suo fontem Castaliae sive Pegaseum produxit; quia virtus, omnia superans, bonam sibi acquirit famam": This is the interpretation given in one of the anonymous treatises published in Bode, 42. Compare the commentary on the beheading of Medusa in the most recent vernacular translation of the *Metamorphoses* Cellini could have seen: "Dice Ouidio che del sangue della detta Medusa nacque vno cauallo con le ali, questo sintende per la fama, la qual vola per lo mondo . . . la uccise et fu tanta la fama che volo di questa sua uittoria che ogni persona che incontraua diuentaua immobile." (Ovid says that from the blood of Medusa was born a horse with wings; this is to be interpreted as "fame" which flies through the world . . . Perseus killed Medusa, and the fame that flew from his victory was such that every person he encountered was petrified); Agostini, 45v. The *locus classicus* of this idea is Fulgentius, *Mythologies* 1.21.

79. G. C. Capaccio wrote that the device of Pegasus, which Cellini made for Pietro Bembo, meant "che l'action virtuosa fà scaturir i fonti della gloria, e della lode"; quoted in Hobson, 32. On the medal, see above, Introduction, n. 11.

80. Ferrero, 821. For the connection between Pegasus and the origin of the visual arts, see esp. Brink and Ketelsen, both with further bibliography. Muller discusses other treatments of the theme; see Muller, esp. 141–3. See also Agostini, 45r: "Per le goccie che caderanno del capo di Medusa sintendino le biade & gli altri frutti, ma per gli serpenti generati di quelle si comprendono le semente di essa terra, che per il coltiuar delle genti moltiplicando abondano nelle diuitie del mondo." (The drops that fell from the head of Medusa are to be interpreted as grains and other fruits; but the serpents generated by those drops should be understood as the seeds of the earth, which, multiplying through human cultivation, pour forth into the wealth of the world); Agostini, 45r. This is a slightly modified plagiarism of Bonsignore, 27r (on the two texts, see also n. 121 below). Its relevance to Cellini's interests at the time he was making the *Perseus* is evidenced by the depiction of the head of Medusa on the breastplate of Cellini's portrait of Cosimo (Fig. 47): there, Medusa's blood is rendered as fruit.

81. Ferrero 475: "Su tu conducessi, Benvenuto mio, così in opera grande questo piccol modellino, questa sarebbe la più bella opera di piazza. – Allora io dissi: – Eccellentissimo mio Signore, in piazza sono l'opere del gran Donatello e del maraviglioso Michelagnolo,

qual sono istati dua, li maggior uomini dagli anitchi in qua. Per tanto Vostra Eccellenzia illustrissima dà un grand'animo al mio modello . . . " ([The Duke said,] 'If you, Benvenuto, would carry out this little model as a large work, it would be the most beautiful work in the piazza.' I answered, 'My most excellent Lord, in the piazza there are the works of the great Donatello and of the marvellous Michelangelo, who were two of the greatest men who have ever lived. Considering that, your most illustrious Excellency gives great spirit to my model); Ferrero, 475.

82. Vasari, 317: "[L]a semplicità del di fuori nello abito et nello aspetto di Giudit, manifestamente scuopre nel di dentro, l'animo grande di quella Donna, et lo aiuto di Dio: si come nella aria di esso Oloferne, il vino et il sonno, et la morte nelle sue membra, che per avere perduti gli spiriti si dimostrano fredde et cascanti . . . "

83. My understanding of Vasari's comments depends on Charles Dempsey's important analysis of this passage, and I am grateful to him for discussing it with me further. See Dempsey 1996b, esp. 54–6.

84. Milanesi 1857, 411.

85. Bocchi, 35: "Il corpo di Medusa è fatto con bella considerazione; & morto, & cascante fa palese à pieno, come la carne, & l'ossa spogliate di spirito sono disposte, & fatte quasi dalle mani di natura."

86. Ferrero, 859.

87. Biringuccio, Book 1 (n.p.): "Et queste si dimostrano quasi con quel modo che stan le vene del sangue ne li corpi de gli animali . . . "

88. Ferrero, 552.

89. Agricola 1563, 6.

90. Agricola 1550, 67.

91. See, for example, the anonymous recipe "Aqua, et Mestruo per preparar il solfo dal avere de li pianeti," BCNF Pal. 863, fols 89ff.

92. On this "licor sanguigno," see Biringuccio, 28r. Cellini himself, when referring to the metal that clotted in his furnace, calls it a *migliaccio*. This is, as Motture points out, the term for the cakes in which copper was sold, though in modern Italian, at least, *migliaccio* is also blood pudding.

93. Ferrero, 945.

94. On Dec. 26, 1557 Cellini sent a *supplica* to Duke Cosimo asking for permission to go home from prison "per non gittar via queste poche ore che Iddio mi presta . . . Sendo chiamato dal mio bel Cristo." Tassi, 77.

95. The word *roba* is equally curious. I have rendered it as "substance," intending to connote its economic senses of money or personal goods, as well as its sustenative possibilities as food, drink, or narcotic. In this regard, "stuff" might serve better, although the modern English sense of that word has become too vague. Depending on how the rest of the line is interpreted, *roba* might, less neutrally, be render as "works," or even "artworks" – the *Grande dizionario della lingua italiana* lists numerous examples of usages with this meaning.

96. See Chantelou, 206: "Nelle mie opere, caco sangue." Though the remark is preserved only in a report of an oral tradition, we might recall what Michelangelo, quoting Dante, wrote on the cross in the drawing he sent to Vittoria Colonna: "No one thinks how much blood it costs." (Non vi si pensa quanto sangue costa.) Leonardo Bruno also compares blood and artworks: "Nam velut sanguis per universum corpus, sic ornamenta delitiaeque per universum urbem diffuse sunt." (Just as there is blood through the whole body, so are there ornaments and delights diffused through the whole city.) See Bruno 1974, 22; I am grateful to Ulrich Pfisterer for this reference.

97. On Cellini's violence, see esp. Arnaldi, 120–29; and Rossi 1997.

98. The poem was first published by Milanesi 1857, 384; it has been reprinted many times, but Cellini's corrections have never been pointed out.

99. Brandt, 409–10.

100. Ovid, 113 (4.753–7).

101. Ovid's own story describes how, as Perseus's opponent Chromis beheaded Perseus's ally Emathion, the head fell onto an altar, and "he breathed out his life in the midst of the flames" (medios animam exspirauit in ignes). Ibid. 119 (5.106).

102. In an epigram on Myron (an ancient sculptor who also made a bronze Perseus, and to whom Cellini was frequently compared), Ausonius adopts the voice of the famous cow the sculptor cast: "Aerea bos steteram; mactata est vacca Minervae; / sed dea proflatam transtulit huc animam." (I had stood here a brazen heifer; a cow was slaughtered to Minerva; but the goddess transferred to me the life breathed forth.) See Ausonius, II, 197. For the Cellini/Myron analogy, see Shearman, esp. 48. For Bronzino's painting, see Cropper 1998 (with further references). Also of interest here is Hendrik Goltzius's *Venus, Bacchus and Ceres* in the Hermitage, St. Petersburg, which shows the artist tempering his burins at the altar/forge of Venus. On this, see Reznicek, esp. 129; Melion 1993 (with further references); and Kaufmann 1997.

103. See Eliade, 31, 62ff. One might consider, in this context, the alchemical process standardly referred to as *mortification*, the killing of the body that contained the life one sought to employ.

104. In fact, the poetry written around the *Perseus* all agrees that Cellini's *Medusa* petrified only Bandinelli's hero, not Michelangelo's. Shearman, however, who looks at the sculpture, and not just at its reception, observes how "it seems that Hercules, even David, as they look opportunely toward Medusa, have *become* marble"; Shearman, 55.

105. Shearman 1992.

106. Ovid, *Met.* 5.249.

107. Since Shearman's ingenious observations, it is impossible to view the statues in the Piazza without considering medium. The basic lines of his reading of the piazza are irresistible, and I am cautious in following only a few of his inferences. The evidence suggests that it was not Cellini himself, but rather his patron, Duke Cosimo I, who determined the site, the medium, and the subject of Perseus and Medusa. This raises the question whether, for such petrification conceits, *any* bronze Perseus in the Loggia would have sufficed, and accordingly, what we should make of the actual thing Cellini spent the culminating decade of his career making. Shearman leaves no doubt about the cleverness with which the setting for Cellini's work was exploited. And even if we conclude that the decisions that allowed this were not Cellini's, the situation nevertheless invites us to view the artist's task as one that was specially bronze-specific and one that, confronting the *David*, had to face the tradition of Michelangelo. I follow Shearman's instinct that Cellini's use of bronze was the basis of his response to his predecessors, and that the subject of Medusa offered the means through which that response could be thought. In contrast to Shearman, however, I am attempting to take into account Medusa's function *within* the monument, and not just her conversion of the beholder. See Shearman 1992, 44–58. Earlier discussions of art and the "Medusa effect" include Freccero, Marin, Hertz, Gallagher, and Cropper 1991.

108. See the document published by Milanesi 1857, 251.

109. Minerbetti notes that he saw two bronze reliefs (*due tavole di bronzo di basso relievo*) not yet poured, but intended for the base of the sculpture; Barocchi 1973, II, 1200. Only one of these, that depicting the plight of Andromeda, was finished and added to the work. Brandt plausibly hypothesizes that "the entire pedestal of the *Perseus* was to be free-standing" 411.

110. Plon 1883, 219, n. 6: "Par ces mots, Gorgoni di Medusa, Benvenuto veut dire sans doute *têtes de Méduse*. On sait que les Gorgones étaient trois soeurs: Sthéno, Euryale et Méduse, filles de Phorcys, et de Céto; elles avaient la puissance de changer en pierre ceux qui osaient les regarder. D'où la tête de Méduse, tranchée par Persée et placée sur l'égide de Minerve, était couramment appelée *la Gorgone*. De l'article où est relevé le porte du

Persée, on peut conclure que le sculpteur fit jeter séparément la tête de Méduse que tient la statue du héros, et cela est d'autant plus vraisemblable que l'inventaire après décès relève una Tête de Méduse en bronze." (With these words, *Gorgoni di Medusa*, Benvenuto no doubt means *heads of Medusa*. We know that the Gorgons were three sisters, Stheno, Euryale and Medusa, the daughters of Phorcys and Ceto; they had the power to change all who dared to look at them to stone. Thus, the head of Medusa, cut off by Perseus and placed on Minerva's aegis, was commonly called *the Gorgon*. Regarding the entry whence the weight of the *Perseus* comes, we can conclude that the sculptor had the head of Medusa, which the hero holds, cast separately; this is all the more probable seeing that the inventory taken at his death includes a Head of Medusa in bronze.)

111. The document was published by Somigli 1958, 45.

112. The chronology of Cellini's castings is most accurately summarized by Trento, 56–64; other important observations are made by Somigli 1958, 9 ff. Intriguingly, the water in Cellini's *Nymph* relief was also cast independently; see the discussion in Grodecki, p. 50 and n. 21.

113. See Avery-Barbaglia, 95.

114. See Tassi, 256–8, no. 324.

115. For this last possibility, see Cartari, 427.

116. Tommaseo-Bellini, vol. 2, part 1, 1156: "Rammentando che Medusa dicevasi amata da Nettuno; e che quarta delle Gorgoni facevasi Scilla co' suoi cani mostruosi; e le Gorgoni abitatrici delle isole Gorgone nell'Atlantico, dicontro agli orti delle Esperidi, è lecito arguirne non tanto che questo sia nome d'isole serpentifere, quanto che questo fosse nome com. di varie singolarità, quasi mostri marini. Onde non a caso fu detto Gorgonii un genere di polipi . . . " (Remembering that Medusa was said to have been loved by Neptune, that the fourth of the Gorgons was made into Scilla with her monstrous dogs, and that the Gorgons were the inhabitants of the Gorgon islands in the Atlantic, opposite the place of the Hesperides, it is less legitimate to conclude that this [*gorgoni*] was the name of the serpentine islands, and more that it was the common name of various peculiar things that were virtually sea monsters. It is thus no chance thing that a family of polyps was called *gorgonii*.)

117. Agricola, 246v: ". . . è stato ancho chiamato Gorgonia; perche i poeti fingono, chele Gorgone fossero convertite in pietre: Scrivendo dunque Plinio de le gemme dice queste parole; la Gorgonia non è altro in effetto, che il Corallo: e la cagione del nome si è, perche si muta e converte in una durezza di pietra."

118. Contrast the entry for *gorgonia* in Facciolati, 494: "*Gorgonia, æ,* f. γοργονια, corallium, a gen. γοργονοσ, quod e sanguine Medusae Gorgonis natum sit, vel quia ex aquis exemptum protinus in duritiem lapidis convertitur, quemadmodum illi, qui Gorgonas aspexerant. *Plin.* 37.10.59." (*Gorgonia, æ,* feminine *gorgonia*, "coral", from the genitive *gorgonos*, because it was born from the blood of the Gorgon Medusa, or because, when removed from water, it was immediately converted into the hardness of stone, just like those who look upon the Gorgons. See Pliny, *Nat. Hist.* 37.10.59.) One might, nevertheless, recall Caravaggio's famous painting of Medusa, which shows her petrified by her own reflection at the moment of her beheading. See Marin's classic discussion of this; compare also Pliny's comments, below.

119. The lexical issues here are convoluted. Tommaseo-Bellini lists no singular for *gorgonii*, but it might be inferred that the singular should be *gorgonio*. If this noun exists, then it is plausible that Cellini's own word, *gorgoni*, is an alternative plural; many Italian words ending in *-io* take both *-i* and *-ii* as acceptible plurals (*principi*/*principii, omicidi*/*omicidii*, etc.). The noun *gorgonio*, however, appears in no dictionary. It is possible that *gorgonii* is an irregular plural for *gorgonia*, since, coming from Greek, the *-a* could go to *-i* (cf. *poeta*/*poeti*, etc.). This does not preclude Cellini's *gorgoni* as another irregular plural. It is also possible that *gorgoni*

(and *gorgonii*) are nominals formed from adjectives: *gorgonio*, as an adjective, means 'gorgon-like,' and *gorgoni(i)* could thus denote "gorgon-like things." On this score, it should be added that *gorgonia* itself functions the same way; like the English cognate *gorgonian*, the word means both "coral" and "gorgon-like." Furthermore, the word, taken as an adjective, can involve the noun: *gorgonian* can mean *gorgonian-like* (coral-like) as well as *gorgon-like*. To all of this, finally, should be added Agricola's implication that gorgons are gorgonian inasmuch as they themselves harden like coral. For the moment, I am considering the possibility that, through one of these circumnavigations, Cellini's word *gorgoni* might suggest, *a priori*, that his blood is also coral. However, a nice alternative suggestion, offered to me by Conte Niccolo Capponi, will prove relevant in a later stage of the discussion: Conceivably, *gorgone* could be an augmentation of *gorgo*, which (in addition to being synonymous with "gorgon") can refer to a whirlpool, eddy, or gurgle. This would place the emphasis, again, on the liquid movement of Cellini's blood, about which, see below.

120. Bonsignore, 26v: "Come Perseo hebbe ucciso la belva dicese dal scoglio & posese a sedere sopra el lito del mare per lavarse: che era tutto insanguinato dil sangue di la belva. Ma percio chel capo di Medusa gli dava impedimento: si lo pose in terra: & perche quello capo non fesse alchuna lebone ala terra. Tolse alquante verge di legno lequal erano nati in mare: & subito quelle verge se induraro in modo de pietra: & del sangue di quello capo ne fecero vermiglie: & cosi sono facti li corali & questi fu li primi corali. Vedendo questo le nymphe del mare se maravegliaro molto: & si anchora per la morte dela belva. & intrando Perseo ne lacqua vennaro le nymphe ala riva del mare & tolsero quelli corali & si li seminaron per mare & subito cominciaron a crescere: in questo modo e abundantia di corali per lo mondo."

121. Bonsignore's translation, written in 1380, went through numerous editions until 1521, at which point it was superseded by the Agostini's. It is evident that Agostini worked closely both with Bonsignore's earlier translation (which is extensively recycled and paraphrased) and with a Latin version. For the story of the generation of coral in particular, Agostini seems not to have controlled Bonsignore against Ovid, but rather to have converted the vernacular prose into *ottava rima*: "Comhebbe morta il giouine pregiato / l'iniqua Belua, uenne su la riua / del mar, doue perch'era insanguinato / lauar si uolse, e la testa copriua / di Medusa c'hauea con seco alato / d'un bel cespo di uerge che n'usciua / fora de l'acqua, le qual s'induraro / e per il sangue rosse diuentaro." (When the honored young man had killed the frightful monster, he came to the bank of the sea. There, because he was covered with blood, he wanted to wash himself. He covered the Medusa's head, which he had at his side, with a beautiful tuft of branches that had been sticking out of the water. This hardened, and, because of the blood, became red); Agostini, 44v. Lodovico Dolce's philologically more ambitious translations of Books Four and Five of the *Metamorphoses* first appeared in 1553, after Cellini's Medusa and her blood had already been cast.

122. Ovid, 112–13 (4.740–52): "Ipse manus hausta victrices abluit vnda. / Anguiferumque caput dura, ne laedat, arena, / Mollit humum folijs, natasque sub aequora virgas / Sternit, & imponit Phorynidos ora Medusae. Virga recens, bibulaque etiam nunc viua medulla / Vim rapuit monstri, tactuque induruit huius / Percepitque nouum ramis & fronde rigorem. At pelagi Nymphae factum mirabile tentant / Pluribus in virgis, & idem contingere gaudent: / seminaque ex illis iterant iactata per vndas. Nunc quoque coralijs eadem natura remansit, / Duritiem tacto capiant vt ab aëre, quodque / Vimen in aequore erat, fiat super aequora saxum." (He washes his victorious hands in water drawn for him; and, that the Gorgon's snaky head not be bruised on the hard sand, he softens the ground with leaves, strews sea-born twigs over these, and lays on this the head of Medusa, daughter of Phorcys. The fresh twigs, but now alive and porous to the core, absorb the power of the monster, harden at its touch and take a new stiffness in their branches and leaves. The sea-nymphs test the wonder on more twigs and are delighted to find the same thing

happening to them all; by scattering these twigs as seeds, they repeat the effect throughout their waters. To this day the same nature has remained in coral, so that they harden when exposed to air, and what was a pliant twig beneath the sea is turned to stone above.) English modified from Miller, 231.

123. Landino 787–8 (32.22): "Ha forma d'arbuscello. Il colore e verde le coccole sue sotto l'acqua sono bianche, & morbide, ma spiccate diventano dure, & rosse di forma, & di grandezza di Corniole dimestiche. Et dicono che toccandogli mentre che sono vivi di subito diventano pietra. Et per questo anticipano in tirargli fuori colle reti, o mozzargli con tagliente ferro. Per questa cagione interpretano che e sia chiamato Corallo."

124. Regius, 50r: "narratur quemadmodum virgae in mari nascentes in coralia fuerunt coversae: inquit eas a Perseo Medusae capiti subiectas induruisse lapidisque figuram contraxisse: q[uan]d[o]q[ui]dem nereides admiratae multa & ipsae virgulta capiti Medusae subiecerunt: atque in mare disiecerunt. q[uae] q[uam]diu aqua teguntur mollia sunt. extracta ad aerem statirigescunt. Quare quidam coralium Gorgoniam vocant Plinius ait quod extractum e mari in duriciam lapidis mutetur tanq[uam] viso Gorgonis capite." ([Ovid] tells how branches born in the sea were converted into coral. He says that these [branches], having been placed by Perseus under the head of Medusa, hardened, and that a figure of stone came together. The sea-nymphs marveled much at this, and they themselves placed twigs under Medusa's head, then strew them through the sea. These things are soft as long as they are covered by water. Extracted, they harden in the air. Pliny says that the reason why certain people call coral Gorgonia is because it is transformed into the hardness of stone when extracted from the sea, just as if the head of a Gorgon had been seen.)

125. See Pliny-Jones, 478, note a.

126. Pope-Hennessy, 185.

127. Ferrero, 122.

128. On the collecting of coral in sixteenth-century Europe, see esp. Schneider. The Medici were interested not only in carved corals, but also in fabricated ones; see, for example, the formulas in the 1561 *Recettario,* BNCF Pal. 1001, fols 14r ff.

129. Morel 1997, 60.

130. Morel 1992, esp. 167–8; Morel 1998, esp. 39–42.

131. At the beginning of the seventeenth century, Michael Maier would write that coral's vegetative origins provided coral with "as much curative power as all herbs together." He cautioned, however, that coral "has to be cut very carefully under water, so that the juice and blood is not lost"; Maier, 227–8. De Jong cites as the source for Maier's passage the *Artis Auriferae,* a 1572 compilation of earlier alchemical texts. Maier had also evidently read Pliny.

132. Compare the comments by Braunfels, McCarthy, Pope-Hennessy, Morel, and Breidecker as in n. 68 above, as well as those in Hirthe and in MacHam. Brandt interprets the killing of Medusa as Cosimo's elimination of Discord, but also observes, suggestively, that "the sculptor transforms [the pedestal] into art, much as the duke tames and cultivates nature's abundance for the good of his people and glorifies his rule by patronizing the arts" (410).

133. On the protective value of coral as an amulet, see Pliny 32.24; and Riccio, 163–71; in the secondary literature, Grabner, and Mandel, esp. 369 (with further references). On the coral worn by the Christ Child in Piero della Francesa's Montefeltro Altarpiece, see Lavin-Redleaf. On bronze as an apotropaion, see Gramaccini.

134. Pagano Pagaini, in Tassi, 488: "... collo veri sanguinis unda fluit."

135. Compare Morel 1997, 66, on Vasari's coral: "Il ne naîtrait pas de la transformation des algues au contact de la tête de Méduse comme le raconte Ovide, mais de la pétrification de son sang au contact de l'eau." (It would not be born from the transformation of seaweed

on contact with the head of Medusa, as Ovid recounts, but from the petrification of her blood on contact with water.)

136. Varchi, II, 286–7.

137. Galen 1541, I, 400–1: "Quippe ita sanguis essent cunctae animalis particulae, is scilicet qui à matre concidente confluit ad maris semen, ac una uniusque formae materia cerae uice artifici subiecta." English from Galen 1979. Galen's comparison is extended, and he goes as far as to say that semen is a great artificer, "analogous with Phidias, whilst the blood corresponds to the statuary's wax." (Nempe semen ipsum. Id enim est artifex, Phidiae ad portionem respondens, sanguis uero cerae rationem habet. Non igitur conuenit, ut cera sibi ipsi mensuram inueniat, sed Phidias. Trahet porrò artifex tantum ad se sanguinis, quanti indiget.)

Chapter Three: The *Ars Apollinea* and the Mastery of Marble

1. Barocchi 1960, I, 25: "Hanno ancora l'arti questa differenza dalle scienze, che esse sono divise e separate l'una dall'altra, di modo che si può essere buon maestro in alcuna di loro senza la cognizione di nessuna dell'altre, dove le scienze hanno una certa convenienza e colleganza insieme . . ."

2. Borghini 1584, 165: ". . . in piazza non ci resta altra figura di cui possiamo favellare; poiche di quelle di bronzo non è nostro intendimento di dire, se non del bel groppo di Giambologna."

3. Milanesi 1857, 409: "Celebrò già fra' pittor Polignoto / Il mondo, Cellin mio, Zeusi e Apelle; / Nel marmo lodò Fidia e Prassitele: / Or nell'uno e nell'altro il Buonarruoto. / Il bronzo era appo noi lodato e noto / Per opre antiche e per opre novelle; / Ma 'l vostro Perseo vince e queste e quelle, / E le fa parer fredde e senza moto."

4. For a discussion related to this point, see Barkan 1999, 330–8.

5. Ferrero, 474–5: "Io poverello isventurato, desideroso di mostrare in questa mirabile Iscuola, che di poi che io ero fuor d'essa, m'ero affaticato in altra professione di quello che la ditta iscuola non istimava, risposi al mio Duca che volentieri, o di marmo o di bronzo, io gli farei una statua grande in su quella sua bella piazza."

6. Ibid., 475: "A questo mi rispose, che arebbe voluto da me, per una prima opera, solo un Perseo."

7. See above, chapter 2, n. 94.

8. There has been some debate over the attribution of the marble reproduction (now in San Francisco) of Cellini's bronze portrait. Since the inventory made on Cellini's death lists an (unfinished) marble bust of the Duke, and since no other candidate for this bust has been found, it is plausible that the San Francisco bust was at least begun by Cellini. Pope-Hennessy speculates that the marble for the bust was acquired in 1549, but that the bust was not begun until the late 1550s, and was still incomplete on Cellini's death. This is consistent with the history of Cellini's skill as a marble sculptor, but difficult to reconcile with Pope-Hennessy's further hypothesis that Cellini's first, bronze, version of the portrait was dispatched to Elba in 1557 because it was "out of key in Florence." Why would Cellini undertake a second, nearly identical version of the portrait after the Duke had concluded that the original was objectionable? One alternative possibility is that Cellini (or one of his assistants) worked on the marble in the late 1540s and early 1550s (at the same time that his portrait of Eleanora, also mentioned in the inventory, was underway), and discontinued the project when it became clear that the Duke would not be interested in it. Another possibility is that Cellini began the copy as a replacement for the bronze, knowing that the original was destined for Elba. What is significant in the present context is that Cellini began the marble copy, but eventually gave up on it. See Pope-Hennessy, 217–18; Avery-Barbaglia, 91–2, and for the inventory, n. 11 below.

9. See the documents on Cellini's *Christ* as summarized by Trento, 75–80.

10. Ferrero, 511: "E in mentre che io lo lavoravo, il Duca veniva a casa mia, e molte volte mi disse: – Lascia stare un poco 'l bronzo e lavora un poco di marmo, che io ti vegga. – Subito io pigliavo i ferri da marmo, e lavoravo via sicuramente."

11. See the items listed in Tassi, 256–8, viz., "302. Statua di marmo dell'Illma. Signora Leonora Duchessa di Firenze (grande quanto il vivo)" (now lost); "303. Statua di marmo di Narciso" (now in the Bargello); "304. Statua di Apollo con Statua (Iacinto) a' piedi"; and "305. Testa di marmo del Gran Duca, non finita" (now in San Francisco?). The inventory also lists another "testa di marmo," which is to date impossible to identify.

12. See the letter Cellini wrote on 20 September 1570, just months before his death, in which he complains to the Duke that he has as yet received "cosa alcuna" for the *Crucifix* or the *Ganimede*; Tassi, 192–97.

13. I know of no evidence to support Charles Avery's suggestion that the *Apollo and Hyacinth* "was sufficiently good for Cosimo de' Medici to commission other works from [Cellini] in marble"; see Avery 1987, 73.

14. On Tadda's activities in Cellini's workshop, see Butters, I, 151. For the question of the authorship of the *Ganymede,* see Appendix.

15. Ferrero, 511: "E perché io lo sentivo tutto crocchiare, io mi penti' più volte di averlo mai cominciato allavorare: pure ne cavai quel che io potetti, che è Appollo e Iacinto, che ancora si vede imprefetto in bottega mia."

16. See above, p. 49.

17. Pope-Hennessy, 230.

18. Poeschke 1992, 216.

19. The literature on the *psychomachia* tradition as it applies to Cinquecento sculpture is cited and critiqued in Kaufmann 1978a. In the particular case of the *Apollo*, at least, I will be maintaining that the term "mastery" is both more descriptively useful and more in keeping with Cellini's own vocabulary than the term "victory," even if the latter description is also relevant. I am also cautious about abandoning moral interpretations of victory imagery in the period at issue, however; contemporaries seem to have taken the *Perseus and Medusa*, at least, to engage the problem of virtue, and perhaps even the opposition of virtue and vice.

20. Ovid, 267 (10.198–99): "Mea dextera leto / Inscribenda tuo est, ego sum tibi funeris auctor." My translation follows that of Cautio, 9r: "Fu la mia destra del tuo fin cagione. / Io stesso son l'autor de la tua morte."

21. Kantorowicz 1957.

22. See Ovid, 20 (1.521): "Inuentum medicina meum est," cited by Varchi in *Opere* II, 353, and Petrarch, "Triomphus Cupidinis," 2.121–3, "E se non fosse la discreta aita / Del fisico gentil, che ben s'accorse; / l'età sua in sul fiorir era finita," cited by Varchi in Barocchi 1960, I, 20.

23. Macrobius 1543, 252–3: "Alij cognominatum Apollinum putant $\dot{\omega}\varsigma\ \dot{\alpha}\pi o\lambda\lambda\dot{\nu}\nu\tau\alpha$ $\tau\dot{\alpha}\ \zeta\tilde{\omega}\alpha$. Ex animat enim, & perimit animantes, cum pestem interperie caloris immittit Hinc est quòd arcu, & sagittis Apollinis simulachra decorantur: ut per sagittas intelligatur uis emissa radiorum Idem autor est & publicae sospitatis: quam creditur sol animantibus praestare temperie. Sed quia perpetuam praestat salubritatem, & pestilens ab ipso casus rarior est: ideo Apollinis simulachra manu dextera Gratias gestant, arcum cum sagittis sinistra: quòd ad noxam sit pigrior, & salutem dextera manus proptior largiatur. Hinc est quòd eidem attribuitur medendi potestas: quia temperatus solis calor morborum fuga est. Nam tam $\dot{\omega}\varsigma\ \dot{\alpha}\pi\epsilon\lambda\alpha\dot{\nu}\nu o\nu\tau\alpha\ \tau\dot{\alpha}\varsigma\ \dot{\alpha}\pi\acute{o}\lambda\lambda\omega\nu\alpha$, quàm $\dot{\alpha}\pi\acute{o}\lambda\lambda o\nu\nu\tau\alpha$, cognominatum putant." English modified from Macrobius 1969, 115ff.

24. Varchi 1859, II, 353: "APOLLO questo è nome greco, come ancora Febo, e da diversi Autori è interpretato quanto alla timologia e dirivazione sua diversamente, conciosia che

alcuni volgiono che egli sia così detto dal verbo 'Aπόλλιν, che significa uccidere, alcuni altri dal verbo 'Aπαλλάττιν, che significa liberare; ed amendue queste significazioni, benchè contrarie, se gli convengono, non essendo Apollo in verità altra che il sole . . . Le saette che gli danno non sono altro che i raggi solari, i quali o per eccitare troppo caldo o per mala disposizione della terra e dell'aria nuocono molte volte, e perciò lo fanno, come si vede nel principio dell'Iliade d'Omero, autore della peste; onde come di sopra giovando si poteva chiamare Apollo dal conservare, così qui nocendo si può chiamare Apollo dall'ammazzare."

25. Ferrero, 951–2.

26. Ibid., 509. My translation supposes that *arte* is the subject of the verb *fé*, though *quella* in line two is, grammatically at least, just as possible. In the latter case, the question would be what *quella* refers to.

27. Poems by Cellini's contemporaries demonstrate the degree to which even they regarded Cosimo's abuse of the sculptor as an encouragement to his art. See esp. the series of sonnets signed "A.P.," that were sent to Cellini while he was imprisoned (discussed below, pp. 204–5, n. 12).

28. Ovid, 263 (10.185–95): "expalluit aequè / Quàm puer ipse Deus conlapsosque excipit artus, / Et modò te refouet, modò tristia vulnera siccat. / Nunc animam admotis fugientem sustinet herbis. / Nil prosunt artes: erat immedicabile vulnus. / Vt si quis violas riguoque pa- pauera in horto, / Liliaque infringat fuluis haerentia virgis, / Marcida demittant subitò caput illa grauatum. / Nec se sustineant spectentque cacumine terram: / Sic vultus moriens iacet, & defecta vigore / Ipsa sibi est oneri cervix, humeroque recumbit." Cautio, 9r, translates the passage as follows: "Non men si dolse, e di color dimorte / Diuenne Apollo, che'l fanciul ferito, / E piglia in braccio il tramortito corpo. / Hor tutto lo riscalda, hora dolente / Asciuga la percoßa, e'l uiuo sangue: / Hora con la uirtù di possenti herbe / Ritien l'aura uitale, che si fugge. / Ma non giouano nulla herbe, od incanti, / Che la rudel ferita era mortale. / Come se nel giardin Viola, o Giglio, / O Papauero uien percoßo, e rotto, / Tal che pur resti ancor sul uiuo stelo: / Quei tosto priuo di uirtute inchina / Il greue capo, e sostenir non puoi, / E con la cima guarda il uerde suolo. / Cosi uicino a morte quel bel uolto / Giacer si uede, e priuo di uigore / Esser greue a se stesso il collo in carco, e / Languido starsi ne l'ignuda spalla."

29. Ovid, 263 (10.180–1): "Decidit in solidam longo pòst tempore terram / Pondus, & exhibuit iunctam cum viribus artem." Cautio, 8v: "Il Disco cadde ponderoso e duro, / Con segno espresso di possanza e d'arte."

30. Ovid, 263 (10.198–9): "Mea dextera leto / Inscribenda tuo est, ego sum tibi funeris auctor." Cautio, 9r: "Io stesso son l'autor de la tua morte."

31. Ovid, 263 (10.204–6): "Semper eris mecum, memorique haerebis in ore. / Te lyra pulsa manu, te carmina nostra sonabunt, / flosque nouus scripto gemitus imitabere nostros." Cautio, 9v: "Da i Fati, ch'immorta mi fanno, sempre / Mi starai nel cor fisso, e sempre in bocca. / Te sonar à la Lira mia, i miei Versi / La tua bellezza canteranno, e'l nome: / E poi che sarai nato Fior nouello, / Porterai scritto 'l segno de miei guai."

32. Ovid, 264 (10.215–16): "Ipse suos gemitus folijs inscribit, & hya / Flos habet inscrip- tum, funestaque littera ducta est." Cautio, 9v: "Ma gli isteßi suoi guai, e'l suo dolore / Volse notar ne le purpuree foglie: / E fu scolpita la funebre nota, / E porta scritto il mesto fior Ai Ai."

33. Ovid, 264 (10.214): "Fuit auctor honoris"; Cautio, 9v: "Egli fu autor d'honor cotanto."

34. Dante, *Paradiso* 1.13–15 reads: "O buono Apollo, all'ultimo lavoro / Fa me del tuo valor sì fatto vaso, / Come dimandi a dar l'amato alloro." See also Varchi's gloss on the lines: "SÌ FATTO VASO DEL TUO VALORE, ciò è empimi di maniera della grazia e favore tuo; COME DIMANDI, come tu ricerchi e richiedi; A DAR L'AMATO ALLORO, innanzi che tu coroni e conceda l'alloro amato da te, ciò è in sentenza: fammi ale quale debba essere un degno poeta"; Varchi 1859, II, 352. For Duke Cosimo's use of Apollonian

themes, see esp. Kemp 1974. For the use of Apollo in early modern court imagery more generally, see Fumaroli, 19–182.

35. For interpretations of the work with reference to Cellini's sexuality, see Saslow, 152, and Barkan 1991, 106–11.

36. Ovid, *Heroides* 5.145 and *Tristia* 3.3.10. See also Wernicke.

37. Barocchi 1960, I, 16: "Dell'arti alcune sono, secondo la distinzione di Galeno, vili et indegne, come quelle che s'esercitano colle forze e fatiche del corpo, che i Greci dall'operare delle mani chiamano *chirugicas*, cioè manuali; altre oneste e liberali, fra le quali pone primieramente la medicina, la rettorica, la musica, la geometria, l'astronomia, l'arismetica, la dialettica, la gramatica e la scienza delle leggi; né vieta che fra queste si ponga la scultura e la pittura, perciocché, se bene adoperano le mani, non però hanno bisogno principalmente delle forze del corpo."

38. See above, p.1, as well as Farrago's remarks on Leonardo's and Galen's views on productive vs. nonproductive arts, 377–8.

39. Barocchi 1960, I, 19: "La medicina è la più degna e la più nobile di tutte l'altre, e la cagione è perché ha il fine più nobile e più degno, il quale è, come si disse di sopra, o conservare la sanità dove ella è, o indurla dove manca; alla cui nobiltà se ne aggiugne un'altra, cioè quella del subbietto, il quale avanza di gran lunga e trapassa tutti gli altri, essendo l'uomo infinitamente più perfetto di tutte le cose mortali."

40. Segni, 1.1: "Et conciosia chè molte sieno l'operationi, l'arti, & le scienze, però anchora interviene, chè molti sieno li fini, perchè nella medicina il fine è la sanità: nell'arte del fabbricare le navi essa nave: nell'arte militare la vittoria & in quella del governo di casa il fine vi è la ricchezza."

41. See Cellini's *Discorso sopra i principi e 'l modo d'imparare l'arte del disegno* (*Discourse on the Principles and on the Method of Learning the Art of Design*), Ferrero, 827–35. On Michelangelo and anatomy, see Holman, Summers 1981, 397–400; Elkins 1984; Mayor; Schultz; and Cazort. Also of interest to the present discussion is Métraux.

42. Saslow's identification of Guidi as the model for Cellini's *Apollo and Hyacinth* (236, n. 15) is based on a misreading of one of Cellini's poems.

43. Guidi 1611b, II, 10: "... vt aliae ipsa effectione contineantur, nec aliquod opus praestent; aliae praeter effectionem opus factum relinquunt perfectius effectione quae ad ipsum dirigitur. In sola actione seu effectione consistit Palestra, ludorum, tybicinum, & citharoedorum peritia, quarum perfectio in ipsa effectione consistit. Relinquit opus post effectionem Pictura, ars fingendi, ars aedificandi. Medicina [Gal. ibi] cum sanitatem faciat quae post effectionem manet, illis artibus adnumerari debet quae non habent finem in faciendo, sed ad opus diriguntur quod relinquendum est."

44. Ibid., II, 10: "Idem quoque accidit arti fingendi, quae multiplex est licet finem unum communem habeat, ut signum & statuam, & una esse videatur, sed alius artifex signa fungit ex aere fuso, alius ex cera format, alius exprimit ex marmore uel alio lapide: Quod si interdum idem homo haec omnia praestet, non propterea tollitur quin artes plures sint inter se differentes. Eadem ratio est sanitatis quam variae artes intendunt, sed medicina proprie in corpore humano. Ex his iam patet quid sit subiectum medicinae: non enim sanitas aut homo, sed corpus [Gal. lib. 1 aphoris comment 1] humanum: vt aliarum artium alia est materia, ueluti lapis, lignum aut aliquod metallum."

45. Guidi 1611b, II, 61: "Ergo cum gignitur aliquid, efficitur noua substantia quae prius non erat, haec neque materia, [Aristo. 7 Metaphys. tex. 26.27 & 53] neque forma est, sed quod ex vtraque componitur ... Idem vsu venit artibus, neque enim efficitur signum aut aes, sed aeneum signum: subijcitur enim materia quae iam est, neque gignitur, sed compositum ex ea fit per formam, quam accipit." For Guidi's term *compositum*, cf. the comments and references above, p. 41.

46. Barocchi 1960, I, 12: "Ancora è da sapere che tutto quello che si fa in tutte le arti da

tutti gli artisti, si fa in ordine e per cagione del fine; e se i medici medicano alcuna volta le infermità incurabili, o s'ingegnano di prolungare la vita senza speranza del fine, o inducono alcuna volta la bellezza tanto naturale quanto artifiziale, non è che il fine vero e propio di tutta la medicina non sia uno solo, cioè la sanità, e gli altri si possono dire aggiunti e quasi accidentali."

47. See Milanesi 1857, lvii: "La Medicina è fatta con ragione./Avicenna, Ipocrate e Galieno/Hanno fatto 'l bilancio, e molto pieno;/Ma e' non derno 'l bilancio alle persone./Quand' a sanar un corpo si compone,/Non lo può far, perchè, o più o meno,/Avvien ch'e corpi ponderati sieno;/E perciò falla chi sanar prepone./Che se 'l medico avesse apponto in mano/La sanità, un sol ne basteria;/Ma fan qual balestrier che tra' nel brocco:/Acconcia il punto all' oriuolo, avvia,/E crede dar nel segnio al primo iscocco;/Po' non truova la grotta, e 'l tratto è vano./Sappi, se no' crediàno/Esser maestri s'intende, e più si scosta il vero."

48. Ferrero, 908.

49. The attractive idea that the poem might actually *be* a reply to a dinner invitation was suggested to me by Mary Pardo.

50. Barocchi 1960, I, 16–17: "Dell'arti alcune fanno cose che si possono fare solamente da l'arte sola, e queste si dicono vincere la natura, come l'architettura; alcune si possono fare dall'arte e dalla natura parimente, come la sanità e l'archimia."

51. The *dichiarazione* (which is mistranscribed in Calamandrei, 145), reads: "Il gran Pianeta del Sole, questo è, sol la Lucerna dell'vniverso e gli Antiqui e maggior nostri lo figurarano e dimostrarano per la figura d'Apollo e pérché dopo quel gran diluuio, che ricoperse tutta la terra, essendose ritornate tutte l'Acque à i lor luoghi, era restata una nebbia foltissima che non lasciaua germinare la terra, ma il Sole con la uirtu de'razzi tanto ferì la nebbia che la risolve: Onde gli Antiqui figurarano Apollo con l'Arco et le saette con le quali ferì Phitone serpente che così fabola puosero nome a quella folta nebbia: e così io l'ho messo in disegno parendomi che la nostra Academia del Disegno sia degna di questa bella Impresa: perche sì come questo è, la vera Lucerna di tutte le Azzioni, che fanno gli Huomini in ogni professione; perche il Disegno è i due sorte, il primo è quello che si fa nell'Immaginatiua, e il secondo tratto da quello si dimostra con Linee, e questo ha fatto l'huomo tanto ardito, che egli si è messo a ghareggiare con questo gra padre Apollo, il quale fa nascere le piante, e l'herbe, e i fiori, e gli Animali, cose tutte merauigliose e ornamento della Terra, dove l'huomo con il suo disegnio ha fabricato in su questa Terra le gran Cittadi con gli stupendi Palazzi, Theatri, Templi, Torri, Loggie, Case e Ponti di poi gli ha addornati di belle figure, d'Animali, di Marmi, di metalli, e la parte di dentro di Questi mirabili Edificij gli ha addornati di Pitture, dipoi ha ornato se stesso di Gioie, e d'oro, e tutto questo ha coll'Artificio del mirabile Disegno; e perche Questo Apollo è, il suo vero Maestro, per questo adunque mi è parso ch'egli sia la sua Insegna." On the seal, see also Kemp 1971 and Winner, esp. 431.

52. Della Porta 1560, 129v: "Un'artificiosa applicatione de gli agenti naturali a suoi debiti e conuenienti suggetti."

53. Ibid., 130v: "Per Pithone e per Febo le due cose principali che usanno in tal mestiero, lequali tanto nelle opere naturali quanto artefitiali si debbono prima trouare: cioè il suggetto o uogliamo dire la materia, e l'Agente, s'uno dequali, bisogna che riceua l'operatione e l'altro operi."

54. Ibid., 129v: "La natura quando la puo, con la forza del calor celeste cauando delle cose cattiue quel meglio ch'ella possa, ella transmuta in animali, introducenoui spirito e uita, accio che non offenda tanto i uiuenti, e le operationi delle cose piu perfette."

55. Cf. BNCF Magl. 16, 43, 100v–101r: "ha in se virtù di congelare et trasmutare l'argentò vivo vulgo in vera natura metallica formale e sustantiale, e ridurre tutti li imperfetti metalli a vera et perfetta sanità" ([the body made by putrefaction] has in itself the power

to congeal and transmute common quicksilver into a true formal and substantial metallic nature, as well as to reduce all imperfect metals to true and perfect health).

56. See Boschini, 711: "con rigorosa osservanza li esaminava, come se fossero stati suoi capitali nemici, per vedere se in loro poteva trovar diffetto; e scoprendo alcuna cosa, che non concordasse al delicato suo intendimento, come chirurgo benefico medicava l'infermo, se faceva di bisogno spolpargli qualche gonfiezza, o soprabondanza di carne, radrizzandogli un braccio, se nella forma l'ossatura non fosse così aggiustata, se un piede nella positura avesse presa attitudine disconcia, mettendolo a luogo senza compatir al suo dolore, e cose simili. Così, operando e riformando quelle figure, le riduceva nella più perfetta simmetria che potesse rappresentare il bello della Natura e dell'Arte; e doppo, fatto questo, ponendo le mani ad altro, sino che quello fosse asciutto, faceva lo stesso" (he examined [his works] with a rigorous eye, as if they were his arch-enemies, to see whether he could find any defect in them. And if he discovered anything that did not correspond to his careful planning, he doctored the sick thing, like a good surgeon, sometimes stripping away a swelling or a bit of excess flesh, sometimes straightening an arm, if, in its form, the skeleton was not properly adjusted, sometimes, if a foot, in its position, had taken an awkward posture, putting it in its place, showing no sympathy to its pain, and similar things. Thus operating and re-forming those figures, he reduced them to the most perfect symmetry that the beauty of nature and art could represent). Cf. 216, n. 20 below.

57. See esp. Vasari's 1550 report of Michelangelo's criticism of Francia for admiring the bronze of his *Julius II* more than the form: "Veggendo egli l'artificio di Michele Agnolo, stupì. Per il che fu da lui domandato che gli pareva di quella figura: ripose il Francia che era un bellissimo getto. Intese Michele che e' lodasse più il bronzo che l'artificio, per che sdegnato e con collera gli rispose: 'Va al bordello tu e 'l Cossa, che siete due solennissimi goffi nell'arte" (Seeing the artifice of Michelangelo he was stupified, and he was consequently asked how the figure seemed to him. Francia replied that it was a most beautiful cast. Michele, having heard Francia praise the bronze more than the artifice, was filled with disdain, and he wrathfully replied, "You and Cossa can go screw yourselves, for you are absolute fools when it comes to art"). The different versions of the story are collected in Barocchi 1962, I, 34, and II, 395.

58. On the portal as a whole, the best recent discussion, one almost unique in the literature for treating the Cellini and Primaticcio contributions together, is that of Herrig, 142–73.

59. Ferrero, 440: "io la facevo stare con gran disagio parecchi e parecchi ore; e stando in questo disagio a lei veniva molto affastidio, tanto quanto a me dilettava, perché lei era di bellissima forma e mi faceva grandissimo onore."

60. Vickers's fundamental discussion concludes by suggesting that the imagery evokes the themes of cuckoldry that appear in Cellini's autobiographical account of his time at Fontainebleau. Alternative interpretations of the horns Hercules wears in Primaticcio's fresco, interpretations that may bear implications for Cellini's devices as well, are offered in Huemer, and in Philip Ford, "L'Hercule androgyne: *Le Satyre* de Ronsard et la Porte dorée à Fontainebleau" (forthcoming).

61. Ferrero, esp. 829: "E perché in tutte le nobilissime arti la maggiore importanza che è in esse, volendole vincere e dominare, non in altro consiste che nel pigliare animo sopra di loro, e' non sarà così pusillo animo di fanciullo che, cominciando a ritrarre un tal bastoncello d'osso, che non si prometta di farlo, se non alla prima, alle due benissimo."

62. See Cropper 1996, and Cole 2001a.

63. Much of the Cellini literature adopts the opinions of its subject, and dismisses Bandinelli's sculpture as crude and unoriginal. A more careful review of Cellini's own sources, however, should raise doubts about the fairness of this judgment. Many of the large works Cellini undertook in Florence responded to, and even borrowed from, Bandinelli's

own inventions. The *Cosimo I* portrait, for example, seems related to a print Bandinelli designed for Niccolo della Casa in 1544, while Cellini's undertaking of his tomb responded to Bandinelli's engagement on a similar project. See Langedijk, I, 444–5, and Lavin 1977.

64. The most recent discussion of and bibliography on the Cellini/Bandinelli rivalry is Vossilla 1997; see esp. 292. Vossilla, who refers to the figures at various points as "Victory" and "Prisoner" types, draws particular attention to the relationship between the *Apollo* and the *Hercules*.

65. Giovanni Bottari, *Raccolta di lettere sulla pittura, scultura ed architettura scritte da' più celebri personaggi dei secoli xv, xvi, e xvii* (Milan: G. Silverstri, 1822), I, 104: "Ma sappia certo vostra signoria, se queste istorie non le fa uno valente disegnatore, la chiesa e questa età sarà bruttissima memoria per l'eccellentissimo paragone, chè Benevenuto è molto più atto a rinettare simili istorie, che a farle da sè, come in verità si vede per le sue figure, che, posto sieno piccole, usa farle piene d'errori, ed enne causa il non avere alcuno disegno." (But Your Lordship certainly realizes that if a valient *disegnatore* does not make these reliefs, both the church and our age will leave, by comparison to other more excellent works, a hideous memory of themselves. Benvenuto is more suited to cleaning reliefs like this, than to making them on his own, as one sees, in truth, in his figures, which, even though they are small, he is accustomed to making with many errors, the cause being that he has no *disegno*.)

66. See BRF 2353, fol. 20v: "io sono istato tre mesi che io non mi sono guadagnato niente Merce dun certo maestro Dante scultore che istava gia col cavaliere Bandinelo."

67. I am grateful to Louis Waldman for clarifying Bandinelli's position at the Duomo for me; see also Pope-Hennessy, 224.

68. Ferrero, 510.

69. Ibid., 913, on the "bel volto" of the model who posed for Apollo. Note also that Cautio's translation of the story draws attention to Hyacinth's "bel uolto" (cf. n. 28 above).

70. Ibid., 508: "Questa virtuosa Scuola dice che se e' si tosassi i capegli a Ercole, che e' non vi resterebbe zucca che fussi tanta per riporvi il cervello; e che quella sua faccia e' non si conosce se l'è di omo o se l'è di lionbue; e che la non bada a quel che la fa, e che l'è male appiccata in sul collo, con tanta poca arte e con tanta mala grazia, che e' non si vedde mai peggio; e che quelle sue spallacce somigliano due arcioni d'un basto d'un asino; e che le sue poppe e il resto di quei muscoli non son ritratti da un omo, ma sono ritratti da un saccaccio pieno di poponi, che diritto sia messo, appoggiato al muro. Così le stiene paiono ritratte da un sacco pieno di zucche lunghe; le due gambe e' non si conosce in che modo le si sieno appiccate a quel torsaccio; perché e' non si conosce in su qual gamba e' posa o in su quale e' fa qualche dimostrazione di forza; né manco si vede che ei posi in su tutt'a dua, sì come e' s'è usato alcune volte di fare da que maestri che sanno qualche soa; be si vede che la cade innanzi più d'un terzo di braccio; che questo solo si è 'l maggiore e il più incomportabile errore che faccino quei maestracci di dozzina plebe'. Delle braccia dicono, che le son tutt'a dua giù distese senza nessuna grazia, né vi si vede arte, come se mai voi non avessi visto degl'ignudi vivi, e che la gamba dritta d'Ercole e quella di Cacco fanno ammezzo delle polpe delle gambe loro . . . "

71. Vasari-Milanesi, VI, 149: "Ercole, il quale avendo rinchiuso il capo di Cacco con un ginocchio tra due sassi, col braccio sinistro lo strigneva con molta forza, tenendoselo sotto fra le gambe rannicchiato in attitudine travagliata, dove mostrava Cacco il patire suo e la violenza e 'l pondo d'Ercole sopra di sé, che gli faceva scoppiare ogni minimo muscolo per tutta la persona."

72. Ibid., VI, 160: "Considerando l'aria poco la favorisse, facendo apparire i muscoli troppo dolci; però fatto rifare nuova turata d'asse intorno, le ritornò addosso cogli scarpelli et affondando in più crude che prima non erano."

73. Ferrero, 900.

74. On this, and on the other satirical sonnets directed at Bandinelli, see most recently Barkan 1999, 271–89.

75. Waldman, 424: "Chi dice gl'ha giardoni; / altri voglion' ch'i'sia advenenato, / parendo lor' in omgni part enfiato."

76. Cf. Ferrero, 506, where Cellini has Bandinelli attack the antique marble *fanciullo* sent to Cosimo from Rome on grounds that "questi antichi non intendevano niente la notomia."

77. See Vasari-Milanesi, VI, 155; also Bush, 118–30.

78. Ferrero, 835: "E per mostrartene un esempio e allegarti un autor grandissimo, vedi le opere di maestro Michelagnolo Buonarroti; ché la sua alta maniera è tanto diversa dagli altri e da quella che per l'addietro si vedeva, ed è tanto piaciuta, non per altro che per avere tenuto questo ordine delle ossa: e che sia il vero, guarda tutte le opere sue tanto di scultura quanto di pittura, che non tanto i bellissimi muscoli ben posti ai luoghi loro gli abbian fatto onore quanto il mostrare le ossa."

79. Cellini, 55v: "La loro creazione si faccia di terra grosa vntuosa congiunta con la commistione dell'acqua, & che poi di terra in fango, & di fango in pietra si riduchino per lo mezzo de raggi del Sole."

80. Ibid., 56r: "quanto più la regione è uicina all'Oriente & al Mezzodì, come l'India e l'Etiopia, tanto più fine et preziose pietre in quelle si generano, per lo contrario quanto più sono distanti dal Sole men lucide & men fini vi nasceranno."

81. Ibid., 55v: "Doppo questa prima grana ho osseruato andarsi negl'altri marmi sempre assottigliando."

82. Ibid., 56r: "Difficilißimi à lauorare, essendo che da i detti smerigli sono mangiati gli scarpelli d'ogni sorte, e talhora saranno vergati da vna delle dette macchie, le quali ingannano facilmente l'Artefice; percioche di fuora sono ricoperti da vna scorza candidißima, & dentro poi celano tali magagne, per le quali si rende brutte e sgraziate l'opere."

83. Ferrero, 791.

84. Cellini, 56r: "inispazio di tempo la detta pietra piglia una durezza quasi com'il marmo, & massimamente nella superficie."

85. This is, intriguingly, a reversal of the influential model Aristotle laid out in the *Physics*, according to which the artificer's assignment was nothing other than the finishing of the creative work nature had begun; see *Physics* 2.8, and comments in Kaufmann 1995, 176–7.

86. Cesalpino, 89. See also the definition in Boselli, fol. 2: "la Pittura imita con li Colori, la Poesia con le Parole, et la Scultura con la candidezza, et durezza, de' Marmi."

87. Ferrero, 981–2.

88. Tassi, 193: "Il crocifisso fatto da me di marmo, quale è di grandezza braccia 3 ¼, in su una Croce di marmo nero, fatto a tutte mia spese e a mia satisfazione, solo per mostrare se con la forza dell'arte mia io potevo trapassare tutti i mia maggiori, i quali non si erano mai provati a tale impresa . . ."

89. Ferrero, 350. Cellini connects the vision to the tomb project in his first testament: see Calamandrei, 73. For other discussions of the vision, see esp. Goldberg and Gallucci 2000.

90. *Paradiso* 1.60.

91. Ibid., 14.103–8.

92. The poem was included in the sonnets by Varchi published in 1573, and is reprinted in Milanesi 1857, 360. The final stanze read: "À me dotto CELLIN prose, nè carmi, / Per far del regno glorioso acquisto / A voi non gioveran bronzi nè marmi / Pigliar la croce addosso, e seguir cristo / Bisogna, se vorrete od io salvarmi. / Pigliam dunque la croce, e

seguiam Cristo." A manuscript version of the sonnet is preserved among Cellini's papers, ARF 2728, 16r.

93. Ferrero, 567. On Cellini's use of black and white marble, see the discussions of Gajante, Lavin 1977, and Lavin 1998.

94. On the relationship between Christ and Apollo, see, e.g., Kantorowicz 1951, 325–38.

95. Ferrero, 808: "Si dipinge in dua modi: l'uno è quello che immita con tutti i colori quell che la stessa natura dimostra; l'altro si è quello che si domanda dipingere di chiaro e scuro."

96. The fundamental discussion of Cellini's testaments and codicils is Calamandrei 59–98; see esp. 77: "In fresco di colore giallo né d'altra diversione di colori, il qule puro colore si domanda fare di chiaro e scuro."

97. See Heikamp 1964, 65: "Chi dice: e' sembra il Tebro, Arno, o Mugnone; / altri un gigante che posto si sia / stracco a dormir per qualche gran fazione."

98. Ibid., 66: "U' fante grosso, biancho, unico e bello / à messo ove tu sai, onde profani / il tempio sommo de' veri Cristiani: / o giusto sangue, o mansueto agniello!"

99. Borghini 1584, 161: "Voi non darete tante lodi al Dio Padre, che è su l'altare, il quale mostra piu del marmo, che dell'arte."

100. "Sonetto in nome di Baccio Bandinelli quando fece l'Ercole, e Cacco in Firenze," BNCF Magl. 7, 873, 53–4: "Fassi fede per mè Baccio scultore / Com'io rinuntio al mio Gigante il segno, / e follo cavalier, che n'è più degno, / Pur con consenso dell'Imperadore. / Io mi vo' ritornare al Dipintore, / e lasciar la scultura pe'l disegno; / Ditemi non ho io hauuto ingegno / In fatti a ravvedermi dell'errore? / E s'io son stato Baccio scarpellino, / Non è che 'l mio Gigante non sia bello, / E bianco, e biondo com'un ermellino; / E se così non s'assimiglia a quello / Che 'n piazza de' signor gli stà vicino, / Non è però che non sia suo fratello. / Scusimi quel modello, / Ch'io feci già per imparar di terra, / Che par un san Cristofano alla sgherra; / Non hà colpa chi erra / Quand'e' non sà più là che si bisogni / Perch'a far un Gigante non son sogni; / Perch'io non mi vergogni / Dirò ch'io non son Baccio, e non son sano, / Così fò fede di mia propria mano."

101. Bush, 149. For recent discussions of Bandinelli's *Christs*, see Vossilla 1996a and 1996b, and Barkan 1999.

102. See Alfonso de' Pazzi's satire on the *Perseus* in BRF 2907, 35r: "Corpo di vecchio e gambe di fanciulla / Ha il nuovo Perseo: e tutto in sieme / Ci puo bello parer' ma non val nulla." (The new Perseus has the body of an old man and the legs of a girl: and the whole thing together might appear beautiful to us, but it is worthless.) This may also lurk behind a topos of Cellini's *Autobiography*, his insistence to his patron, virtually every time he shows a presentation model, that the large version will also turn out well. On Pazzi's antagonism toward Cellini, see Heikamp 1957, 144–5 and Plaissance, 421.

103. For a related discussion, see Arasse, 72–91. My identification of the Christ Child follows Steinberg.

104. See Barkan 1991, 110.

105. On Cellini's strategic gift-giving, see Cole 1998.

106. For the exactly contempory fountain of Asclepius, commissioned by Cosimo, designed by Tribolo, and carried out by Antonio Lorenzi at Castello, see Keutner.

107. For this, and for the identification of Cosimo and Apollo, see esp. Middeldorf; Kemp 1974; and Langadijk, I, 93–5.

108. On this pun, see Cox-Rearick 1984, 18 and *passim*.

109. Segni, 540–1 (10.9).

110. Cf., e.g., address of the final stanza of Michelangiolo Vivaldi's sonnet on Cellini's *Perseus* to "Cosimo . . . a cui piacque / Difendere e nutrir mastro sì raro." (Cosimo, who is pleased to defend and nourish so rare a master.) Milanesi 1857, 404. Some of the features of Cellini's cuirass, including the muscled surface, the mustachioed heads at the shoulders, and

the Medusa head on the breast are conventional ones. The inclusion of the eagles, however, seems to have no precedent. They evoke the imagery of Jupiter, recalling both the figure of Jupiter (who, in the inscription beneath, promises to punish *Perseus*'s enemies) that Cellini included on the comtemporary *Perseus* socle, and the eagle of Jupiter that completes the identity of Cellini's restored marble *Ganymede* (on which, see Chapter 4). These figures imply Jupiter's role, respectively, as protector and admirer, and they can consequently be regarded as consistent with the actions of the patron implied by Cellini's portrait. For a survey of classical portraits with muscled cuirasses, see Vermeule. On Cellini's bust, see Pope-Hennessy, 215–18 (with further bibliography).

111. In a 1547 letter to Varchi, Cellini writes that "la pittura non è altro che o arbero o uomo o altra cosa che si specchi in un fonte." (Painting is nothing other than a tree or a man or another thing that is reflected in a fountain), an allusion to Alberti's mythical account of the invention of painting: "Io sono usato dire fra amici, che l'inuentor de la pittura sia stato quel Narcisso, il quale secondo l'opinion de i Poeti fu mutato in un fiore. Percioche essendo la pittura fiore di tutti l'arti tutta la fauola di Marcisso alhoro si confarà a questa materia. Perche che altro e dipingere, che abbracciare con arte quella superficie de la fonte?" (I am accustomed to saying to friends that the inventor of painting was that Narcissus, who, according to the opinion of the Poets, was transformed into a flower. Since painting is the flower of all the arts, the entire fable of Narcissus now suits this material very well. For what else is painting, but embracing with art that surface of the fountain?) See Ferrero, 983, and Alberti 1547, 19r. Claudia Nordhoff was the first to recognize the allusion to Alberti; she discusses it in the context of his interest in *paragone*. See Nordhoff, 205–14. On Cellini's use of the flower as a figure for his art, see the important discussion in Kemp 1974, esp. 222 and 233. It may well also have been relevant to Cellini that Ovid has the transfixed Narcissus become "like marble," and that Callistratus wrote an ekphrasis on a Narcissus statue; see Pfisterer 2001, with extensive further bibliography.

112. Ferrero, 61.

113. Barolsky, 118ff., helpfully discusses Cellini's remarks about inventing the escutcheon, but does not mention the surviving drawing. Stylistically, the best comparandum for the drawing is Cellini's sheet from the late 1550s showing designs for Cellini's tomb. Compare Fig. 3, and the comments in Cole 1998.

114. Lions function virtually as signatures across Cellini's work: A lion's head appears on the *Saltcellar*, lion's feet on his tomb, complete lions on most of his seal designs. He refers to casting bronze in a city (Florence) he calls "Lion"; when calling on sculptors to abandon Vasari's *scuola*, he enjoins them to leave the bull (of St. Luke) for the lion.

Chapter Four: The Design of Virtue

1. Vieri 1568, 54–5: "Scoltura, è un'arte, per la quale si rappresenta qualche persona degna à fine di mantenere uiua la vertù & la gloria di quella nella memoria degli'huomini."

2. See Calamandrei, 3.

3. See Symonds, xii.

4. See Cortissoz, xxv.

5. Pope-Hennessy, 255.

6. Goethe, 500: "Bei dieser Empfänglichkeit für sinnliche und sittliche Schönheiten, bei einem fortdauernden Wohnen und Bleiben unter allem was alte und neue Kunst Großes und Bedeutendes hervorgebracht, mußte die Schönheit männlicher Jugend, mehr als alles, auf ihn wirken."

7. Goethe, 501: "Unserm Helden schwebt das Bild sittlicher Vollkommenheit, als ein unerreichbares, beständig vor Augen."

8. Ferrero, 59: "Tutti gli uomini d'ogni sorte, che hanno fatto qualche cosa che sia

virtuosa, o sì veramente che le virtù somigli, doverieno, essendo veritieri e da bene, di lor propia mano descrivere la loro vita."

9. Borghini 1974, 44: "La virtù nell'uso comune è molto generale, e pare che *virtuoso* e virtù importi cosa buona congiunta coll'eccellenza e si distende a molte cose, perché non solo nelle affezioni dell'animo, giustizia, prudenza, e altre morali, ma agli abiti dell'intelletto, come sono le scienze, si distende, e non solo a queste ma alla pratica delle cose ancora; e così si dice *virtuoso* un casto e temperato, un filosofo e dottore, uno architetto e musico. L'uso comune 'imparare o darsi alle virtù' è apparare qualche arte d'ingegno come lettere, musica ecc. . . . "

10. See Borghini 1990, 33: "La prima cosa a questo pare, che diretta mente si contrapponga l'opinione comune tenuta infin da' Legisti, che vuole, che ciascuno si possa a sua volontà pigliare arme, e che è peggio, si vede tutti 'l giorno come cosa piana mettere in opera: nè è sì vile arteficiuzzo, che non voglia oggi l'arme." (The first thing, regarding this matter, seems to be that it is directly opposed to the common opinion, held even by the legists, who wish that everyone be allowed, at will, to carry arms – and what is worse, we see every day, as plain as can be, that this desire is carried out. Today there is no vile artificer who does not wish to carry arms.) For Borghini's mockery of Cellini, see Barocchi 1973, I, 617–19.

11. Ferrero, 361: "Che d'allora in qua, che io tal cosa vidi, mi restò uno isplendore, cosa maravigliosa!, sopra il capo mio; il quale si è evidente a ogni sorta di uomo a chi io l'ho voluto mostrare, qual sono stati pochissimi."

12. The sonnet is one of a series of four poems that appear in BRF, MS Rice. 2728, folios 14-15. There are no corrections in this, or any of the other poems, which suggests that they are final drafts; this is not surprising if we take their presence among Cellini's papers to imply that they were sent to the sculptor. At the end of the fourth poem in the series are the letters "A.P.," which probably identify the author. Though this evidence is, in itself, somewhat slim, it should be noted that the only person with the initials A.P. who is known to have written other poems to Cellini is Alfonso de' Pazzi.

Pazzi was also the only writer who, at the unveiling of the *Perseus*, satirized it rather than praising it (see p. 202, n. 102 above), which might encourage skepticism about his authorship of these clearly sympathetic lines. In the same manuscript where the series is found, however, there is also a fifth sonnet, in the same hand as the four by "A.P." (fol 35r: Mabellini, 327-8, published a slightly different transcription, as anonymous) This poem, likewise written to Cellini, and like Pazzi's satire, written in a burlesque mode, reads as a kind of recantation:

> Io credittj esser escha à far' far' fuocho,
>> Benvenuto, peltuo diujno ingegnio,
>> Ma 'l succiesso e' contrario à'l mio disegnio
>> Che non m'ai mai risposto o molt'l pocho.
> Ond'io per l' advenir' vo' mutar' giuocho
>> Et quel ch' 'o schritto o ditto 'o per indegnio
>> Due dimè, è adisdirmi io vegnio.
>> Et lo sentenzio, et lo condanno a'l fuocho
> Et rinuntio a' castalie, et a' parnaso
>> Aghanippe, alle Muse, et vorrei ancho
>> Batter in terra d'Helichona 'lvaso.
> Et venir' poss' Apoll' il mal del fiancho
>> Et 'l figliuol' sia sbarbato non che raso
>> Et spenghinsi i poeti, et venghin' mancho
>>> Et rovjni anch' il bancho
> D'Anphione, et d'Orpheo, et d'Orione

> D'ogn'altro cerretan' ghoffo, et coglione
>> Che per non far quistione
> Techo, ò coll'altre tua virtù divine
> Misia testimon' questo della fine.

If the reference, in line 6, to "that which I wrote, or said," can be read in relation to Pazzi's jokes on the *Perseus*, the case for his authorship of the consolatory sonnets becomes very plausible. The final lines here, with their reference to Cellini's "divine virtues," are also well in keeping with the spirit of the later verses.

13. The conceit of the poem seems similar to one later employed by Goltzius. See the illuminating discussion in Melion 1995a.

14. Highlights in the literature on the place of *disegno* in sixteenth-century Italian art theory include Alpers, esp. 204ff.; Gombrich, 81–96; Rosand 1970; Barocchi 1973, II, 1897–2118; Kemp 1974; Summers 1981, 250–61; Barzman 1991; Hattendorff; Rubin, 241–6; Roggenkamp 1996a and 1996b; Williams; and Barzmann 2000.

15. See Panofsky 1968, 65, 82.

16. On *disegno* and absolutism, see Kemp 1974, esp. 233–8; Rubin, 95, 214; Williams, esp. Chapters 1 and 3, and Barzman 2000.

17. See Williams, introduction. Significant for the present discussion, it must be noted, is the way in which Williams shades his arguments through the chapters that follow. See, for example, his claim, on p. 49, that *"disegno* can be said to pervade all human activities," or that on p. 145, that *"disegno* presides over the virtues."

18. Vasari-Milanesi, I, 168: "Disegno . . . cava di molte cose un giudizio universale, simile a una forma ovvera idea di tutte le cose della natura."

19. Arguably, it is not even the best synthesis of Vasari's views. See the discussion in Williams.

20. Here and in what follows, I follow the intuition of Horst Bredekamp, who, in discussing Cellini's medals, has proposed to think of *disegno* as a "deed." See the section entitled "Cellinis Prachtmedaille. Disegno als Tat," in Bredekamp 1995 b, 46–54.

21. On Cellini's seals see Calamandrei, 123–146 and 165–71; Kemp 1974; Van den Akker, 9–10; and Lee, 156–67. Vasari recalled that the Academy sought a seal showing "i piú bei capricci e le piú stavaganti e belle fantasie che si possono immaginare"; see Vasari-Milanesi, VI, 659.

22. See above, Chapter 3, n. 51.

23. On this point, Cellini's argument about *disegno* bears comparison with that of Francisco de Holanda. In the second of Holanda's dialogues, he refers to the "great virtue and force of design" (*gram virtude e força do debuxo ou desenho*), maintaining that design is the art or science from which all others proceed. Among the activities which follow *debuxar ou pintar* (designing or printing) are agriculture, navigation, battle, and "all our operations, movements and actions" (*todas as mais nossas operações, movimentos e ações*). Significantly, Holanda's dialogue puts these ideas into the mouth of Michelangelo. See Holanda, 262–4, and Summers 1981, 257–61.

24. The text on Cellini's drawing reads: "Hauendo io considerato quanto queste nostre arti, che procedono dal disegno, siano grandi, non potendo l'huomo alcuna cosa perfettamente operare, senza riferirsi al disegno, dal quale egli trae sempre i miglior consigli, e perche io crederrei benissimo far capaci tutti gl'huomini con viue ragioni, à le quali non si potrebbe contradire, essere uerissimo, che il disegno essendo ueramente origine, e principio di tutte le azzioni dell'huomo, e solo quella Iddea uera della Natura, che fu da gli Antiqui con molte poppe figurata, per significare, ch'ella nutrisce ogni cosa, come sola, e principale ministra di Dio, che di Terra sculpi, e creò il primo huomo ad'imagine e similitudine di sè, et che per conseguenza non possono i professori dell'Arti del disegno hauere per Suggello, e per Impresa loro, niuna cosa, ne piu somigliante al uero, ne piu propria degli esercizij

loro, che la detta Iddea della Natura, come piu largamente dimostrarei, senza ristringermi a tanta breuità, se io non conoscessi voi tanti Artefici nobilissimi, non meno esercitati in discorrere le merauigliose opere della Natura che virtuosissimi, et excellenti nelle cose, che dal disegno procedono. Hora quanto della forma similmente del nostro suggello, hauendomi voi fatto degnio di dire il parer mio fra voi beliss[imi] Ingegni, che riaccendere il gran Lume poco manco che spento, di una cosi grande, e honorata scuola com'è, la nostra, et aiutati dalla diuina et immortal virtù del nostro Illustrissimo e gloriosissimo Duca Cosimo de Medici Amatore del uero."

25. For a similar play on words in Leonardo, see Belting, 481 and 554.

26. See Calamandrei, 133: "l'arte del disegnio si è la vera madre di tutte le azioni de l'huomo . . ." Importantly, the "idea della Natura" that Cellini later proposes as a figure for *disegno* is already present on the base of the *Perseus*; see above, p. 165. Meller, who was not aware of Cellini's *ricordo*, interprets the figure as a hieroglyph for "impossibility."

27. Cf. Federico Zuccaro, who calls *disegno* "a concept formed in our mind, that enables us explicitly and clearly to recognize any thing, whatever it may be, and to operate practically in conformance with the thing intended." Cited Panofsky 1968, 85; see also Rossi 1974; Kieft; Herrmann-Fiore 1982; Cropper 1984, Chapter 2; Pfisterer 1993; and Williams, 135–150.

28. Segni, 44 (1.7): "Come al Sonatore di Flauto, & allo Statuario, & à ciascuno Artefice avviene, & à tutti quegli, che fanno qualche operatione; chè l'essere, & il bene essere (dico) d'esse arti, & operationi consista in esse opere: così avverrà anchora à esso huomo, posto chè egli habbia uffitio alcuno, che sia propio di lui." Unless otherwise indicated, I have used Segni's edition of Aristotle to guide my English translations; I make reference to the Acciaoli Latin edition to clarify points of philological importance.

29. Ibid., 291 (6.4): "L'arte sia intorno all'effettione, et non all'attione."

30. Vieri 1568, 55: "Ma se qui alcuno mi dicesse, che queste due professioni cioè la Pittura, & la Scoltura sono arti ueramente fattiue, & non meritano di essere annouerate tra le notizie, che habbiano per soggetto le azioni nostre, & che siano attiue, io gli risponderei, che bene è uero, che quanto al modo dell'operare in materia esteriormente & di fuori, che non è pare di chi opera, elle sono assolutamente arti, ma rispetto al fine, donde si prende el nome, & donde si fà giudicio delle cose, elle sono da annouerarsi tra le dottrine, le quali hanno del morale & attiuo, per operare à fine di muouersi all'imitazione della uertuose operazioni degl'huomini di pregio."

31. Segni, 130 (3.3): "Il Consiglio è delle cose, che da noi si posson' mettere ad esecutione. Et questa sorte di cose ci resta à mettere sotto il Consiglio, chè invero le cagioni di tutti gli affetti pare, chè sieno queste, cioè Natura, Necessità, Fortuna & dipiù la Mente, & ciò, che procede dalla humana voglia. Non è anchora il Consiglio circa le discipline esatte, & che à bastanza si sanno, come è quella delle lettere; perchè e' non si consulta in qual' modo i caratteri si debbino scrivere, mà si consulta sopra di tutte quelle cose, che da noi si posson' fare, & dove non si tien' sempre il medesimo modo nel farle, com'è circa l'arte della medicina, & dell'arte, che è intorno a' guadagni, & di quella del regger' la nave tanto più ché della arte ginnastica, quanto ella è men'certa. Et il simile avviene discorrendo per l'altre facultà. Et maggiormente si consulta nell'Arti ché nelle Scienze, perchè circa l'Arte noi haviamo piu dubbii . . . "

32. Ibid., 131 (3.3): "Mà ciascuno havendosi imprima qualche fine pressuposto considera qualmente, & per quai mezi ei possa conseguirlo: & quando e'si può conseguire per più, e' considera per quali d'essi e' possa conseguirlo più agevolmente, & meglio; & sè e'non si può haverlo senon per uno, per qual via e'si possa haverlo per quello uno, & quello uno per quale altra, insino à tanto chè e' si pervenga alla cagion' prima, la quale è l'ultima, che si ritrova: perchè chi si consiglia pare, chè cerchi d'una cosa, & chè la risolva nel modo detto, non altrimenti ché avviene nella disegnatione delle linee."

33. On the Academy's requirement of *virtù*, see Barzman 1985, 325. For the connection of virtue and virtuosity, Fletcher; Carroll, 138–59, esp. 143; Melion 1995a and 1995b; and Jacobs 1997. Also relevant to all of the themes in this chapter is Summers 1987, 266–310.

34. Barocchi 1960, I, 31: "L'arti consultano e deliberano, e molte volte molto più che le scienze non fanno." See also Varchi's explanation that the arts are contingent (whereas the sciences are necessary), because their being depends on the variable actions of the artificer who practices them; Barocchi 1960, I, 10. On Varchi's use of the *Nicomachean Ethics* in his *Lezzioni*, see Rossi 1980; Summers 1981, 203–33; Mendelsohn; Cropper 1984, 77–8; Quiviger; and Roggenkamp 1996b.

35. Barocchi 1960, I, 26: "Sono bene l'arti e le virtù simili in questo, che amendue s'apparano coll'esercizio e col fare assai." For Varchi's reading of Aristotle in these lectures, see Cropper 1984, Chapter 2 (with further references), and Williams, Chapter 1.

36. Barocchi 1960, I, 44–5: "Il disegno è l'origine, la fonte e la madre di amendue loro." Barzman 1985, 39 and n.17, refers to the passages in Varchi, comparing them with Aristotle's definition of "principle" in the *Metaphysics*. Varchi could also have been thinking about the *Ethics*, where *principio* is a ubiquitous term. If Elizabeth Cropper is correct that "All the sciences, according to Varchi, belong to the contemplative intellect because their purpose is to contemplate the causes of things," whereas "[t]he arts, on the other hand, belong to the active intellect, which is concerned with doing and making," then Cellini's blithe reference to the *causa* that made him form the seals effectively collapses the distinction that Varchi upholds between the sciences and the arts. If this is the case, however, it may well have been Varchi himself who gave Cellini the tools to do this. See Cropper 1984, 78, as well as Cellini's comment, in Calamandrei, 133: "Hora io ritorno a quella causa che mi fa fare la forma del nostro suggello quadra, avendomi fatto degnio che io dica il mio parere," Calamandrei, 133. For further discussion of Varchi's distinction between the *arti* and *scienze*, see Williams, 34–40.

37. See above, p. 165.

38. See e.g., Shearman 1992, 51, n. 75.

39. Bonsignore, 27r: "Per la belva podemo anchor intendere moralmente & anchor che Perseo havesse lale: cioe se intende lhomo virtuoso elquale ha le penne angeliche. Per la belva intendo il demonio elquale e pieno di tutti gli vicii liquali sono morte de le virtute."

40. Agostini, 45v: "Per la Belua anchora si potria intendere moralmente lo inimico della natura, ilqual ben che posti assai vien scacciato, et in ogni impresa contra la virtu riman perdente."

41. See also the interpretation given in the anonymous fifteenth-century treatise published in Bode, 42: "Perseus . . . in figura virtutis ponitur."

42. One question raised in this chapter is whether "movement" is the best rubric under which to discuss the subject matter of the visual arts in Cellini's world, which consisted almost exclusively of dynamic human figures. David Summers and others have demonstrated the degree to which writers took recourse to a language focused on figural movement when describing works like Cellini's, arguing that artists were admired when, in a medium that was by nature still, they rendered the effect of energy, grace, or inner fire in their figures. Yet inasmuch as the works at issue often took virtue as their primary theme, we might ask whether this language of movement – a language derived above all from classical rhetoric, and a language that highlights qualities like naturalism and well-wroughtness – is always the one best suited for the figures it would explain, whether, in specific cases, what is shown can not also, or better, be described with the ethical language of *action*. What distinguishes an action from a movement? And what might an action, as opposed to a movement, look like?

43. Ovid, 110 (4.675–7): "Trahit inscius ignes, / Et stupet eximiae correptus imagine formae, / Penè suas quatere est oblitus in aëre pennas." The English translation is guided

here by the Italian of Dolce, 105: "Stupido gli occhi ne i begli occhi tiene, / Onde saetta in lui sì dolce lume, / E tal fiamma gli corre entro le uene, / Che quasi si scordò batter le piume."

44. Agostini, 44r: "Perseo come la uide prestamente / impugno il suo falcion da sir'ardito / e con cor animoso uirilmente / uerso di lei uolando ne fu ito."

45. Ibid., 47r: "Per Calliope madre di Andromeda sintende la superbia, per Andromeda che era ligata al sasso sintende la mente nobile, laquale per la superbia e rimossa & tolta da Dio, et e data al demonio, per Perseo sintende la uirtu, laquale tol la mente nobile & diuina per sua moglie, et la discioglie et libera dalle mani diaboliche con le belle & salutifere parole."

46. Segni, 474 (9.8): "L'huomo buono opera quello, che e' debbe, conciosia chè ogni mente voglia à se stessa quello, che è ottimo: & il virtuoso ubbidisce alla mente."

47. Ibid., 130 (3.3): "Invero le cagioni di tutti gli affetti pare, chè sieno queste, cioè Natura, Necessità, Fortuna & dipiù la Mente, & ciò, che procede dalla humana voglia." (In truth, it appears that the causes of all effects are the following: Nature, Necessity, Fortune, and, in addition, Mind, and that which proceeds from human will.)

48. Ibid., 281 (6.2): "L'elettione non possa esser' senza mente, & senza discorso, nè ancora senza il morale appetito; conciosia chè senza mente, & senza costume non si possa fare attion' buona; nè anchora attione, che sia rea. Mà essa mente niente muove, mà quella sola, che è per qualche fine, & che è operativa; Et questa tale signoreggia alla fattiva." For the translation of the term *costume* from the *Ethics* into Italian art theory, see Summers 1989, esp. 17ff.

49. Segni, 370 (commentary to Aristotle's comment at 7.8 that "la Virtù conserva il principio; & il Vitio lo distrugge"): "La Virtù conserva il principio (& questo è la mente) & il Vitio lo distrugge."

50. For the inscriptions, see Tassi, 490ff.; and Heikamp, 144, n. 1.

51. The roles of Mercury and Minerva (on whom, see below) are the easiest to account for, for the combination of wisdom and eloquence they represent is a topos of Renaissance academicism; see Kaufmann 1982, esp. 123ff., with a comprehensive bibliography of earlier literature on the subject. My tentative suggestion here is that the figures of Danaë (who, as Bronzino, at least, noticed, resembles Venus) and Jupiter be interpreted in the spirit of the other two. For an alternative view, which interprets the figures in the niches as the personae of specific Medici family members, and which takes the inscriptions to refer to specific events in Medici family history, see Brandt, esp. 410, n. 173.

52. Compare, however, Niccolo da Modena's portrait of King Francis I, which shows the ruler as a composite of the virtues of Minerva, Mars, Diana, Cupid, and Mercury; see Cox-Rearick 1996, 16–17.

53. For the art theoretical implications of this "ruse," see Marin, 115 ff.

54. See Fulgentius, *Mythologies* 1.21 and 2.1. According to the commentary accompanying the 1520 Italian edition of the *Metamorphoses*, Pallas equips Perseus with *sapienza*; according to contemporary editions of Boccaccio, Pallas offers "armed counsels." See Bonsignore, 26v, and Boccaccio 1545, 9r.

55. Tassi, 492.

56. Ibid., 491.

57. Ovid, 110 (4.673–5): "Vidit Abantiades, nisi quòd leuis aura, capillos / Mouerat, & tepido manabant lumina fletu, / Marmoreum ratus esset opus." Compare Dolce, 105: "Da lui la bella Donna fu ueduta / Legata, com'io dico, al mare a canto. / Vna statua l'hauria Pérseo creduta, / Se non uedea stillar da gli occhi il pianto." The importance of Ovid's diction to sixteenth-century artists is discussed by Muller, 143; Dempsey 1996a, esp. 206; and Vossilla 1997, 287.

58. By the 1540s, writers were arguing for the association between the rustic and Tuscan art as such. The symbolism of the rustic, political and otherwise, would have been of considerable importance to Duke Cosimo, who had moved in 1540 from the Palazzo Medici, the premier example of the stylishly rusticated private palace, to the former Palazzo della Signoria, one of the prototypes for rustication in Florence. There is evidence, moreover, to suggest that Cellini's awareness of recent theoretical propaganda about the "rustic." Working on architectural projects at Fontainebleau in the years immediately preceding the commission for the Perseus, Cellini would have had contact with the preeminent promoter of the rustic, Sebastiano Serlio. The snake on the back of the *Narcissus* pedestal, like the naturalistic details of the *Ganymede* base (Fig. 72), can be viewed as advisedly "rustic" motifs, as can these bases' very rockiness. I wish to thank John Pinto for suggesting the relevance of rustication in the context of the relief, and for guiding me into the extensive literature, of which especially relevant here is Ackerman, 495–541, with further references. The fundamental study of the rustic style as an issue for sculptors around Cellini remains that of Kris.

59. Brandt, 409–10.

60. On Cellini and the pursuit of many-sided sculpture, see Larsson, esp. 88–90.

61. Tassi, 485.

62. Ferrero, 821.

63. Cf. also the anonymous poem on the Perseus in Tassi, 489, in which the giving of *mente* is equated with the giving of life: "Non spectas vivum Persea et Andromeden, / Sed sic expressa est Persei, Andromedesque figura / Apte et concinne, ut quod magis esse potest. / His igitur mentem si Juppiter adderet, ipse / Spectares verum Persea et Andromedem." (You do not see the living Perseus and Andromeda, yet the figure of Perseus and Andromeda is so aptly and elegantly sculpted that something even greater is possible. If Jupiter were to give them a mind, you yourself would be looking at the real Perseus and Andromeda.) See also Varchi's poem on the work, in which the viewers, their minds on the sculpture, are gorgonized: "Tu che vai, ferma 'l passo: e ben pon mente / Alla grand'opra che ' buon mastro feo; / Oggi non sol Medusa, ma Perseo / Fanno di marmo diventar la gente." (You, passerby, halt your step, and give your attention to the great work which the good master made; today, not only Medusa, but Perseus too makes the people turn to marble.) See Milanesi 1859, 403.

64. Compare the remark by Niccolo Martelli quoted in Chapter 2, n. 73, in which *Cosimo*'s ideation of the *Perseus* is envisioned as a descent from heaven. See also Panofsky 1968, 56 ff.

65. I use metonymy in the sense defined by Cellini's contemporary Simone Fornari, who explains that *metonimia* is the figure "by which poets are accustomed to naming a thing made instead of its maker and reason for being, and vice versa" (usò Metonimia, per la quale sogliono i poeti nominare una tal cosa fatta invece del fattore & cagionatore d'essa, & per contrario); see Fornari, 75, also n. 111 below.

66. See the published version of Tebalducci's 1587 lecture "Del Furor Poetico," in Tebalducci, 53–73: "Noi presupponiamo, che si come la mano per operare fortemente tende i nervi, e fa una certa forza & adunanza di spiriti, e l'occhio similmente quando si affisa, fa una cotale intensione per cosi dire, cosi quelle parti interne che conoscono, qualunque volta vogliono attentamente operare, si corroborano in se stesse, e si fortificano, molti spiriti a se richiamando."

67. For the attribution of the drawing, see most recently Joannides, esp. 53. In addition to the literature he cites on the drawing, see esp. Wallace 1983, 83–98, and Summers 1981, 304–7; also Panofsky 1972, 225–8; Testa; and Kliemann.

68. Ryan, 4–5: "Dinanzi mi s'allunga la corteccia, / e per piegarsi adietro si ragroppa, / e tendomi com'arco soriano. / Però fallace e strano / surge il iudizio che la mente porta, / ché

mal si tra' per cerbottana torta." (In front my hide is stretched, and behind the curve makes it wrinkled, as I bend myself like a Syrian bow. So the thoughts that arise in my mind are false and strange, for one shoots badly through a crooked barrel.) For a discussion of this poem in relation to Michelangelo's art, see Lavin 1993.

69. Segni, 277 (6.1): "Egli è certo in tutti gli habiti sopraraccconti, come anchora in tutti gli altri, ritrovarsi un'certo segno, ove, ponendo la mira chi hà la ragione, allenta, & intende l'arco: & darsi un'certo termine nelle mediocrità, le quali sono infra il più, & il meno, secondo ché comanda la retta ragione." The Latin text reads "In omnibus enim dictis habitibus (quemadmodum & in caeteris) est quoddam signum, ad quod is inspiciens qui rationem habet, intendit, atque remittit. estque quidam terminis mediocritatum, quas inter exuperationem defectumque dicimus esse ita sese habentes ut tecta ratio statuit"; see Acciaioli, 257.

70. See Acciaioli, 259–60: "recta ratio est illa quae respicit signum ad quod tendere debemus, atque illa determinat mediocritatem."

71. Macchiavelli, 30: "Né si potendo le vie d'altri al tutto tenere, né alla virtù di quelli che tu imiti aggignere, debbe uno uomo prudente intrare sempre per vie battute da uomini grandi, e quelli che sono stati eccellentissimi imitare, acciò che, se la sua virtù non vi arriva, almeno ne renda qualche odore: e fare come li arcieri prudenti, a' quali, parendo el loco dove disgnono ferire troppo lontano, e conoscendo fino a quanto va la virtù del loro arco, pongono la mira assai più alta che il loco destinato, non per aggiugnere con la loro freccia a tante altezza, ma per potere, con lo aiuto di sí alta mira pervenire al disegno loro." On Federico Zuccaro's equation of *disegno* with *segno*, see Panofsky 1968, 88.

72. See Kahn, 21.

73. Regarding Macchiavelli's specification that this variety of imitation is "prudent," compare the argument at p. 32, above, that providence, and by association prudence, could be considered as a sort of design.

74. Cf. here the continuation of Acciaioli's comments, in which he uses the example of artistic action to show that having right reason is not enough, that something must be carried out: "Non tamen hoc sufficit ad percipiendam rectam rationem, ut exemplo artis probatur. Sicut recta ratio faciendi se habet ad factibilia, & ea quae ab arte conficiuntur: ita recta ratio agendi se habet ad agibilia. Sed ad bene faciendum in quavis arte non sufficit scire faciendum esse secundum praecepta artis: ergo in rebus agendis non sufficit scire agendum esse secundum rectam rationem: sed determinanda est ista ratio, quaenam sit, & quae sit eius definitio, ut particulariter & distinctè cognoscatur." Michelangelo himself may have agreed with Cicero, who, in commenting on the same metaphor in *De Finibus* (Cicero 1914, 3.4), points out that moral responsibility extends only far enough to cover the drawing of the bow, not what happens to the shot arrow: "Ut enim si cui propositum sit collineare hastam aliquo aut sagittam, sicut nos ultimum in bonis dicimus, sic illi facere omnia quae possit ut collineet: huic in eiusmodi similitudine omnia sint facienda ut collineet, et tamen, ut omnia faciat quo propositum assequatur, sit hoc quasi ultimum quale nos summum in vita bonum dicimus, illud autem ut feriat, quasi seligendum, non expetendum." (If a man were to make it his purpose to take a true aim with a spear or arrow at some mark, his ultimate end, corresponding to the ultimate good as we pronounce it, would be to do all he could to aim straight: the man in this illustration would have to do everything to aim straight, and yet, although he did everything to attain his purpose, his "ultimate End," so to speak, would be what corresponded to what we call the Chief Good in the conduct of life, whereas the actual hitting of he mark would be in our phrase "to be chosen" but not "to be desired.")

75. Segni, 369 (7.8): "Nell'attioni il fine è principio."

76. See Agostini, 44r.

77. Cellini's recourse to "intention" is, we might say, the best means he knew to show

Perseus's liability to cause. By evoking both rest and motion, the figure of Perseus implies motion's beginning or end.

78. David's famous scowl indicates that he understands what he is about to confront – a giant, and to judge by David's own scale, a giant of immense proportion. The scowl may, as Summers has argued, reflect Michelangelo's familiarity with Aristotelian physiognomic theory; see Summers 1978, 113–24. It can also be viewed within the context of David's larger act: His whole body is intent upon the task at hand.

79. See above, 189, n. 82.

80. Compare the fitting description in Poeschke 1993, 404: "[Judith's] deed has been dictated by external forces; it does not rise out of her own inner strength. Judith, therefore, appears to be the tool of a higher will, and this is what makes her such a potent symbol of humility."

81. *Affetto*, the standard term in Italian art theory for a figure's expressed emotion, is also the normal Italian partner to *cagione* or *causa*, letting any theoretical discussion of emotion border on a discussion of motion; see, for example, the way Segni uses the terms in n. 31, above; see also the discussion of *affetti* in Cropper-Dempsey, 46–8.

82. Ferrero, 508.

83. For the recent controversy on how Michelangelo's lines should be connected with the sculpture, see esp. Seymour; Lavin 1993; and Kliemann, 303.

84. Borghini 1584, 73: "Perche non si potu'egli fare l'historia d'Andromeda, disse il Michelozzo, poiche ella faceua compimento col Perseo, che gli è à lato?" ("Why could he not have made the story of Andromeda," Michelozzo asked, "such that it would have made a *compimento* to the Perseus, which is beside it?")

85. Borghini 1584, 72: "Punto dallo sprone della virtù, si dispose di mostrare al mondo, che egli non solo sapea fare le statue di marmo ordinarie, ma etiandio molte insieme, e le piu difficili, che far si potessero, e doue tutta l'arte in far figure ignude (dimostrando la manchouole vecchiezza, la robusta giouentù, e la delicatezza feminile) si conoscesse; e così finse, solo per mostrar l'eccellenza dell'arte, e senza proporsi alcuna historia, vn giouane fiero, che bellissima fanciulla à debil vecchio rapisse, & hauendo condotta quasi à fine questa opera marauigliosa, fù veduta dal Serenissimo Francesco Medici Gran Duca nostro, & ammirata la sua bellezza, deliberò che in questo luogo, doue hor si vede, si collocasse. Laonde perche le figure non vsisser fuore senza alcun nome, procaccio Giambologna d'hauer qualche inuention all'opera sua diceuole, e gli fù detto, non so da cui, che sarebbe tanto ben fatto, per seguitar l'historia del Perseo di Benuenuto, che egli hauesse finto per la fanciulla rapita Andromeda moglie di Perseo, per lo rapitore Fineo zio di lei, e per lo vecchio Cefeo padre d'Andromeda."

86. Key elements of Giambologna's *concetto* are, to a certain extent, anticipated in Cellini's and Tetrode's *Ganymede* (Fig. 66). This, too, incorporates references to victory (the foot of the boy treads on that of the eagle, and the boy, like Cellini's Perseus and Apollo, wears a symbolic diadem) into an imagery of ravishment (wittily reversing the story's traditional agency, Cellini suggests that it is the boy who is "ravishing" and the eagle Jupiter who is "enraptured," "rapt"). Counting the eaglet Ganymede holds aloft, Cellini's composition, like Giambologna's, might even be considered as a three-figure arrangement. Along these lines, it is intriguing to ask whether the eaglet in Ganymede's hand might belong to the family of imagery discovered by Charles Dempsey (1996b): Rather than being, as some commentators have proposed, a sort of love offering, the eaglet might represent the eagle Jupiter's spirit, shown captured by the young boy. Such a premise would allow both that Cellini restored the antique torso that forms the core of the work to something like an ancient prototype (even if no ancient example of Ganymede includes a second eagle), and also that he interpreted this prototype in terms of the poetic moment Ovid creates with his story of Ganymede (*Met.* 10.155–7). Cellini would render ardor with imaginative

directness, having Ganymede literally steal Jupiter's spirit, possessing him. On the work, see Kempter, 51; Pope-Henessy, 227–9; Saslow, 142–74; and Barkan 1991, 99–111. Saslow's comparison of Ganymede with Cupid here seems especially pertinent; see, for example, Varchi's explanation of Cupid's curly hair in "Della Pittura d'Amore"; Varchi 1859, II, 493. Compare also the lines that Cellini's friend Lasca addressed to Giorgio Vasari's brother Piero (448–9): "Si dirà poi, rimirandolo fiso / e con attenzion da capo a piede: / costui fa co' begli occhi e col bel viso / della beltà del cielo in terra fede. / A lato a lui saria brutto Narciso, / Giacinto, Croco, Adone, e Ganimede, / e Giove, se non fusse rimbambito, / a quest'otta l'arebbe in ciel rapito." (Then it will be said, admiring him fixedly and with attention from head to feet, that he, with his beautiful eyes and beautiful face, attests on earth to the beauty in heaven. Beside him, Narcissus, Hyacinth, Crocus, Adonis, and Ganymede would be ugly, and Jupiter, had he not been rebabied, would have stolen [*rapito*] him at this hour up to heaven.) For the eagle's gaze as a figure of knowledge, see Dante, *Paradiso* I.46–8; and Varchi 1859, II, 370–1 and 617. For the question of who executed Cellini's *Ganymede* design, see appendix. MacHam, 173, observes that Giambologna's statue clearly shows a 'rape,' even if a generic one.

87. BCNF Magl. 7, 874, 202r. Though the poem is published here for the first time in its entirety, it is related to one published already in Giambologna's day by Michelagnolo Sermartelli, and reprinted in Barocchi 1973, II, 1221.

88. Cf. Peletier's description of poets, who, in a *fureur* "ravished and abstracted from terrestrial thoughts, conceive heavenly, divine, natural, and worldly secrets, in order to present them to men." (rauiz, e abstrez des pansemans terrestres, conçoeuet les secrez celestes, diuins, naturez e mondeins: pour les manifester aus hommes.) Cited in Castor, 34. I wish to thank David Sedley for this reference.

89. See Ficino's translation, as edited by Allen, 52: "Tertia vero a Musis occupatio et furor, suscipiens teneram intactamque animam, suscitat illam atque afflat." Compare also Ficino, who explains that "questa gratia di virtù, o figura, o voce che chiama l'animo a sè rapisce per mezzo della ragione, viso e audito, rectamente si chiama bellezza." (This grace of virtue, or figure, or voice, which calls the soul to itself, [and] ravishes by means of reason, sight, or hearing is properly called beauty); see also Ficino 1544, 80. Varchi comments similarly, "grazia . . . è quella che ci diletta e muove sopra ogni cosa: onde molte volte ci sentiamo rapire per una donna la quale sia graziata, ancora che nella figura e ne' colori potesse esser assai meglio proporzionata" ([Grace] is that which delights and moves us above all else; whence many times we feel ourselves ravished [*rapiti*] by a woman who is graced, even when she could be rather better proportioned in figure or color); see his *Libro della beltà e della grazia*, in Barocchi 1960, I, 86.

90. One might, borrowing a term from Eve Kosofsky Sedgwick, call this conflict "homosocial," emphasizing the way in which both the statue and the poems gender creativity as a possessive strength, substituting virility for female generativity, and reducing the sculpture's woman to an attribute over which male agencies fight. See Sedgwick, as well as the remarks of Carroll, 145: "Viewing the sculpture as Giambologna's bid to outstrip his rivals and Michelangelo, perhaps its is inevitable that his contemporaries should have invoked the imagery of the Sabine rape to liken the young sculptor to the youthful victor in his group, triumphant over and establishing filial ties with the father at his feet."

91. See Carroll, 143: "A contemporary description of the standing man as a burning, or ardent, youth was no doubt suggested by the flamelike shape of the composition."

92. See Barocchi 1973, II, 1218: "Oppressa in quello appar debil vecchiezza, / Viril giovin furor, ratto di pura / Vergin leggiadra, tal non vista altrove."

93. Agostini, 44r.

94. The recent interpretations of this figure, as well as the other characters of the right-hand side of the relief, are surveyed in Vossilla 1997, esp. 289–90; Vossilla adds his own largely convincing explanation of the subsidary characters.

95. Michelangelo himself never referred to the drawing by any name, but two other sixteenth-century sources give it that label. The first of these is a well-known engraving by Rosso, roughly contemporary with the drawing and certainly in dialogue with it, if not based on it, to which a poem was added calling the figure a *furie*. The second is an inventory of Francesco I de' Medici, the first direct reference to the drawing, which calls it "un Viso quasiche di furia." See Gilbert, who also illustrates the Salamanca print. For Cellini's character as Furor, see Hirthe, 214. For the quotation of Michelangelo, Parronchi, 43–5, and Joannides, 53.

96. See Hirthe, 214, and Vossilla 1997, 290–1.

97. In Ovid, *Met.* 5.13–15, Cepheus cries out to his brother, "What are you doing? What mind leads you, furying, into crime? Is this the thanks you give to so much merit?" (Quid facis? . . . quae te, germane, / furentem mens agit in facinus? meeritisne haec gratia tantis / redditur?)

98. *Aeneid*, 1.294–6. See also Gilio's description of the motif, 115v.

99. On the medal, see esp. Chastel, 190.

100. Manilius's Latin work had been available in print in Italian translation since the Quattrocento. For Cellini, whose interests in astrology are demonstrated by his poetry, Manilius should have had some appeal, being one of the few astrological compendia known from antiquity. For Cosimo and his courtiers, Manilius must have had more particular interest, having been the astrologer to the Roman Emperor Augustus, to whom the Florentine Duke's astrologically savvy panegyrists made primary reference. On Cosimo's use of astrological imagery to cast himself as a new Augustus, see Wright, as well as Cox-Rearick 1984, 272, n. 79, which considers Manilius, calls attention to Cellini's capricorns, and includes a useful bibliography of the growing literature on Renaissance astrology. It can also be established that Varchi was reading Manilius, for he cites him in his *Della maggioranza delle arti*; see Barocchi 1960, I, 19.

101. Manilius, 5.620–8 (n.p.): "Veniet, peneque minister / Carceris, & duri custos, quo stante superbe / Prostrate iaceant miserorum in limine matres / Per noctesque patres cupiant extrema suorum / Oscula, & in proprias animam transferre medullas / Carnificisque venit mortem ducentis imago, / Accensisque rogis & stricta sepe securi / Supplicium vectigal erit qui denique possit / Pendentem ex scopulis ipsam spectare puellam." My English modifies the translation in Manilius 1977.

102. Pope-Hennessy, 182.

103. See Tyard, 8–12: the distinction is between the *fureur* arising from excessive *cholere*, "de laquelle ceux qui sont tourmentez, deviennent soudaine (sinon continuels) à se perdre en cholere, sans estre aucunement irritez, assaillent indifferement tous ceuxz, qui se trouvent devant eux" and that which results when the "intention de celuy qui desire est toute empeschée aux pensers de la chose desirée." Cellini's time in Paris would have given him ample opportunity for exposure to the proto-academic literary circles that constitute Vigenère's own background. See Yates, esp. 59, 77–94 and 131–4, which discusses numerous French writers' preoccupation with "furor" in and after the time of Francis I.

104. Bruno 1985, II, 986–7: "Poneno, e sono, più specie de furori, li quali tutti si riducono a doi geni: secondo che altri non mostrano che cecità, stupidità ed impeto irrazionale che tende al ferino insensato; altri consisteno in certa divina abstrazione per cui dovegnono alcuni megliori, in fatto, che uomini ordinarii . . . Altri, per essere avezzi o abili alla contemplazione, e per aver innato un spirito lucido ed intellettuale, da uno interno stimolo e fervor naturale, susitato dall'amor della divinitate, della giustizia, della

veritade, della gloria, dal fuoco del desio e soffio dell'intenzione, acuiscono gli sensi; e nel solfro della cogitativa facultade accendono il lume razionale con cui veggono piú che ordinariamente: e questi non vegnono, al fine, a parlar ed operar come vasi ed instrumenti, ma come principali artefici ed efficienti."

105. The key texts in Florence in the 1540s were Plato, *Phaedrus* 245A; *Ion*, esp. 533D ff.; Ficino 1959, II, esp. 1365, 1374–5; and Ficino 1975, I, 42–8, 98–9, and V, 56.

106. See Cicero, *Tusc. disp.* 3.5.2; also Klibansky, 43–4.

107. Another detail that speaks for using something like Agostini's allegory in reading of Cellini's relief is the sculptor's individualization of Andromeda's parents. Pope-Hennessy (182) has suggested that the gesture of Andromeda's mother was inspired by that of the Virgin in Donatello's London *Descent from the Cross*; whether or not the connection with Donatello needs to be so specific, the gesture should be read as one of grief, especially when viewed as a counterpart to the gesture of Cassiopaia's husband, King Cepheus. His posture depends on a vocabulary developed for Christian Passion scenes, and specifically adopts the standard attitude of John the Evangelist at the Crucifixion. Together, Andromeda's parents enact a response to *loss* – their demeanors are fully keyed to the punishment of having their daughter taken away from them. They do not register the fear that the approaching dragon might be expected to instill, nor do they acknowledge the arrival of the hero who will rectify everything. The left–right antithesis, then, is not merely one between virtue and vice, but also as one between gain and loss. For similar poses, see Davis 1985a.

108. Ferrero, 352–3.

109. Calamandrei,

110. Ferrero, 811: "Un pittore valente uomo come era il detto Michelagnolo conduceva un ignudo grande quanto il vivo di pittura con tutti quelli studi e quelle virtù che in esso poteva operare. Il più tempo che e' vi mettessi si era una settimana, ché molte volte io viddi dalla mattina alla sera aver fatto un ignudo finito con tutta quella diligenzia che promette l'arte; ma io non mi voglio ristringere a sì breve tempo, perché sono certi furori che nelli uomini sua pari virtuosissimi qualche volta gli avvenivano . . . "

111. For discussions of Michelangelo, Cellini and *furia*, see Summers 1981, 60–70, and Gardner. The credibility of Blaise's dramatic characterization of Michelangelo has been overrated by a long line of romantic art historians, beginning with Steinmann 1907, 76. The nature of the sculptural act it describes is sharply different from most contemporary Italian descriptions, and it is for this reason, I imagine, that Summers omits mentioning it. Summers does cite a passage from Callistratus: "The hands of sculptors, also, when they are seized by the gift of a more divine inspiration, give utterance to creations that are possessed and full of madness. So Scopias, moved as it were by some inspiration, imparted to the production of this statue the divine frenzy within him" (Summers 1981, 475, n. 1). This passage is especially pertinant, for it is in his translation of Callistratus, just five pages before the discussion of Scopias, that Blaise's comments on Michelangelo appear; see Vigenère, 105v–110v. On Vigenère and the imagery of Michelangelo, see most recently Lavin 1993. On *disegno* as *afflatus*, see Panofsky 1968, 91ff.

112. Vasari viewed it as a sign of progress that, "dove prima da que' nostri maestri si faceva una tavola in sei anni, oggi in un anno questi maestri ne fanno sei." (Whereas before [the time of] these masters of ours, it took six years to make one painting, today our masters make six paintings in one year); Vasari-Milanesi, IV, 13; cited Williams, 57, n. 2. Cellini tried to present this as a shortcoming of Vasari's: "A chi piace 'l far presto: un, meglio e tardo. / Or se Dio presta vita all'Aretino, / gli è per dipinger tutto questo mondo." (One man likes to make things quickly, another, better, and slowly. If God lent life to the Aretine [Vasari], it was so that he would paint the entire world); Ferrero, 849.

113. Ferrero, 522.

114. Furor, incidentally, is also the example given for metonymy in the definition of

it I have been following, that of Simone Fornari. Writing of Ariosto's Orlando, Fornari comments: "Diremo, che l'Ariosto dica in questa guisa, io diro d'Orlando, etc. Se mi fara concesso tanto d'ingegno dalla mia donna, laquale quasi m'ha fatto tale, come se dicesse simile ad Orlando furioso & stolto." (We will say that Aristoto in this guise [i.e., with metonymy] says *io diro d'Orlando*, etc.: if such wit is conceded to me by my lady, who has almost made me, as they say, like Orlando, furious and mad); see Fornari, 75.

Conclusion: Cellini's Example

1. Goethe, 497: "In einer so regsamen Stadt, zu einer so bedeutenden Zeit, erschien ein Mann, der als Repräsentant seines Jahrhunderts und, vielleicht, als Repräsentant sämtlicher Menschheit gelten dürfte."

2. See the 1553 letter by Fernando Gonzaga, describing Leoni's *Furore*, in Plon 1887, 369: "Siede poi sopra belli ornmenti di spoglie et de arme sottilmente lauorati et con gran pacienza, onde tante cose insieme fondute, in un pezzo solo fanno il getto marauiglioso et la uista bellissima." (He sits, then, upon beautiful ornaments, consisting of spoils and arms, worked subtly and with great patience, whence, so many things being cast together, in one piece, they make the cast marvelous and the sight most beautiful.)

3. After specifying that his seated bronze figure of Paul III was 17 palms high, that it was 40 palms in circumferance, and that it had cost of 8,000 scudi to make, Della Porta observed that "La statua che a fato Benvenuto in fiorenza costa scudi dodecimila et è di mancho grandezza della sopra ditta et non eccede nell'altre qualità." (The statue that Benvenuto made in Florence cost 12,000 scudi, and it is smaller than [mine] and does not exceed it with its other qualities.) See Gramberg, 1964, I, 105–6.

4. On this work generally, see the fundamental studies by Diemer 1986 and 1987.

5. For the chronology of Giambologna's early years in Florence, see Avery 1987, 16.

6. For the forge, see the description of Vecchietti's house in Borghini 1584, 14, cited in Butters, I, 282. Vecchietti was Cellini's banker and friend. In 1562, he acted as a witness for the baptism of Cellini's child; later, he obtained the original *modello* for the *Perseus*. Giambologna, it can be assumed, would have followed Cellini's sculptural activities especially closely. On Vecchietti, see Bury; also BRF 2791, 67v: "Giovedi / Adi 29 dottobre 1562 / Ricordo come ildetto a hore 3 4/3 di notte seguente mi naqque una figliuola dime e' della piera di salvatore de parigi laquale stava meco et sabato seguente a di ultimo detto la battezzamo et gli posi nome elisabetta per rifare mia madre et li compari furno Bernardo di giovanni vecchietti e' zanobi di francescho buona gratia et luca di girolamo mini."

7. See Vossilla 1994, esp. 143.

8. On De Vries as a caster, see Bewer.

9. Summers 1979, 505–12: "Più Legne, e piu Carbon' io arsi in vano, / che in Etna non ne tien' cotanti accesi / l'antichissima Fabro Siciliano." The difficulties Danti encountered when trying to establish himself as a caster in Florence must have been particularly devastating, since earlier, in Perugia, he had succeeded in casting a large portrait of Julius III. For more on this, see Davis 1985b.

10. See Scholten, 201–9 and 243–7.

11. See Cole 2002.

12. See Biringuccio, 22v.

13. See Gotti, I, 364–5.

14. For a helpful *riassunto* of the problem, see Heikamp 1995.

15. See the remarks by Testelin, in Mérot, 334: "On dit, en parlant sur le grand *Torse*, qu'on avait remarqué entre les excellents sculpteurs quatre manières différentes; l'une que l'on nomma forte et ressentie, laquelle a été attribuée à la ville d'Athènes. La seconde,

un peu faible et efféminée, qu'ont tenue maître Étienne Delaune, Franqueville, Pilon et même Jean de Bologne, laquelle avait été estimée venir de Corinthe. La troisième, pleine de tendresse et de grâces, particulièrement pour les choses délicates, que l'on tenait qu'Apelle, Phidias, et Praxitèle ont suivie pour le dessin."

16. See, for example, Della Porta 1658, 47–52.

17. On scientific recipe books generally, see Eamon; on Cellini and recipe books, Rossi 1998.

18. See, for example, the famous passages in the *Asclepius* on the making of statues, Copenhaver, 81, 90.

19. Kris–Kurz, 53–4.

20. Boschini, 712: "Con un striscio delle dita pure poneva un colpo d'oscuro in qualche angolo, per rinforzarlo, oltre qualche striscio di rossetto, quasi goccia di sangue, che invigoriva alcun sentimento superficiale; e così andava a riducendo a perfezione le sue animate figure"; see the discussions of the passage in Rosand, 24 and n. 27, and in Reilly.

21. Rubens's painting in the Alte Pinakothek in Munich – and many of his other figural works as well – can be read against the short essay he wrote on the imitation of antique statues, in which he contends that moderns should give particular attention to the rendering of *carne*. The Latin original and a translation were cited in a major treatise by the seventeenth-century's great defender of color, Roger de Piles; see De Piles, 86–92.

22. See esp. Cropper and Dempsey's discussion of the painting, which emphasizes the artist's "infusion of painted blood into fictive marble and its ebbing away again"; Cropper and Dempsey, 272.

23. The themes of desire, touch, and loss, to which Bolland (with further references) has recently tied Bernini's *Apollo* are also at the heart of Cellini's statue.

24. See Zuccaro, I, 18.

25. For Zuccaro and Aristotle, see most recently Williams, 175, n. 100 and *passim*.

26. See, for example, entries no. 8 and 14 in Scholten.

27. See Picinellus, *Mundus Symbolicus*, as cited in Kauffmann, 57.

28. Fabri, 85r: "III.6 De fortitudine & forti . . . In sacris literis David puer inermis, impavidus aggreditur gigantem, hamata lorica, multiplicique telo tumentem: nudus occupat armatum, occupatum obtruncat. unus puer fortis decem milia cedere cogit. ecce quid per cultu divino generosae mentis virtus, infractaque fortitudo valere debeat: cui semper virtutum dominus & fortissimus rerum aspirat ab alto."

29. Bernini is reported to have remarked that, in his portrait of Louis XIV, he conveyed the king's majesty by representing the king's *mente*. See the entry for 28 September in Chantelou.

30. Bernini, 18: "Nel operare si sentiva tanto infiammato, e tanto innamorato di ciò, che faceva, che divorava, non lavorava il Marmo, e come poi disse nella sua più vecchia età, Non dava mai colpo nella sua giovinezza in fallo."

31. See above, p. 99 and n. 61.

32. Ferrero, 495.

33. Plon 1887, 369: "[è] di più grandezza che la naturale in una attitudine molto contorta et horribile . . . ". The statue's inscription, CAESARIS VIRTUTE DOMITUS FUROR, explicitly identifies the work as an image of 'mastery.'

34. Barocchi 1973, I, 558:

> N. . . . mi pare che bisogni mostrarti che la pittura e la scoltura non si possono mettere in opera senza il disegno, del quale puó malamente dare l'arte la sua sentenza, che cosa egli sia.
>
> A. Io direi che fusse industria dell'intelletto, con atto di mettere in opera il suo potere.

35. This topic has recently been discussed, in different manners, by Williams, Sousloff, and Barzman 2000.

36. Ferrero, 594.

37. On the changing status of the mechanical arts in the sixteenth century, see Summers 1987, 264–5 and 316–17, with further references.

38. BRF 2353, 103v: "Io non voglio ubbidire / alla mia fantasia / Avendo / Acogitare questo exilio / a mosso a pieta fa / Impi ladron che della roba / altrui / laver forza di / trasgredire / a un cosi gran signiore / Allinmagin / timoss / Avevo mostro almondo / Avevo mostro almondo."

Appendix: On the Authorship of the Bargello Marble *Ganymede*

1. The foundational study of Cellini's drawings remains that of Winner; see also Cole 1999, n. 1.

2. See, e.g., Camesasca, 43, who allows that the work might be a later cast after a Cellini model.

3. The attribution is upheld both by Pope-Hennessy and by Radcliffe 1998, and rejected by Avery-Barbaglia and again by Avery 1986. Pope-Hennessy and Radcliffe also agree in attributing a small horse Florence's Museo Archaeologico to Cellini, although this has been challenged by Avery 1986 and Penny 1986, as well as by Francesco Vossilla's recent entry in *Magnificenza*, 146–7. For the controversy surrounding Cellini's medal for Pietro Bembo, see p. 167, n. 11 above; for the controversy surrounding the marble *Duke Cosimo I* bust in San Francisco, see p. 194, n. 8.

4. An important exception, the only one of which I am aware, is Radcliffe 1988, esp. 931.

5. See Bertolotti, 231–32: "Un barbiere riferiva, a dì 19 ottobre 1562, di aver medicato Guglielmo scultore fiammingo abitante in piazza delle Padelle con due ferite una letale alla testa altra piccola nella fronte per sassate da un incognito in piazza di Siena, e perciò esservi pericolo della vita" (*Liber Relat. Barber., 1562–3, fol. 127*).

"Ecco che rispondeva il ferito al notaro de malefizi nel giorno dopo, che lo qualificò *Magister Guillelmus q. Danielis* – 'Questa mattina passando in piazza di Siena con Stefano falegname francese fummo assaltati con sassate da un mondo di gente e fummo feriti tutti due, fuggimmo. Sospetto di un Gaspare tedesco che con altro vidi nell'osteria del Fiore mentre tutti bevevamo. Io non ho altra inimicizia che con lui perchè trovandomi io circa doi anni o tre anni sono in Pitigliano per ingegnero d'uno studiolo che faceva fare il conte per donarlo al Re Filippo, dove lui ancora stava a lavorare con molti altri maestri, perchè io lo riprendeva talvolta che era ignorante havessimo una volta parole insieme et d'allora in qua mi ha sempre portato odio se bene ci parlavamo. (*Liber Visitationum Notar., an. 1562, fogli 134–5*).'"

6. Gaye, III, 69–70:

"Illustrissimo et Eccellentissimo Signor Duca

Già circa anni 13 sono che io Guilelmo, fiamingo, stetti qui in Fiorenza, et racconciai per V. Illna. E. un ganimede di marmo anticho, che al presente, come intendo, si trova a Piti, il quale, per quanto mi fu riferto, non dispiacque a V.I.E., e doppo mi parti' per Roma. Ultimamente mi conciai con il Conte di Petigliano, per il quale ho lavorato parecci anni sin al tumulto popolare, che fu alli giorni passati iscacciato di stato, con speranza desser non solamente esser pagato della mia fatica di varie opere, che gl'havevo fatto, ma di quelche honesto sossidio della mia vecciaia; il che tutto il suo sinistro governo mi ha interposo, di modo che essendo creditore di buona somma di danari, per non puoter lui godere la mia fatica, non mi ha volsuto pagare. Ed havendo fra laltre opere mie fattogli un scrittoio signorile, che il presente Conte, suo padre, manda perme a donare a V.I.E., fatto di mia mano, come V.I.E. potrà intendere per la adgiunta soa lettera, mi offerisco a quella di corregere alchuni difetti, che forse V.I.E. in quello considerare potrà, imperò

che essendo stato mal da lui trattato et pegio pagato, non puotetti usare in tutto et per tutto quella diligenza, che conveniva, paghando. V.I.E. si degni havere la mia industria per raccomandata, offerendomi in simili et altre opere di servire V.I.E. per quanto et dove et quando a quella piacerà, preghando Iddio che conserbi quella sempre in ogni felicità. Da Fiorenza alli 25 di giugnio 1562.

> Humilissimo Servo
> Guilielmo scultore fiamingho"

7. Vasari-Milanese, VII, 549–50: "E stato creato di costui [della Porta] un Guglielmo Tedesco, che, fra altre opere, ha fatto un molto bello e ricco ornamento di statue piccoline di bronzo, imitate dall'antiche migliori, a uno studio di legname (così lo chiamano) che il conte di Pitigliano donò al signor duca Cosimo; le quali figurette son queste: il cavallo di Campidoglio, quelli di Montecavallo, gli Ercoli di Farnese, l'Antinoo ed Apollo di Belvedere, e le teste de' dodici Impera tori, con altre, tutte ben fatte e simili alle proprie . . . "

8. The fundamental article is Divigne.

9. See the discussions in Boon, Radcliffe 1985, Nijstad, and Massinelli.

10. The key documents are available in Trento, 72–4.

11. Tassi, III, 194: "E al Ganimede di marmo, il quale è a Pitti, per essere delle più belle figure che mai mi paressi vedere degli antichi, io fui contento di restaurarla di testa, braccia, piedi, ed un'aquila maggiore che il naturale, tutto fatto di marmo . . . "

12. Carpani, II, 497: "1545 [1546]. In Febbrajo Benvenuto restaurò una figurina antica, per il Duca Cosimo, dell'altezza di braccia uno e mezzo, alla quale ha rifatto la testa, le braccia, e i piedi." Saslow, 235, n. 4, uses this as a terminus ante quem for the entire sculpture.

13. BRF 2788, 10v: "dj 17 dagosto 1549/da Reverendissimo cadinale di ravenna adj 17 dagosto scudi cento doro inoro per conto duna saljera dargento gia comjncjato per lcardinale salvjatj et ldetto cardinale di ravenna meglja pagatj abuon conto per largento eparte di fattura— ∇ 107.1.0.0."

Bibliography of Works Cited

Manuscript Sources

ASF 2563 Florence, Archivio di Stato, Notarile Antecosimiano, 2563.

BMLF 234 "Vita di Benvenuto Cellini orefice et scultore scritta di sua mano propia," Florence, Biblioteca Mediceo-Laurenziana, Codice Medici Palatino, 234.

BMV 5134 Venice, Biblioteca Marciana, Codice Marciano, 5134.

BCNF Magl. 7, 873 Florence, Biblioteca Nazionale Centrale, Fondo Magliabechiano, Cl. VII, 873.

BNCF Magl. 7, 874 Florence, Biblioteca Nazionale Centrale, Fondo Magliabechiano, Cl. VII, 874.

BNCF Magl. 16, 36 Florence, Biblioteca Nazionale Centrale, Fondo Magliabechiano, Cl. XVI, 36.

BNCF Magl. 16, 43 "Gherardi Dornh capitula tria extracta ex eius libro de lapide philosophico," Florence, Biblioteca Nazionale Centrale, Fondo Magliabechiana, Cl. XVI, 43.

BCNF Pal. 863 Florence, Biblioteca Nazionale Centrale, Fondo Palatino, 863.

BNCF Pal. 1001 Florence, Biblioteca Nazionale Centrale, Fondo Palatino, 1001.

BRF 1009 Florence, Biblioteca Riccardiana, Codice Riccardiano, 1009.

BRF 2353 Florence, Biblioteca Riccardiana, Codice Riccardiano, 2353.

BRF 2728 Florence, Biblioteca Riccardiana, Codice Riccardiano, 2728.

BRF 2787 Benvenuto Cellini, "Libro segnato A e dj m[esser] Benvenuto dj maestro Giovannj cielljnj scultore sulquale si terra conto dj tutte lopere chel detto m[esser] Benvenuto fara a sua E[ccellenzi]a I[llustrissim]a et della provjsione che per gratia dj essa s[ua] E[ccellenzia] I[llustrissima] da et dara al detto m[esser] benvenuto comjncando aprima carta," Florence, Biblioteca Riccardiana, Codice Riccardiano, 2787.

BRF 2788 Benvenuto Cellini, "Libro di Benvenuto di m[aestro] giovanni celljnj schultore intjtolato giornale segnjato A," Florence, Biblioteca Riccardiana, Codice Riccardiano, 2788.

BRF 2789 Benvenuto Cellini, "Libro intitolato Debitori et Creditori segniato A," Florence, Biblioteca Riccardiana, Codice Riccardiano, 2789.

BRF 2790 Benvenuto Cellini, "Libro segniato B, intitolato de' debitori e creditori," Florence, Biblioteca Riccardiana, Codice Riccardiano, 2790.

BRF 2791 Benvenuto Cellini, "Giornale Segnato B," Florence, Biblioteca Riccardiana, Codice Riccardiano, 2791.

BRF 2907 "Alfonso de Pazzi detto l'Etrusco," Florence, Biblioteca Riccardiana, Codice Riccardiano, 2907.

BRF 3617 "Questo libro è di me Benvenuto cellini dove io tengo e mia conti di spese e'altro per mio solointeresso," Florence, Biblioteca Riccardian, Codice Riccardiano, 3617.

Published Sources

ACCIAOLI Donato Acciaoli, *Aristotelis Stagiritae Peripateticorum Principis, Ethicorum ad Nicomachum Libri Decem. Ioanne Argyropylo Byzantio interprete, nuper ad Graecum exemplar diligentissimè recogniti. Cum Donati Acciaioli Florentini viri doctiβimi Commentarijs, denuò in lucem editis.* Venice, 1565 [first edition 1478].

ACKERMAN James Ackerman, "The Tuscan/Rustic Order," reprinted in *Distance Points: Essays in Theory and Renaissance Art and Architecture.* Cambridge, MA: MIT Press, 1991, 495–541.

AGOSTINI Niccolo degli Agostini, trans., *Di Ovidio le Methamorphosi cioe trasmutationi, tradotte dal latino diligentemente in volgar verso, con le sue Allegorie, significationi, & dichiarationi delle Fauole in prosa.* Milan: Bernardino di Bindoni, 1548 [first ed. 1521].

AGRICOLA 1550 Georgius Agricola, *De la generatione de le cose, che sotto la terra sono, e de le cause de' loro effetti e nature.* Venice: Michele Tramezzino, 1550.

AGRICOLA 1562 Georgius Agricola, *L'arte de' metalli.* Translated by Michelangelo Florio. Basil: Hieronimo Frobenio and Nicolao Episcopio, 1563.

ALBERTI 1547 Leon Battista Alberti, *La Pittura.* Translated by Lodovico Domenichi. Venice: G. Giolitti di Ferrari, 1547.

ALBERTI 1553 Leon Battista Alberti, *L'Architecture et art de bien bastir.* Translated by Ian Martin. Paris: Iaques Keruer, 1553.

ALBERTUS Albertus Magnus, *Book of Minerals.* Translated by Dorothy Wyckoff. Oxford: Oxford University Press, 1967.

ALLEGRETTI Antonio Allegretti, *De la trasmutatione de metalli.* Edited by Mino Gabriele. Rome: Mediterranee, 1981.

ALLEN Michael J. B. Allen, *Marsilio Ficino and the Phaedran Charioteer.* Berkeley: University of California Press, 1981.

ALPERS–BAXANDALL Svetlana Alpers and Michael Baxandall, *Tiepolo and the Pictorial Intelligence.* New Haven: Yale University Press, 1994.

ALPERS Svetlana Alpers, "*Ekphrasis* and Aesthetic Attitudes in Vasari's *Lives*" *Journal of the Warburg and Courtauld Institutes* 23 (1960): 190–215.

APHRODISIAS Alexander of Aphrodisias, *Commentaria in dvodecim Aristotelis libros de prima philosophia.* Venice, 1561.

ARASSE-TÖNNESMANN Daniel Arasse and Andreas Tönnesmann, *La Renaissance maniériste.* Paris: Gallimard, 1997.

ARASSE Daniel Arasse, *Le Sujet dans le tableau.* Paris: Flammarion, 1997.

ARISTOTLE 1545 Aristotle, *De generatione animalivm libri V.* Translated by Theodoro Gaza. Venice: Hieronymus Scotus, 1545.

ARISTOTLE 1564 *Francisci Vicomercati Mediolamensis in Quatuor Libres Aristotelis Meteorologicorum Commentarij.* Venice: Domenico Guerrei, 1564.

ARNALDI Ivan Arnaldi, *La vita violenta di Benvenuto Cellini.* Rome: Laterza, 1986.

ASHBEE C.R. Ashbee, trans., *The treatises of Benvenuto Cellini on goldsmithery and sculpture.* New York: Dover, 1967 [1888].

AUSONIUS Ausonius, *Epigrams.* Translated by Hugh G. Evelyn White. Cambridge, MA: Harvard University Press, 1949.

AVERY 1986 Charles Avery, "The Pope's Goldsmith," *Apollo* (July 1986): 61–3.

AVERY 1987 Charles Avery, *Giambologna: The Complete Sculpture*. New York: Moyer Bell, 1987.

AVERY-BARBAGLIA Charles Avery and Susanna Barbaglia, *L'opera completa di Cellini*. Milan: Rizzoli, 1981.

BACCI Orazio Bacci, ed., *Vita di Benvenuto Cellini*. Florence: Sansoni, 1901.

BAKER Malcolm Baker, "Limewood, Chiromancy, and Narratives of Making." *Art History* 21 (1998): 498–530.

BAND Rolf Band, "Donatellos Altar im Santo in Padua." *Mitteilungen des kunsthistorischen Institutes in Florenz* 19 (1940): 315–41.

BARB A. A. Barb, "Diva Matrix." *Journal of the Warburg and Courtauld Institute* 16 (1953): 193–238.

BARKAN 1991 Leonard Barkan, *Transuming Passion: Ganymede and the Erotics of Humanism*. Stanford: Stanford University Press, 1991.

BARKAN 1999 Leonard Barkan, *Unearthing the Past: Archaeology and Aesthetics in the Making of Renaissance Culture*. New Haven: Yale University Press, 1999.

BAROCCHI 1960 Paola Barocchi, ed., *Trattati del Arte del Cinquecento: Fra Manierismo e Controriforma*, 3 vols. Bari: Gius, Laterza & Figli, 1960.

BAROCCHI 1962 Paola Barocchi, ed., *La Vita di Michelangelo nelle redazioni del 1550 e del 1568*. Milan: Riccardo Ricciardi, 1962.

BAROCCHI 1973 Paola Barocchi, ed., *Scritti del Arte del Cinquecento*, 3 vols. Milan and Naples: Riccardo Ricciardi, 1973.

BAROLSKY Paul Barolsky, *Giotto's Father and the Family of Vasari's Lives*. State College: Pennsylvania State University Press, 1992.

BARZMAN 1985 Karen-edis Barzman, "The Università, Compagnia ed Accademia del Disegno." Ph.D. diss., Johns Hopkins University, 1985.

BARZMAN 1991 Karen-edis Barzman, "Perception, Knowledge, and the Theory of *Disegno* in Sixteenth-Century Florence." In Larry Feinberg, ed., *From Studio to Studiolo: Florentine Draftsmanship under the First Medici Grand Dukes*. Seattle and London: University of Washington Press, 1991, 37–48.

BARZMAN 2000 Karen-edis Barzman, *The Florentine Academy and the Early Modern State: The Discipline of Disegno*. New York: Cambridge University Press, 2000.

BAXANDALL 1971 Michael Baxandall, *Giotto and the Orators – Humanist observers of painting in Italy and the discovery of pictorial composition 1350–1450*. Oxford: Oxford University Press, 1971.

BAXANDALL 1972 Michael Baxandall, *Painting and Experience in Fifteenth-Century Italy: A Primer in the Social History of Pictorial Style*. Oxford: Clarendon Press, 1972.

BAXANDALL 1985 Michael Baxandall, *Patterns of Intention: On the Historical Explanation of Pictures*. New Haven: Yale University Press, 1985.

BAXANDALL 1990 Michael Baxandall, *The Limewood Sculptors of Renaissance Germany*. New Haven and London: Yale University Press, 1990.

BEARZI Bruno Bearzi, "La tecnica fusoria di Donatello." In *Donatello e il suo tempo: Atti dell'VIII Convegno Internazionale di Studi sul Rinascimento*. Florence: Istituto Nazionale di Studi sul Rinascimento, 1968, 97–105.

BELTING Hans Belting, *Likeness and Presence: A History of the Image before the Era of Art*. Translated by Edmund Jephcott. Chicago: Chicago University Press, 1994.

BELTRAMI Luca Beltrami, *Documenti e memorie rituardanti la vita e le opere di Leonardo da Vinci*. Milan: Allegretti, 1919.

BERNINI Domenico Bernini, *Vita del Cavalier Gio. Lorenzo Bernino*. Rome: Rocco Bernabò, 1713 [1999 reprint].

BERTOLOTTI Antonio Bertolotti, *Artisti belgi ed olandesi a Roma nei secoli xvi e xvii*.

Notizie e documenti raccolti negli archivi romani. Florence: Tipografia editrice della Gazetta d'Italia, 1880.

BEWER Francesca Bewer, "'Kunststück von gegossenem Metall:' Adriaen de Vries's bronze technique." In Frits Scholten, ed., *Adriaen de Vries, 1556–1626,* exh. cat. Amsterdam: Rijksmuseum, 1998, 64–77.

BIAGI Maria Luisa Altieri Biagi, "La *Vita* del Cellini: Temi, Termini, Sintagmi." In *Problemi attuali di scienza e cultura: Benvenuto Cellini artista e scrittore.* Rome: Accademia dei Lincei, 1972.

BIRINGUCCIO Vannoccio Biringuccio, *De la pirotechnia* [1540], facs. ed. Edited by Adriano Carugo. Milan: Il Polifilo, 1977.

BLÜMNER Hugo Blümner, "Salz." In Wilhelm Kroll and Kurt Witte, ed., *Paulys Real-Encyclopädie.* Stuttgart: J. B. Metzler, 1920, series 2, vol. 1, 2075–99.

BOBER Phyllis Pray Bober, *Renaissance Artists & Antique Sculpture: A Handbook of Sources.* Oxford: Oxford University Press, 1986.

BOCCACCIO 1494 Giovanni Boccaccio, *Genealogiae.* Venice: Bonetus Locatellus for Octavianus Scotus, 1494.

BOCCACCIO 1531 Giovanni Boccaccio, *Génealogie.* Paris: P. Le Noir, 1531.

BOCCACCIO 1545 Giovanni Boccaccio, *Delle Donne Illustre.* Translated by Giuseppe Betussi. Venice: Comin da Trino di Monferrato, 1545.

BOCCHI Francesco Bocchi, *Le bellezze della città di Firenze* [1591], facs. ed. Amsterdam: Demand Reprints, 1984.

BODE Georg Heinrich Bode, *Scriptores rerum mythicarum latini tres romae nuper reperti.* Cellis: Schultz, 1834.

BOLLAND Andrea Bolland, "*Desiderio* and *Diletto*: Vision, Touch, and the Poetics of Bernini's *Apollo and Daphne.*" *Art Bulletin* 82 (2000): 309–330.

BONSIGNORE Giovanni Bonsignore, *P. Ovidio metamorphoseos vulgare novamente stampato. Diligentemente correcto & historiato.* Milan: Nicolo da Gorgonzola, 1520.

BOON Karel G. Boon, "Vier tekeningen van Willem Danielsz. Tetrode." *Oud Holland* 80 (1965): 205–10.

BORGHINI 1584 Raffaello Borghini, *Il Riposo.* Florence: Giorgio Marescotti, 1584.

BORGHINI 1974 Vincenzo Borghini, *Storia della Nobiltà Fiorentina.* Edited by J. R. Woodhouse. Pisa: Marlin, 1974.

BORGHINI 1990 Vincenzo Borghini, *Dell'Arme delle familie fiorentine.* Florence: Festina Lente, 1990.

BOSCHINI Marco Boschini, *La carta del navegar pitoresco.* Edited by Anna Pallucchini. Rome: Istituto per la Collaborazione Culturale, 1966.

BOSELLI Orfeo Boselli, *Osservazioni dell scoltura antica e altri scritti.* Edited by Phoebe Dent Weil. Florence: Edizioni S.P.E.S., 1978.

BOSTRÖM Antonia Boström, "Antonio Lastricati: a newly discovered document." *Burlington Magazine* 136 (1994): 835–36.

BOTTARI Giovanni Bottari, *Raccolta di lettere sulla pittura, scultura ed architettura scritte da' più celebri personaggi dei secoli xv, xvi, e xvii.* Milan: G. Silverstri, 1822.

BOUCHER Bruce Boucher, *The Sculpture of Jacopo Sansovino.* New Haven: Yale University Press, 1991.

BRACESCO Giovanni Bracesco, *La Espositione di Geber Philosopho . . . nella quale si dichiarano molti nobilissimi secreti della natura.* Venice: Gabriel Giolito de' Ferrari, 1551.

BRANDT Kathleen Weil-Garris [Brandt], "On Pedestals: Michelangelo's *David,* Bandinelli's *Hercules and Cacus,* and the Sculpture of the Piazza della Signoria." *Römisches Jahrbuch für Kunstgeschichte* 20 (1983): 377–415.

BRAUNFELS Wolfgang Braunfels, *Benvenuto Cellini: Perseus und Medusa* [1948]. Stuttgart: Reclam, 1961.

BREDEKAMP 1995a Horst Bredekamp, *The Lure of Antiquity and the Cult of the Machine: The Kunstkammer and the Evolution of Nature, Art and Technology*. Translated by Allison Brown. Princeton: Markus Wiener Publishers, 1995.

BREDEKAMP 1995b Horst Bredekamp, *Repräsentation und Bildmagie der Renaissance als Formproblem*. Munich: Carl Friedrich von Siemens Stiftung, 1995.

BREIDECKER Volker Breidecker, *Florenz, oder 'Die Rede, die zum Auge spricht': Kunst, Fest und Macht im Ambiente der Stadt*. Munich: Fink, 1990.

BRINK–HORNBOSTEL Claudia Brink and Wilhelm Hornbostel, *Pegasus und die Künste*. Exh. cat., Museum für Kunst und Gewerbe, Hamburg. Munich: Deutscher Kunstverlag, 1993.

BRINK Claudia Brink, "Pegasus und die Künste: Eine Einführung." In Brink and Wilhelm Hornbostel, ed., *Pegasus und die Künste*, exh. cat., Museum für Kunst und Gewerbe, Hamburg. Munich: Deutscher Kunstverlag, 1993, 10–25.

BRUNO 1974 Leonardo Bruno, *Oratio de laudibus Florentine urbis*. Edited by Giuseppe de Toffol. Florence: La Nuova Italia, 1974.

BRUNO 1985 Giordano Bruno, *Dialoghi Italiani*. Edited by G. Gentile, 2 vols. Florence: Sansoni, 1985.

BURCKHARDT Jacob Burckhardt, *The Civilization of the Renaissance in Italy*. Translated by S.G. Middlemore. New York: Phaidon, 1955.

BURY Michael Bury, "Bernardo Vecchietti, Patron of Giambologna," *I Tatti Studies* 1 (1985): 13–56.

BUSH Virginia, Bush, *The Colossal Sculpture of the Cinquecento*. New York: Garland, 1976.

BUTTERS Suzanne B. Butters, *The Triumph of Vulcan: Sculptors' Tools, Porphyry, and the Prince in Ducal Florence*, 2 vols. Florence: Olschki, 1996.

CALAMANDREI Piero Calamandrei, *Scritti e inediti celliniani*. Edited by Carlo Cordiè. Florence: La Nuova Italia, 1971.

CAMESASCA Ettore Camesasca, *Tutta l'opera del Cellini*. Milan: Rizzoli, 1955.

CAMILLE Michael Camille, *The Gothic Idol: Ideology and Image-Making in Medieval Art*. Cambridge: Cambridge University Press, 1989.

CAPLOW Harriet McNeal Caplow, *Michelozzo*. New York: Garland, 1977.

CAPRETTI Elena Capretti, "Cellini, Benvenuto." In Günther Meissner, ed., *Allgemeines Künstler-Lexicon* 17. Munich and Leipzig: Saur, 1997, 495–8.

CARDANUS Hieronymus Cardanus, *De subtilitate*. Basel: Sebastianus Henricpetri, 1582.

CARPANI *La Vita di Benvenuto Cellini*. Edited by Giovanni Palamede Carpani. Milan: Società Tipografia de' Classici Italiani, 1806–11.

CARROLL Margaret D. Carroll, "The Erotics of Absolutism: Rubens and the Mystification of Sexual Violence." Reprinted in Norma Broude and Mary D. Garrard, eds., *The Expanding Discourse: Feminism and Art History*. New York: HarperCollins, 1992, 139–59.

CARTARI Vincenzo Cartari, *Le immagini degli dèi*. Edited by Caterina Volpi. Rome: De Luca, 1996.

CASTOR Grahame Castor, *Pléiade Poetics. A Study in Sixteenth-Century Thought and Terminology*. Cambridge: Cambridge University Press, 1964.

CAUTIO Camillo Cautio, *Il decimo libro de le trasformationi d'Ovidio novamente tradotto*. San Luca: 1548.

CAZORT Mimi Cazort, Monique Kornell, and K.B. Roberts, eds., *The Ingenious Machine of Nature: Four Centuries of Art and Anatomy*. Exh. cat. Ottawa: National Gallery of Canada, 1996.

CELLINI Benvenuto Cellini, *Dve trattati vno intorno allo otto principali arti dell'oreficeria. L'altro in materia dell'Arte della Scultura; doue si veggono infiniti segreti nel lauorar le Figure di Marmo, & nel gettarle di Bronzo*. Florence: Valente Panizzij & Marco Peri, 1568.

CERVIGNI Dino S. Cervigni, *The* Vita *of Benvenuto Cellini: Literary Tradition and Genre.* Ravenna: Longo, 1979.

CESALPINO Andrea Cesalpino, *De metallicis libri tres.* Rome: Aloysij Zannetti, 1596.

CHANTELOU Paul Fréart de Chantelou, *Journal de Voyage du Cavalier Bernin en France.* Edited by Jean Paul Guibbert. Paris: Pandora, 1981.

CHASTEL André Chastel, *The Sack of Rome, 1527.* Translated by Beth Archer. Princeton: Princeton University Press, 1983.

CHURCHILL Sidney Churchill, "Bibliografia celliniana." *La Bibliofilia* 9 (1907): 173–77, 262–69.

CIANCHI Renzo Cianchi, "Figure nuove del mondo vinciano. Paolo e Vannoccio Biringuccio da Siena." *Raccolta Vinciana* 20 (1964): 277–97.

CICERO 1511 *Opera M. T. Ciceronis Philosophica.* Paris: Iodocvs Badius Ascensius, 1511.

CICERO 1914 Cicero, *De Finibus Bonorum et Malorum.* Translated by H. Rackham. London: Heinemann and New York: Macmillan, 1914.

COLE 1998 Michael Cole, "Benvenuto Cellini's Designs for his Tomb." *Burlington Magazine* 140 (1998): 798–803.

COLE 2001a Michael Cole, "The *Figura Sforzata*: Modeling, Power, and the Mannerist Body." *Art History* 24 (2001): 520–51.

COLE 2001b Michael Cole, "Lasca, Allori, and Judgment in the Montauti Chapel." *Mitteilungen des Kunsthistorischen Institutes in Florenz* (in press).

COLE 2002 Michael Cole, "The Medici *Mercury* and the Breath of Bronze." In Peta Motture, ed., *Studies in the History of Art: Large Bronzes of the Renaissance* (in Press).

COLLARETA Marco Collareta, "Considerazioni in margine al *De Statua* ed alla sua fortuna." *Annali della Scuola Normale Superiore di Pisa* 3 (1982): 171–87.

COPENHAVER Brian P. Copenhaver, *Hermetica: The Greek* Corpus Hermeticum *and the Latin* Asclepius *in a new English translation, with Notes and Introduction.* Cambridge: Cambridge University Press, 1992.

CORTI Gino Corti, "Il testamento di Zanobi Lastricati, scultore Fiorentino del Cinquecento." *Mitteilungen des Kunsthistorischen Instituts in Florenz* 32 (1988): 580–81.

CORTISSOZ Royal Cortissoz, introduction to *The Life of Benvenuto Cellini Written by Himself.* New York: Brentano, 1906.

CORWEGH Robert Corwegh, *Benvenuto Cellini.* Leipzig: Xenien-Verlag, 1912.

COX-REARICK 1984 Janet Cox-Rearick, *Dynasty and Destiny in Medici Art: Pontormo, Leo X, and the Two Cosimos.* Princeton: Princeton University Press, 1984.

COX-REARICK 1995 Janet Cox-Rearick, *The Collection of Francis I: Royal Treasures.* Antwerp: Abrams, 1995.

CROPPER 1984 Elizabeth Cropper, *The Ideal of Painting. Pietro Testa's Dusseldorf Notebook.* Princeton: Princeton University Press, 1984.

CROPPER 1991 Elizabeth Cropper, "The Petrifying Art: Marino's Poetry and Caravaggio." *Metropolitan Museum Journal* 26 (1991): 193–212.

CROPPER 1996 Elizabeth Cropper, "Michelangelo Cerquozzi's Self-Portrait: The Real Studio and the Suffering Model." In Victoria V. Flemming and Sebastian Schütze, ed., *Ars naturam adiuvans: Festschrift für Matthias Winner.* Mainz: Philipp von Zabern, 1996, 401–12.

CROPPER 1998 Elizabeth Cropper, *Pontormo: Portrait of a Halbadier.* Los Angeles: Getty Museum, 1998.

CROPPER-DEMPSEY Elizabeth Cropper and Charles Dempsey, *Nicolas Poussin: Friendship and the Love of Painting.* Princeton: Princeton University Press, 1996.

CROW Thomas Crow, *The Intelligence of Art.* Chapel Hill: University of North Carolina Press, 1999.

CUST Robert H. Hobart Cust, *The Autobiography of Benvenuto Cellini*, 2 vols. London: G. Bell and Sons, 1910.

DALUCAS Elisabeth Dalucas, "'Ars erit archetypus naturae': Zur Ikonologie der Bronze in der Renaissance." In Volker Krahn, ed., *Von Allen Seiten Schön: Bronzen der Renaissance und des Barock. Wilhelm Bode zum 150. Geburtstag.* Exh. cat., Staatliche Museen, Berlin, 1995, 70–81.

DAVIS 1976 Charles Davis, "Benvenuto Cellini and the Scuola Fiorentina," *North Carolina Museum of Art Bulletin* 13 (1976): 1–70.

DAVIS 1985a Charles Davis, "Shapes of mourning: sculpture by Alessandro Vittorio, Agostino Rubini, and others." In Andrew Morrogh *et al.*, ed., *Renaissance studies in honor of Craig Hugh Smyth.* Florence: Giunti Barbèra, 1985, II, 163–75.

DAVIS 1985b Charles Davis, "Working for Vasari. Vincenzo Danti in Palazzo Vecchio." In Gian Carlo Gafagnini, ed., *Giorgio Vasari tra decorazione ambientale e storiografia artistica.* Florence: Olschki, 1985; 205–71.

DE PILES Roger De Piles, *The Principles of Painting.* London: J. Osborn, 1743.

DEBUS Allen G. Debus, *The French Paracelsians: The Chemical Challenge to Medical and Scientific Tradition in Early Modern France.* Cambridge: Cambridge University Press, 1991.

DEL BRAVO Carlo Del Bravo, *Bellezza e pensiero.* Florence: Le lettere, 1997.

DELLA PORTA 1560 Giambattista Della Porta, *Dei miracoli et maravigliosi effetti dalla natura prodotti.* Venice: L. Avanzi, 1560.

DELLA PORTA 1658 John Baptista Della Porta, *Natural Magick.* London: Thomas Young and Samuel Speed, 1658.

DEMPSEY 1986 Charles Dempsey, "The Carracci Reform of Painting." In *The Age of Correggio and the Carracci: Emilian Painting of the Sixteenth and Seventeenth Centuries.* Washington: National Gallery, 1986, 236–54.

DEMPSEY 1996a Charles Dempsey, "L'impression de merveilles à la galerie du palais Farnèse." In Françoise Jiguret and Alain Laframbroise, eds., *Andromède, ou le héros à l'épreuve de la beauté.* Paris: Louvre, 1996.

DEMPSEY 1996b Charles Dempsey, "Donatello's *Spiritelli*." In Victoria V. Flemming & Sebastian Schütze, eds., *Ars naturam adiuvans: Festschrift für Matthias Winner.* Mainz: Von Zabern, 1996, 50–61.

DIEMER 1986 Dorothea Diemer, "Bronzeplastik um 1600 in München: Neue Quellen und Forschungen." *Jahrbuch des Zentralinstituts für Kunstgeschichte* 2 (1986): 107–77.

DIEMER 1987 Dorothea Diemer, "Bronzeplastik um 1600 in München: Neue Quellen und Forschungen: II. Teil." *Jahrbuch des Zentralinstituts für Kunstgeschichte* 3 (1987): 109–68.

DIVIGNE Marguerite Divigne, "Le Sculpteur Willem Danielsz. van Tetrode, dit en Italie Guglielmo Fiammingo." *Oud Holland* 56 (1939): 89–96.

DOLCE Lodovico Dolce, *Le Trasformationi di M. Lodovico Dolce. In questa sesta impreßione da li in molti luoghi ampliate, con l'aggiunta de gli argomenti, et allegorie al principio & al fine di ciascun Canto.* Venice, 1561.

DOREN A. Doren, *Das Aktenbuch für Ghiberti's Matthäusstatue an Or S. Michele zu Florenz.* Kunsthistorisches Institut in Florenz, Italienische Forschungen, I. Berlin, 1906.

EAMON William Eamon, *Science and the Secrets of Nature: Books of Secrets in Medieval and Early Modern Culture.* Princeton: Princeton University Press, 1994.

ELIADE Mircea Eliade, *The Forge and the Crucible.* Translated by Stephen Corrin. Chicago: University of Chicago Press, 1956.

ELKINS James Elkins, "Michelangelo and the human form: his knowledge and use of anatomy." *Art History* 7 (1984): 176–86.

ETTLINGER Leopold D. Ettlinger, *Antonio and Piero Pollaiuolo.* London: Phaidon, 1978.

EVEN Yael Even, "The Loggia dei Lanzi: A Showcase of Female Subjugation." In Norma Broude and Mary D. Garrard, eds., *The Expanding Discourse: Feminism and Art History.* New York: HarperCollins, 1992, 126–37.

FABRI, *Ethicorum Aristotelis Philosophi Clarissimi libri decem ad Nicomachum, ex traductione diligentissimi ac eruditissimi viri Ioannis Argyropili Byzantij: familiariq. necnon admudum copioso Iacobi Fabri Stapulensis Commentario elucidati, & singulorum capitum argumentis praenotati, Adnoamentis quoq. marginalibus illustrati: nuperrimeq. quàm hactenus fuerint, multò castigatiores redditi. Adiectus est Leonardi Aretini de moribus Dialogus ad Galeotum, Dialogo parvorum Moralium Aristotelis ad Eudemium ferèm respondens.* Florence: Jacobus Giunta, 1535.

FACCIOLATI Jacobi Facciolati, *Totius Latinitatis Lexicon.* London: Baldwin and Cradock, 1828.

FARRAGO Claire J. Farrago, *Leonardo da Vinci's* Paragone. *A Critical Interpretation with a New Edition of the Text in the* Codex Urbinas. Leiden, NY, Copenhagen and Cologne: Brill, 1992.

FERRERO Giuseppe Guido Ferrero, ed., *Opere di Benvenuto Cellini.* Turin: UTET, 1980.

FFOLLIOTT Sheila ffolliott, *Civic Sculpture in the Renaissance: Montorsoli's Fountains at Messina.* Ann Arbor: UMI Research Press, 1984.

FICINO 1544 Marsilio Ficino, *Sopra lo amore o ver' Convito di Plato.* Florence: Néri Doteláta, 1544.

FICINO 1959 Marsilio Ficino, *Opera Omnia.* Turin: Bottega d'Erasmo, 1959.

FICINO 1975 *The Letters of Marsilio Ficino.* London: School of Economics, 1975.

FIORAVANTI Leonardo Fioravanti, *La Cirugia.* Venice: The Heirs of Melchiorre Sessa, 1570.

FLETCHER Angus Fletcher, *The Transcendental Masque: An Essay on Milton's* Comus. Ithaca: Cornell Univeristy Press, 1972.

FOCILLON Henri Focillon, *Benvenuto Cellini.* Paris: Presses Pocket, 1992.

FORNARI Simone Fornari, *La spositione sopra l'Orlando furioso di M. Ludovico Ariosto.* Florence: Lorenzo Torrentino, 1549.

FRECCERO John Freccero, "Medusa: The Letter and the Spirit." *Yearbook of Italian Studies* 2 (1972): 1–18.

FREEDBERG David Freedberg, "Holy Images and Other Images." In Susan C. Scott, ed., *The Art of Interpreting.* University Park: Pennsylvania State University Department of Art History, 1995, 68–86.

FUMAROLI Marc Fumaroli, *L'École du Silence. Le sentiment des images au XVII^e siècle.* Paris: Flammarion, 1984.

GAJANTE Juan López Gajante, *El Cristo Blanco de Cellini.* Madrid: Estudios Superiores del Escorial, 1995.

GALEN 1541 Galen, *Operum Omnium.* Venice: 1541.

GALEN 1979 Galen, *On the Natural Faculties.* Translated by Arthur John Brock. London: Heinemann; Cambridge, Mass.: Harvard, 1979.

GALLAGHER Catherine Gallagher, Joel Fineman, and Neil Hertz, "More about 'Medusa's Head.'" *Representations* 4 (1983): 55–72.

GALLUCCI 1995 Margaret Ann Galucci, "The Unexamined Life of Benvenuto Cellini: Poetic Deviation and Sexual Transgression in 16th-century Italy." Ph.D. diss., University of California, 1995.

GALLUCCI 2000 Margaret A. Gallucci, "A New Look at Benvenuto Cellini's Poetry." *Forum Italicum* 34 (2000): 343–71.

GALLUCCI 2001 Margaret A. Gallucci, "Cellini's trial for sodomy: power and patronage at the court of Cosimo I." In Konrad Eisenbichler, ed., *The Cultural Politics of Duke Cosimo I de' Medici.* Aldershot: Ashgate, 2001, 37–46.

GARDNER Victoria C. Gardner, "Homines non nascuntur sed figuntur: Benvenuto Cellini's 'Vita' and the Self-Presentation of the Renaissance Artist." *Sixteenth Century Journal* 28 (1997): 447–65.

GATTO Vittorio Gatto, *La protesta di un irregolare: Benvenuto Cellini.* Salerno: Edizioni Scientifiche Italiane, 1988.

GAURICUS Pomponius Gauricus, *De Sculptura.* Edited by André Chastel and Robert Klein. Geneva: DROZ, 1969.

GAYE Giovanni Gaye, ed., *Carteggio inedito d'artisti dei secoli xiv. xv. xvi.* Florence: Molini, 1860.

GILBERT Creighton Gilbert, "'Un Viso quasiche di furia'." In Craig Hugh Smyth with Ann Gilkerson, ed., *Michelangelo's Drawings.* Washington, D.C.: National Gallery of Art, 1992.

GILIO Giovanni Andrea Gilio da Fabriano, *Due Dialogi* [1564]. Florence: SPES, 1986.

GLORIA Andrea Gloria, *Donatello fiorentino e le sue opere mirabili nel tempio di S. Antonio di Padova.* Padua: Tipografia e libreria Antoniana, 1895.

GOETHE Johann Wolfgang Goethe, *Leben des Benvenuto Cellini.* Edited by Hans-Georg Dewitz and Wolfgang Pross. Frankfurt: Deutscher Klassiker Verlag, 1998.

GOLDBERG Jonathan Goldberg, "Cellini's *Vita* and the Conventions of Early Autobiography." *MLN* 89 (1974): 71–83.

GOMBRICH Ernst Gombrich, *Norm and Form: Studies in the Art of the Renaissance.* London: Phaidon, 1966, 81–96.

GOTTI Aurelio Gotti, *Vita di Michelangelo Buonarroti narrata con l'aiuto di nuovi documenti.* Florence: Le Monnier, 1875.

GRABNER Elfriede Grabner, "Die Koralle in Volksmedizin und Aberglaube." *Zeitschrift für Volkskunde* 65 (1969): 183–95.

GRAMACCINI Norberto Gramaccini, "Zur Ikonologie der Bronze im Mittelalter." *Städel Jahrbuch* 11 (1987): 147–70.

GRAMBERG Werner Gramberg, *Die Düsseldorfer Skizzenbücher des Guglielmo della Porta.* Berlin: Gebr. Mann, 1964.

GRODECKI Catherine Grodecki, "Le Séjour de Benvenuto Cellini à l'Hôtel de Nesle et la fonte de la Nymphe de Fontainebleau d'après des notaires Parisiens." *Bulletin de la société de l'Histoire de Paris et de l'Ile-de-France* (1971): 1–36.

GUASTI Gaetano Guasti, ed., *La Vita di Benvenuto Cellini.* Florence: Barbèra, 1890.

GUGLIELMINETTI Marziano Guglielminetti, Memoria e scrittura. Turin: Einaudi, 1977.

GUIDI 1611a Guido Guidi, *De Tuenda Valetudine Generatim.* (Venice: Iuntas, 1611).

GUIDI 1611b Guido Guidi, *Institutionum Medicinalium.* (Venice: Iuntas, 1611).

HALL Marcia Hall, "Reconsiderations of Sculpture by Leonardo da Vinci." *J.B. Speed Art Museum Bulletin* 29 (1973): 11–17.

HATTENDORFF Claudia Hattendorff, "Francesco Bocchi on disegno." *Journal of the Warburg and Courtauld Institutes* 55 (1992): 272–7.

HEIKAMP 1956 Detlef Heikamp, "Arazzi a soggetto profano su cartoni di Alessandro Allori." *Rivista d'Arte* 30 (1956): 105–155.

HEIKAMP 1957 Detlef Heikamp, "Rapporti fra accademici ed artisti nel Firenze del '500." *Il Vasari* 15 (1957): 139–63.

HEIKAMP 1964 Detlef Heikamp, "Poesie in vituperio del Bandinello." *Paragone* 175 (1964): 59–68.

HEIKAMP 1995 Detlef Heikamp, "La Fontana del Nettuno in Piazza della Signoria e le sue acque." In Niccolò Rosselli del Turco and Federica Salvi, eds., *Bartolomeo Ammannati-Scultore e Architetto, 1511–1592.* Florence: Alinea, 1995, 19–25.

HERRIG Dorothee Herrig, *Fontainebleau. Geschichte und Ikonologie der Schloßanlage Franz I.* Munich: tuduv, 1992.

HERRMANN-FIORE Kristin Herrmann-Fiore, "Disegno and Giudizio, Allegorical Drawings by Federico Zuccaro and Cherubino Alberti." *Master Drawings* 20 (1982): 247–56.

HERTZ Neil Hertz, "Medusa's Head: Male Hysteria under Political Pressure." *Representations* 4 (1983): 27–54.

HIRTHE Thomas Hirthe, "Die Perseus-und-Medusa-Gruppe des Benvenuto Cellini in Florenz." *Jahrbuch der Berliner Museen* 29 (1987/88): 197–216.

HOBSON Anthony Hobson, *Apollo and Pegasus: An Enquiry into the Formation and Dispersal of a Renaissance Library.* Amsterdam: Gérard Th. van Heusden, 1975.

HOLDERBAUM James Holderbaum, "Notes on Tribolo." *Burlington Magazine* 99 (1957): 336–43, 369–72.

HOLANDA Francisco de Holanda, *Da pintura antiga.* Edited by Angel Gonzlez Garcia. Lisbon: Nacional-Casa da Moeda, 1984.

HOLMAN Beth Holman, "Verrocchio's Marsyas and Renaissance Anatomy." *Marsyas* 19 (1977/78): 1–9.

HOPE Charles Hope, "Artists, Patrons and Advisors in the Italian Renaissance." In Guy Fitch Lytle and Stephen Orgel, eds., *Patronage in the Renaissance.* Princeton: Princeton University Press, 1981, 293–343.

HUEMER Frances Huemer, "A Dionysiac Connection in an Early Rubens." *Art Bulletin* 61 (1979): 562–74.

HYMANS H. Hymans, "Une Visite chez Rubens, racontée par un contemporain." *Bulletin de l'Academie royale de Belgique* 56 (1987): 150.

JACOBS 1988 Fredrika H. Jacobs, "An Assessment of Contour Line: Vasari, Cellini, and the *Paragone,*" *artibus et historiae* 18 (1988): 139–50.

JACOBS 1997 Fredrika H. Jacobs, *Defining the Renaissance Virtuosa. Women Artists and the Language of Art History and Criticism.* Cambridge: Cambridge University Press, 1997.

JANSON 1941 H. W. Janson, "The Sculptured Works of Michelozzo di Bartolommeo." Ph.D. diss., Harvard University, 1941.

JANSON 1957 H. W. Janson, *The Sculpture of Donatello.* Princeton: Princeton University Press, 1957.

JESTAZ Bertrand Jestaz, *La Chapelle Zen à San Marc de Venise: D'Antonio à Tullio Lombardo.* Stuttgart: Steiner, 1986.

JOANNIDES Paul Joannides, *Michelangelo and His Influence: Drawings from Windsor Castle.* London: Lund Humphries Publishers, 1996.

JOHNSON Geraldine A. Johnson, "Idol or Ideal? The Power and Potency of Female Public Sculpture." In Geraldine A. Johnson and Sara F. Matthews Grieco, eds., *Picturing Women in Renaissance and Baroque Italy.* Cambridge: Cambridge University Press, 1997, 222–45.

KAHN Victoria Kahn, *Macchiavellian Rhetoric.* Princeton: Princeton University Press, 1994.

KANTOROWICZ 1951 Ernst Kantorowicz, "Dante's 'Two Suns'" [1951]. In Kantorowicz, *Selected Studies.* New York: J. J. Augustin, 1965, 325–38.

KANTOROWICZ 1957 Ernst Kantorowicz, "On the Transformations of Apolline Ethics" [1957]. In *Selected Studies.* New York: J. J. Augustin, 1965, 319–408.

KAUFFMANN Hans Kauffmann, *Giovanni Lorenzo Bernini: Die figürlichen Kompositionen.* Berlin: Gebr. Mann, 1970.

KAUFMANN 1978a Thomas DaCosta Kaufmann, "Empire Triumphant: Notes on an Imperial Allegory by Adriaen de Vries." *Studies in the History of Art* 8 (1978): 63–76.

KAUFMANN 1978b Thomas DaCosta Kaufmann, "Remarks on the Collections of Rudolph II: the *Kunstkammer* as a Form of *Representatio*." *Art Journal* 38 (1978): 22–8.

KAUFMANN 1982 Thomas DaCosta Kaufmann, "The Eloquent Artist: Towards an Understanding of the Stylistics of Painting at the Court of Rudolf II." *Leids Kunsthistorisch Jaarboek* 1 (1982): 119–48.

KAUFMANN 1995 Thomas DaCosta Kaufmann, *Court, Cloister and City: The Art of Central Europe*. Chicago: University of Chicago Press, 1995.

KAUFMANN 1997 Thomas DaCosta Kaufmann, "Kunst und Alchemie." In Heiner Borggrefe, Vera Lüpkes, and Hans Ottomeyer, eds., *Moritz der Gelehrte: Ein Renaissancefürst in Europa*. Erausberg: Minerva, 1997, 371–77.

KEMP 1974 Wolfgang Kemp, "*Disegno*: Beiträge zur Geschichte des Begriffs zwischen 1547 und 1607." *Marburger Jahrbuch für Kunstwissenschaft* 19 (1974): 219–400.

KEMP 1981 Martin Kemp, *Leonardo da Vinci: The Marvellous Works of Nature and Man*. London, Melbourne, Toronto: J. M. Dent and Sons, 1981.

KEMPTER Gerda Kempter, *Ganymed: Studien zur Typologie, Ikonographie und Ikonologie*. Cologne: Bhlau, 1980.

KENNEDY Ruth Wedgwood Kennedy, "Cellini and Vincenzo de' Rossi." *Renaissance News* 4 (1951): 33–9.

KETELSEN Thomas Ketelsen, "Das Lob der Malerei: Pegasus und die Musen in der italienischen Kunst." In Claudia Brink and Wilhelm Hornbostel, eds., *Pegasus und die Künste*. Exh. cat., Museum für Kunst und Gewerbe, Hamburg. Munich: Deutscher Kunstverlag, 1993, 46–60.

KEUTNER Herbert Keutner, "Niccolò Tribolo und Antonio Lorenzi: Der Äskulapbrunnen im Heilkräutergarten der Villa Castello bei Florenz." In Kurt Martin, ed., *Studien zur Geschichte der Europäischen Plastik. Festschrift Theodor Müller*. Munich: Hirmer, 1965, 235–44.

KIEFT Ghislain Kieft, "Zuccari, Scaligero e Panofsky." *Mitteilungen des Kunsthistorischen Instituts in Florenz* 33 (1974): 355–368.

KIRWIN 1995 W. Chandler Kirwin (with Peter G. Rush), "Bubble Reputation: In the Cannon's and the Horse's Mouth (or The Tale of Three Horses)." In Diane Cole Ahl, ed., *Leonardo da Vinci's Sforza Monument Horse. The Art of Engineering*. Bethlehem, PA: Lehigh University Press, 1995.

KIRWIN 1997 W. Chandler Kirwin, *Powers Matchless: The Pontificate of Urban VIII, the Baldachin, and Gian Lorenzo Bernini*. New York: Peter Lang, 1997.

KLEIN Robert Klein, "L'art et l'attention au technique." In André Chastel, ed., *La Forme et l'intelligible*. Paris: Gallimard, 1970, 362–93.

KLIBANSKY Raymond Klibansky, Erwin Panofsky and Fritz Saxl, *Saturn and Melancholy: Studies in the History of Natural Philosophy, Religion, and Art*. New York: Basic Books, 1964.

KLIEMANN Julian Kliemann, "Kunst als Bogenschiessen. Domenichinos *Jagd der Diana* in der Galleria Borghese." *Römisches Jahrbuch der Bibliotheca Hertziana* 31 (1996): 273–311.

KRAUTHEIMER Richard Krautheimer, *Lorenzo Ghiberti*. Princeton: Princeton University Press, 1982.

KRIEGBAUM Friedrich Kriegbaum, "Marmi di Benvenuto Cellini ritrovati." *L'Arte* 11 (1940): 3–25.

KRIS Ernst Kris, "Der Stil *Rustique*: Die Verwendung des Naturabgusses bei Wenzel Jamnitzer und Bernard Palissy." *Jahrbuch der Kunsthistorischen Sammlungen in Wien* 1 (1926): 137–208.

KRIS–KURZ Ernst Kris and Otto Kurz, *Legend, Myth, and Magic in the Image of the Artist*. Translated by Alastair Laing and Lottie M. Newman. New Haven: Yale University Press, 1979.

KRISTELLER Paul Oskar Kristeller, "The Modern System of the Arts." In Kristeller,

Renaissance Thought and the Arts: Collected Essays. Princeton: Princeton University Press, 1980, 163–222.

LANDINO Christophoro Landino, *Historia naturale di C. Plinio Secondo, di Latino in volgare tradotta per Christophoro Landino, et nuovamente in molti luoghi, dove quella mancava, supplito.* Venice, 1543.

LANGEDIJK Karla Langedijk, *The Portraits of the Medici, 15th–18th Centuries.* Florence: SPES, 1981.

LÁNYI Jenö Lányi, "Problemi della critica Donatelliana." *La Critica d'Arte* 4 (1939): 9–23.

LARSSON Lars Olof Larsson, *Von allen Seiten gleich schön: Studien zum Begriff der Vielansichtigkeit in der europäischen Plastik von der Renaissance bis zum Klassizismus.* Stockholm: Almqvist and Wiksell, 1974.

LASCA Carlo Verzone, ed., *Le Rime Burlesche edite e inedite di Antonfrancesco Grazzini detto il Lasca.* Florence: Sansoni, 1882.

LAVIN 1977 Irving Lavin, "The Sculptor's 'Last Will and Testament.'" *Allen Memorial Art Museum Bulletin* 35 (1977–78): 4–39.

LAVIN 1993 Irving Lavin, "David's Sling and Michelangelo's Bow: A Sign of Freedom." In Lavin, *Past-Present: Essays on Historicism in Art from Donatello to Picasso.* Berkeley: University of California Press, 1993, 29–61.

LAVIN 1998a Irving Lavin, "Bernini's Bust of Medusa: An Awful Pun." *Docere delectare movere: Affetti, devozione e retorica nel linguaggio artistico del primo barocco romano.* Rome: De Luca, 1998, 155–74.

LAVIN 1998b Irving Lavin, "*Ex Uno Lapide:* The Renaissance Sculptor's *Tour de Force.*" In Matthias Winner *et al.*, eds., *Il cortile delle statue. Der Statuenhof des Belvedere im Vatikan.* Mainz: Philipp von Zabern, 1998, 191–210.

LAVIN–REDLEAF Marilyn Aronberg Lavin and Miriam I. Redleaf, "Heart and Soul and the Pulmonary Tree in Two Paintings by Piero della Francesca." *Artibus et Historiae* 31 (1995): 9–17.

LECOQ Anne-Marie Lecoq, *François I^er Imaginaire: Symbolique et politique à l'aube de la Renaissance française.* Paris: Macula, 1987.

LEE Hansoon Lee, *Kunsttheorie in der Kunst: Studien zur Ikonographie von Minerva, Merkur und Apollo im 16. Jahrhundert.* Frankfurt am Main: Peter Lang, 1996.

LINK-HEER Ursula Link-Heer, "'Fare' und 'dire' in der 'Vita' Cellinis." In Helmut Kreuzer *et al.*, ed., *Von Rubens zum Dekonstuktivismus: Festschrift für Wolfgang Drost.* Heidelberg: 1993, 170–195.

LOMAZZO Gianpaolo Lomazzo, *Trattato dell'Arte della Pittura, Sculptura ed Architettura.* Rome: Giuseppe Gismondi, 1844.

LUCRETIUS *T. Cari Lucretii Poetae, ac Philosophi Vetustissimi, De Rerum Natura Libri Sex.* Lyons: Seb. Gryphium, 1540.

LUCRETIUS-ROUSE *De rerum natura.* Translated by W. H. D. Rouse. London: W. Heinemann; Cambridge, Mass.: Harvard University Press, 1937.

MABELLINI Adolfo Mabellini, *Delle rime di Benvenuto Cellini.* Rome: Paravia, 1885.

MACCHIAVELLI Niccolò Macchiavelli, *Il Principe e Discorsi sopra la prima deca di Tito Livio.* Edited by Segio Bertelli. Milan: Feltrinelli, 1977.

MACHAM Sarah Blake MacHam, "Public Sculpture in Renaissance Florence." In MacHam, ed., *Looking at Italian Renaissance Sculpture.* New York: Cambridge University Press, 1998, 149–88.

MACROBIUS 1543 *Macrobii Ambrosii Theodosii . . . In Somnium Scipionis, Lib. II. Saturnaliorum, Lib. VII.* Lyons: Seb. Gryphium, 1543.

MACROBIUS 1969 Macrobius, *Saturnalia.* Translated by Percival Vaughan Davies. New York and London: Columbia University Press, 1969.

MAGNIFICENZA *Magnificenza alla corte dei Medici. Arte a Firenze alla fine dal Cinquecento.* Exh. cat., Florence, Palazzo Pitti, 1997.

MAIER 1951 Bruno Maier, *Svolgimento storico della critica su Benvenuto Cellini scrittore.* Trieste: 1950–51.

MAIER 1952 Bruno Maier, *Umanità e stile di Benvenuto Cellini scrittore.* Milan: Luigi Trevisini, 1952.

MAIER 1969 Michael Maier, *Atalanta Fugiens. Sources of an Alchemical Book of Emblems.* Edited by H. M. E. de Jong. Leiden: Brill, 1969.

MANDEL Corinne Mandel, "Mythe, mariage et métamorphose Piazza della Signoria." In Françoise Jiguret and Alain Laframbroise, eds., *Andromède, ou le héros à l'épreuve de la beauté.* Paris: Louvre, 1996.

MANILIUS 1494 Marcus Manilius, *Astronomicon.* Rome: 1494.

MANILIUS 1977 Marcus Manilius, *Astronomicon.* Translated by G.F. Goold. Cambridge: Harvard University Press, 1977.

MARIN Louis Marin, *To Destroy Painting.* Translated by Mette Hjort. Chicago: University of Chicago Press, 1995.

MARTIN Jean-Pierre Martin, *Providentia deorum: recherches sur certains aspects religieux du pouvoir impérial romain.* Rome: École française, 1982.

MASSINELLI Anna Maria Massinelli, "I Bronzi dello Stipo di Cosimo I de' Medici." *Antichità Viva* 26 (1987): 36–45.

MATTINGLY Harold Mattingly, *Coins of the Roman Empire in the British Museum.* London: British Museum, 1965.

MAYOR A. Hyatt Mayor, *Artists and Anatomists.* New York: Metropolitan Museum of Art, 1984, 68–73.

MCCARTHY Mary McCarthy, *The Stones of Florence.* New York: Harcourt, Brace and Company, 1959.

MELION 1993 Walter S. Melion, "Love and Artisanship in Hendrick Goltzius's *Venus, Bacchus and Ceres* of 1606." *Art History* 16 (1993): 60–94.

MELION 1995a Walter S. Melion, "Self-imaging and the engraver's virtù: Hendrick Golzius's *Pietà* of 1598." *Nederlands kunsthistorisch jaarboek* 46 (1995): 104–143.

MELION 1995b Walter S. Melion, "Memorabilia aliquot Romanae Strenuitatis Exempla: The Thematics of Artisanal Virtue in Hendrick Goltzius's Roman Heroes." *MLN* 110 (1995): 1090–1134.

MELLER Peter Meller, "Geroglifici e ornamenti 'parlanti' nell'opera del Cellini." *Arte Lombarda* 3/4 (1994): 9–16.

MENDELSOHN Leatrice Mendelsohn, *Paragone: Benedetto Varchi's* Due Lezzioni *and Cinquecento Art Theory.* Ann Arbor: UMI Research Press, 1982.

MÉROT Alain Mérot, ed., *Les Conférences de l'Académie royale de peinture et de sculpture au XVIIᵉ siècle.* Paris: École nationale supérioeure des Beaux-Arts, 1996.

MÉTRAUX Guy P. R. Métraux, *Sculptors and Physicians in Fifth-Century Greece: A Preliminary Study.* Montreal and Kingston: McGill University Press, 1995.

MIDDELDORF Ulrich Middeldorf and Friedrich Kriegbaum, "Forgotton Sculpture by Domenico Poggini." *Burlington Magazine* 53 (1928), 9–17.

MILANESI 1857 Carlo Milanesi, ed., *I Trattati dell'Oreficeria e della Scultura di Benvenuto Cellini.* Florence: Le Monnier, 1857.

MILANESI 1873 Gaetano Milanesi, "Documenti riguardanti le statue di marmo e di bronzo fatte per le porte di San Giovanni di Firenze da Andrea del Monte San Savino e da G. F. Rustici." In *Sulla storia dell'arte toscana: Scritti varii.* Siena: 1873, 247–61.

MILANESI 1875 Gaetano Milanesi, *Le Lettere di Michelangelo Buonarroti edite ed inedite coi ricordi ed i contratti artistici.* Florence: Le Monnier, 1875.

MIROLLO James Mirollo, *Mannerism and Renaissance Poetry: Concept, Mode, Inner Design*. New Haven: Yale University Press, 1989.

MOREL 1990 Philippe Morel, "La théâtralisation de l'alchimie de la nature: Les grottes artificielles et la culture scientifique à Florence à la fin du XVIe siècle." In *Symboles de la Renaissance* 3 (1990): 154–83.

MOREL 1996 Philippe Morel, "La chair d'Andromède et le sang de Méduse: Mythologie et rhétorique dans le *Persée et Andromède* de Vasari." In Françoise Jiguret and Alain Laframbroise, eds., *Andromède, ou le héros à l'épreuve de la beauté*. Paris: Louvre, 1996.

MOREL 1998 Philippe Morel, *Les grottes maniéristes en Italie au XVIe siècle: théâtre et alchimie de la nature* . Paris: Macula, 1998.

MOTTURE Peta Motture, *Bells and Mortars and Related Utensils*. London: Victoria and Albert Publications, 2001.

MULLER Jeffrey Muller, "The 'Perseus and Andromeda' on Rubens's House." *Simiolus* 12 (1981–2): 131–46.

NAGEL Alexander Nagel, *Michelangelo and the Reform of Art* (New York: Cambridge University Press, 2000).

NIJSTAD Jaap Nijstad, "Willem Danielsz. van Tetrode," *Nederlands Kunsthistorisch Jaarboek* 37 (1986): 259–78.

NORDHOFF Claudia Nordhoff, *Narziss: Spiegelbilder eines Mythos in der Malerei des 16. und 17. Jahrhunderts*. Hamburg: LIT, 1992.

ORSINO Margherita Orsino, "Il fuoco nella Vita di Benvenuto Cellini: Aspetti di un mito dell'artista-fabbro," *Italian Studies* 52 (1997): 94–110.

OVID P. *Ovidii Nasonis Metamorphoseon, hoc est Transformationum, libri XV cum breuissimis in singulas quasque fabulas Lactantij Placidi argumentis*. Lyons: Vincenti, 1542.

OVID-MILLER Ovid, *Metamorphoses*. Translated by Frank Justus Miller. London: William Heinemann; and Cambridge, MA: Harvard University Press, 1960.

PAGEL Walter Pagel, *Paracelsus: An Introduction to Philosophical Medicine in the Era of the Renaissance*. Basel and New York: Karger, 1958.

PALAGI Giuseppe Palagi, *Di Zanobi Lastricati: Sculptore e Fonditore Fiorentino del Secolo XVI*. Florence: Palagi, 1871.

PALISSY Bernard Palissy, *Oeuvres complètes*. Edited by Keith Cameron *et al.*, 2 vols. Mont-de-Marsan: SPEC, 1996.

PANOFSKY 1968 Erwin Panofsky, *Idea: A Concept in Art Theory*. New York: Columbia, 1968.

PANOFSKY 1972 Erwin Panofsky, *Studies in Iconology: Humanistic Themes in the Art of the Renaissance*. New York: Harper and Row, 1972.

PARKER Deborah Parker, *Bronzino: Renaissance Painter as Poet*. New York, Cambridge University Press, 2000.

PARMA Christian Parma, *Pronoia und Providentia: Der Vorsehungsbegriff Plotins und Augustins*. Leiden: Brill, 1972.

PARRONCHI Alessandro Parronchi, "Une tête de satyre de Cellini." *Revue de l'art* 5 (1969): 43–5.

PEDRETTI Carlo Pedretti, "Un disegno per la fusione del cavallo per il monumento Sforza." *Raccolta Vinciana* 20 (1964): 271–5.

PENNY 1986 Nicholas Penny, "Geraniums and the River." *London Review of Books* 8 (20 March 1986): 13–14.

PENNY 1993 Nicholas Penny, *The Materials of Sculpture*. New Haven: Yale University Press, 1993.

PFISTERER 1993 Ulrich Pfisterer, "Die Entstehung des Kunstwerks: Federico Zuccaris 'L'idea de' pittori, scultori et architetti.'" *Zeitschrift für Ästhetik und allgemeine Kunstwissenschaft* 38 (1993): 237–68.

PFISTERER 1996 Ulrich Pfisterer, "Künstlerische *potestas audendi* und *licentia* im Quattrocento. Benozzo Gozzoli, Andrea Mantegna, Bertoldo di Giovanni." *Römisches Jahrbuch der Biblioteca Hertziana* 31 (1996): 107–48.

PFISTERER 2001 Ulrich Pfisterer, "Künstlerliebe: Der *Narcissus*-Mythos bei Leon Battista Alberti und die Aristoteles-Lektüre der Frührenaissance." *Zeitschrift für Kunstgeschichte* (forthcoming 2001).

PINTO John Pinto, *The Trevi Fountain*. New Haven: Yale University Press, 1986.

PIROTTI Umberto Pirotti, *Benedetto Varchi e la Cultura del Suo Tempo*. Florence: 1971.

PLAISSANCE Michel Plaisance, "Culture et politique à Florence de 1542 à 1551: Lasca et les Humidieux prises avec l'Académie Florentine." In André Rochon, ed., *Les écrivains et le pouvoir en Italie à l'époque de la Renaissance*. Paris: 1974, 149–242.

PLATO Plato, *Timaeus*. Translated by Marsilio Ficino. Paris: Thomas Richardus, 1551.

PLINY-JONES *Natural History*. Translated by W. H. S. Jones. London: Heinemann; Cambridge: Harvard University Press, 1963.

PLON 1883 Eugène Plon, *Benvenuto Cellini: Orfèvre, Médailleur, Sculpteur*. Paris: Plon, 1883.

PLON 1887 Eugène Plon, *Les matres italiens au service de la maison d'Autriche. Leone Leoni, sculpteur de Charles-Quint, et Pompeo Leoni, sculpteur de Philippe II*. Paris: E. Plon, 1887.

POESCHKE 1992 Joachim Poeschke, *Michelangelo and His World: Sculpture of the Italian Renaissance*. Translated by Russell Stockman. New York: Harry N. Abrams, 1992.

POESCHKE 1993 Joachim Poeschke, *Donatello and His World: Sculpture of the Italian Renaissance*. Translated by Russell Stockman. New York: Harry N. Abrams, 1993.

POPE-HENNESSY John Pope-Hennessy, *Cellini*. New York: Abbeville Press, 1985.

POSNER Donald Posner, "The Picture of Painting in Poussin's Self-Portrait." In *Essays in the History of Art Presented to Rudolf Wittkower*. Edited by Douglas Fraser *et al.* Bristol: Phaidon, 1967, 200–3.

PRATER Andreas Prater, *Cellinis Salzfaß für Franz I*. Stuttgart: Steiner, 1988.

PREIMESBERGER 1985 Rudolph Preimesberger, "Themes from art theory in the early works of Bernini." In Irving Lavin, ed., *Gianlorenzo Bernini: New Aspects of His Art and Thought*. University Park: Penn State University Press, 1985, 1–24.

PREIMESBERGER 1986 Rudolph Preimesberger, "Berninis Cappella Cornaro: eine Bild–Wort–Synthese des siebzehnten Jahrhunderts?: zu Irving Lavins Bernini-Buch." *Zeitschrift für Kunstgeschichte* 59 (1986): 190–219.

PRESSOUYRE Sylvia Pressouyre, "Note Additionnelle sur la Nymphe de Fontainebleau." *Bulletin de la Société de l'Histoire de Paris et de l'Ile-de-France* 98 (1971): 81–92.

QUIVIGER François Quiviger, "Benedetto Varchi and the Visual Arts." *Journal of the Warburg and Courtauld Institutes* 50 (1987): 219–24.

RADCLIFFE 1985 Anthony Radcliffe, "Schardt, Tetrode, and Some Possible Sculptural Sources for Goltzius." In Görel Cavallli-Björkman, ed., *Netherlandish Mannerism*. Stockholm, Nationalmuseum, 1985, 97–108.

RADCLIFFE 1988 Anthony Radcliffe, Review of John Pope-Hennessy, *Cellini*, *Burlington Magazine* (1988): 929–32.

REGIUS *P. Ovidii Metamorphosis cum luculentissimis Raphaelis Regii enarrationibus*. Venice: Leonardo Laredano, 1517.

REILLY Patricia L. Reilly, "The Taming of the Blue: Writing Out Color in Italian Renaissance Theory." In Norma Broude and Mary Garrard, ed., *The Expanding Discourse: Feminism and Art History*. New York: HarperCollins, 1992, 126–37.

RETI Ladislao Reti, ed., *The Madrid Codices*. New York: McGraw-Hill, 1979.

REZNICEK E. K. J. Reznicek, *Die Zeichnungen von Hendrick Goltzius*. Utrecht: Haentgens Dekker & Gumbert, 1961.

RICCIO Agostino Del Riccio, *Istoria delle pietre*. Edited by Raniero Gnoli and Attila Sironi. Turin: Umberto Allemandi, 1996.

RINALDI Alessandro Rinaldi, "La ricerca della 'terza natura': artificialia e naturalia nel giardino toscano del '500." In Marcello Fagiolo, ed., *Natura e artificio: L'ordine rustico, le fontane, gli automi nella cultura del manierismo europeo.* Rome: Officina, 1971.

RIPA Cesare Ripa, *Iconologia.* New York: Garland, 1976.

ROGGENKAMP 1996a Bernd Roggenkamp, *Die Töchter des 'Disegno': Zur Kanonisierung der drei Bildenden Künste durch Giorgio Vasari.* Cologne: LIT, 1996.

ROGGENKAMP 1996b Bernd Roggenkamp, "Vom 'Artifex' zum 'Artista': Benedetto Varchis Auseinandersetzung mit dem aristotelisch-scholastischen Kunstverständnis." In Jan A. Aertsen and Andreas Speer, eds, *Individuum und Individualität im Mittelalter.* Berlin and New York: Walter de Gruyten, 1996, 844–60.

ROOSES Max Rooses, *Correspondance de Rubens et documents épistolaires concernant sa vie et ses oeuvres,* 6 vols. Antwerp: Veuve de Backer, 1887–1909.

ROSAND 1970 David Rosand, "The Crisis of the Venetian Renaissance Tradition." *L'Arte* 3 (1970): 5–34.

ROSAND 1982 David Rosand, *Titian: His World and his Legacy.* New York: Columbia University Press, 1982.

ROSSI 1974 Sergio Rossi, "Idea e accademia. Studio sulle teorie artistiche di Federico Zuccaro; 1. Disegno Interno e Disegno Esterno." In *Storia dell'Arte* 20 (1974): 37–56.

ROSSI 1980 Sergio Rossi, *Dalle Botteghe alle accademie.* Milan: Lithos, 1980.

ROSSI 1994 Paolo Rossi, "The Writer and the Man: Real Crimes and Mitigating Circumstances: *Il caso Cellini.*" In Trevor Dean and K.J.P. Lower, eds., *Crime, Society and the Law in Renaissance Italy.* Cambridge: Cambridge University Press, 1994, 157–83.

ROSSI 1998 Paolo L. Rossi, "*Sprezzatura,* Patronage, and Fate: Benvenuto Cellini and the World of Words." In Philip Jacks, eds., *Vasari's Florence: Artists and Literati at the Medicean Court.* Cambridge: Cambridge University Press, 1998, 55–69.

RUBIN Patricia Rubin, *Giorgio Vasari: Art and History.* New Haven and London: Yale University Press, 1995.

RYAN Christopher Ryan, ed. and trans., *Michelangelo: The Poems.* London: Dent, 1996.

SASLOW James Saslow, *Ganymede in the Renaissance: Homosexuality in Art and Society.* New Haven: Yale, 1986.

SCALINI Mario Scalini, *Benvenuto Cellini.* Translated by Kate Singleton. Florence: Scala, 1995.

SCHLOSSER 1896 Julius von Schlosser, "Giusto's Fresken in Padua und die Vorläufer der Stanze della Segnatura." *Jahrbuch der kunsthistorischen Sammlungen des allerhöchsten Kaiserhauses* 17 (1896): 13–100.

SCHLOSSER 1927 Julius Schlosser, "Das Salzfaß des Benvenuto Cellini." In Schlosser, ed., *Präludien.* Berlin: Bard, 1927, 340–56.

SCHMIDT Charles Schmidt, *La poésie scientifique en France au XVIᵉ siècle.* Paris: Rencontre, 1970.

SCHNEIDER Erich Schneider, "Korallen in fürstlichen Kunstkammern des 16. Jahrhunderts." *Weltkunst* 52 (1982): 3447–50.

SCHOLTEN Frits Scholten, ed., *Adriaen de Vries, 1556–1626.* Exh. cat. Rijksmuseum; Nationalmuseum; Los Angeles: The J. Paul Getty Museum; In association with Waanders, 1998.

SCHULTZ Bernard Schultz, *Art and Anatomy in Renaissance Italy.* Ann Arbor: UMI Research Press, 1985.

SEDGWICK Eve Kosofsky Sedgwick, *Between Men: English Literature and Male Homosocial Desire.* New York: Columbia University Press, 1985.

SEGNI Bernardo Segni, *L'Ethica d'Aristotile tradotta in lingua vulgare fiorentina et comentata.* Florence: Lorenzo Torrentino, 1550.

SEMPER Hans Semper, *Donatello, Seine Zeit und Schule.* Vienna: Braumüller, 1875.

SERLIO Sebastiano Serlio, *Il terzo libro d'architettura*. Venice: Sessa, 1551.

SEYMOUR Charles Seymour, Jr., *Michelangelo's David. A Search for Identity*. New York: Norton, 1974.

SEZNEC Jean Seznec, *The Survival of the Pagan Gods*. Princeton: Princeton University Press, 1972.

SHEARMAN 1967 John Shearman, *Mannerism*. London: Penguin, 1967.

SHEARMAN 1992 John Shearman, *Only Connect . . . Art and the Spectator in the Italian Renaissance*. Princeton: Princeton University Press, 1992.

SMYTH Craig Hugh Smyth, *Mannerism and Maniera*. Vienna: IRSA, 1992.

SODERINI Giovanni Vittorio Soderini, *Trattato degli arbori*. Bologna: Bacchi dalla Lega, 1904.

SOMIGLI 1952 Guglielmo Somigli, "Leonardo da Vinci e la fonderia." *La Fonderia Italiana* 7 (1952).

SOMIGLI 1958 Somilgli, Guglielmo, *Notizie storiche sulla fusione del Perseo*. Milan: Associazione Italiana di Metallurgia, 1958.

SPALLANZANI Marco Spallanzani, "The Courtyard of Palazzo Tornabuoni-Ridolfi and Zanobi Lastricati's Bronze Mercury." *The Journal of the Walters Art Gallery* 37 (1978): 7–21.

STEINBERG Leo Steinberg, "Who's Who in Michelangelo's Creation of Adam: A Chronology of the Picture's Reluctant Self-Revelation." *Art Bulletin* 74 (1992): 552–566.

STEINER Reinhard Steiner, *Prometheus: Ikonologische und anthropologische Aspekte der bildenden Kunst vom 14. bis zum 17. Jahrhundert*. Munich: Klaus Boer, 1991.

STEINMANN 1907 Ernst Steinmann, *Das Geheimnis der Medicigräber Michel Angelos*. Leipzig: K. W. Hiersemann, 1907.

STEINMANN 1913 Ernst Steinmann, *Die Portraitdarstellungen des Michelangelo*. Leipzig: Klinkhardt and Biermann, 1913.

SUMMERS 1978 David Summers, "David's Scowl." In Wendy Steadman Sheard and John Paoletti, eds., *Collaboration in the Italian Renaissance*. New Haven and London: Yale University Press, 1978, 113–24.

SUMMERS 1979 David Summers, *The Sculpture of Vincenzo Danti: A Study in the Influence of Michelangelo and the Ideals of the Maniera*. New York: Garland, 1979.

SUMMERS 1981 David Summers, *Michelangelo and the Language of Art*. Princeton: Princeton University Press, 1981.

SUMMERS 1987 David Summers, *The Judgment of Sense: Renaissance Naturalism and the Rise of Aesthetics*. Cambridge: Cambridge University Press, 1987.

SUMMERS 1989 David Summers, "ARIA II: The Union of Image and Artist as an Aesthetic Ideal in Renaissance Art." *artibus et historiae* 20 (1989): 15–31.

SUMMERS 1993 David Summers, "Form and Gender." *New Literary History* 24 (1993): 243–71.

SYMONDS John Addington Symonds, trans., *The Life of Benvenuto Cellini*. New York: Scribners, 1924.

TASSI Ferdinando Tassi, *Prose e poesie di Benvenuto Cellini con documenti la maggior parte inediti*. Florence: Guglielmo Piatti, 1829.

TEBALDUCCI Lorenzo Giacomini Tebalducci Malespini, *Orationi e Discorsi*. Florence: Sermartelli, 1597.

TESTA Judith Ann Testa, "The Iconography of the the *Archers*. A Study of Self-Concealment and Self-Revelation in Michelangelo's Presentation Drawings." *Studies in Iconography* 5 (1979): 45–72.

TOMMASEO–BELLINI Niccolò Tommaseo and Bernardo Bellini, *Dizionario della lingua italiana*. Turin: Unione tipografico, 1861–79.

TRENTO Dario Trento, *Benvenuto Cellini: Opere Non Esposte e Documenti notarili.* Exh. cat. Florence: Museo Nazionale del Bargello, 1984.

TYARD Pontus de Tyard, *Oeuvres: Solitaire Premier.* Geneva: Droz, 1950.

VALENTINER W. R. Valentiner, "Cellini's Neptune Model." *Bulletin of the North Carolina Museum of Art* 1 (1957): 5–10.

VAN DEN AKKER Paul van den Akker, *Sporen van vaardigheid: De ontwerpmethode voor de figuurhouding in de Italiaanse tekenkunst van de renaissance.* Amsterdam: Uitgeverij Uniepers, 1991.

VARCHI 1555 *I Sonetti di M. Benedetto Varchi.* Venice: Pietrasanta, 1555.

VARCHI 1827 Bendetto Varchi, *Questione sull'alchimia.* Florence: Stamperia Magheri, 1827.

VARCHI 1859 Benedetto Varchi, *Opere.* 2 vols. Trieste: Lloyd Austriaco, 1859.

VASARI Giorgio Vasari, *Le Vite de' Più Eccelenti Architetti, Pittori, et Scultori Italiani, da Cimabue insino a' Tempi Nostri* (1550). Edited by Luciani Bellosi & Lorenzo Torrentino. Turin: Einaudi, 1986.

VASARI-MILANESI Gaetano Milanesi, ed., *Le Vite de' piu eccellenti pittori, scultori ed architettori.* Florence: Sansoni, 1880.

VERMEULE Cornelius C. Vermeule, "Hellenistic and Roman Cuirassed Statues: The Evidence of Paintings and Reliefs in the Chronological Development of Cuirass Types." *Berytus Archaeological Studies* 13 (1959): 1–82.

VICKERS Nancy J. Vickers, "The Mistress in the Masterpiece." In Nancy K. Miller, ed., *The Poetics of Gender.* New York: Columbia University Press, 1986, 19–41.

VIERI 1568 Francesco de' Vieri, *Discorso...del soggetto, del numero, dell'uso, et della dignità et ordine degl'habiti dell'animo, cioè dell'arti, dottrine morali, scienze specolatiue, e facolta stormentali.* Florence: Giunti, 1568.

VIERI 1576 Francesco de' Vieri, *Discorso intorno a' dimonii, volgamente chiamati spiriti.* Florence: Bartolomeo Sermartelli, 1576.

VIERI 1581 *Trattato di M. Francesco de' Vieri...nel quale si contengono i tre primi libri delle Metheore.* Florence: Giorgio Marescotti, 1581.

VIERI 1586 Francesco de' Vieri, *Discorso...delle maravigliose opere di Pratolino et d'Amore.* Florence: Giorgio Marescotti, 1586.

VIGENERE Blaise de Vigenère, *La Description de Callistrate de Quelques Statues.* Paris: Bourbonnois, 1602.

VOSSILLA 1994 Francesco Vossilla, "Storia d'una fontana. Il Bacco del Giambologna in Borgo San Jacopo." *Mitteilungen des kunsthistorischen Institutes in Florenz* 38 (1994): 130–46.

VOSSILLA 1996a Francesco Vossilla, "L'Altare Maggiore di Santa Maria del Fiore di Baccio Bandinelli." In Cristina De Benedictis, ed., *Altari e committenza: Episodi a Firenze nell'età della Contrariforma.* Florence: Angelo Pontecorboli, 1996, 37–67.

VOSSILLA 1996b Francesco Vossilla, "Da scalpellino a cavaliere: L'altare-sepolcro di Baccio Bandinelli all'Annunziata." In Cristina De Benedictis, ed., *Altari e committenza: Episodi a Firenze nell'età della Contrariforma.* Florence: Angelo Pontecorboli, 1996, 68–79.

VOSSILLA 1997 Vossilla, Francesco. "Baccio Bandinelli e Benvenuto Cellini tra il 1540 ed il 1560: Disputa su Firenze e su Roma." *Mitteilungen des Kunsthistorischen Institutes in Florenz* 41 (1997): 254–313.

WALDMAN Louis Waldman, "'Miracol' novo et raro': Two unpublished contemporary satires on Bandinelli's 'Hercules'." *Mitteilungen des Kunsthistorischen Institutes in Florenz* 38 (1994): 419–27.

WALLACE William H. Wallace, "Studies in Michelangelo's Finished Drawings," Ph.D. diss., Columbia University, 1983.

WARNCKE Carsten-Peter Warncke, "Cellinis 'Saliera' – der Triumph des Goldschmieds." *artibus et historiae* 42 (2000): 41–52.

WERNICKE Konrad Wernicke, "Apollon." In *Paulys Real-Encyclopädie* Stuttgart: J. B. Metzler, 1920, vol. 2, part 1, 2–111.

WILLIAMS Williams, Robert, *Art, Theory, and Culture in Sixteenth-Century Italy: From Techne to Metatechne.* Cambridge: Cambridge University Press, 1997.

WINNER 1968 Matthias Winner, "Federskizzen von Benvenoto Cellini." *Zeitschrift für Kunstgeschichte* 31 (1968): 293–304.

WINNER 1983 Mattias Winner, "Poussins Selbstbildnis im Louvre als kunsttheoretische Allegorie. *Römisches Jahrbuch für Kunstgeschichte* 20 (1983): 417–49.

WITTKOWER 1964 Rudolf and Margot Wittkower, *The Divine Michelangelo. The Florentine Academy's Homage on his Death in 1564.* London: Phaidon, 1964.

WITTKOWER 1977 Rudolf Wittkower, *Sculpture: Processes and principles.* New York: Harper & Row, 1977.

WRIGHT David Roy Wright, "The Medici Villa at Olmo a Castello:Its History and Iconography." Ph.D. diss., Princeton University, 1976.

YATES Frances Yates, *The French Academies of the Sixteenth Century.* London: Warburg Institute, 1947.

ZUCCARO *Scritti d'arte di Federico Zuccaro.* Edited by Detlef Heikamp. Florence: L. S. Olschki, 1961.

Index